Chicago Painting 1895 to 1945
THE BRIDGES COLLECTION

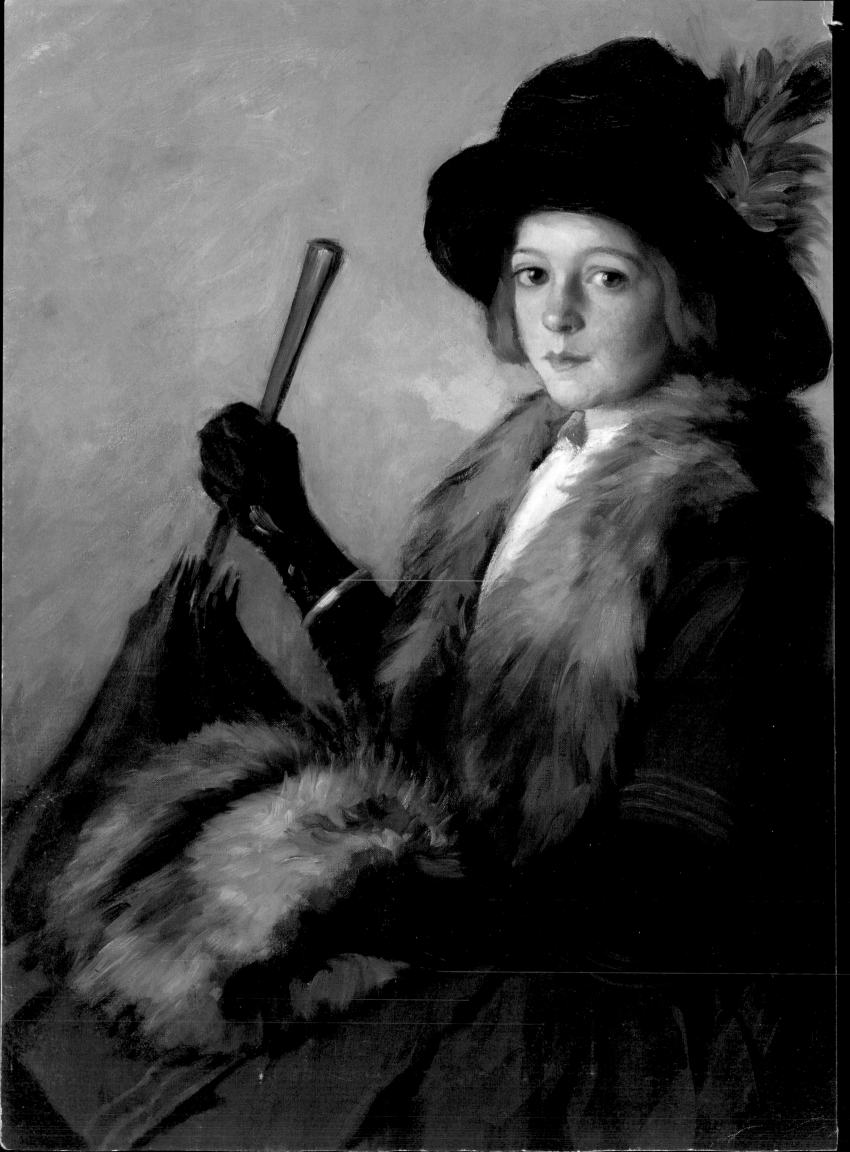

Chicago Painting

1895 to 1945

THE BRIDGES COLLECTION

essays by
Wendy Greenhouse
Susan Weininger

with an introduction by
Susan C. Larsen

and preface by
Kent Smith

University of Illinois Press
with the
Illinois State Museum
Springfield
2004

The Illinois State Museum is a division of the
Illinois Department of Natural Resources.

Rod R. Blagojevich, Governor
Joel Brunsvold, Director
R. Bruce McMillan, Director, Illinois State Museum

Published by University of Illinois Press
with the
Illinois State Museum
502 South Spring Street
Springfield, Illinois 62706-5001

© 2004 Illinois State Museum
All rights reserved.
Manufactured in China.
P 5 4 3 2 1

Greenhouse, Wendy, Susan Weininger, and
Susan C. Larsen

Chicago Painting 1895–1945: The Bridges Collection

ISBN: 0-252-07222-7

Exhibition Curator and Project Coordinator:
Kent Smith

Design: Gene Skala Design, Chicago
Photography: Michael Tropea
Printing: University of Illinois Press

This book was published following the exhibition
The Bridges Collection: Chicago Painting 1895 to 1945
organized by the Illinois State Museum and presented
at the:

Illinois State Museum
Chicago Gallery, Chicago
January 31–May 19, 2000

Illinois State Museum
Southern Illinois Art Gallery, Whittington
September 17, 2000–January 15, 2001

Illinois State Museum
Springfield
February 11–September 2, 2001

Illinois State Museum
Lockport Gallery, Lockport
September 22–December 22, 2001

Library of Congress Cataloging-in-Publication Data

Greenhouse, Wendy, 1955–
Chicago painting, 1895 to 1945: the Bridges collection / essays by Wendy Greenhouse and
Susan Weininger; with an introduction by Susan C. Larsen and preface by Kent Smith.
p. cm.
Catalog of an exhibition held at four of the Illinois State Museum's five locations around the state
from 1999 to 2001. Organized by the Illinois State Museum Society.
Includes bibliographical references.
ISBN 0-252-07222-7 (pbk. : alk. paper)
1. Art, American–Illinois–Chicago–19th century–Exhibitions. 2. Art, American–Illinois–
Chicago–20th century–Exhibitions. 3. Bridges, Powell–Art collections–Exhibitions. 4. Bridges,
Barbara A.–Art collections–Exhibitions. 5. Art–Private collections–Illinois–Exhibitions.
I. Weininger, Susan. II. Illinois State Museum. III. Illinois State Museum Society. IV. Title.
ND235.C45G74 2004
759.173′11′07477311–dc22 2004016262

Contents

Preface

Kent Smith, Director of Art, Illinois State Museum

It has been our great pleasure to present the exhibition *Chicago Painting 1895 to 1945: The Bridges Collection* at four of the Illinois State Museum's five locations around the state from 2000 to 2001 as part of the Museum's Year 2000 celebration for the people of Illinois. The exhibition, and this book, highlight an outstanding, private, Illinois collection assembled by Barbara and Powell Bridges of Wilmette. The Bridges are among a handful of collectors seriously assembling collections of Illinois art from this time period. Their willingness to lend their collection offered the Illinois State Museum an opportunity to present a traveling exhibition of the finest work available by Chicago artists of this era. We trust this publication will continue what the exhibition began and inform a new generation about the painters who lived and worked in Chicago during the late nineteenth and early twentieth centuries.

For over three years Susan C. Larsen, Ph.D., Collector Archives of America Art, Wendy Greenhouse, Ph.D., Art Historian and Independent Curator, and Susan Weininger, Professor, Roosevelt University, have undertaken research on the artists and the specific paintings represented in the collection. In this publication Susan C. Larsen provides a profile of the collectors and an overview of the breadth of the Bridges Collection, Wendy Greenhouse offers a host of insights into the lives and work of the artists who worked prior to the turn of the last century and into the early decades of the twentieth century, and Susan Weininger guides us into the Modernist era and Chicago's particular approach to painting through the second World War. We are extremely grateful to each of them for their efforts and contributions to the project.

Special thanks to Museum Director R. Bruce McMillan, Associate Director of Science Bonnie Styles, and Associate Director for Policy and Planning Karen Witter for their support and encouragement of this project. Museum staff Estie Karpman, Robert Sill, Amy Jackson, Carole Peterson, Phil Kennedy, Jane Stevens, Judith Lloyd, Koyo Konishi, Doug Stapleton, Debra Tayes, Jim Zimmer, and Geoffrey Bates have all made important contributions to the success to the project. Prior to the presentation of the exhibition, Agass Baumgartner, President of Baumgartner Fine Art Restoration, was engaged to conserve the majority of the paintings and period frames in the collection.

Michael Tropea photographed the collection, Faye Andrashko has provided excellent advice as editor, and Gene Skala has provided the handsome graphic design for the project publications. The Illinois State Museum is pleased to work once again with the University of Illinois Press and Director Willis G. Regier and his professional staff in the copyediting, publication, and distribution of this publication.

I have learned much from the Bridges about the paintings in their impressive collection, about the artists who created them, and the thoroughness of their approach to collecting. It has been a delight to work with Powell and Barbara on every aspect of the project.

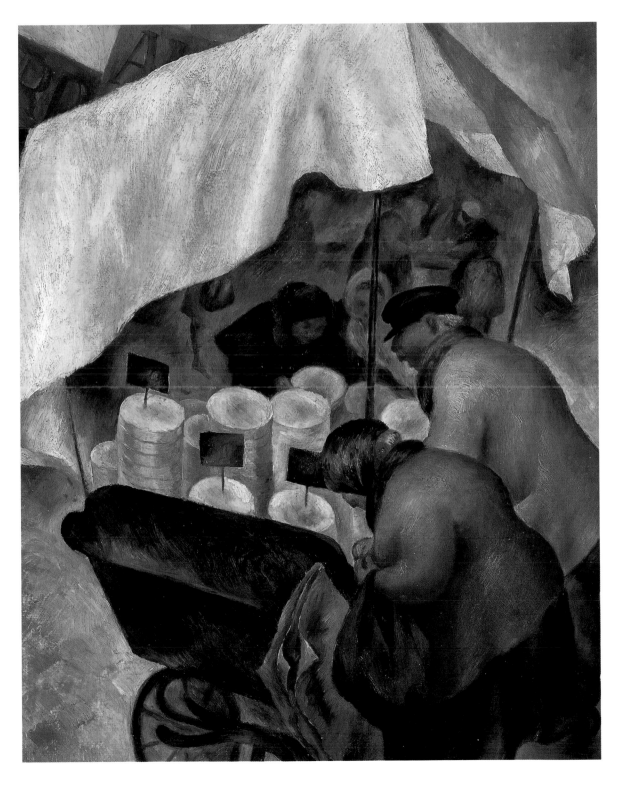

Frances Foy, *Cheese Seller* [Paris Cheese Vendor, Paris, France] (detail), 1928, oil on masonite, 27³/₄ × 24 in., Cat. 36.

The Powell and Barbara Bridges Collection

Susan C. Larsen

In our times, the word "collector" has taken on a casual and friendly meaning. The habit of accumulation is widespread in our culture. In other times and other places, referring to a person as a serious collector has meant much more. It described a purposeful and committed individual who had acquired expertise in a field focused upon a group of highly valued objects. It implied great learning and the heart and spirit to engage in a pursuit of the rare and the beautiful. The collector's ardent pursuit of beautiful things involved financial risk, which was often spurred on by spirited competition. Collectors used their wits, resources, and hard-won personal prestige in the competitive world of art to gain access to the best works and the best advice while also following their own passionate course. In the end, they alone were responsible for determining the ultimate scope and character of their collections.

Although collections, especially art collections, are defined by the beauty and the nature of the works within them, a collection is also an intellectual and an emotional construction. Collections are temporary alliances of particular objects brought together by the desire and extraordinary effort of the collector. Collections have a way of expressing the personality and personal values of their owners. This is especially so if they are large ensembles involving many choices and the orchestration of a central theme by period, style, subject matter, or other criteria. Collections are also the embodiment of a vision. Some collections appear quite suddenly fueled by a burst of enthusiasm. More typically, the collector's vision evolves through time, profits from self-education, and gains dramatic impact from the high adventure of creating a unique ensemble that puts each element into a new relationship with art history.

Such an adventure belongs to the Chicago-area collectors Powell and Barbara Bridges, who have played a significant role in transforming our understanding of the artistic life of Chicago. When Powell Bridges began his program of research and acquisition in the 1970s, he bought a broad range of American paintings created during the period 1880 to 1945.

Bridges formed lasting friendships with scholars and other collectors while refining his own sensibility, gaining insight into artistic quality, and forming a great personal library that at one point amounted to over a thousand volumes on American art. Paintings came and went as Bridges replaced individual works with finer ones. His standards of excellence evolved and deepened over time. He and his wife Barbara began to engage in a dialogue with each other and with the art that enhanced and animated every room of their family home. Powell Bridges soon aspired to create something unique and of lasting value to the field of American art. Bridges' collecting activity, now much more than a pastime, needed to find a permanent focus.

A successful attorney whose habits of research and precision have served him well in all areas of endeavor, Powell Bridges turned his attention to the artistic history of early-twentieth-century Chicago, with the thought of forming a wide-ranging and definitive collection. This shift of emphasis and intention took place in the 1980s as Bridges focused upon the art of Chicago during the period of 1880 to 1945, a period of American art he already knew quite comprehensively. Focusing exclusively upon the artists of the Chicago area, he found exciting and beautiful work, many remarkable and under-recognized individual artists, and an entire field of study just beginning to enjoy serious scholarly interest. Almost immediately, Bridges' activity as a collector helped demonstrate the high level of artistic practice in Chicago and engage the interest of other collectors, curators, and scholars in the accomplishments of outstanding individual artists.

The present exhibition is the happy outcome of Powell Bridges' achievement as an art collector and his willingness to share the outcome of his adventures with all of us. It is an impressively comprehensive panorama of advanced art of the Chicago area up until World War II. It was not created merely as a decorative adjunct to life but as a purposeful investigation of a place and a time through the art of its most ardent innovators. As it so happened, one of Powell Bridges' early posts was that of investigating attorney for the Federal Trade Commission. This intriguing position brought him to Chicago from his native Tennessee in the late 1950s. He would go on to become a distinguished member of the legal community in Chicago, a person respected for his evenness of temper, exacting attention to detail, and his lively curiosity. Living very much in the mainstream of American life, Powell Bridges has an avid appreciation for the many tributaries of culture, the ethnic and racial diversity that enliven and support mainstream artistic achievement in America. Even today, Bridges' warm, accented speech reflects his calm, centered approach to life, a felicitous blending of Southern and Midwestern values such as modesty, openness, the habit of hospitality, and a graceful generosity.

Powell Bridges' typical thoroughness and attention to detail and his respect for finding the absolute and complete truth about any given set of circumstances has perhaps shown itself most plainly in the sweeping, inclusive nature of his art collection. He has searched for the diverse, multicultural, artistic melting pot of modern styles finding their way into Chicago art in the early twentieth century. Powell Bridges has his personal favorites among these canvases, but expresses his greater love in the grand and comprehensive view his collection affords us as an ensemble, showing us the enormous energy of an artistic world coming into existence in the American Midwest. The artistic history of Chicago has typically taken second position to a universal celebration of the city's great achievements in the

realm of architecture and design. Chicago is also renowned as a city with internationally important collections of art, predominantly European art of the nineteenth and early twentieth centuries. Indeed, the city's deep ties to the Midwestern countryside have been important to architects, painters, sculptors, poets, and philosophers, and have given Chicago culture a distinct identity as an urban community on the prairie.

Anyone familiar with the many ethnic neighborhoods within the city of Chicago would also be aware of its complex and lingering cultural, linguistic, and religious affiliations with much of Europe, especially Eastern Europe, with Scandinavia, and more recently with Asia and Latin America. Many young native-born Chicago painters of the time chose to study in a European city of their forebears, reasoning that a family language and culture might provide a sense of familiarity as they sought out avant-garde ideas to challenge their Midwestern artistic upbringing.

The result was a grand polyglot art world in touch with a multiplicity of new ideas as well as traditional academic values coming from many parts of Europe. At times these crosscurrents made for lively art and spirited discourse. On other occasions, the multiplicity of viewpoints prevented a cohesive scene from developing around a few central personalities and clearly expressed and sharply focused artistic concepts. In short, there was no single dominant style or nationally influential avant-garde artistic movement coming out of the Chicago art scene as there would be in the 1960s. There is, however, a distinctive character to the art of the Midwest during the period 1880–1945. It can be clearly seen and felt and perhaps also understood through the remarkable art collection of Powell Bridges. For this new perspective on the artistic life of Chicago and the generous, expansive overview afforded by this important collection, we thank Powell and Barbara Bridges for parting with it temporarily. They have offered the contemporary art community an opportunity to reflect upon the perennial character, habits, and values of the Midwest as a cultural region.

The overwhelming impression created by the Powell and Barbara Bridges Collection installed within their Wilmette, Illinois, home is one of warmth, sensuous pleasure, and pride in the regional landscape dotted by humor and human stories told with fond frankness by genre painters of this region. Powell Bridges' focus upon turn-of-the-century painters of the Chicago area sharpened after 1987 with his purchase of several canvases by Alfred Juergens, who was active in the region from the 1880s until his death in 1934. "My first love was Impressionism," recalled Powell Bridges, even as he recounted his intensive study of modern art in several university seminars and the creation of a vast art library to serve his daily inquiries into the history of American painting. Early acquisitions such as Juergens' *The Back Porch* (c. 1911) and his *A September Garden* (c. 1921) satisfied Powell Bridges' fond appreciation for the beauties of Impressionist style, while putting the collector in touch with a generation of Chicago area painters. These graceful landscape painters celebrated the quieter everyday pleasures of the rural and suburban meadows, lakes, and rivers surrounding the great urban center of Chicago.

Powell Bridges has owned a number of Juergens canvases, buying and selling to refine his collection and to give it greater coherence. He certainly achieved his focus with an important group of three late Juergens paintings of downtown Chicago: *LaSalle Street at Close of Day* (1915); *State Street, Armistice Day* (1918); and *State Street* (third Palmer House hotel) (c. 1920). These paintings are striking in their ambitious scale, the dramatic interplay of many figures in the urban landscape and the artist's faithful record of the city's justly celebrated architecture. Bridges' collection of Alfred Juergens paintings demonstrates the artist's growth and development from a spirited disciple of European landscape conventions to an alert and sensitive citizen of a great city, who is able to blend important historical events, and a sense of narrative with the skills of a fine landscape painter.

Finding himself on solid ground in his admiration for the art of Alfred Juergens, Powell Bridges quickly moved to acquire important canvases by Chicago area landscape painters who frequented the Brown County Colony in Indiana at the turn of the century. Brown County Colony attracted the most idealistic and gifted of Midwestern artists, many of whom were attracted by its emulation of the Barbizon School and the plein-air practices of the French Impressionists. One of the best was Adam Emory Albright (1862–1957), who often painted country children combining activities of work and play.

Albright's children have an earthy charm and an otherworldly beauty. A highlight of the Bridges Collection is his [Landscape with Six Children] (c. 1914–15) a luminous and endearing work that happens to be a favorite of Barbara Bridges. Certainly the subject of children in the out-of-doors is appealing. The work also affirms an idealized rural way of life as it was often portrayed by Albright's Midwestern contemporaries who joined him in summer retreats at the Brown County Art Colony. The beautiful children in Albright's painting have the added virtue of caring for one another, the older children looking after and even carrying the little ones. Traveling down a country road bathed in sunlight, they may not yet distinguish work from play. Their innate grace is captivating, their fond mutual regard affirms the American spirit of brotherhood and egalitarian fellowship.

Adam Emory Albright studied at The Art Institute of Chicago, the Chicago Academy of Fine Arts, and the Pennsylvania Academy of Fine Arts. He returned to Chicago in 1888 and took up residence as an artist, with frequent sojourns to nearby and also exotic places in search of new subject matter. [Landscape with Six Children], painted around 1914–15, may have been sketched in Pennsylvania. Powell Bridges has perused a number of archival sources on the artist's travels and practices and become acquainted with various periods and moods in his art. The canvas [Venezuelan Landscape] (1917–18), provides a useful comparison and a charming companion piece to the larger [Landscape with Six Children].

The impact of French Impressionism lingered in the art of Chicago, especially in the work of those who studied or taught at The Art Institute of Chicago, with its world-renowned collection of Impressionist art. Charles F. Browne (1859–1920) came to Chicago from Massachusetts in the 1890s as an advocate of Impressionist style without the coloristic excesses being advanced by French Post-Impressionists and their radical offspring, the Fauves. His [Landscape with River and Boat] was painted in France around c. 1908. This quiet, elegant view was created as Cubism was being conceived by Picasso and Braque and the art of the French Fauves was causing a riot in the world of Parisian art. C. F. Browne's approach has the solid virtues of classical composition, clear spatial recession, and crisp, carefully delineated form. His version of Impressionist style appealed to a Midwestern sensibility preferring clarity to vagueness, calm plenitude to fragmentation and tumult.

As his career unfolded, Charles F. Browne would adopt some of the broader brushstrokes and blocky forms of the early-twentieth-century moderns. *Autumn Hillside* (Oregon, Illinois) (1917) featured massed planes of brighter color, an exciting diagonal view, and a more responsive sensibility to portraying the landscape as it might have actually existed. Here, idealism and formula have given way to living reality. Browne's journey as an artist would be repeated in the careers of many Chicago Modernists.

A more brusque yet friendly spirit animates the canvases of Charles Dahlgreen (1864–1955), whose work has a special place in the Powell and Barbara Bridges Collection. *Deserted Cabin* (Brown County, Indiana) (c. 1920) has a colorful and rusticated character reflecting the values of this important artists' colony of the early twentieth century. Dramatic simplicity and a faithful rendering of the Midwestern landscape combine in *Wolf River* (Wisconsin), of c. 1927. Charles W. Dahlgreen studied at The Art Institute of Chicago and the Chicago Academy of Fine Arts before setting up his studio in Oak Park, Illinois. He was a leading exponent of a new Midwestern Modernism akin to the experimental ideals of architects Louis Sullivan and Frank Lloyd Wright. Deriving their forms and colors from the prairie, these individuals hoped to create a new idiom faithful to nature while embracing the radical simplicities of the new century in design.

The art of Carl Krafft (1884–1938) has long been popular among collectors of American landscape painting. His compositions are often startling in their high color and dramatic, almost theatrical, presentations of nature's odd and transcendent moments. Powell Bridges has been able to secure rare and particularly choice works by most of the artists of the Chicago area. However, the earliest works of Carl Krafft have so far eluded the collector's grasp. His canvas by Krafft, *The Old Mill in Winter* (c. 1925–26), is a late example with a softer, less pyrotechnic palette than the earlier most sought-after works of Krafft. A veteran of the Brown County Art Colony (1908–12), Krafft took his spiritualized vision to many parts of the country, transforming everything he saw through the lens of his remarkable personality.

Strong temperament and a taste for the dramatic are also factors in the art of Frank Peyraud (1858–1958), who came to Chicago from his native Switzerland. He studied in Paris and at The Art Institute of Chicago before settling in Peoria, Illinois. Peyraud gained a considerable reputation as a painter of dramatic landscapes such as *Souvenir of the Berkshires* (1914) and the luminous *Autumn on the Des Plaines* (c. 1925–30). In the latter canvas he has employed a close, dramatic framing of the scene so typical in the art of Monet. His color, however, is more radical as it reflects his acquaintance and understanding of Fauvist principles. Painters such as Dahlgreen, Krafft, Peyraud, and others of their circle did not necessarily wish to keep up with developments in Paris but borrowed elements suited to their own needs and sensibilities. Artificial colors and intellectual experiments seemed out of place in the Midwestern landscape and in the drawing rooms of Midwestern homes. These artists have more in common with poets like Edgar Lee Masters and Carl Sandburg and architects like Louis Sullivan, D. H. Burnham, and Frank Lloyd Wright. A celebration of nature's intellectual and spiritual architecture as seen in the lexicon of natural forms was a more universally consulted text than the latest theories coming from Paris. It is also possible that a bit of national and regional pride was attached to deriving one's own style from materials and issues close at hand.

The art of Lucie Hartrath (1868–1962) found favor with her Midwestern audiences as she blended Impressionist techniques with familiar scenes. *The Creek* (c. 1917) is a typically pleasing yet also typical view of the Brown County, Indiana, landscape, with its winding rivers and mellow topography. One of the genuine opportunities presented to Powell and Barbara Bridges was the availability of high-quality paintings by women artists who had worked and prospered in the Chicago area during the early twentieth century. The Bridges' were quick to understand the value of these women painters and made very astute selections. To hear

Powell Bridges converse on the role of women in the artistic life of Chicago is to understand how proud he is of the collection and how cognizant he is of the role of women artists past and present. The art of Chicago women abounds in this distinguished collection and has played a major and irreplaceable role in its evolution, as we shall see.

In the Bridges' home, some works of art stand out for their exceptional beauty and dramatic presence. One such painting is Rudolph Ingerle's *Morn on the Tuckasegee*, Smoky Mountains, of 1928. Its luminosity and wild beauty that are very different from the more even-toned and gentle topography of the Midwest. Ingerle (1879–1950) and other Chicago-area painters of his generation loved to travel to exotic locations, especially within the United States, in search of unusual and dramatic views. This canvas, with its exoticism and its glowing, incandescent color, is a show-stopper.

In matters of subject, one special focus within the Bridges Collection is its dedication to scenes of urban life in Chicago and the semi-urban landscape of the surrounding countryside. Anyone familiar with the city is immediately impressed by its system of wonderful parks and forest preserves that open up urban spaces, provide a setting for shared leisure activities, and help to foster a democratic spirit in the population. Among the earliest of these views within the Bridges Collection is *Old Stone Bridge, Garfield Park* (1917) by William Clusmann (1859–1927) and a stunning companion piece, *Bandshell, Garfield Park* (1917). Patterned upon the urban leisure activities so lovingly depicted by the French Impressionists, Clusmann's paintings celebrate the graceful and beautiful aspects of prosperous people at play. In his art, the city is a grand backdrop, a stage upon which the population may fulfill its private pleasures and civic pride.

More intimate, fond, and emotional is Anthony Angarola's *Bench Lizards, Lincoln Park* (1922). According to Powell Bridges, Anthony Angarola (1893–1929) lived just blocks away from Lincoln Park and was an avid observer of daily patterns of life and activity among its citizens. The artist's wife, daughter, and son are depicted among the habitués of beautiful Lincoln Park. Angarola's park visitors are arranged in family groups, in friendly neighborhood conversations, all with an air of convivial warmth and gaiety. His forms are outlined and slightly flattened into curved shapes, which project a charming sense of simplicity and forthrightness. Angarola's painting reflects the traditional spirit of Chicago's many ethnic neighborhoods where people found a sense of belonging and permanence within the big American city.

A similar emphasis upon neighborhood pride and middle-class pleasures can be found in *The Bridge, South Pond* [Lincoln Park] (1924) by Gustaf Dalstrom (1893–1971). As in the previous painting by Angarola, the art of Dalstrom projects a love of children and a joy in their presence. Children and family appear with great frequency in the Bridges Collection, certainly because they are cherished by the collectors but also because family life was a favorite subject of Chicago artists. Only infrequently does one see the sophisticated life of adult evening entertainment. Much more typical are views of neighborhood recreation including mothers, children, and elders of the community. Gustaf Dalstrom's *[School Yard, Abraham Lincoln School, Chicago]*, painted in the early 1930s, is a joyous and celebratory painting, full of a child's pleasure in pattern, repetition, and bright color.

The times required that artists stick together for mutual benefit. Gustaf Dalstrom was the director of the Mural Division of the WPA/Federal Art Project in Chicago and a generous colleague who encouraged and supported the work and careers of fellow artists. He was married to painter Frances Foy (1890–1963), who also focused upon the joys of urban and family life. Her *Cheese Seller* (1928)

is one of the warmest and most appealing canvases in the Bridges Collection. Likewise, her *Portrait of Frances Strain* (1932) is an affectionate view of a fellow painter represented in the Bridges Collection. Frances Strain maintained a studio in the Hyde Park area. This portrait shows her as a fashionable young woman in a sophisticated setting. The bohemian ambience of *The Visitor* (1929) by Frances Strain (1898–1962) reveals the artist's live-in studio; her gentleman visitor, artist Emil Armin; and a taste for simple inexpensive furnishings in bright colors. Artists were not always encouraged in Chicago, as elsewhere in America, where the professional status of the artist—and particularly the woman artist—was seldom understood or respected. Artists turned to one another for support, intellectual dialogue, and companionship.

A sober, poignant, and dramatic view of Chicago life is found in the widely appreciated art of Herman Menzel (1904–88). In his *Art of Today, Chicago 1933*, Menzel's contemporary, the critic J. Z. Jacobson, posed the question, "Why, I ask, should an artist expressing the spirit or soul or inner movement of Chicago be expected to paint skyscrapers or stockyards, or steel mills, or river barges, or elevated trains, or masses of people, or pushcart markets, or the lake front, or the impoverished lodgers under the bridges, or any other familiar objects or groups of objects?" Menzel's *Bridges, South Chicago* (c. 1937), offers an eloquent answer to Jacobson's query in the form of a poetic and pointedly urban twentieth-century image. Menzel's Chicagoans live within the industrial heart of the city. It is an overpowering and awe-inspiring place precisely because of its massive industrial infrastructure, which seems to envelop all of nature, including human beings. Menzel's emphasis upon the working class of Chicago, their essential humanity and their dire economic plight, transmutes the spectacle of the city into a dialogue between man and nature, community and commerce. His paintings are confidently and beautifully truthful. A recent exhibition of Menzel's

art, curated by Wendy Greenhouse and Susan Weininger, demonstrated the strength and interest of this artist's work and went a long way to securing his place in the general history of American twentieth-century art.

Calmer celebrations of the great cityscape are more common in the art of successful Chicago area painters such as Emil Armin (1883–1971). Armin's *North from Jackson* (1934) offers a splendid view and specific topographical and architectural landmarks. Pride in the city's famous skyline and in its economic power is evident in Armin's loving attention to detail. He was also capable of a looser, more casual style evident in the spirited *Tawny Dunes* of 1924, with its Expressionist brushwork recalling some of the landscapes of the German Expressionists of the turn of the century.

Expressionism would come to dominate the art of the Chicago area as the twentieth-century unfolded. Especially in the period after World War II, the Chicago imagist movement and the work of artists such as Jim Nutt, Gladys Nilsson, Karl Wirsum, Roger Brown, Ed Paschke, and many others would begin to define Chicago art for the rest of the nation. Seeds of this Expressionist imagery were sown in the 1920s and 1930s by figurative painters who often distorted natural forms to achieve maximum emotional impact. One of the best known Chicago Expressionists is Aaron Bohrod (1907–92), whose long artistic career and great influence as a teacher of art have earned him a central place in the history of Chicago art. Bohrod studied with New York figurative painters Kenneth Hayes Miller and John Sloan, picking up the vivid color and the expressive style, as well as the social ethos of the Ashcan School.

Bohrod's Chicagoans are individuals who often stand for entire segments of the population. They are "types" or characters playing parts in the artist's narrative structure. His curvilinear and

well-muscled figures are reminiscent of statuesque city dwellers painted by Reginald Marsh and Thomas Hart Benton. The rolling, suggestive gait of the fashionably and colorfully clad woman in *State and Grand* (1934) contrasts with the gritty, world-weary stare of the newspaper vendor on the corner. Bohrod is an astute observer of neighborhood life that has dominated Chicago cultural politics throughout the century.

Bohrod worked on the WPA Federal Art Project in Chicago during the Great Depression. In doing so, he found personal good fortune when he won a Guggenheim Fellowship in 1936. Chicago neighborhoods were hit hard by the Depression, as one can see in Bohrod's *North Clark Street* of 1938. Bohrod's devotion to the specific places and people of Chicago made him a valuable witness to the artistic and social life of the city. As an influential teacher, he argued for regional cultural values and inspired subsequent generations of Chicago artists to search within themselves and within their own lives to find a truly innovative regional style.

A key figure in the modern evolution of figurative painting in Chicago was Ivan Albright (1897–1983), who has been revered as an important artist within the city and also internationally. Generations of Chicagoans have toured rooms set aside at The Art Institute of Chicago for the city's most famous and popular modern painter. Grotesque, technically obsessive, and also fascinating, Ivan Albright's draftsmanship is like no other.

Focusing upon decrepitude and flesh falling into an advanced state of decay, Albright suggests moral parallels through his frightening yet fascinating figures. No collection of Chicago area art would be complete without a work by Albright. Building upon this part of the collection in the late 1980s, Powell Bridges found himself at a disadvantage. The important works of Albright had already entered public and private collections.

After going directly to the artist, who was then still alive, Powell Bridges later secured two paintings from the Benton Collection that were conceived and drawn in the 1940s but finished in the artist's old age. These are *From Yesterday's Day* (1971–72) and *The Image After* (1972). Although they are small examples, they are full of the detail and power for which the artist is celebrated.

A very pleasant revelation is the art of Frederick Fursman (1874–1943), who excelled in the portrayal of the mood and character of contemporary Chicagoans. An early painting, *Maizie under the Boughs*, of 1915 has a stylish modern edge recalling Post-Impressionist and Fauvist tendencies to transpose natural color into hotter, more expressive tonalities. Fursman obviously knew the work of Matisse, perhaps also Bonnard. In *Maizie* he has created a portrait describing not only the face and form of the subject but her inner sense of style. Fursman used a very different palette for his portrait of *Sam Gibson* in 1924. Wearing suspenders and a plain shirt and pants, Gibson is presented as a working man with plain and enduring virtues. Leisure, fashion, and a hint of symbolism animate Fursman's *[Young Woman]* of 1931. His paintings are among the largest and most dramatic in the Bridges Collection, with obvious ties to Modernism and also to more conventional values of representation and faithfulness to the truth of his subjects.

Chicago women were very active as artists in the decades of the 1920s and 1930s as we have seen throughout the collection of Powell and Barbara Bridges. One of these women, Ruth Van Sickle Ford (1897–1989), shows a style that is rough and vivid but also charming in its directness. She studied French Cubism very thoroughly, as can be seen in her circa 1933 painting *Belgian Village* [Chicago World's Fair], created to commemorate that important cultural event in the city's history. She returns to a more representa-

tional style in *State and Ohio* of around 1935, which very accurately describes the crowded streets, dense traffic, and excitement of the city. *Jenny*, a portrait painted in around 1935 at Old Lyme, Connecticut, presents a remarkable character—certainly no beauty by usual standards, but a person with enormous charm and vivacity—sewing as she enjoys a summer breeze from her window.

The work of William Schwartz (1896–1977) charted a brave new world in Chicago art, that of the unabashed Modernist trying to maintain a career in a basically conservative art community. An atmosphere of idealism and loneliness pervades his Cubist-styled *Making a Lithograph*, painted in the late 1920s. More completely his own is the beautiful *Symphonic Forms No. 16* of circa 1932, which could hold its own in any display of American abstraction. Artists like William Schwartz will become part of the standard history of American Modernist art as collectors such as Powell Bridges make the case for their inclusion, and in doing so prompt scholarly and critical inquiry and awareness of these artists.

Religious fervor as well as Modernist style combine in the major canvas *Sermon on the Mount* (1933) by Carl Hoeckner (1883–1972). It is the only work by this artist in the Bridges Collection, but it is a powerful piece and a large one whose presence is felt within the ensemble. Hoeckner's Modernist forms seem to have been chosen to convey a sense of spiritual otherworldliness. Painting visions is an abstract enterprise, and many modern artists, for example, Kandinsky and Marc, relied upon the suggestive, imaginative properties of abstraction to portray a spiritual realm.

The influence of Kandinsky upon American Modernists has been studied and proven by art historians researching artistic and intellectual currents of the 1920s and 1930s. It can be clearly seen in a good many of the works of Chicagoan Rudolph Weisenborn (1881–1974), who campaigned for a more progressive understanding of modern art in the city and painted in a spiritualized abstract style. *[Geometric Abstraction]* of 1939 has affinities with the work of New York painters such as Hilla Rebay, Vaclav Vytlacil, Carl Holty, and many others. Weisenborn often exhibited with the American Abstract Artists group in New York City during the 1930s and was heralded by his fellow artists as one of the few Modernists flourishing in the Midwest.

One of the earliest Modernist works in the Bridges Collection is also one of the best. *Fireman* (1912) by Manierre Dawson (1887–1969) is an impressive work by an American artist who clearly understood the implications of Cubism and Futurism in advance of the Armory Show of 1913. Dawson has emerged in recent years as a seminal American Modernist, his work rising in esteem and value and finding its place in the larger history of American twentieth-century art. Powell Bridges spent a considerable period of time studying Dawson's entire output and sought scholarly and curatorial advice in the selection of this fine example. In the end, the choice was his own, and he feels very pleased to have been able to secure such a vivid and typical early work.

In all of its diversity, sweep, and scale, the Powell and Barbara Bridges Collection is a valuable resource for the citizenry, the artists, the scholarly world, and the museum community of the Midwest. Despite his soft-spoken and modest demeanor, Powell Bridges is very proud of the collection and eager to share it with those who seek a truer and broader understanding of the cultural history of Chicago and the surrounding region. It is not a tidy picture dominated by one personality or one single style.

We are now able to see that the Chicago area boasted a vigorous and large community of creative individuals who came to the Midwest from other parts of America and other parts of the world. Powell Bridges has had the zeal, the grit, and the stamina to embrace this wonderful artistic melting pot. In so doing, he has given us all a challenge and a gift. This exhibition is just the beginning of a long relationship between the collector, the artists, and the audience they all hoped eventually to find.

Rudolph Ingerle, *Morn on the Tuckasegee*, 1928, oil on canvas, 28⅛ × 40¼ in., Cat. 50.

"More of Beauty and Less of Ugliness": Conservative Painting in Chicago, 1890–1929

Wendy Greenhouse

NOTES

1. See Sue Ann Prince, ed. *The Old Guard and the Avant-Garde: Modernism in Chicago, 1910–1940* (Chicago: The University of Chicago Press, 1990).

2. *Inter Ocean* quoted in Daniel Rich, "Half a Century of American Exhibitions" in Peter Hastings Falk, ed., *Annual Exhibition Record of the Art Institute of Chicago 1888–1950* (Madison, Conn.: Soundview Press, 1990), 8.

Except in broad surveys and biographical treatments, Chicago's "old guard" artists have received far less attention from scholars and museums than the "avant-garde" for whom they seem to serve as a convenient foil.[1] For some time now, this lopsided view has been refuted by collectors' interest in the work of many so-called conservative Chicago painters who resisted contemporary challenges to conventions of naturalism, representationalism, and idealism. These artists helped create the institutions and ideals that would become the establishment against which more independent spirits would rebel. But the evolution of their seemingly monolithic establishment between the World's Columbian Exposition of 1893 and the Great Depression was a dynamic process. It was shaped by evolving organizational relationships, artistic ideals, and local cultural identity. By examining those factors this essay attempts to sketch a "map" of the issues that define and characterize art in Chicago in that period, in particular the nature of artistic conservatism in the Chicago setting.

The 1880s was a decade of optimism and promise for art in Chicago. The city's artistic infrastructure of clubs and societies, dealers, exhibitions, art schools, art journalism, and private collections had more than recovered from the disastrous Fire of 1871. Chicago's phenomenal post-Fire growth and wealth prompted an influx of new painters and sculptors who joined the return to Chicago of its first generation of European-trained artists. Chicago's resident artists founded several groups, notably the Bohemian Club, a club for women artists formed in 1882, and the Chicago Society of Artists, begun in 1888, today the nation's longest-lived such organization. The inauguration that same year of the annual exhibition of paintings and sculpture by American artists at The Art Institute of Chicago was the occasion of one of innumerable confident pronouncements that "the clouds of indifference to art have lifted and above the horizon of business enterprise there is visible a new dawn"[2]

The enthusiasm with which some Chicagoans hailed the arrival of art in the Metropolis of the West was, characteristically, matched by self-doubt and insecurity. Chicago's "second-city" mentality, a self-conscious, chip-on-the-shoulder attitude, has long shaped the city's cultural character.[3] Chicago was a relative latecomer among modern American cities, and her phenomenal growth and enviable wealth rested on a gritty foundation of basic industries—transportation, lumber processing, steel manufacturing, meat packing, mass retailing—that was perceived by Chicagoans and outsiders alike as furnishing an inhospitable setting for the cultivation of the fine arts. "Chicago," noted one observer hopefully, "has a passionate zest for life; it is arrogant, swaggering, half drunken with pride, puffed up at its benevolence, its large-mindedness, and its ingenuity; and it conceals, as a blustering young man will conceal a virtue or a tenderness, the nostalgia for beauty which yearns in its heart."[4]

Since the pre-Fire days the acute contrast between the city's gritty self-image and its "keen, persistent and crying demand for the beautiful"[5] had fostered a conservative artistic mentality. "Chicago, perhaps just because it knows that the world is likely to accuse it of the contrary, is, if anything, almost unduly anxious to be modest, quiet, and well-bred" in cultural matters. She was an acknowledged follower, rather than a setter, of artistic trends.[6] In the nineteenth century her well-to-do citizens, mostly migrants from the East, were enthusiastic collectors of Old Master works and of Hudson River School-style paintings by both eastern and Chicago-based artists. Images of picturesque and familiar eastern locales by such artists as Junius Sloan (fig. 1) and Daniel Folger Bigelow (fig. 2) offered Chicagoans escape hatches into remote and beautiful worlds.[7] The

3. Kevin Consey, Foreword, *Art in Chicago, 1945–1995* (exh. cat., Museum of Contemporary Art, Chicago, 1996), 8.

4. Elia W. Peattie, "The Artistic Side of Chicago," *The Atlantic Monthly* 84 (Dec. 1899), 831.

5. "The Chicago Beautiful–Woman and Art: The Vital Force," *Fine Arts Journal* (Chicago) 30 (June 1914), 298.

6. Harrison Rhodes, "The Portrait of Chicago," *Harper's Magazine* 135 (June 1917), 89.

7. For information on early Chicago art collectors and their taste, I am indebted to an unpublished paper by Patrick Sowle, "Chicago's Pioneer Art Collectors" (1996), cited with permission from the author.

FIG. 1 Junius Sloan, *Memphremagog, Vermont*, 1871, oil on canvas, 10$^1/_2$ × 18$^1/_2$ in., Cat. 71.

native romanticism and exacting detail of such landscapes found a counterpart in the intimate still-life paintings of Cadurcis Plantagenet Ream (fig. 3), whose modestly priced fruit pictures continued to find buyers well after the tide of cosmopolitanism had turned more sophisticated collectors in the direction of French academic art and Barbizon landscapes. To a great extent, the history of artists in Chicago can be written as the struggle to capture the attention, the respect, and the purses of eastward- and Europe-oriented collectors while forging a distinctive regional identity.

For local painters at the end of the nineteenth century, portraiture proved the most reliable genre, thanks to the steady patronage of the city's business and institutional communities. Its dominance had been established by the powerful example of portraitist George Peter Alexander Healy, who arrived in the city in 1855 to open a studio at the invitation of former first mayor William Butler Ogden. The sophisticated naturalism of Healy's style and the prestigious cosmopolitanism of his career alike helped raise artistic standards and expectations in his adopted hometown, even if—or perhaps because—he was often away on important commissions during the twelve years of his Chicago residency. The portrait would continue to hold a special niche in the work of Chicago painters. Artists such as Louis Betts and Ralph Clarkson devoted their careers to portraiture, and portrait commissions proved a main source of support for painters whose work also ranged into landscape and figure painting, such as Oliver Dennett Grover and Pauline Palmer. Later, members of a more progressive generation would embrace this familiar genre as the vehicle for artistic innovation. Of only minor significance in our conventional retrospective view of Chicago painting compared with the related genre of figure painting and

FIG. 2 Daniel Folger Bigelow, *Untitled [Landscape]*, c. 1895, oil on canvas, 24 × 42 in., Cat. 14.

FIG. 3 Cadurcis Plantagenet Ream, *Untitled [Apples]*, undated, oil on canvas, 14 × 20 in., Cat. 67.

8. See for instance "Many Attractions in Art World: Annual Exhibit at the Institute," *Chicago Record Herald*, Nov. 12, 1911.

9. In the first attempt at a history of painting in Chicago, in 1921, Ralph Clarkson listed seventy talented painters who had left the city to pursue a livelihood elsewhere ("Chicago Painters, Past and Present" in "Chicago as an Art Center," special issue of *Art and Archaeology* 12:3/4 [Sept.–Oct. 1921], 135–36).

10. See for example Ralph Clarkson, "The Art Situation in Chicago (Paper read before the Fortnightly Club)," *Arts for America* 7 (Feb. 1898), 270–73 and Emily Genauer, "The Chicago Art Story," *Theatre Arts* 35 (July 1951), 26–29, 86–883

with landscape, portraiture was the deep, partly submerged foundation on which more decorative, imaginative, or speculative creations were supported. Among the exhibition-going public, however, portraits, especially those of public figures, elicited a level of attention that may seem baffling today.[8] Chicagoans' seemingly insatiable appetite for likenesses of themselves drew a host of distinguished painters from outside the region, notably Eastman Johnson and Gari Melchers.

Healy's Chicago career seems prophetic of the perennial tendency of artists to make the city only a temporary home before departing, usually for New York City or Europe, in pursuit of steadier work or greater status, especially in the eyes of the very Chicago patrons they left behind.[9] The city's failure to hold on to its artists was the subject of perpetual lament,[10] but it was also partly a matter of exaggerated perception. For in actuality a large number of artists did choose to make Chicago their home base, maintaining a local studio address, club memberships, and a presence in local exhibitions, if not continuous residency. Painters were attracted by opportunities for commercial illustration, cyclorama and decorative painting, and teaching. Many came to Chicago for training and stayed, or returned after further studies abroad; some relocated to Chicago after beginning their careers elsewhere; others divided their time between Chicago and more picturesque or prestigious locales but considered Chicago their professional home. Painters as diverse as Ralph Clarkson and Archibald J. Motley Jr. would invest themselves wholly in the city, throwing their professional weight into communal

11. William H. Gerdts, *Art Across America: Two Centuries of Regional Painting 1710–1920. The South and the Midwest* (New York: Abbeville Press, 1990), 302.

12. Helen Lefkowitz Horowitz, *Culture & The City: Cultural Philanthropy in Chicago from the 1880s to 1917* (Chicago and London: The University of Chicago Press, 1976), 172; Leslie Goldstein, "Art in Chicago and the World's Columbian Exposition of 1893" (M.A. thesis, University of Iowa, 1970), 127.

13. Quoted in Rich, "Half a Century of American Exhibitions," 9, n. 6.

14. Rachel Perry, "Introduction: An American Art Colony," in Lyn Letsinger-Miller, ed., *The Artists of Brown County* (Bloomington and Indianapolis, Ind.: The Indiana University Press, 1994), xxiii.

15. Henry E. Willard, "Adam Emory Albright, Painter of Children," *Brush and Pencil* 12 (Apr. 1903), 4.

16. See Wendy Greenhouse, "'To Unify and Elevate': Midwestern Art Organizations, 1890–1930" in *Mathias Alten: Journey of an American Painter* (exh. cat., Grand Rapids Art Museum, 1998), 92–96.

efforts to promote local art life or embracing Chicago as inspiration or subject. By the 1890s the vigor of Chicago's art life was reflected in the importance of its art journalism, in which it led the region.[11] The achievements of its many artists were acknowledged with the Art Institute's establishment of an annual "Artists of Chicago" (later "Chicago and Vicinity") salon, in 1897. By that date, if Chicago was not yet America's new cultural capital, as critic Hamlin Garland proclaimed, it certainly promised as much.[12]

For many Chicago artists, however, the realities were discouraging. In the cosmopolitan spirit of the last two decades of the century, Chicago's cultural insecurities were manifested in local collectors' habit of buying abroad. "The way to get the Wild West to buy American pictures is to exhibit them in Paris or London," noted *The New York Times* derisively.[13] Poor sales and low prices prompted many artists to settle elsewhere, and those who remained eked out a living by working in a number of capacities. Abundant opportunities for commercial work supported numerous aspiring fine artists. Joseph Birren, for example, painted cycloramas before working as a successful newspaper illustrator and commercial artist. Oliver Dennett Grover was a principal in a scene-painting business, painted panoramas, and took on portrait commissions. Charles Dahlgreen and Louis Ritman began their careers as sign painters. Charles Francis Browne, James William Pattison, and Edgar Cameron were prominent as writers, lecturers, and editors, as well as painters. Many artists were employed as instruc-

tors, not only in professional schools such as the Art Institute's, but in their own private classes and in the summer schools and amateur classes that proliferated as the gospel of art spread after the turn of the century. Most of the Chicago artists who largely made up the Brown County, Indiana, art colony between 1908 and the 1930s "had at times supported themselves as sign painters, commercial artists, and illustrators."[14] Painter Adam Emory Albright was considered remarkable because he did not also teach or write—a mark not only of his love of seclusion but of his commercial success.[15]

In a city that mingled promise and opportunity with discouraging reality, the founding of artists' clubs reflected at once the vigor and the shortcomings of local artistic life. Not merely social in intent, clubs were organized to address specific needs and create opportunities to remedy the deficiencies of Chicago's art life that discouraged many from pursuing careers there in the long term.[16] The Chicago Society of Artists instituted its members' exhibitions in 1890, when local artists had few venues for showing their work to the public. The Palette and Chisel Club was founded primarily to provide further opportunities for study from the model (fig. 4). Excluded from such typically all-male organizations, women artists created their own—the Bohemian Club. For all such organizations, promoting the interests of members went hand in hand with improving the artistic life of the city as a whole, a notion summarized in the official mission of the Chicago Society of Artists: "The Advancement of Art in Chicago,

and the cultivation of social relations among its members."[17]

Concern over Chicago's failure to patronize its own and the resulting perceived artistic hemorrhage energized her most influential citizens. For culturally conscious Chicagoans, the metropolis's need for the arts was proportional to the industrial ugliness, social ills, and cutthroat commercialism that discouraged its flowering. Proud Chicagoans were forever looking "through the dust and smoke of Chicago as she is, to see the fair and noble form of our city as she will be."[18] Convinced of their city's promise of greatness, they sought to establish permanent institutions and organizations simultaneously to provide greater opportunities for artists and to stimulate and elevate public taste—to foster art for the mutual benefit of Chicago and of her artists. Altogether different from today's corporate sponsorship, the "cultural philanthropy" of men like Charles L. Hutchinson, Martin A. Ryerson, and Edward Burgess Butler was personal and impassioned, founded on a powerful sense of civic mission and a deep conviction of art's power for moral uplift and, by extension, civic improvement.[19] Well into the new century this mission would furnish abundant work for numerous organizations inspired by the conviction that "Chicago must not be stamped as a city famous for nothing but its commercialism and ability to produce fortunes, but must be taught to develop its art appreciation and give some thought to matters more cultural and less material…."[20]

The most permanent product of such sentiments was The Art Institute of Chicago. Founded in 1879 as the Chicago Academy of Fine Arts, it was renamed three years later.[21] The new name was significant, for while the insti-

17. "An Historical Sketch [of the CSA]," c. 1895, collection of the Chicago Historical Society, reprinted in Louise Dunn Yochim, *Role and Impact: The Chicago Society of Artists* ([Chicago]: The Chicago Society of Artists, 1979), 32.

18. George Adams, speaking at the dedication of Orchestra Hall, quoted in Helen Lefkowitz Horowitz, "The Art Institute of Chicago: The First Forty Years," *Chicago History* 8 (Spring 1979), 13.

19. This theme is thoroughly discussed in Horowitz, *Culture and the City* (1976). See also Robert I. Goler, "Visions of a Better Chicago" in Susan E. Hirsch and Robert I. Goler, *A City Comes of Age* (exh. cat., Chicago Historical Society, 1990), 90–153.

20. "And It Came To Pass That—" *The Cow Bell* (published by the Palette and Chisel Club), May 1922, unpaged.

21. For a summary of the early history of the Art Institute, see Horowitz, "The Art Institute of Chicago" in *Chicago History* 8 (Spring 1979), 2–15.

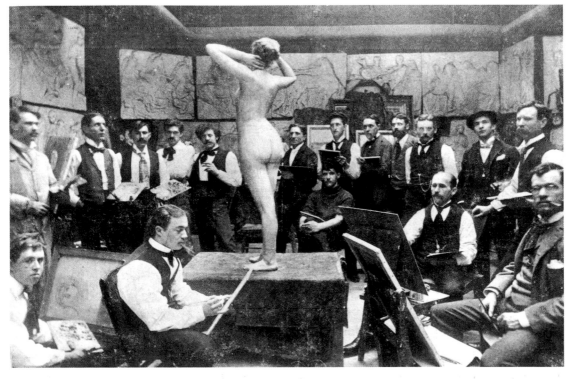

FIG. 4 Palette and Chisel Club members sketching model, 1896. From Palette and Chisel Club Log Book volume 1 (1895-1905), on deposit at the Newberry Library. Photograph courtesy of the Palette and Chisel Academy of Fine Arts, Chicago.

22. It was through the Academy of Design, however, that "the assumption of communal responsibility for culture by members of Chicago's elite first surfaced," according to Horowitz, *Culture and the City*, 38.

23. On the relationship of school and museum see Peter C. Marzio, "A Museum and a School: An Uneasy but Creative Union," *Chicago History* 8 (Spring 1979), 20–23, 44–52. Marzio (44) notes that these functions were symbolically united in the Art Institute's first director, William M. R. French. Trained as a landscape painter and the brother of a prominent sculptor, French taught at the Art Institute's school in addition to serving as the museum's director and sometime curator in its early years.

24. Marzio, "A Museum and a School," 23.

25. Ethel Joyce Hammer, "Attitudes Toward Art in the Nineteen Twenties in Chicago" (Ph.D. dissertation, University of Chicago, 1975), 29–30.

26. Eugenia Remelin Whitridge, "Art in Chicago: The Structure of the Art World in a Metropolitan Community" (Ph.D. dissertation, University of Chicago, 1946), 52–57.

tution originated in secession from the Chicago Academy of Design, a professional art school that served as the primary association for Chicago's artists in pre-Fire days, the Art Institute was intended to embrace a wider function and serve a broader constituency.[22] Founded not by artists for their own professional advancement but by a group of civic-minded business leaders intent on bringing culture to the city, the Art Institute was from the outset both school and museum.[23] This linkage embodied the lingering classical conception of artistic creation as a historical continuum, a continuous, progressive search for ideal truth and beauty that respected and built on the achievements of the past, as enshrined in the very names inscribed on the cornice of the Art Institute's 1892 building: Raphael, Reynolds, and the like.[24] On the very eve of Modernism's assault on such assumptions, the Art Institute was founded to nurture the past, present, and future of art under a single broad roof, with the hope that in so doing it would assert a much needed spirit of grandeur and permanence amidst the whirlwind of change that was Chicago.[25]

While the School of the Art Institute quickly became a magnet for aspiring artists from throughout the vast middle section of the United States, the museum soon established itself in the local public's consciousness as the heart of its art life.[26] In its early, pre-endowment years, the Art Institute's heavy financial dependence on a quickly growing membership placed it on an interdependent footing with Chicago's citizens. Possessing few original works of art of its own in its first decade, the Art Institute showcased citizens' private collections, for which the museum often would be the ultimate repository.[27] Changing exhibitions attracted constant attention: receptions, concerts, educational lectures, and twice-weekly days of free admission welcomed visitors in a democratic spirit that was applauded as thoroughly Chicagoan.[28] Attendance rivaled that of New York's Metropolitan Museum of Art and popular support for the Art Institute was legendary, indicative of "many lights in this city of some shadows," according to one outside observer.[29]

Yet the Art Institute reconciled this broad public role and appeal with the preservation of high art at a lofty remove from daily urban life. Outwardly it reflected none of the commercial associations of such earlier art venues as

27. Until the mid-1930s, when a chronological arrangement was first instituted, the museum's collections were grouped by donors in galleries individually named for the museum's benefactors.

28. Whitridge, "Art in Chicago," 54. See also Peattie, "The Artistic Side of Chicago," 829.

29. On attendance see Esther Sparks, "A Biographical Dictionary of Painters and Sculptors in Illinois, 1808–1945" (Ph.D. dissertation, Northwestern University, 1971), vol. 1, 96; on observer comment see "A Visit to Chicago: The Art Center of the Midwest," *Kalamazoo Gazette*, Dec. 12, 1911; see also "Art and Artists. Should be Endowed. Great Achievement of the Art Institute in the Face of Odds," *Chicago Evening Post*, Feb. 8, 1896.

Crosby's Opera House, where exhibitions had flourished in pre-Fire days, and at the annual shows of the Interstate Industrial Expositions of the late 1870s and 1880s. Both the architectural style and the lakeside siting of the Art Institute's eventual home, a classical temple isolated on the eastern side of Michigan Avenue yet hard by the city's central business district, underscored the complex relationship between art and commerce in the City of Broad Shoulders.[30] Like the White City of the World's Columbian Exposition (of which its building was one of the few permanent physical legacies), the Art Institute offered a redemptive alternative to the commercial culture of which it was so conspicuously a byproduct.

By the turn of the century the Art Institute had established itself as the indisputable center of professional life for the city's artists. Its school, which employed numerous artists as teachers, drew large numbers of students from throughout the region, many of whom stayed to begin their working careers in the city. The museum supported most of the local art organizations by providing a dedicated meeting space and hosting their annual exhibitions.[31] Its prestigious annual juried salons of American painting and sculpture and of work by artists of Chicago, and the prizes awarded there, defined the professional standing of individual artists. They were also sales events in which the Art Institute acted as dealer. Interest was further encouraged through opening receptions for organizations ranging from women's clubs to civic associations, the groups funding many of the prizes awarded to works in the exhibitions. In 1910 the Art Institute hardly exaggerated in describing itself as "at once a storehouse, a university, and a general exchange for art for the whole middle west."[32] In its first half-century it dominated the local art scene to an extent unrivaled by comparable museums in other major urban settings. "It has been the constant policy of the Art Institute," asserted its *Bulletin*, "to assist all movements in the city aiming at the promotion of art, and to do this without attempting to dominate other organizations."[33]

But if the Art Institute was a "Mecca," in the words of Adam Emory Albright, on which the city's artists depended, it was also conspicuously independent of their control—a fact with important consequences in later decades. The old Academy of Design had been "managed and controlled entirely by artists,"[34] and was by definition dedicated to local interests. The Art Institute, in contrast, was run by members of the city's commercial and social elites, soon to be assisted by a staff drawn from the first generation of professional art curators. In their catholic objective of bringing the best art before the Chicago and national public, the Art Institute's leadership assigned a necessarily circumscribed place to local, contemporary artists. The latter's interests, activities, and achievements were shoe-horned into the encyclopedic program that was bringing the institution national and international prestige.

The qualified status of local artists at the Art Institute perpetuated the importance of independent artists' organizations even as the Art Institute offered opportunities for study, exhibition, and

30. For an excellent discussion of the relationship between commerce and culture as expressed by the siting and style of Chicago's temples of culture (the Chicago Public Library and the Art Institute), see Daniel Bluestone. *Constructing Chicago* (New Haven and London: Yale University Press, 1991), 164–72.

31. Adam Emory Albright, *For Art's Sake* (Chicago: privately printed, 1953), 167. In 1910 the Art Institute hosted 23 such organizations. See "Privileges of Societies in the Art Institute." *Bulletin of the Art Institute of Chicago* 4 (Oct. 1910), 22.

32. *Annual Report of the Art Institute of Chicago*, 1910–11, 29, quoted in Whitridge, 111. Lorado Taft described the Art Institute as an "art center" and "community house" (Lorado Taft, Introduction to brochure for "Paintings by Charles Francis Browne," Art Institute of Chicago, Dec. 16, 1919–Jan. 22, 1920, unpaged). See also Rollin Lynde Hartt. "Our Coming University of Art," *Chicago Tribune*, Jan. 12, 1918.

33. "Privileges of Societies in the Art Institute," *Bulletin of the Art Institute of Chicago* 4 (Oct. 1910), 22. Those organizations included ones dedicated to architects, ceramicists, and photographers, in addition to fine artists.

34. Clarkson, "The Art Situation in Chicago," 133.

35. Whitridge, "Art in Chicago," 69.

36. On the Fine Arts Building see Perry Duis, "'Where is Athens Now?': The Fine Arts Building 1989–1918," *Chicago History* 6 (Summer 1977), 66–78.

sales that those groups had earlier been founded to supply. The flourishing of artists' clubs and societies owed something to the geographical concentration in a limited downtown area of commercial employers and public transportation as well as the Art Institute. An urban art colony of sorts had congregated around the first permanent of the Art Institute, at the corner of Michigan Avenue and Van Buren Street, which had rented out its third-floor studios to artists (fig. 5).[35] By the time of the Art Institute's move to grander—and more isolated—quarters up and across Michigan Avenue, in 1894, the artists' neighborhood was securely anchored at its southern end by the Auditorium Building (completed in 1889) and the Auditorium Annex (1892), as well as by the older Athenaeum

Building, at 59 East Van Buren, which housed many artists' studios and the clubrooms of the Chicago Society of Artists. The northside Tree Studios building, which opened in 1894, quickly proved that renting studio space to artists could be profitable, inspiring the speculative transformation of the Studebaker Brothers' carriage factory and showroom on Michigan Avenue into the Fine Arts Building, a complex of studios occupied by artists, illustrators, designers, musicians, and dramatists soon after its opening in 1898.[36] Lorado Taft, Charles Francis Browne, and Oliver Dennett Grover were among the influential tenants whose gatherings in Ralph Clarkson's tenth-floor studio in a club known as the Little Room were later formalized in the Cliff Dwellers Club and in the exclusive

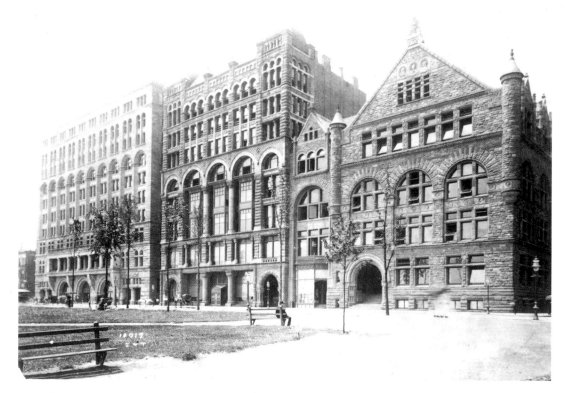

FIG. 5 Michigan Avenue between Congress and Van Buren streets, one boundary of an area that hosted numerous artists' studios, organizations, and art-related businesses, in photo taken circa 1889-93. From left to right: the Auditorium Building, the Studebaker Building (converted to the Fine Arts Building in 1898), and The Art Institute of Chicago. Photograph courtesy of the Chicago Historical Society. Negative number ICHI-32403.

Oregon, Illinois, summer art colony known as Eagle's Nest. Exhibitions held at the Fine Arts Building gave Chicago painters an alternative to the Art Institute's salons, where many felt overshadowed by expatriate artists or dominated by the whims and tastes of the women's and civic groups that wielded considerable influence in the new Chicago artists' annual exhibition.[37] Ironically, several of those women's groups had their headquarters in the Fine Arts Building as well,[38] thus bringing numerous potential patrons into contact with artists on a regular basis. Eventually resident artists and craftspeople formalized their occasional exhibitions and consolidated their salesrooms in The Artists' Guild, founded in 1910, whose main function was to stimulate sales of members' work through a shop located in the building.[39] The Fine Arts Building's lively mixing of the arts was not only the realization of a contemporary Arts and Crafts ideal but an expression of the Chicago setting, where few painters could maintain rigid boundaries between the different arenas that invited their talents: mural and cyclorama painting, illustration, speculative easel painting, and even art journalism. With its combination of studios, salesrooms, and clubrooms, the Fine Arts Building reified the close relationship between the artistic and the commercial that formed the necessary basis for Chicago's creative endeavors. It also mingled artists of varying artistic temperaments and outlooks. Such a setting saw conservative landscapist Charles Francis Browne collaborating at the Little Theater with Jerome Blum, who had created a sensation with his Fauvist landscapes.[40]

An especially independent group of commercial artists with higher aspirations came together in 1895 to form the Palette and Chisel Club, with modest headquarters in the Athenaeum Building. Its founders saw themselves as relative outsiders in relation to the establishment represented by the Chicago Society of Artists and its elite core with their studios in the Fine Arts Building, although it shared the CSA's policy of exclusive membership and genteel aspirations.[41] The Palette and Chisel quickly assumed the mantle of Bohemianism in Chicago, while establishing itself as a fixture in the city's artistic and social scenes. In 1898 the Art Institute jury's rejection of work by some members gave rise to the club's first "Salon de Refuse," which presented members' parodies of works by established painters including Edgar S. Cameron and Frank "Payrod" [Peyraud].[42] In contrast to the Salon des Refusés mounted by Chicago Modernists in 1922 (likewise modeled on the French Impressionists' exhibition of 1874), this exhibition evinced a spirit of rebellion that was largely affected, humorous, and self-deprecating; the printed program acknowledged a "special permit from the City Garbage Inspector,"[43] and the jury was said to consist of the janitor and two elevator conductors of the Athenaeum Building. The Palette and Chisel was certainly one of Chicago's liveliest artistic venues, but the distinction between it and the city's establishment was blurry at best. One of the club's founders, Charles A. Mulligan, became head of the sculpture department at the Art Institute school and

37. Whitridge. "Art in Chicago." 91, note 1.

38. Duis. "'Where is Athens Now?': The Fine Arts Building 1898–1918." 74, and Sharon S. Darling. "Arts and Crafts in the Fine Arts Building." *Chicago History* 6 (Summer 1977), 80.

39. Darling. "Arts and Crafts." 85.

40. Kenneth Hey, "Five Artists and the Chicago Modernist Movement, 1909–1928" (Ph.D. dissertation, Emory University, 1973), 87.

41. Hey. "Five Artists." 28.

42. "Burlesques on Art Prizes." *Chicago News*, Feb. 12, 1898: "Artists Lampoon Critics." *Chicago Chronicle*, Feb. 13, 1898: "Art for the Masses." *Chicago Inter Ocean*, Feb. 13, 1898: "Mr. Sherman's Caricatures of the Exhibit and Mr. Finnigan's Ribald Criticisms." *Chicago Chronicle*, Mar. 5, 1899: "Salon de Refuse Opens." *Chicago Tribune*, Mar. 12, 1899; "Burlesques of Art Institute Paintings at the Salon de Refuse." *Chicago Times-Herald*, Mar. 12, 1899.

43. Printed program for 1898 Salon de Refuse in Palette and Chisel Club Logbook 1 (1895–1905), 65, on deposit at the Newberry Library.

summered at Bass Lake, Indiana, with Taft and Browne.[44] Bastions of the Art Institute elite contributed to the club's exhibitions, were invited to jury those shows, and were honored guests at the club's "smokers," "high-jinks," and other home-grown entertainments, which, like the "Bohemian Nights" and "Black-and-White Balls" of the CSA, became well-publicized society events.[45] The club continued to draw many of its members from the ranks of commercial artists, but both its regular sessions of sketching from the model and summer expeditions for landscape study affirmed their more academic ambitions to paint what they called "idealistic pictures."[46] While such members as Joseph Birren, Rudolph Ingerle, Adam E. Albright, and J. Jeffrey Grant would exhibit repeatedly at the Art Institute, the club maintained its independence from the museum; it held its own exhibitions in its clubrooms or, as in the case of its first public exhibition, in 1901, at the Marshall Field & Company store gallery.[47] But in 1916, as a mark of its "maturity," the club's annual exhibition was held at the Art Institute;[48] the club had already earned representation on the founding board of the Commission for the Encouragement of Local Art in 1914, and beginning in 1917 it counted members on the jury of the prestigious American annual exhibition at the Art Institute.

The 1890s was the end of an era dominated by such broad-based, artist-driven organizations as the Chicago Society of Artists and the Palette and Chisel Club, with their mission of uniting painters, sculptors, illustrators, and others in the cause of improving Chicago's artistic climate as well as the professional lives of individual members. Nationally and locally, the future favored association based less on civic identity than on professional specialization. Chicago saw the genesis of the Chicago Water Color Club (1907), the Chicago Society of Etchers (1910), and the Society of Miniature Painters (1912); many Chicagoans joined such groups as the National Sculpture Society (1893), the National Society of Mural Painters (1895), and the National Association of Portrait Painters (1912), all New York-based but serving artists throughout the U.S. Somewhat later, artists in the Chicago metropolitan area began to distinguish themselves on the basis of geography. Many successful artists, joining the middle-class exodus from the city, helped found suburban art associations, notably the Austin, Oak Park, and River

44. Timothy Garvey, *Public Sculptor: Lorado Taft and the Beautification of Chicago* (Urbana and Chicago: The University of Illinois Press, 1988), 106.

45. For instance, Taft, Browne, Buehr, Grover, and the visiting William Merritt Chase were guests at a Palette and Chisel Club reception in 1902; Cameron and Browne contributed pictures to the Club's annual exhibition of that year, though they were not actually members. The Club's 1905 annual was juried by Art Institute faculty members Charles Boutwood, Karl Buehr, and Charles Mulligan, and in 1904 and 1905 members were treated to lectures by Art Institute director French and Browne.

46. "Art and Artists," *Chicago Evening Post*, Mar. 2, 1916. Likewise, the Palette and Chisel club-rooms, on the seventh floor of the Athenaeum Building, were decorated in an eclectic style that mixed Chinese lanterns and old armor, evoking the contemporary genteel image of the fine artist as collector, aesthete, and sophisticate.

47. Palette and Chisel Club Logbook 1 (1895–1905), opp. p. 60; "Art and Artists," *Chicago Evening Post*, Mar. 2, 1916.

48. *Catalogue: Twenty-first Annual Exhibition of the Palette & Chisel Club* (Art Institute of Chicago, April 25–May 8, 1916), unpaged.

Forest Art League (1921), the North Shore Art Association (1924), and the South Side Art Association (1925). For some, ethnicity became a basis of association, as the founding of the Swedish American Art Association (a Chicago-based national organization) and the Bohemian Arts Club, in 1905 and 1913 respectively, testifies.[49]

The larger mission of cultural amelioration, meanwhile, was increasingly assumed by civic organizations that were the creatures of lay apostles of art, for, as Forbes Watson noted in 1925, "Apparently whenever a group of American men and women decides to uplift art, the means can be found to organize a new association or club."[50] The fortunes of art in Chicago, and only incidentally that of Chicago artists, were the focus of several such organizations, notably the Friends of American Art (founded in 1910), which was dedicated to building the Art Institute's collection of American art. Others, such as the Commission for the Encouragement of Local Art (1914), directed their efforts toward the betterment of artistic Chicago mostly through public education and the collecting and disseminating of art. The most important of these organizations, the Municipal Art League, founded in 1899, officially brought the mission of patronizing native artists and guiding local taste into concert with broader ideals of civic beautification that included eliminating "the smoke nuisance and the obnoxious billboard."[51] In addition to acquiring works by local artists for a Municipal Art Gallery, the League served as an umbrella organization to coordinate the concerns and activities of civic and women's clubs, which were increasingly active as art patrons.[52] Indeed, the Art Institute's Chicago artists' annual exhibition has been described as virtually controlled by the art committees of such prominent organizations as the Chicago Woman's Club, the Union League Club, the Chicago Architectural Club, and the Arché Club, which were united as the Chicago Art Association until the Municipal Art League assumed its functions.[53] The unprecedented prominence of women's organizations in these activities represented one way in which leisured, middle-class Chicago women exercised important influence over the local art scene, patronizing Chicago's own artists while their male counterparts, noted one observer, confined themselves to comissioning murals and official portraits on behalf of their businesses.[54]

This occasionally dictatorial patronage on the part of civic groups was not entirely beyond the control of artists themselves, of course. The city's elite practitioners, men like Grover, Clarkson, Browne, Victor Higgins, and Lorado Taft, were active in such alliances of professionals and laypeople as the Commission for the Encouragement of Local Art (under the sponsorship of the City of Chicago),[55] the Municipal Art League, the Cliff Dwellers, and other civic groups; the last two, in fact, had their origins in meetings in Clarkson's hospitable studio. But the organizations through which art practitioners exerted their influence were largely cooperative efforts of artists and civic patrons united by common ideals and concerns. Chicago was remarkable for the extent

49. On the Swedish American Art Association see Whitridge, "Art in Chicago," 336.

50. Forbes Watson, untitled editorial, *The Arts* 8 (Nov. 1925), 241.

51. Everett L. Millard, "The Municipal Art League of Chicago," in "Chicago as an Art Center," special issue of *Art and Archaeology* 12, nos. 3–4 (Sept.–Oct. 1921), 189.

52. "Art," *Chicago Tribune*, Jan. 30, 1898.

53. Whitridge, "Art in Chicago," 91. The Chicago Art Association was founded in the wake of the first Chicago artists' exhibition, in 1897, when its member organizations jointly committed an impressive $12,000 for the purchase of works from the next year's annual (*Chicago Tribune*, Jan. 30, 1898). It merged with the Municipal Art League in 1901 (*The Municipal Art League* [Chicago], 1930, 11).

54. Arthur Nicholas Hosking, "Oliver Dennett Grover," *The Sketch Book* 5, no. 1 (Sept. 1905), 1.

55. On the Commission see Dean A. Porter, *Victor Higgins: An American Master* (Salt Lake City: Gibbs Smith, 1991), 39–40, 47–48.

56. On the Tree Studios see *Capturing Sunlight: The Art of Tree Studios* (exh. cat., Chicago Department of Cultural Affairs, 1999).

57. Rhodes, "The Portrait of Chicago," 89–90.

58. Michal Ann Carley, "Frederick Frary Fursman," in *Frederick Frary Fursman: A Rediscovered Impressionist* (exh. cat., UWM [University of Wisconsin, Milwaukee] Museum, 1991), 9.

FIG. 6 The Palace of Fine Arts, World's Columbian Exposition, where many Americans received their initial exposure to Impressionist painting. Photo by Charles Dudley Arnold, 1893. Courtesy of Avery Architectural and Fine Arts Library, Columbia University in the City of New York.

to which promotion of the local art scene was given official welcome and was institutionalized under the sponsorship of such organizations driven by lay art enthusiasts. Only in Chicago, perhaps, would an art colony spring up as the deliberate result of backyard philanthropy, as when Judge Lambert Tree and his wife Anna erected a block of artists' studios on their North Side property in 1894.[56] Chicagoans "domesticated" art, even in its mildly Bohemian manifestations, with a "persistent efficiency" applauded by contemporaries as thoroughly in keeping with the character of their energetic, self-made city.[57]

Nonetheless, local boosterism largely failed to address the fundamental cultural insecurities that continued to send Chicago collectors east in the conviction that art was a commodity imported from more mature, more refined settings. The "Bohemian" pretensions and essentially academic aspirations of the Palette and Chisel and other artists' clubs of the time reflected pervasive nostalgia for Europe as the artistic fountainhead. The 1880s had seen the return of Chicago's first generation of European-trained artists, including painters John Vanderpoel, Oliver Dennett Grover, Frederick W. Freer, and Charles E. Boutwood, and sculptor Lorado Taft. Their influence as both teachers and practitioners of a new, cosmopolitan style of painting underscored the bias of the Art Institute's exhibitions and the city's collectors to confirm the status of Europe as the finishing ground for artistic training and the arbiter of taste. Locally, instruction was premised on "finishing" abroad. Smith's Academy, a private downtown art school, had a quasi-official policy of sending its graduates on to the Academie Julian in Paris.[58] The Art Institute's school,

modeled on French academic organization and methodology, measured its prestige by the European studies and sojourns of its teachers and students, and rewarded its most promising graduates with fellowships for further training abroad;[59] students were offered the opportunity for French language study in preparation. In fine art, Europe was regarded as the measure of all things artistic, source of both revered academic tradition and of the latest innovations.[60] Not surprisingly, for many Chicago artists, notably Walter McEwen, expatriation seemed essential not only for finding subject matter and inspiration, but for cultivating the attention and respect of hometown patrons and public.[61] At home, Chicago artists hankered after a local "Bohemia" and summered at Midwestern "Barbizons." Even such a seemingly nationalistic organization as the Friends of American Art was consciously modeled on the Parisian Societé des Amis du Louvre, founded in 1897. Only the outbreak of war in Europe would shake this outlook, although well into the new century Chicago's collectors and their great museum would still be accused of judging art on the basis of

the rule that "the farther it is away the better it looks."[62]

Incarnating this mindset and confirming Chicago's cultural insecurities was the World's Columbian Exposition of 1893, a visual triumph of academic classicism that one historian has characterized as "New York's beachhead along Chicago's shoreline" (fig. 6).[63] If the exposition's idealized White City of Beaux-Arts palaces, manicured landscaping, and social decorum was an implicit reproach to the physical realities of the real city beyond its gates, the contributions of Chicago planners, muralists, and sculptors to the fair's creative genesis confirmed the city's cultural arrival by demonstrating her technically accomplished conformity to Beaux-Arts ideals. Local artists' modest showing in the American section of the fair's enormous international art exhibition was likewise unexceptional.[64] The success of Chicago artists in fitting in, and more notably the city's success in building and hosting the impressive exposition, produced the sense of self-congratulation that inspired some, notably critic Hamlin Garland, to proclaim Chicago America's new cultural capital.

59. Whitridge, "Art in Chicago," 63, 69.

60. Rich, "Half a Century of American Exhibitions," 10.

61. Rich, "Half a Century of American Exhibitions," 10, 11.

62. Kenneth Shopen, "Art Lesson, Chicago Style: The Farther It Is Away the Better It Looks," *Chicago Daily News*, Sept. 24, 1954.

63. Kenan Heise, *The Chicagoization of America 1893–1917* (Evanston, Ill.: Chicago Historical Bookworks, 1990), chap. II.

64. Of the 460 painters listed in the catalog of the American section of the fine arts exhibition only 22 listed Chicago as their address; sculptors fared somewhat better, with 15 of 67 being Chicago residents (see "Catalogue of American Paintings and Sculptures Exhibited at the World's Columbian Exhibition Revised and Updated" in *Revisiting the White City: American Art at the 1893 World's Fair* [exh. cat., National Museum of American Art and National Portrait Gallery, Washington, D.C., 1993], 80; 118, n. 88; 193–383). These apparently pitiful numbers seem considerably more impressive when taken in relation to the total number of professional artists in the city at the time, which has been estimated at as low as 100 (Whitridge, "Art in Chicago," 69).

65. William H. Gerdts, *American Impressionism* (New York: Abbeville Press, 1984), 142–44. For a discussion of what "Impressionism" meant to Chicago critics, see Goldstein, 39–41. Goldstein (126–27) discusses Garland's interconnected ideas of cultural nationalism and Impressionism in his philosophy of "veritism."

66. On the Central Art Association see Gerdts, *Art Across America*, 302; Goldstein, "Art in Chicago," 127–29. On art associations in general see Greenhouse in *Alten*, 101–2.

67. *Chicago Tribune*, Aug. 20, 1893, quoted in Goldstein, "Art in Chicago," 120.

68. Charles Yerkes quoted in Sparks, "A Biographical Dictionary," vol. 1, 98; Rich, "Half a Century of American Exhibitions," 9; Goldstein, "Art in Chicago," 41–43.

69. Printed program for the 1898 Salon de Refuse in Palette and Chisel Club Logbook 1 (1895–1905), 43, on deposit at the Newberry Library.

70. J. W. Moran, "Works of Chicago Artists— Exhibition at Art Institute," *Fine Arts Journal* 20 (Mar. 1909), 169. Reference courtesy of Patrick Sowle, with additional thanks to Joel Dryer, Director, Illinois Historical Art Project.

The inherent paradox of such conformity apparently disturbed none but Louis Sullivan, the renegade architect whose radically anticlassical Transportation Building embodied his lonely protest against the fair's celebration of European tradition.

Ironically, Chicago's most noteworthy contribution to the fair came not from her artists but from such advanced, European-oriented collectors as the Potter Palmers, whose French Impressionist pictures flooded the fair's galleries with unaccustomed light and color. Impressionism's coloristic brilliancy and free brushwork, its informality and stress on the immediate, the local, and the contemporary, offered a compelling alternative to the artificial polish of academic painting, the somber tones of the Munich school, and the romantic pastoralism of Barbizon landscape. But the fair also introduced the related work of American Impressionists and nonacademic Dutch and Scandinavian painters, which was influential in suggesting essentially regional Impressionist strategies. Impressed by their example, Garland, one of the most eloquent advocates for the new spirit of regional identity generally infecting the Chicago cultural community in the period, promoted Impressionism as the vehicle for a revolt against European, and more specifically French, dominance.[65] In the fair's wake, Garland pursued this mission through the Central Art Association, which he founded with Lorado Taft in 1894. Focused on stimulating popular interest in art and regional artistic expression through lectures, publications, and traveling exhibitions, the organization was the harbinger of a national "art association" movement that did much to legitimize fine art as a middle-class commodity in the next three decades.[66]

In 1893 enthusiasm for "the new school" of Impressionism brought a sympathetic group together in informal weekly dinner meetings known as the Vibrant Club.[67] However, for most Chicagoans, Impressionism, with its "summary treatment and eccentricities of drawing," was the shocking Modernism of the 1890s.[68] It defied Beaux-Arts convictions that drawing and the ideal human figure form the foundation of fine art, as practiced in the academic schools of Europe and imitated in the pedagogy of the Art Institute. Impressionism's challenge to such conventions presented sufficient offense that conservative collector Charles Yerkes endowed a prize for a painting by a member of the Chicago Society of Artists on the specific condition that it *not* be awarded for an Impressionist work. Even that gadfly of the Chicago art world, the Palette and Chisel Club, parodied the Impressionism of such painters as William Merritt Chase and Frank Peyraud in its tongue-in-cheek "Salon de Refuse" exhibitions of 1898 and 1899. Among the awards it offered for the worst art was a prize for "the painting showing the dizziest results of the pink and blue Impressionist movement."[69]

However radical, Impressionism was at the vanguard of a general loosening up of technique to which even the most retardataire of painters, such as the elderly Daniel Folger Bigelow, were beginning to respond.[70] By 1906 even the archconservative Charles Francis Browne, influenced by the naturalism of the Glasgow School, was executing landscapes that

evinced a new freedom from the "god of Truth" worshiped in the life class and was advocating for artistic originality and individuality.[71] Still, insisted James William Pattison in his profile of Browne, "the worship of truth while standing upright and not bowed down to the petty truths of little nothingness" could only be achieved from a basis of sound academic training.[72] This emphasis on craft and technique, and with it conventional assumptions about the linkage of art and beauty, qualified the local engagement with Impressionism. Chicago Impressionists would never abandon a fundamental insistence on art as idealized representation.

The resulting Impressionism of Chicago's own painters was cautious, fundamentally rooted in inherited conventions of genteel good taste and craftsmanship, and freely eclectic in its sources. Peyraud himself imposed Impressionist colorism on the romantic shadowing and moodiness of Tonalism (fig. 7). In Grover's landscapes of the 1890s the influence of Impressionism, as in the informal subject and rapid brushwork of his untitled Illinois scene (fig. 8),

71. James William Pattison, "The Art of Charles Francis Browne," *The Sketch Book* 5 (Jan. 1906), 201–4, 207; report of a lecture given by Browne at the Palette and Chisel Club in *Chicago Evening Post*, Jan. 14, 1905, Palette and Chisel Club Logbook 1 (1895–1905), 43, on deposit at the Newberry Library.

72. Pattison, "The Art of Charles Francis Browne," 202.

FIG. 7 Frank C. Peyraud, *Souvenir of the Berkshires*, 1914, oil on canvas, 20 × 26 in., Cat. 64.

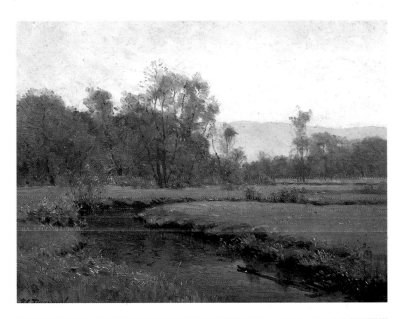

FIG. 8 Oliver Dennett Grover, *Untitled [Landscape with River]*, 1915, oil on canvas, 24 × 30 in., Cat. 46.

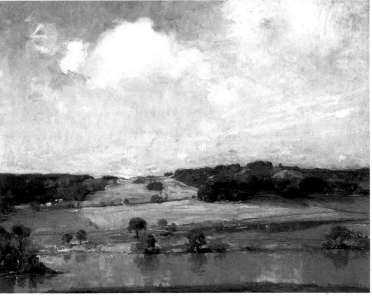

73. Annette Blaugrund with Joanne W. Bowie, "Alice D. Kellogg: Letters from Paris, 1887–1889," *Archives of American Art Journal* 28, no. 3 (1988), 18.

74. For an analysis of Midwestern Impressionism see William H. Gerdts, "Post-Impressionist Landscape Painting in America," *Art & Antiques* 6 (July–Aug. 1983), 60–67.

75. William H. Gerdts and Judith Vale Newton, *The Hoosier Group: Five American Painters* (Indianapolis: Eckert Publications, 1985), 26–31, and Gerdts, *Art Across America*, 264–70.

76. Richard W. Bock, *Memoirs of an American Artist: Sculptor Richard W. Bock*, Dorathi Bock Pierre, ed. (Los Angeles: C. C. Publishing Co., 1991), 50; "Pictures at the Cosmopolitan Club Exhibition," *Chicago Tribune*, Mar. 8, 1896. On the Society of Western Artists, see Gerdts, *Art Across America*, 175–77.

77. Rich, "Half a Century of American Exhibitions," 10.

FIG. 9 Alice Kellogg Tyler, *Untitled [Mabel and John in the Garden]*, c. 1898, oil on canvas, 27 × 19 in. Cat. 76.

is derived more from his studies in Munich and with Duveneck in Italy than from French precedent. Alice Kellogg Tyler, another important Chicago pioneer of the new style, confined her experiments with Impressionism's informality and rapid execution to small, casual, studylike paintings of family members, such as *John and Mabel in the Garden* (fig. 9); her formal portraiture, meanwhile, remained essentially academic.[73] Such Chicago Impressionists remained loyal to conventions of pictorial representation while partaking of the lively brushwork and heightened color and light that superficially characterized the new mode.[74] Ultimately, like the Modernism of Chicago's avant-garde of the 1920s, Impressionism was not so much a definable, visible product on the canvas as the affect of a progressive attitude, one expressed more in subject

matter than in style or technique. In this respect Chicago painters echoed the example of the Hoosier Group of Indianapolis, artists whose conservative Impressionist landscapes, seen at the World's Columbian Exposition and enthusiastically presented in Chicago by the Central Art Association, were considered noteworthy not so much for stylistic breakthroughs as for embracing the bucolic setting of their native state.[75]

On the eve of the fair, in 1892, the new interest in regional identity and in Impressionism motivated a group of progressive Chicagoans, including Peyraud, Tyler, Hardesty Maratta, Adam Emory Albright, and Alfred Juergens, to found the Cosmopolitan Club. From its inception the Club looked beyond Chicago and sought the participation of artists from other Midwestern centers. Its 1896 exhibition was the occasion for a regional convocation that gave birth to the Society of Western Artists.[76] Comprising chapters representing the six major art centers of the region—Chicago, Cincinnati, Cleveland, Detroit, Indianapolis, and Saint Louis—the Society brought together artists from throughout the Midwest in important annual exhibitions that circulated to its member cities.

Priding itself on expressing "what there is of a characteristic western feeling, a western ideality and spirit in art," the Society of Western Artists was an implicit counterweight to the powerful presence and prestige of expatriate artists in the Art Institute's American annual.[77] It appealed directly to "those who desire to see the West take its proper position in the country" to support the work of artists

of the region.[78] Implicit in this call was a protest against the domination of foreign subject matter typified by "wooden shoes, and the picturesque, toil-bowed, blue-garmented people of the mist"—namely, the ubiquitous Dutch and Breton peasants that peopled contemporary academic painting.[79] Peyraud publicly questioned whether expatriate artists could be called American if they did not paint American subjects.[80] His view was shared by some not yet ready to endorse Impressionism, such as Browne, who declared that "American art must be developed by the artists in happy sympathy with American surroundings, and supported by a public loving the home things more than imported foreign sentiment."[81] This cautiously assertive new spirit was the visual arts complement to the search for indigenous expression in Midwestern literature and architecture that produced the Prairie School. It linked the cause of Chicago-based artists with that of creating a truly national art, consciously free from European influence.

One obvious manifestation of this movement was the growing popularity of landscape painting that featured recognizably local settings rendered in a modified Impressionist manner.

Beginning in the early 1890s local summer excursions for landscape study and painting became a commonplace of Midwestern art life; summer art schools, club camps, and summer art colonies flourished as artists embraced the practice of *plein air* painting and their native surroundings with equal enthusiasm.[82] They headed to such places as Delavan, Wisconsin; Bass Lake, Indiana; and Oregon, Illinois, home of Eagle's Nest, the exclusive seasonal colony of writers, patrons, and artists mostly drawn from the elite of the Fine Arts Building.[83] Members of the fledgling Palette and Chisel Club earned their fares to similar destinations by contributing their picturesque renderings of them to railroad companies' advertising; later the club acquired a cottage on the Des Plaines River at Lyons and in 1905 established its own summer camp at Fox Lake. Three years later, Palette and Chisel members (including Albright and Ingerle), numbered heavily among the Chicago painters who began to "colonize" rustic Brown County, Indiana, perhaps the most important setting for the establishment of Midwestern Impressionism between 1908 and the 1920s.[84] In Saugatuck, Michigan, the Ox-Bow Summer School, founded in 1910 by

78. Rich, "Half a Century of American Exhibitions," 10–11. Statement in catalogue of Fifteenth Annual Exhibition of the Society of Western Artists, St. Louis City Art Museum, 1911, unpaged.

79. "Art and Artists," *Chicago Evening Journal*, Mar. 12, 1896.

80. Peyraud quoted in Lakeview Museum of Arts and Sciences, *Frank C. Peyraud: Dean of Chicago Landscape Artists*, essay by Jan Harmer and Miriam Lorimer (Peoria, Ill.: The Museum, 1985), unpaged.

81. *Impressions on Impressionism* (1894), quoted in Gerdts, *American Impressionism*, 144–45.

82. Whitridge, "Art in Chicago," 69, n. 2.

83. On Eagle's Nest see Josephine Craven Chandler, "Eagle's Nest Camp, Barbizon of Chicago Painters," *Art and Archaeology* 12 (May 1921), 195–204; Garvey, *Public Sculptor*, 106–13.

84. Gerdts, *American Impressionism*, 149. On Palette and Chisel Club members in Brown County, see "Brown County, Indiana," *Chicago Tribune*, Dec. 5, 1909.

85. Chicago painters
John W. Norton and
John Johanson had
worked at Saugatuck
beginning in 1898,
and Fursman had
visited the area
before his departure
for Europe in 1906.
Carley, "Frederick
Frary Fursman,"
15–18; Roger
Gilmore, ed., *Over
a Century: A History
of the School of
the Art Institute of
Chicago 1866–1981*
(Chicago: The
School, 1982), 80.

86. Lena M. McCauley,
"Illinois Landscape
as the Inspiration of
Chicago's Painters,"
*Chicago Evening Post
Magazine of Art*,
Aug. 14, 1928.

87. "Forest Preserve
Art," *Chicago
Evening Post*,
Nov. 18, 1919.

88. Minnie Bacon
Stevenson,
"A Painter of
the Indian Hill
Country," *American
Magazine of Art* 12
(Aug. 1921), 278.

89. Evelyn Marie Stuart,
"Exhibitions at the
Chicago Galleries,"
The Fine Arts Journal
35 (May 1917), 373;
Chandler, 195–204;
"Chicago Artists
Trying Painting in
Open Air," *Chicago
Evening Post*, July
10, 1914.

FIG. 10 Frank C. Peyraud
Autumn on the Desplaines, c. 1925–30
Oil on canvas, 28 × 34 in.
Cat. 65

Chicago painters Frederick Fursman and Walter Marshall Clute, became an extension of the Art Institute school in 1919.[85] Not far from Chicago, artists set up their easels along the Des Plaines, Fox, Illinois, and Rock Rivers and lent their efforts to the preservation campaigns of such groups as The Friends of Our Native Landscape to create the forest preserves that now dot the metropolitan region (fig. 10).[86] By 1919 a Society of Painters of the Forest Preserve had been organized.[87] Many artists, relocating to the leafy suburban villages of Beverly, Hyde Park, Oak Park, Park Ridge, and Winnetka, found subjects in their immediate neighborhoods. While Europe, established East Coast art colonies, and newer artistic communities in the Southwest and California continued to draw many Chicago artists, Midwestern settings increasingly appealed to local artists intent on capturing the unassuming beauties of a familiar nature. As one typical description of Brown County read: "This quaint, picturesque country is an inspiration for the poetic in nature, and the works of the painters are imbued with a lyric quality."[88] Significantly, though, through the teens, critical and artistic appreciation of the native landscape was refracted through a European lens. Just as Chicagoans yearned for their own Bohemia in the city, they described the Eagle's Nest colony as a Midwestern Barbizon, praised Brown County's light and atmosphere as like that of northern France, and dubbed Saugatuck a "colony" of Giverny.[89]

The discovery of local landscape by Chicago's painters was shortly followed by new appreciation of the city itself as

an artistic subject.[90] In the late-nine-teenth century, even as American painters began to explore the parks and boulevards of Paris, New York, and Boston, Chicago's physical reality had remained unthinkable as the subject of serious art for the very reasons that the city had presented a seemingly inhospitable setting for high culture. By the turn of the century, however, international interest in Chicago kindled by the World's Columbian Exposition and the dramatic development of the central business district had begun to attract new attention to and appreciation of the city's striking visual qualities. When, in 1900, French-born painter Albert Fleury presented a one-person Art Institute show called *Picturesque Chicago*, his images of the city were conspicuously in the vanguard.[91] But only five years later members of the Palette and Chisel took their sketching expedition in the city instead of to the usual rural spot and attempted "to catch the local color of the diverse sides of city life."[92] Applauding the club's efforts in this direction, a newspaper account proudly noted: "Chicago, with all her sins of esthetic

omission and commission, is dedicated to the service of a free people, and is their latest and best expression."[93] The civic campaign for greater appreciation of Chicago assumed mutual benefits for both the city and her citizenry. Thus, declared the Municipal Art League in 1930: "Our citizens should be given a wider knowledge of what we have in Chicago that is beautiful, and thus stimulate their pride in their city and arouse a feeling among them that we should have more of beauty and less of ugliness."[94]

Far from the self-styled rebels of New York's Ashcan School, who brought a realist spirit of contemporary reportage to their deliberately unlovely views of urban life, Chicago's portrayers held the real city at a genteel distance. "Chicago Will Be Idealized," ran the headline as the *Chicago Tribune* announced the Palette and Chisel's efforts "in spreading knowledge of the beauties of Chicago."[95] For many painters, Impressionism's fleeting generalization of form, emphasis on transience, and broad, rapid brushwork made it the ideal medium for a deliber-

90. For further discussion of Chicago artists' treatment of their city, see Wendy Greenhouse, "Picturing the City: Chicago Artists and the Urban Theme," *BlockPoints: The Annual Journal and Report of the Mary and Leigh Block Museum of Art, Northwestern University* 3/4 (1998–1999), 76–97.

91. Fleury had arrived in Chicago in 1888 with a commission to decorate the new Auditorium Theater. In 1904 one critic noted that his works revealed "beauties and even poetry itself, which native artists have failed to discover" (Maude I. G. Oliver, *International Studio* 22 [Mar. 1904], 21).

92. *Chicago Evening Post*, Jan. 14, 1905, in Palette and Chisel Club Logbook 1 (1895–1905), 91, on deposit at the Newberry Library.

93. "Making Chicago Beautiful," Chicago *Journal*, Jan. 26, 1905, in Palette and Chisel Club Logbook 1 (1895–1905), 91, on deposit at the Newberry Library.

94. *The Municipal Art League of Chicago* ([Chicago?], 1930), 7.

95. "Chicago Will Be Idealized," *Chicago Tribune*, Jan. 11, 1905, in Palette and Chisel Club Logbook 1 (1895–1905), 181, on deposit at the Newberry Library; see also "Making Chicago Beautiful," cited above.

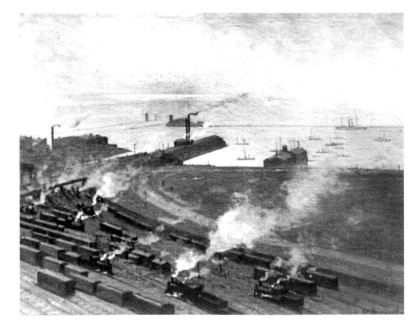

FIG. 11 Frank C. Peyraud, American, 1856/58, *After Rain*, Chicago, 1911, oil on canvas, 36 × 46⅛ in., Friends of American Art Collection, 1913.133 Reproduction, The Art Institute of Chicago.

96. Contemporary images of New York City were characterized by similar romantic strategies. See Wanda Corn, "The New New York," *Art in America* 61 (July–Aug. 1973), 60; H. Barbara Weinberg, Doreen Bolger, and David Park Curry, *American Impressionism and Realism: The Painting of Modern Life, 1885–1915* (exh. cat., The Metropolitan Museum of Art, 1994), 162–64.

97. Minnie Bacon Stevenson, "By the Lake—Chicago," *The Art Student* 1 (Feb. 1916), 114.

98. The Downs Prize was awarded to a painting in the Hoosier Salon, an annual exhibition of work by artists of Indiana, held at Marshall Field & Company through 1941. The first recipient of the Downs Prize was George Ames Aldrich for his painting *Steel*.

ately "artistic" softening of gritty urban scenes. "Typical" Chicago suggested further artistic strategies for eliding the city's less picturesque aspects. By emphasizing such actualities as its dramatic weather conditions and industrial smoke and steam, the blur of hustling downtown crowds, the legendary glories of its skyscrapers and the lofty perspectives they afforded, and the unexpected beauties of its parklands, painters could deliver recognizable but still flattering imagery.[96] Thus Frank Peyraud's bird's-eye view of the lakeside expanse of railroad tracks under a rainy sky (fig. 11) was "not a hard literal translation, but a poetic interpretation, a grey symphony, where the mists and smoke veil and soften the harsher realities," according to one approving critic.[97]

Business and official patronage expanded beyond commemorative portraits and allegorical murals to ingratiat-ing views of the bustling downtown and skyscraping skyline, such as Alfred Juergens's *LaSalle Street at Close of Day* (fig. 12), first owned by the Northern Trust Company, whose 1905 building looms in the picture's center. Flattering images of industrial Chicago complemented the statistical superlatives that described the city's physical might. In 1929 the Downs Prize, reserved for the "Best Industrial Scene Painted Anywhere along the Route of the Illinois Central Railroad," was offered by the railroad to encourage just such flattering applications of the art of landscape to the city scene.[98] Fulfilling this boosterish view of contemporary Chicago were nostalgic images of the city in bygone days. Civic pride in the mighty metropolis of modern times was fueled by contrasting visions of Chicago as an Indian trading

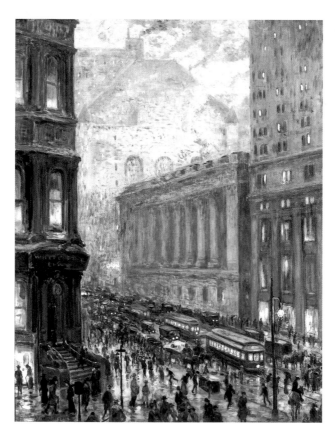

FIG. 12 Alfred Juergens, *LaSalle Street at Close of Day*, 1915, oil on canvas, 40 × 30 in., Cat. 53.

post or as an overgrown frontier village of wood frame houses.[99]

Landscape painting dominated the exhibitions and garnered the prizes in Chicago from the world's fair to the Great War, according to art historian Esther Sparks.[100] Its hegemony reflected the growth of a new middle class of art patrons throughout the country. In Chicago, art consumerism developed under the prestigious leadership of the Art Institute, the energetic patronage of civic and women's clubs, the promotional activities of such bodies as the Municipal Art League, the Society of Western Artists, and the Commission for the Encouragement of Local Art, and art awareness fostered by a host of local art associations founded throughout the region in this period;[101] wide coverage of art matters in both the local press and in national domestic magazines brought art directly into middle-class homes, while such organizations as the Public School Art Society (founded in 1895) and the Businessman's Art Club (1920) expanded the penetration of art appreciation beyond the women's clubs that so dominated the art scene. By 1920 the Art Institute had actively entered the movement with the Better Homes Institute, whose lecturers, armed with collapsible model rooms and exemplary artwork, traveled throughout the Midwest in a campaign to elevate popular taste in domestic furnishing and to cultivate aesthetic appreciation generally.[102] Understanding the role of domestic interior design in stimulating demand for paintings, artist Joseph Birren in 1921 endowed the Birren Prize to encourage architects to create designs conducive to the integration of artworks into the home.[103]

FIG. 13 Lorado Taft, *Fountain of the Great Lakes*, 1913, shown in its original location on the south wall of The Art Institute of Chicago. Frederick O. Bemm, photographer. Photograph courtesy of University of Illinois at Urbana-Champaign Archives.

For their part, artists following the trend toward a conservative Impressionism were creating works that could be incorporated naturally into the current decor of the modern high-rise apartment or suburban home.[104] Such popular artists as Palmer and Peyraud painted landscapes and figural works that were stripped of all but superficial narrative content, often distinctly local or contemporary in subject, and freshly engaging in their lush palette, decorative brushwork, and freedom from academic "finish." Such works marked the assimilation of a conservative Impressionism into the canon of middle-class respectability between 1900 and 1920.

Seemingly set against the direction of such market forces, however, was a still-powerful bias toward the ideal

99. For example, Chicago's history was the theme of two major commissions from the city government, both in 1911: a series of twelve large canvases by Edgar S. Cameron and thirty-four murals for the Council Chamber by Frederic Clay Bartlett. A few years earlier, Lawrence Carmichael Earle had executed a series of lunettes for the Central Trust Company building showing the city's development (see Evelyn Marie Stuart, "Epochs in the History of a Great City Told in Art," *Fine Arts Journal* 21 [Sept. 1909], 123–35).

100. Sparks, "A Biographical Dictionary," vol.1, 138. In 1913, concern over the "lack of general interest in figure painting" prompted the Municipal Art League to establish a prize for portraiture to be awarded to a work in the Chicago artists' exhibition. *The Municipal Art League* (1930), 16.

101. "Art," *Chicago Tribune*, Jan. 30, 1898.

102. "The Growth of Extension Work," *Bulletin of the Art Institute of Chicago* 14 (Mar. 1920), 50–54; Frederic J. Haskin, "Evangelist of Art," *Fall River (Massachusetts) Evening Herald*, Aug. 7, 1920.

103. "Exhibitions," *Bulletin of the Art Institute of Chicago* 14 (Mar. 1921), 131.

104. See, for instance, "Pictures Now Bought to Suit Decorations," *Chicago Evening Post Magazine of the Art World*, Mar. 1, 1927.

human figure, a bias that persisted well past the turn of the century. At the Art Institute's school, in particular, the Beaux-Arts dogma of ideal figurative art ruled. By contrast, landscape painting, though taught much earlier, was not even listed as a course offering until the late 1920s, and then it was an elective subject for students who had already mastered the drawing and painting of the figure.[105] This prejudice reflected the influence of the charismatic French-trained teacher John Vanderpoel, whose emphasis on drawing and on the study of the live model shaped the outlook of the school long after his death in 1911, thanks to the national success of his manual *The Human Figure* (1907). Beyond the confines of the Art Institute, the figural ideal was reinforced in the Beaux-Arts public sculpture and mural painting that proliferated in the wake of the World's Columbian Exposition. The development of Chicago's parks, implementation of features of the 1909 Plan of Chicago, and the erection of ever more imposing civic and commercial structures demanded appropriately grand decoration. Lorado Taft, champion of regional identity and high ideals in

art, demonstrated in his own work the possibilities of grafting a Beaux-Arts sensibility onto Midwestern themes; his *Fountain of the Great Lakes* (1913) (fig. 13), for example, personified each of the bodies of water as an idealized young woman in classical drapery.[106] The genteel liberalism of Taft's approach set the tone for Chicago's artistic establishment's reaction to radical Modernism. Despite calls for greater artistic individuality and freer creative expression, the linkage between art and beauty remained fundamentally unchallenged; so too did the attendant disassociation between art and modern urban reality.[107] Accordingly, the civic patronage of such organizations as the Municipal Art League was founded on the notion of art as a weapon in the battle against urban ills both visual and spiritual.[108]

Complementing this agenda was an emphasis on mastery of technique as a foundation for high art, another Beaux-Arts ideal. This also reflected an intimacy between the fine and applied arts peculiar to Chicago. By the end of the nineteenth century Chicago's image as a center of heavy industry was matched by its reputation for fine craftsmanship in

105. Landscape painting, taught by Karl Buehr and later by De Forrest Schook, first appears in the school's catalog for 1927–28 as a subject for third-year students in the fine arts course. (Landscape sketching appeared somewhat earlier among the courses in the Saturday and Normal divisions.) On the teaching of landscape painting at the Art Institute at the turn of the century, see Charlotte Moser, "'In the Highest Efficiency': Art Training at the School of the Art Institute of Chicago," in *Old Guard*, 198.

106. Taft's *Fountain of the Great Lakes* was the first sculptural project funded by the B. F. Ferguson Monument Fund for public sculpture in Chicago. Originally sited along the south wall of the Art Institute's 1891 building, it now stands against the west wall of the museum's Morton wing. See Garvey, *Public Sculptor*, especially 1–6 and 140–42.

107. See, for instance, Austen K. De Blois, "The History of Art in Illinois," in Frances Cheney Bennett, ed., *History of Music and Art in Illinois* (Philadelphia: Historical Publishing Co., 1904), 18.

108. Hammer, "Attitudes Toward Art," 29–30.

furniture, stained glass, wrought iron, and other consumer goods. Fine artists, as already noted, often crossed over into such fields as commercial art and mural and decorative painting, where technical ability was emphasized over creativity and personal expression. The Art Institute's school, founded in the midst of a fever of concern over the state of industrial design in the United States, was distinguished by a special emphasis on applied arts.[109] There, aspiring fine artists worked in close proximity to fledgling designers, illustrators, decorative painters and sculptors, and architects.

The conscious emphasis on beauty and on craftsmanship became the banner under which Chicago's conservative artists and their public rallied to the defense of convention in the face of Modernism's challenge. Returning from a tour of Europe in 1911, sculptor Charles A. Mulligan warned that Chicago must "guard against extremes in methods, to be true to the traditional, to be cautious, although generous, in accepting and making standards."[110] When, in 1913, the latest developments in Modernist art came to The Art Institute of Chicago in the International Exhibition of Modern Art, popularly known as the Armory Show, local reaction, dramatized by the burning of an

effigy of Henri Matisse by Art Institute students, was predictable. Walt Kuhn, one of the show's organizers, denounced Chicago as a "Rube Town!" for its not-unexpected failure to appreciate the radically new art forms. But Chicagoans were convinced that their very refusal to grasp the "artfulness" of the Modernist works in the Armory Show only proved their cultural sophistication; their resistance to being taken in by the latest "isms" demonstrated their loyalty to self-evident standards of truth and beauty. They congratulated themselves on their open-mindedness in hosting the event at all, and on the sanity, good sense, and sense of humor expressed in local reaction, such as the "Futurist Party" and the mock Cubist exhibition staged by the Chicago Society of Artists and the Cliff Dwellers Club, respectively.[111] The reactions of individual artists ranged from the complacent tolerance of Ralph Clarkson to the outrage of Rudolph Ingerle who, alarmed at the enthusiasm of one Chicago collector (probably Arthur Jerome Eddy), dismissed the entire Modernist movement as "a clever scheme for separating men from their money."[112]

The Art Institute's hosting of the exhibition seems all the more remarkable in light of the strong reservations of

109. Marzio, "A Museum and a School," 45; Moser, "'In the Highest Efficiency,'" 195–96; Gilmore, ed., Over a Century, 76–77, 80–83.

110. H. Effa Webster, "Europe Eyes Chicago Art," Chicago Evening Examiner, Dec. 16, 1911.

111. For summaries of Chicago's reaction to the Armory Show, see Milton W. Brown, The Story of the Armory Show (New York: Abbeville Press, 1988), ch. 10; Sue Ann Prince, "'Of the Which and the Why of Daub and Smear': Chicago Critics Take on Modernism" in Prince, ed., Old Guard, 95–118; Andrew Martinez, "A Mixed Reception for Modernism: The 1913 Armory Show at the Art Institute of Chicago," The Art Institute of Chicago Museum Studies 19 (1993), 31–57.

112. Richard Tuetsch, "Ralph Clarkson, 1861–1942," Tri-Color (published by Illinois Athletic Club, Chicago), May 1942, 7; Ingerle quoted in Emily Grant Hutchings, "Art Hill Is Becoming Nationally Famous; Advertise It, Visitors Advise St. Louis," St. Louis Globe Democrat, Nov. 7, 1915.

113. French quoted in Martinez, 38. Martinez's description of the process by which the Art Institute brought the Armory Show to Chicago makes it clear that the museum bungled its way into hosting the exhibition through a combination of noble intentions and naivete, largely thanks to the energetic promotion of trustee Arthur Aldis, a Modernist sympathizer who wanted Chicago on the map of cultural sophistication.

114. Martinez, "A Mixed Reception for Modernism," 40–41.

115. *Annual Report of the Art Institute of Chicago*, 1910–11, 29, quoted in Whitridge, "Art in Chicago," 111.

its leadership, especially Director William M. R. French, who found the Modernist art works "subversive of good taste, good sense, and education; of everything that is simple, pure, and of good report."[113] Yet it was French who insisted that the Chicago showing of the exhibition fully represent the notorious "extraordinary foreigners," such as Matisse, Cézanne, Picasso, Van Gogh, and Duchamp—even, if space was wanting, at the expense of their American counterparts.[114] Bringing even potential-ly offensive but cutting-edge art before the Chicago public was consistent with the Art Institute's self-appointed role as the region's clearinghouse or "university" of art.[115] Shortly after the Armory Show opened within its walls, the Art Institute defended its decision to display "the strange works of the cubists and post-Impressionists" by declaring that its policy "has always been liberal, and it has been willing to give a hearing to strange and even heretical doctrines, relying upon the inherent ability of the truth

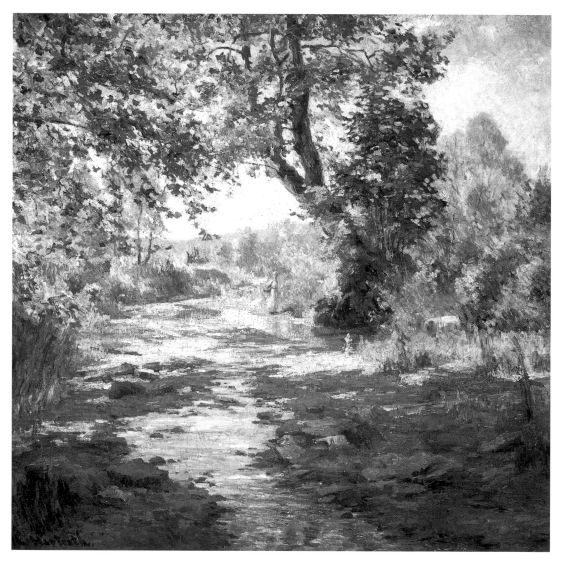

FIG. 14 Lucie Hartrath, *The Creek*, 1917, oil on canvas, 36 × 36 in., Cat. 48.

ultimately to prevail."[116] Indeed, the museum had already established a tradition of presenting new developments in contemporary art, from the American Impressionists in 1890 to modern Scandinavian art (including the work of Edvard Munch) only a month before the opening of the Armory Show in Chicago.[117] In giving the eccentric "isms" of the avant-garde a respectful showing, the Art Institute intended at once to satisfy public curiosity, to defuse any threat to its standards, and to present a tolerant, if not progressive, image.

In the immediate aftermath of the show those aims seem to have been realized. While a handful of mostly younger artists eagerly began absorbing the new ways of seeing and art-making suggested by the cutting-edge works of the Armory Show Modernists, most of Chicago's established painters and sculptors seemed little affected by what they could complacently dismiss as a passing fad. Alfred Juergens's upbeat *LaSalle Street* of 1915 and Lucie Hartrath's placid 1917 painting *The Creek* (fig. 14), for example, make no more reference to the recent upheavals in the art world than they do to the European conflict into which the United States was then being drawn.

In the wake of Chicago's brush with radical Modernism, such works seemed refreshingly accessible and wholesome by comparison, particularly for their affectionate rendering of a familiar landscape. Enhanced appreciation of Chicago's homegrown art as a refuge from foreign Modernist insanity added to familiar pleas for support of the city's own artists. Browne noted with satisfaction that American patrons were increasingly liberated from their conviction that "the foreign name and foreign subject" were necessary to make a work of art; "See American Art first!" he urged, as he promoted The Artists' Guild shop for Chicago artists and crafts workers.[118] In 1915, pride in Chicago's own was extended as far as a retrospective exhibition of paintings and sculpture by Chicago artists created prior to the World's Columbian Exposition, organized by the Municipal Art League at the Art Institute.[119] In 1914, the year after the Armory Show, the municipal authorities followed the example of commercial and professional patronage with the founding of the Commission for the Encouragement of Local Art, which purchased works of art

116. "Exhibition of Modern Art." *Bulletin of the Art Institute of Chicago* 6 (April 1913), 51.

117. On reaction to the Society of American Artists' exhibition in 1890, see Rich. "Half a Century of American Exhibitions," 9; on the Scandinavian exhibition, see Martinez, "A Mixed Reception for Modernism," 34.

118. Charles Francis Browne, "Why Not Patronize American Artists?" in *An Illustrated Annual of Works by American Artists and Craft Workers* (Chicago: The Artists Guild Galleries, 1915), 21.

119. *The Municipal Art League of Chicago* ([Chicago], 1930), 15.

for the City of Chicago to display in municipal buildings and schools.[120] Catching the isolationist spirit of the mid-teens, conservative critics stressed the wholesome "sincerity" that would make Chicago the future center of a national art.[121] The influence on the commission of Arthur Jerome Eddy, a supporter and collector of Modernist art (and Mayor Carter H. Harrison's personal representative), was more than balanced by the weighty presence of Taft and Clarkson. The commission's acquisitions were safely conservative, characterized by fellow commission member and painter Victor Higgins as "'modern' though not 'ultra-modern,'" a description he qualified by noting approvingly that "most of the Chicago painters belong to the modern or Impressionistic school. Even post-Impressionism hasn't made much headway here."[122]

Several of Higgins's own works purchased by the commission and by the Municipal Art League were Southwestern images he executed as a member of the budding art colony in Taos, New Mexico. Like Walter Ufer and E. Martin Hennings, who also saw Chicago as their primary market while painting in Taos, Higgins

had been encouraged to work there by Mayor Harrison, the guiding spirit behind the founding of the Commission for the Encouragement of Local Art. These Chicago artists, along with later arrivals Ethel Coe, Joseph Birren, Edgar S. Cameron (fig. 15, see p. 55), and Grace Ravlin, found a receptive home audience for their decorative, brilliantly colored but concretely rendered images of the stolid natives, monumental architecture, stark landscape, and clear light of the southwestern high country. Their paintings celebrate the permanence and solidity of a distinctly American place and, by implication, of the art that represents it in an analogous manner. While Taos has been known principally for the avant-garde artists, from B. J. O. Nordfeldt to Georgia O'Keeffe, who worked there from the midteens on, it also served a conservative agenda with Midwestern roots.[123]

As war put an end to artistic sojourns to Europe and conservatives rejected the "crazy art movement" imported from abroad, the search for distinctly American subjects and settings was reinvigorated.[124] In addition to Taos, the Missouri Ozarks, first "discovered" by

120. The board of the Society was to consist of three members chosen by the Art Institute, one by the Municipal Art League, one by the Friends of American Art, one by the Palette and Chisel Club, and one by the mayor. "City Buys 13 Art Works in Heated Debate," *Chicago Examiner*, Dec. 18, 1914; "Foresee Center Here of Art in America," unidenti- fied clipping in Palette and Chisel Logbook 2 (1906–1915), 94, on deposit at the Newberry Library. The first year's acquisitions were partly donated by the artists to make up for the small amount of available funding. "Artists Give Up $2500 for City," *Chicago Herald*, Dec. 18, 1914. On the Commission see also Porter, *Victor Higgins*, 39–40, 47–48.

121. Albrecht Montgelas, "Reflections on National Art," *The Art Student* 1 (Oct. 1915), 17–18; see also "Chicago Has Spirit of America," *Chicago Examiner*, Nov. 17, 1917.

122. "Art Commission Bows to 'Mrs. Grundy,'" *Chicago Tribune*, Dec. 2, 1914.

123. Arrell Morgan Gibson, *The Santa Fe and Taos Colonies: Age of the Muses, 1900–1942* (Norman, Okla.: The University of Oklahoma Press, 1983), chap. 3.

124. Ingerle quoted in Hutchings, "Art Hill"; Evelyn Marie Stuart, "Chicago Artists' Twenty-Second Annual Exhibition," *Fine Arts Journal* 36 (Mar. 1918), 5–6.

Chicago painters Rudolph Ingerle and Carl Krafft in 1912, blossomed in these years into a full-fledged art colony with the founding of the Society of Ozark Painters in 1915.[125] California, especially Southern California, continued to draw artists from Chicago: Hovsep Pushman and Edgar Payne, for example, settled there in 1916 and 1917, respectively. In 1914 and 1915 Adam Albright returned to his parents' birthplace in Appalachia to paint his typical rural children. In 1917 it was noted that Provincetown, Massachusetts, was drawing "quite a colony of our Chicago artistic folk," led by Pauline Palmer.[126] Closer to home, painters such as Frank Dudley and Hermon More were attracted to the Indiana Dune country; just beyond, Michigan beckoned with its "winsomeness of a homelike country and the needed variety of hills, woods and water that make for the picturesque."[127] The Art Institute's 1919 American art annual was considered noteworthy for the pervading Americanness of the subjects shown.[128]

As Higgins's complimentary reference to "modern" indicates, however, many Chicagoans puzzled by the aesthetic atrocities of the Armory Show were at the same time eager to be identified as up-to-date and as broad-minded, if discriminating. Between the Armory Show and the Armistice, lines had not yet hardened between self-styled Modernists and conservatives, and a spirit of lively experimentation was in the air. The "always progressive and enthusiastic" Palette and Chisel Club represented this relative open-mindedness in its eclectic exhibitions and in the experimental compositions of several of its members, led by Higgins, who grouped themselves together in 1915 as the "Abstractionists." Their work, mostly inspired by music, was graciously received by critics who found their lack of evident subject matter redeemed by pleasing color harmonies and effective compositions; it demonstrated that art "could diverge from nature without being abnormal."[129]

Thus it was not abstraction *per se* but sheer hideousness that proved unacceptable. Even the "radical" Palette and Chisel drew the line at Gordon Ertz's appropriately "repulsive" depiction of *Sin* in his one-person show in 1915, to the disgust of some of its more liberal members.[130] In the 1918 Chicago and vicinity annual, Ejnar Hansen's painting *Mrs. F.*, "a woe-begone and ill-conditioned figure devoid of charm or beauty," painted out of "socialistic sympathy for the oppressed ... rather than any truly aesthetic motive," demonstrated that "the unescapable and ever present nature of a picture all but demands a subject that is at least not distressing, or a softened treatment that is poetic A crude statement of an unhappy condition is a doubtful reason for a work of art." On the other hand, even Chicago's immigrant slums could make attractive subject matter if handled "artistically": in the same exhibition, Oskar Gross's ghetto images won praise as "a revelation of the color, life, and cosmopolitan atmosphere of Twelfth and Halsted streets done into true works of art" by means of attractive technique and a "bright, humorous sympathy with the common aspects of life."[131] The admission of contemporary life, of local

125. Evelyn Marie Stuart, "Twentieth Annual Exhibition of Chicago Art," *Fine Arts Journal* 34 (Mar. 1916), 116.

126. "The Editor," "Chicago Artists' Twenty-first Annual Exhibition," *Fine Arts Journal* 35 (April 1917), 271, 272.

127. Evelyn Marie Stuart, "Chicago Artists' Twenty-Second Annual Exhibition," 8.

128. Marguerite Williams in *The [Chicago] Daily News* quoted in Rich, "Half a Century of American Exhibitions," 14.

129. Lena McCauley, "Art and Artists," undated clipping from the *Chicago Evening Post* in Palette and Chisel Logbook 2, opp. p. 110, on deposit at the Newberry Library; undated clipping from *Chicago Sunday Herald*, May 23, 1915, in Palette and Chisel Logbook 2, opp. p. 110.

130. "'Sin' is Ostracized; Hidden in a Closet," *Chicago Herald*, Nov. 16, 1915, in Palette and Chisel Logbook 2, 122, on deposit at the Newberry Library. "*Sin* will never do," L. O. Griffith, Joseph Kleitsch, and Emil Carlsen were quoted as saying. "This is a radical club and all that, but she's beyond the limit entirely." R. Victor Brown (the club's current president) and John E. Phillips retorted: "Well, she's repulsive, but so is sin, and that's what Ertz means to convey."

131. All quoted from Stuart, "Chicago Artists' Twenty-Second Annual Exhibition," 12.

An Art Institute Alumni exhibit by F red Stearns, class of 1905.

132. Carley, "Frederick Frary Fursman," 18–21.

133. All quoted in Stuart, "Twentieth Annual Exhibition of Chicago Art." 114–15; "Art and Artists," *Chicago Post,* Sept. 30, 1915.

FIG. 16. Fred Stearns, "An Art Institute Alumni Exhibition," *Chicago Examiner,* Dec. 10, 1922. Stearns captures the outrage felt by many Chicago artists and ordinary exhibition-goers confronted by Modernism's seeming disdain for technique and decorum.

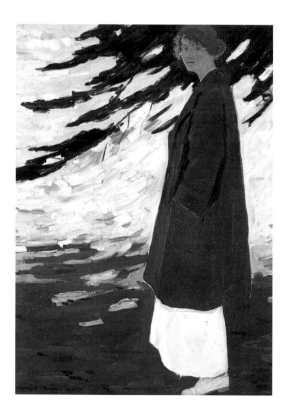

FIG. 17. Frederick Fursman, *Maizie under the Boughs [#16 Saugatuck, Michigan],* 1915, oil on canvas, 40 × 30 in., Cat. 39.

scenery, and of Chicago itself to the canon of acceptable artistic subject matter had not shaken fundamental convictions of the inseparability of art and beauty. Indeed, the very admission of the seemingly unpicturesque depended on the qualifying medium of a recognizably aesthetic interpretation, as well as adherence to familiar technical standards. Conservative artists' loyalty to those embattled standards is vividly portrayed in Fred Stearns's cartoon commentary on the 1922 Art Institute alumni exhibition (fig. 16), where outraged visitors appear shocked at "what gets by."

Within this conservative framework, changes that marked the "modern" quality identified by Higgins were observed in the work of many conservatives within a few years of the Armory Show. By the late teens Higgins's own paintings tended toward a stylized massing of form that may indicate the influence of Post-Impressionism. Similarly, Frederick Fursman's outdoor genre scenes shifted around 1913 from an Impressionist preoccupation with broken, reflected light to a focus on almost abstract patterned surfaces in intense, Post-Impressionist color, as seen in *Maizie under the Boughs* of 1915 (fig. 17).[132] Karl Buehr's works in the Chicago and Vicinity annual of 1916 were "bigger and stronger than formerly and not so vibrant with tiny spottings of color, but characterized rather by a more continuous and flowing technique," and Adam Albright's familiar images of rural children were noticeably heightened in color and light (fig. 18).[133] Similar qualities characterize Anna Lee Stacey's portrayal of an unidentified woman reading (fig. 19). In the 1920s, Joseph Birren

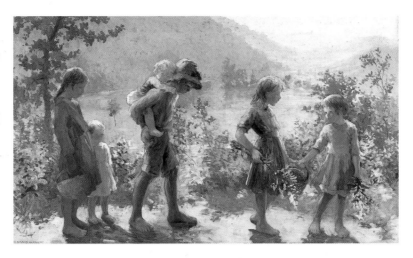

FIG. 18 Adam Emory Albright, *Untitled [Landscape with Six Children]*, c. 1914–15, oil on canvas, attached to plywood by the artist; 36 × 50 in., Cat. 3.

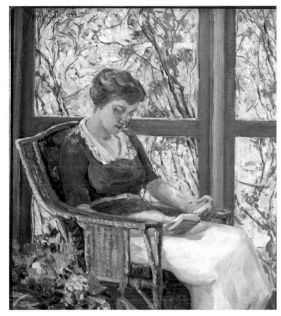

FIG. 19 Anna Lee Stacey, *Untitled [Woman Reading]*, 1921, oil on canvas, 16 × 14 in., Cat. 72.

painted with an impasto in a personal style he termed "Tactilism" that was "modernist" and yet, according to a contemporary, redeemingly grounded in craftsmanship and sound emotional content.[134]

The subtle influence of Post-Impressionism may have been at work among these conservative "moderns," as it certainly was in the paintings of Frederic Clay Bartlett, who emerged as a major collector of Post-Impressionism

after 1919.[135] But other, local factors contributed to these stylistic shifts. At the Art Institute's school, the passing of an era dominated by Vanderpoel saw a new emphasis on composition and color at the expense of drawing, a tendency encouraged further by the school's war-related work in camouflage and poster design, which resulted in "stronger delineation and brave color," in the view of critic Eleanor Jewett.[136] And Charles Dahlgreen attributed his own broader handling of paint, beginning in 1915, to the atmospheric brilliance of Brown County, where he had begun working in that year.[137]

Regardless of its sources, this updating of the Impressionist aesthetic only fed into a growing emphasis on decorative effect. As early as 1911 the shift to a new kind of Impressionism was evident and "few were willing to return wholesale to [the] detailed style of technique, which marks the work of a generation past."[138] By 1917 Hartrath's work, for example, had "mellowed": "The masses of foliage in her pictures ... seemed softer, more decorative, and the entire scheme more atmospheric and poetic" than formerly.[139] In their sense of

134. Bernard Johns, "Joseph Birren's Texture Quality," introduction to *The Chicago Galleries Association, An Exhibition of Paintings ... by Joseph Birren* [1928], unpaged. In a copy of this publication housed in the Ryerson Library, The Art Institute of Chicago, throughout Johns's short text the word "texture" has been crossed out and "tactile" written in; these annotations, as well as the date on the cover of the brochure and prices next to the listings of painting titles, appear to be in the artist's hand.

135. Erne R. and Florence Frueh, "Frederic Clay Bartlett: Chicago Painter and Patron of the Arts," *Chicago History* 8 (Spring 1979), 18.

136. Whitridge, "Art in Chicago," 115; Eleanor Jewett quoted in Rich, "Half a Century of American Exhibitions," 13; Moser, "'In the Highest Efficiency,'" 202.

137. Charles Dahlgreen, MS Autobiography, 291, in Charles Dahlgreen Papers, Archives of American Art, microfilm reel 3954.

138. See previous note 29, "A Visit to Chicago." (1911).

139. "The Editor," *Fine Arts Journal* 35 (1917), 278.

abstract patterning the almost arcadian rural images of Carl Krafft, Otto Hake, and Rudolph Ingerle attain a heightened naturalism mediated by dreamlike effect.

The decorative Impressionism of the late teens was a manifestation of the "stricter conservatism" with which Chicago art recoiled from the shock of the Armory Show.[140] Conservative observers of the Art Institute's annual salons of the late teens were heartened by "the return to beauty and idealism which characterized most of the pictures" as artists rejected "the freakish and the faddish" that had symptomized the "mental infection" of mid-decade.[141] Chicago's native art was lauded as evolutionary rather than revolutionary, building on the solid foundation of the achievements of the past and on such tried-and-true qualities as sound technique, home-grown subject matter, and pictorial beauty.[142] Its "uniformity and complacency" provoked one Modernist sympathizer to wonder "how the race of Titans that produced the skyscrapers

about him are capable of the gentle art" in the exhibition. Concluding "that the impulse which produced the skyscrapers was a genuine art expression with us and that the impulse which produced the pictures was not," he urged his readers to "disabuse ourselves of our adolescent conception of art as a sublime succession of masterpieces ranged in some stately palace," to "come out of our dream world to see and cultivate art as it is in its present living tradition … ."[143]

The Art Institute itself was no longer that "stately palace." Throughout the twenties, under the progressive leadership of Director Robert B. Harshe, the museum, in a pattern common to many American museums of the time, cautiously assimilated Modernism through special exhibitions (especially those organized for the Art Institute by the Arts Club) and, eventually, acquisitions.[144] It was hardly the "grey solemn mausoleum" denounced by Modernist sympathizers,[145] having accommodated itself to the inevitable with a philosoph-

140. Rich, "Half a Century of American Exhibitions," 12.

141. Stuart, "Chicago Artists' Twenty-Second Annual Exhibition," 3; Rich, "Half a Century of American Exhibitions," 13.

142. Stuart, "Chicago Artists' Twenty-Second Annual Exhibition," 5.

143. Jean Paul Slusser, "Old Masters and New," *The Art Student* 1 (Summer 1916), 206, 210.

144. See Richard R. Brettell and Sue Ann Prince, "From the Armory Show to the Century of Progress: The Art Institute Assimilates Modernism," in Prince, ed., *Old Guard*, 209–225; John W. Smith, "The Nervous Profession: Daniel Catton Rich and the Art Institute of Chicago, 1927, 1958," *Museum Studies* 19 (1993), 61.

145. Lupa de Braila, "The Independent Exhibition," *The Little Review* 3 (June 1916), 27, quoted in Hey, 46.

ic attitude summarized in its *Bulletin* in 1920: "Modernism is probably not so bad as the conservatives think, nor so good as the modernists think. But it lies in the path ahead of us and there is nothing to do but go through it or stand still."[146]

Responsible standards, however, were to be maintained; on these grounds the Art Institute refused to open its doors to the all-inclusive shows mounted by the No-Jury Society beginning in 1922.[147] Nor had the Art Institute abandoned its former symbiotic relationship with the city's conservative artists, who continued to dominate the school's rather inbred faculty and the notoriously conservative juries of the Chicago and Vicinity annuals.[148] Such was the power of the latter that Chicago's artistic radicals of the 1920s found a common identity more under the banner of the no-jury movement than in actual aesthetic revolt. Controversy over the makeup of the juries and their decisions enlivened Chicago's art scene throughout the 1920s. After the 1923 show, when the radicals briefly gained control of the jury and hanging committee, power was returned to the conservatives at the cost of autonomy, for Harshe ended the practice of artists electing the jury.[149] By decade's end, voting power had passed into the hands of artists from outside Chicago and from them into the control of the museum's trustees. The 1928 exhibition was considered a triumph for Modernism, but a qualified one, for in its selection the Art Institute had "proved quite conclusively that it would not take up with it [Modernism] unless it has been thoroughly digested and made to conform with tradition."[150]

The Art Institute nonetheless continued to promote the fortunes of individual Chicago artists not just through sales at the annual salons and solo exhibitions for established artists, but through the active work of its staff. For instance, in 1920, independent of the exhibition, Curator of Exhibitions

146. G. W. E. [George W. Eggars], "1920–1921," *Bulletin of the Art Institute of Chicago* 14 (Mar. 1920), 83.

147. Hey, "Five Artists," 209. In 1925 further reforms of the Chicago and Vicinity jury system restricted access to the jury, gave power to make awards to outside judges, and gave the Art Institute director sole discretion in the arrangement of the exhibition. These reforms were vehemently opposed by Palette and Chisel members Carl Hoeckner, Emil Zettler, and Gordon Saint Clair, who published a manifesto entitled "Proposed Art Jury 'Reforms' and What They Mean to You," (copy in Palette and Chisel Logbook 3 [1916–1931], 252, on deposit at the Newberry Library). The manifesto claimed that the proposed reforms meant essentially handing control of the exhibitions over to the Chicago Society of Artists.

148. Moser, "'In the Highest Efficiency,'" 202.

149. Hey, "Five Artists," 219–20. In 1927 critic Charles Fabens Kelley proposed that the Art Institute's American annual be judged by parallel juries ("Suggests Two Juries, One Modern, One Academic, for Chicago," *The Art Digest* 2 [mid-Nov. 1927], 7), and in 1926 the first exhibition of the All-Illinois Society of Fine Arts at the Carson Pirie Scott galleries featured "a Conservative Jury and a Modernist Jury" ("The President's Message," *First Exhibition by Artists of Illinois at the Galleries of Carson Pirie Scott and Company Sept. 27 to Oct. 16, 1926*, 6); each artist was to designate which jury would pass judgment on his submission.

150. Marguerite B. Williams, "Here and There in the Art World. The Chicago Artists," *Chicago Daily News*, Feb. 8, 1928; Ernest L. Heitkamp, "Orthodox Painters Get Jolt," *Chicago Examiner*, Nov. 11, 1928.

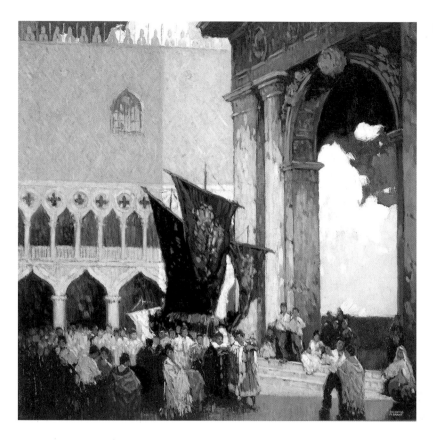

151. Charles Burkholder to Charles Dahlgreen, Aug. 6, 1920, Dahlgreen Papers, Archives of American Art, microfilm reel 3953, frame 1279.

152. C. H. B. [Charles H. Burkholder], "Pictures in the Home," *Bulletin of the Art Institute of Chicago* 14 (Mar. 1920), 35.

153. Yochim, *Role and Impact*, 39.

154. Whitridge, "Art in Chicago," 140–41; *Association of Chicago Painters and Sculptors* (n.p., n.d. [c. 1934]), unpaged.

155. Marion Deane Tufts, "The Artists' Guild: Its Birth and Progress" in *A National Association of Artists and Craft Workers* (Chicago: The Artists' Guild, 1917), 9.

FIG. 20 Frederic M. Grant, *The Departure of Marco Polo* c. 1926, oil on canvas, 30 × 30 in., Cat. 42.

Charles Burkholder helped arrange for sales of two of Dahlgreen's paintings, one to an out-of-state collector. The Friends of American Art continued to include works by Chicagoans among the unadventurous acquisitions it made for the Art Institute's collections.[151] The museum also took steps to harness the rapidly widening art public for the benefit of Chicago artists. Its Better Homes Institute combined a campaign for improving the level of taste in home decorating with its marketing of Chicago artists. "The east comes to Chicago to buy pigs, steel, and many kinds of merchandise, why should it not come to Chicago for its pictures?" queried Burkholder, with admirable if inflated optimism.[152]

The Art Institute's rapprochement with Modernism was partly shared by Chicago's established artists' organizations. The venerable Chicago Society of Artists, for instance, cautiously aligned itself with the "evolutionary growth of the modern art movement in this country."[153] But even this qualified endorsement alienated a conservative faction (including Ingerle, Taft, Grover, Karl Buehr, Palmer, and J. Jeffrey Grant), which split off in 1921 as the Association of Chicago Painters and Sculptors, under the Latin motto *mens sana*, or "A Healthy Mind."[154] The Arts Club, created in 1916 as a genteel "town club" to support the conservative Artists' Guild, quickly evolved into a champion of avant-garde art in the 1920s under the direction of Alice Roullier and Rue Winterbotham Carpenter.[155] The once "Bohemian" Palette and Chisel confirmed its status as an establishment institution with its

move to new headquarters, an Italianate mansion on Dearborn Street that it purchased in 1921. At $100 (up from an original $1.50 in 1895), membership was beyond the means of all but established artists, though it was within the reach of the rapidly growing numbers of successful businessmen and amateurs who supported the club financially as associate members. Despite its key position within Chicago's artistic establishment and the "ultra-conservative" character of its members' shows, however, the Palette and Chisel, in the interest of advancing Chicago artists, threw its support to the no-jury movement.[156] It encouraged its members' participation in the No-Jury Society's 1923 exhibition on the grounds that any increase in art activity in Chicago benefited all, while reassuring members of the show's legitimacy: "The notion that only freakish productions are acceptable in these exhibitions is entirely untenable, although it is part of the propaganda of the pro-juryites and cuckoo humorists in the daily press to convey that impression."[157] By 1926 club member Corydon G. Snyder was proposing a no-jury system for the Palette and Chisel's own

annual exhibitions, but this was not adopted.[158] Given the increasing numbers of amateur members, such a move would have been more a concession to those important supporters than a signal of artistic radicalism.

The prosperous postwar period saw the reassertion of the connection between art and commerce in an unprecedented stress on art's ability to cater to market demand.[159] One student deplored a tendency at the Art Institute's school "toward the mercenary and the commercial."[160] Modernism had offered the ultimate challenge to "the confusion between art and uplift" that had long sustained Chicago's cultural life.[161] Now the opportunities presented by a rapidly widening art public prompted even traditionalists to ask that art merely please the eye without having a deep message to communicate.[162] An Ozark landscape by Krafft was praised as "one of those pictures whose beauty and fascination are universally recognized, something that does not require being understood and cannot fail to be enjoyed."[163] Declaring that "pictures are something to enjoy, not to criticise," Lucie Hartrath urged the art public "to

156. Eleanor Jewett, "Palette and Chisel Do Admirable Work," *Chicago Tribune,* Apr. 18, 1926.

157. "The No-Jury Show," *The Cow Bell* (published by the Palette and Chisel Club), Sept. 1923, unpaged.

158. "Member Proposes No-Jury System for Palette and Chisel Club's Annual Show," unidentified clipping in Palette and Chisel

Club Logbook 3 (1916–1931), 277, on deposit at the Newberry Library.

159. Hammer, "Attitudes Toward Art," 119.

160. Louis G. Ferstadt to Robert B. Harshe, undated (probably from Oct. 1922), Robert Harshe Papers, General Correspondence, Box 1, Art Institute of Chicago Archives.

161. Watson in *The Arts*, 241.

162. Frederic Tellander, preface to *An Exhibition of Paintings by Frederic Tellander, Thursday, April 22, to Saturday, May 8 [1926] ... at the Chicago Galleries Association,* unpaged brochure.

163. Evelyn Marie Stuart, "Twentieth Annual Exhibition of Chicago Art," 116. In the 1916 "Chicago and Vicinity" annual exhibition at the Art Institute, Krafft was represented in

the exhibition by five landscapes. The one singled out by Stuart, described only as "an ambitious canvas shimmering with the mists of moonrise over the purple deeps of a valley," may well have been *The Charm of the Ozarks*, purchased by the Municipal Art League and now in the collection of the Union League Club of Chicago.

164. Hartrath quoted in Arietta Wimer Towne, "Art Notes of the Two Villages Specifically About the Art Exhibition," *The Oak Parker*, Jan. 17, 1925, 8.

165. Karen Fisk, "The Twenty-Ninth Annual Exhibition by Chicago Artists at the Art Institute," *American Magazine of Art* 16 (Mar. 1925), 137–38.

166. Eleanor Jewett, "Art and Artists," *Chicago Tribune*, May 15, 1927.

167. Karen Fisk, "The Annual American Exhibition at the Art Institute of Chicago," *The American Magazine of Art* 16 (Dec. 1925), 647–48.

168. "Annual Exhibition by Artists of Chicago and Vicinity," *Christian Science Monitor*, Feb. 12, 1926.

169. Eleanor Jewett, "Sheffer Paintings Well Worth Visit," *Chicago Tribune*, Oct. 18, 1925, sec. 4, p. 6. Sheffer had two one-person exhibitions at the Palette and Chisel Club and a one-person exhibition at the Chicago Galleries Association in the mid-1920s.

170. *The Municipal Art League of Chicago Presents the Following Plan for the Organization of the Chicago Galleries Association* [Chicago, 1925], 12.

try to understand the language of the individual artist, rather than pass judgment."[164] The 1925 Chicago and Vicinity annual, noteworthy for "decorative" canvases by F. M. Grant and E. Martin Hennings, gave a lasting impression of "friendliness, brightness, charm, poise," with much of the work tending conspicuously "not so much towards a new means of expression as toward greater perfection in methods already well established."[165] Whereas the "moderns" were said to set their art on a pedestal "and wave the strong incense of many words in mystifying clouds before it," their traditionalist contemporaries imposed "no obligation to bow down before gods of any kind," for "words are idle in the face of good painting."[166]

By the mid-1920s the emphasis on purely visual enjoyment was even moderating earlier insistence on national subject matter, with the realization that "mere choice of scene does not insure significant or 'national' art."[167] A new element of decorative fantasy was evident in both the Art Institute's American and Chicago and Vicinity annuals. Frederic M. Grant's "gorgeous decorative work" of historical fiction, *The Departure of Marco Polo* (fig. 20), complemented the mania for exotic pasts that was sweeping American culture (notably in architecture) by mid-decade.[168] Painter Glen Sheffer's semi-erotic depictions of luscious nudes, often in exotic settings, captured much attention: "His models are all pretty and well built," commented Eleanor Jewett in the *Chicago Tribune*; "it comes as a relief to see them after trying to wring something human from the usual nude exposed by the modern painter … ."[169]

A similar element of outright fantasy or lyrical romanticism informed the idiosyncratic work of some artists associated with Chicago's Modernist scene, such as Raymond Jonson, Harvey Pruschek, William S. Schwartz, and Ramon Shiva.

In the market-oriented climate of the prosperous 1920s efforts were renewed to harness the growing, and increasingly middle-class, art public for the benefit of Chicago artists. The Palette and Chisel, for example, inaugurated its small-picture exhibitions and bidding sales to stimulate purchases by less-wealthy patrons. The partisan nature of the Chicago and Vicinity jury on the one hand, and the shock of the radicals' coup there in 1923 and the Art Institute's comparative receptiveness to Modernism on the other, reinforced awareness of the relative distance between the institution and the local artists who had long so closely depended on it.

This climate gave birth in 1925 to the Chicago Galleries Association. A project of the Municipal Art League, the CGA was intended to extend the League's campaign for civic betterment and beautification to middle-class homes by making preselected, affordable works of art available for purchase or rental. Describing itself euphemistically as a "co-operative association of laymen and artists," the nonprofit CGA would "provide a place where the artists and the public may meet on a social as well as a business basis."[170] But with artists deliberately confined to an advisory capacity, the Association merely continued the local pattern of patron-driven arts organizations. In its gallery

at 220 North Michigan Avenue it functioned as a dealer (taking a 25 percent commission on sales) but incorporated elements of traditional exclusive clubs, "inviting" selected artist "members" to join and awarding purchase prizes at its semiannual juried exhibitions.[171] Somewhat in the spirit of the Society of Western Artists (which had ceased its exhibitions in 1914), the CGA sought to represent artists from Ohio west to California, but most of its artist membership consisted of well-established figures in the Midwest, from Adam Albright and George Ames Aldrich to Taft and Frederick Tellander. Its conservative sympathies made it the adopted home of the conservative Association of Chicago Painters and Sculptors, which held its annual exhibitions at the CGA galleries.

More catholic in scope were the All-Illinois Society of Fine Arts, also established in 1925, and the Illinois Academy of the Fine Arts, which developed from the Society the following year.[172] Both aimed to be inclusive and to embrace both conservative and Modernist artists. They acknowledged the gulf between the factions, however, in having separate juries for each persuasion and hanging their works separately, a scheme also suggested for the Art Institute's American Artists' annual in 1927.[173] The All-Illinois Society placed special emphasis on art education, especially for school children, in its goal of cultivating the state's art and artists; the Illinois Academy of the Fine Arts, which circulated exhibitions throughout the state, was specifically concerned with the establishment of a permanent collection of Illinois art in the state museum at Springfield. Both organizations were resolutely democratic: "An original work of art by an artist of Illinois in every school and home of Illinois" was the slogan of the All-Illinois Society, which was open to any resident of the state regardless of professional status.

The All-Illinois Society was founded by a consortium of Chicago women's clubs in response to the arrival in Chicago in 1925 of an important annual exhibition, the Hoosier Salon.[174] Organized by the Daughters of Indiana, the Salon was a showcase for artists working in that state, including such Chicago-based painters as Aldrich, Dahlgreen, and L. O. Griffith. Like numerous arts organizations ranging from the Palette and Chisel Club to the Arts Club and the No-Jury Society, the Hoosier Salon was held not at the Art Institute but at a department store gallery. Marshall Field & Company and Carson Pirie Scott were the most prominent among the Chicago retail establishments that offered important alternate venues for solo as well as group exhibitions. In a city in which few commercial dealers existed to counterbalance the monolithic power of the Art Institute, that "university of art," the cooperation of department stores with independent artists' and patrons' organizations filled the increasing gap between the museum and Chicago's native artists. It was the ultimate expression of the intimate relationship between art and commerce that had long characterized Chicago's cultural life.

171. Lay membership, like that at the Art Institute, was nonexclusive, but at $200 per year was beyond the reach of many potential patrons. In return, members received works by the member artists. The opportunity to purchase from the gallery was open to anyone.

172. Sparks, "A Biographical Dictionary, vol. 2, 692; Yochim, Role and Impact, 19–24.

173. Catalogue of the First Art Exhibition by Members of the Illinois Academy of the Fine Arts in the Galleries of the Illinois State Museum, Springfield, Illinois ([Springfield, Ill.], 1926), 6; All-Illinois Society of Fine Arts, Inc., First Exhibition by Artists of Illinois at the Galleries of Carson Pirie Scott and Company ([Chicago], 1926), 3–4; Kelley, "Suggests Two Juries," 7.

174. Marguerite Williams, "Exhibit of Prints Thrills Art Lovers … Illinois Painters and Sculptors," Chicago Daily News, Mar. 11, 1926.

175. Rich quoted in Genauer, "The Chicago Art Story," 86; see also Watson in *The Arts.*

176. Ernest L. Heitkamp, "Native Art Represented by One Man Shows Here; 'Moderns' Linked to Madhouse," *Chicago Herald Examiner,* Mar. 20, 1927.

177. Announcement "The Room of Chicago Art," 1942. Artists were "advised to keep their prices low if they wish to sell their work."

178. In 1934 the conservatives revolted against their exclusion by the Chicago and Vicinity annual's museum-appointed jury, which consisted mostly of museum directors. Ernest L. Heitkamp, "Artists Rebel, Demand Say in Naming Jury," *Chicago American,* Feb. 26, 1934; Heitkamp, "Chicago Artists Are in Open Revolt Against Museum Directors' Juries," *Herald and Examiner,* Feb. 26, 1934.

179. Dahlgreen, MS autobiography, 297, in Charles W. Dahlgreen Papers, Archives of American Art microfilm reel 3954.

Ironically, however, it was the ostensible lack of artistic commercialism that distinguished the Chicago art scene and ensured its conservatism. The department store galleries and civic organizations so important in promoting local artists were stand-ins for the independent dealers that largely failed to flourish in Chicago, dubbed by the Art Institute's Daniel Rich "the graveyard of good art galleries."[175] Whereas New York claimed its status as the national art center by virtue of its concentration of galleries, Chicago's professional art life was uniquely dominated by its great museum and a host of civic organizations that echoed the Art Institute's status as disinterested guardian of public taste. The fortunes of Chicago's artistic establishment were tied to those organizations' agendas of widening the art public while promoting a decorous taste in art, or what one conservative critic championed as "art hygiene."[176] This construction of Chicago's cultural life, where art was institutionalized as a civic commodity, may go a long way toward explaining the conservative tenor of much of Chicago painting in the formative period between the world's fair and the Depression.

The story of Chicago's conservative artists could be told almost entirely in terms of their relationship with The Art Institute of Chicago, the undisputed and indispensable fulcrum of artistic Chicago. Born as the expression of the shared ideals of civic and artistic elites, the Art Institute by the 1920s was permanently fixed on a trajectory at odds with the concerns of Chicago's artists, especially the conservatives. As the gap between art in Chicago and art of Chicago widened conspicuously, local artists would find themselves increasingly ghettoized within the institution's walls. In the 1930s, their one-person shows were relegated to what the Art Institute itself termed "the so-called 'doldrums' season"; beginning in 1942 these shows were replaced by the "Room of Chicago Art," which strongly favored local Modernists over traditionalists.[177] The latter already had been effectively ousted from the Chicago and Vicinity annuals, which finally ceased in 1950.[178] "Modern art was creeping into the Art Institute and the conservative painters were gracefully left in the cold," recalled Dahlgreen.[179]

From the conservatives' point of view, they were the true, if beleaguered, heirs of the ideals that inspired the founding of the Art Institute, bearers of the banners of traditional artistic ideals and civic pride. Viewing themselves as at once liberal and properly discriminating, Chicago's conservative painters appropriated new modes and styles as fresh vehicles for ideals and conventions that remained essentially little changed over a half-century of challenge and upheaval. Their insistence on well-honed technique as the foundation of art was matched by their passionate conviction that art's most basic purpose was to effect moral and spiritual uplift by exposing the inner truth and beauty of the world around them. Constancy to academic ideals informed an evolving search for local artistic identity on the part of Chicago painters. The period saw the application of their European training and their qualified assimilation of influential new styles, from Impressionism to Modernism, to a remarkable shift in standards of acceptable subject matter.

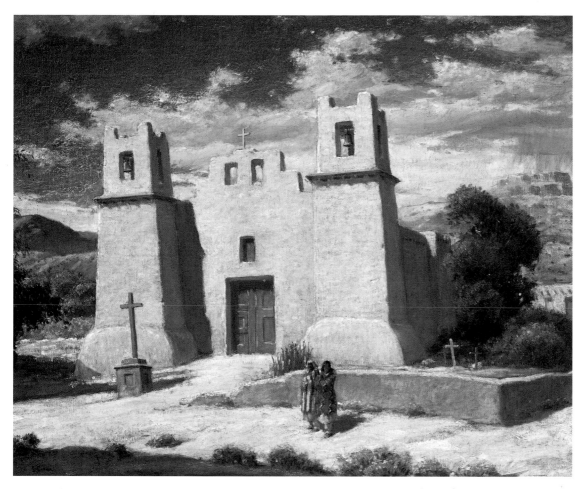

FIG. 15 Edgar Spier Cameron, *Santa Cruz*, c. 1917–21, oil on canvas, 24 × 29 in., Cat. 20.

From a seeming contradiction in terms, "Chicago painting" struggled to become an art by, for, and about Chicago and the region in its most characteristic manifestations, yet interpreted through a medium of amelioration and emendation. Nothing so aptly mirrored the "artless" nature of Chicago as her conscious cultivation of an art that ultimately transcended her reality, delivering a vision of her yearnings for "more of beauty and less of ugliness."

"The Spirit of Change": Modernism in Chicago

Susan Weininger

NOTES

1. The Committee, "Foreword,"*First Annual Exhibition of the Chicago No-Jury Society of Artists* (Chicago, 1922), n.p.

2. Paul Kruty, "Declarations of Independents: Chicago's Alternative Art Groups of the 1920s," in Sue Ann Prince, ed., *The Old Guard and the Avant-Garde* (Chicago: University of Chicago Press, 1990), 82.

In 1922, the newly formed Chicago No-Jury Society of Artists, a group dedicated to freedom from juried exhibitions and "individual conception and style" in art, had their first annual show.[1] The cover of the catalogue was graced with a circular image of a classically inspired, if somewhat decoratively distorted, almost nude figure holding a torch aloft in one hand while resting the other on a blank canvas sitting on an easel. The stylized torch reappears in the elegant and intricate border surrounding the image, emphasizing the enlightenment that is the result of exposure to art. Beneath the illustration the title of the exhibition is displayed in script that includes the Latin V-shaped *u* in an effort to underscore once again the link with the classical past, resonant with culture, refinement, and beauty. Flanking the text, two stylized trees sag with ripe fruit, suggesting the richness and fecundity that art bestows. This image is by James Cady Ewell, an artist whose conservatism is clear. That a work of this artist served as the public face for this radical exhibition of free spirits yearning for independence from the strictures imposed by the established art world, represented particularly by The Art Institute of Chicago, seems surprising. And indeed, the catalogue design was completely revamped for the 1923 exhibition. The second exhibition catalogue cover was graced by a flat, stylized, purposively naive figure, arms aloft, holding a torch in one hand and what could be a "fistful of rushes that could be arrows" in the other.[2] Surrounded by a border decorated with simple, repeating triangular motifs, and flanked by stylized palm trees, artist Emil Armin's design could not be more different than Ewell's. Its deliberate naiveté, emphasis on formal relationships to convey the energy and dynamism of the art in the exhibition, and reference to a vaguely primitive culture rather than to the classical traditions valued so highly by the traditional Chicago art world represent a real alteration in approach. Its implication that art is active and engaging rather than passive and receptive is expressive of the Modernist ethos. These two images give

us insight into the sometimes conflicted and fitful development of Modernism in Chicago, which was often manifested more in the ideas of the artists than in their practice. The images and what they stand for also suggest a number of other important themes that emerge in an attempt to understand the unique Modernism that emerged in Chicago painting in the early twentieth century: even among those who were self-professed independents and radicals, there was a strong attachment to the idea that art had an elevating function, that beauty equated with moral good; there was high regard for the classical, idealized nude figure as a subject; traditional artists and progressive or "radical" artists often worked and exhibited together peaceably, and even self-defined Modernists often created art that looked conventional, while conservative artists sometimes created work that looked Modernist.

As recently as 1999, when the Whitney Museum of American Art organized the two-part exhibit *The American Century: Art and Culture*, the canonical view of the development of modern art in the United States was once again displayed, discussed, and extensively catalogued. This vision of the evolution of American art (and culture) as a phenomenon that took place primarily in New York, however, is one that seems ready for dismantling. Even the *New York Times* art critic Holland Cotter, not normally prejudiced in favor of art produced west of the Hudson, points out the shortcomings of the approach taken by the Whitney. In a review of the first half of the Whitney exhibition, Cotter states that the organization of the show is dependent on a definition of twentieth-century American art "with roots firmly planted in European Modernism. By its lights, an avant-garde, generically and monolithically conceived, is the arbiter of value. Provincialism, whatever that means, is anathema. Art is something produced in a New York studio, not an Iowa church hall or a sharecropper's kitchen in Georgia or a tenement bedroom in Baltimore."[3] As the Whitney exhibition makes clear, the canonical view is still powerful, and indeed, until about a decade ago, the history of Modernist art in America was the story of what happened in New York: the early Modernism fostered by Alfred Stieglitz, Walter Arensberg, the Synchromists, and the postwar development of the indigenous style called Precisionism. Recently, however, as Cotter acknowledges, studies of art produced in geographical areas ranging from California to Ohio, New Mexico to Maine, and Michigan to Texas have begun to build a history of the growth of Modernism in the United States that is richer and more complex than previously suspected. The ever-increasing number of works of art that have come to light and the scholarship documenting and interpreting them allows us to see a more complex picture of the growth of American art in the early twentieth century. In consequence, the canonical narrative has become less and less viable. At this point in the developing picture of Modernism in Chicago, we are beginning to have a clear

3. Holland Cotter, "Nation's Legacy, Icon by Icon," *New York Times*, 23 April 1999.

sense of who the artists were, the kind of work they were producing, what and where they studied, where they exhibited, and who was supporting their work.[4]

This study, inspired by the collection of Modernist paintings in the Bridges Collection, is dependent on such groundwork. In this essay, I will look at the particular way in which Modernism took shape and developed in Chicago. Early groundbreaking but isolated experiments with radical Modernism were subsumed into a dominant conservatism that dovetailed with the goals of the Ashcan School artists in New York. A longstanding comfort and familiarity with Symbolist art and with the Arts and Crafts tradition conditioned Chicagoans to the potential for abstract relationships of line, shape, and color to convey meaning and a respect for craft as well as fine art. In many ways, the Modernism that emerged in Chicago remained linked to the late nineteenth-century movements that sought to embody spiritual truth in abstract configurations of formal elements. Modernist rhetoric went hand in hand with academic, finely crafted, polished, and highly finished works dependent on the values embedded in the traditional Beaux-Arts education offered by The Art Institute of Chicago. At the same time, by the 1930s artists in Chicago approached Modernism in open, flexible, and deeply personal ways that culminated in the emergence of a surreal, or at least idiosyncratic, sensibility that marked the avant-garde in Chicago with its own distinct stamp. Because the work produced in Chicago does not look like, nor develop on the same timetable as, the normative Modernism of New York, it has been largely overlooked or disparaged. While Alfred Stieglitz and a number of New York critics attempted to define, shape, and promote a uniquely American Modernism in the teens and 1920s, Chicago artists were less interested in issues of national identity than in creating "genuinely alive, sincere and competent" expression.[5] Like their traditional counterparts in the city, the Modernists valued European art as the repository of the highest cultural achievements. Indeed, a hallmark of Chicago Modernists is their relative disregard for developments in New York (aside from the Ashcan School) in the search for a progressive art. By looking at the circumstances of training, exhibition, critical reception, and patronage, we can begin to see how the development of Modernism in Chicago follows a trajectory that sometimes mirrors the

4. Since the 1990 publication of the germinal volume, *The Old Guard and the Avant-Garde*, a series of essays treating various aspects of Modernism in Chicago, there have been a good number of monographic studies of progressive artists, as well as investigations of the educational institutions, artists groups, exhibition venues, critics, and patrons associated with Modernism in the city. Gertrude Abercrombie, Ivan Albright, Anthony Angarola, Emil Armin, Aaron Bohrod, Belle Baranceanu, Kathleen Blackshear, Manierre Dawson, Frederick Frary Fursman, Vin and Hazel Hannell, Raymond Jonson, Paul Kelpe, Herman Menzel, Archibald J. Motley Jr., Tunis Ponsen, William S. Schwartz, and Julia Thecla have been the subject of exhibitions and accompanying catalogues. These monographic studies provide a basis for developing a picture of the artistic community that is multi-layered and varied. Other studies have addressed the image of the city, women artists, the relationship of Chicago artists to the theories and work of the Russian innovator Wassily Kandinsky, and institutions such as the Renaissance Society at the Unversity of Chicago and the Arts Club of Chicago. Artists who lived and worked in Chicago have also been integrated into group shows that are not geographically localized. Art produced in Illinois during the period of the Great Depression, particularly for the government-supported art projects, has also been the subject of specific studies.

5. J. Z. Jacobson, "Introduction," *Art of Today: Chicago, 1933* (Chicago: L. M. Stein, 1932), xviii.

EARLY MODERNISM

Chicago has a distinguished history of avant-garde architecture, theater, and literature that flourished from the late-nineteenth century into the second decade of the twentieth. Louis Sullivan, Dankmar Adler, Frank Lloyd Wright, Daniel Burnham, John Wellborn Root, William LeBaron Jenney, Maurice Browne, Floyd Dell, Harriet Monroe, Margaret Anderson, Theodore Dreiser, Vachel Lindsay, and many others, were inspired to create buildings, theatrical productions, poetry, and literature that was experimental, daring, and proclaimed the unique position of Chicago as a thriving urban community. There are, in fact, many parallels between these eminent architects and writers and the largely forgotten Chicago Modernist painters, all of whom sought to make sense of the constantly changing face of the rapidly developing metropolis and its myriad contradictions. As Carl Smith has pointed out, the energy, self-determination, and industrial might of Chicago attracted writers who sought to find new forms to embody the unique city emerging from the plains. The fact that Chicago was a city of immigrants with a relatively short history (in comparison with the older metropolises of the East Coast and Europe), dominated by skyscrapers, railroads, and stockyards, a city of contrasts between wealth and poverty, cleanliness and dirt, crowded streets and tenements, and open parks and lakefront, was a challenge and an inspiration.[6] Artists faced the same formidable challenges in their attempts to give form to something new and contradictory. In an effort to be true to themselves, to achieve authenticity and sincerity, artists resorted to the same crudeness that was noted by writers from Stanley Waterloo to Sherwood Anderson.[7] The artist, often the subject of literature about Chicago from the period, did not fare well in the city, either in fact or in fiction. Despite this, artists working in the city in the first four decades of the century did persevere, attempting to impose order, beauty, and even morality on the chaos of the new urban reality. Like the writers of the same period, painters facing the industrial modernity of the city were forced to conceive of new modes of expression in order to respond to it.[8] While writers such as Hamlin Garland sought to create an authentic national art in the Heartland in the 1890s, even the self-consciously avant-garde artists clung to some of the traditional modes of expression learned at the School of the Art Institute to embody new, more internally expressive content. The conventional idea that visual art expressed transcendent values embedded in traditional ideas of beauty, transmitted as often as not through the ideal human form, had a tenacious hold on both progressives and conservatives. This created an environment that allowed the traditionalists and Modernists to enjoy a fluid relationship, moving fairly easily between both stylistic modes and exhibition venues.

The Art Institute of Chicago was the center of artistic life for both conservatives and progressives through the first two decades of the twentieth century.

6. Carl Smith, *Chicago and the American Literary Imagination, 1880-1920*, University of Chicago Press, 1984, 4-7.

7. Smith 4–5.

8. Smith, 11.

9. Although there was a group of avid collectors of nineteenth-century art, particularly French Impressionist and Post-Impressionist painting, the Art Institute's collection of nineteenth-century art was not established until the 1920s. See Stefan Germer, "Traditions and Trends: Taste Patterns in Chicago Collecting," and Richard R. Brettell and Sue Ann Prince, "From the Armory Show to the Century of Progress: The Art Institute Assimilates Modernism," in Prince, ed., *The Old Guard and the Avant-Garde*, 171–91 and 209–25.

10. *Bulletin of the Art Institute of Chicago* 6:4 (April 1913), 51.

11. Andrew Martinez, "A Mixed Reception for Modernism: The 1913 Armory Show at the Art Institute of Chicago," *Museum Studies* 19 (1993), 33–34.

12. In addition to Martinez, important sources for information about the Armory Show in Chicago include Milton Brown, *The Story of the Armory Show*, 2nd ed. (New York: Abbeville Press, 1988), particularly 187–214; Randolph J. Ploog, "Critiquing Cubism," *Chicago History* 23:2 (Fall 1994), 58–72; and Sue Ann Prince, "'Of the Which and the Why of Daub and Smear': Chicago Critics Take on Modernism," in Prince, ed., *The Old Guard and the Avant-Garde*, 97–102.

13. Martinez, "Mixed Reception for Modernism," 53.

Most of the artists in Chicago, whether natives or immigrants, were drawn to the School for its respected educational opportunities. The Museum provided access to a growing permanent collection not only of Old Masters but of turn-of-the-century American art.[9] In addition, the juried annuals of local and national art and a series of important traveling exhibitions provided the major venue for seeing firsthand a wide variety of contemporary and historical art. Despite the traditional Beaux-Arts pedagogy employed in the School through the 1920s and into the 1930s, and the generally conservative nature of the annual exhibitions in the early years of the century, it is instructive to examine some of the exhibitions sponsored and promoted by the Art Institute during the period between 1905 and 1915. Notwithstanding its traditionalism, the statement the Museum made in defense of hosting the 1913 International Exhibition of Modern Art (the Armory Show), that "the policy of the Art Institute … has always been liberal, and it has been willing to give a hearing to strange and even heretical doctrines, relying upon the inherent ability of the truth ultimately to prevail," applies to a variety of shows that were seen in the years between 1905 and 1915.[10]

Thus, along with numerous noncontroversial exhibitions, the Institute hosted several radical displays of European Modernism before the Armory Show in March 1913. In January of that year, an *Exhibition of Contemporary German Graphic Art,* featuring work by Kandinsky, Nolde, Beckmann, and Pechstein, elicited little excitement in the press. In contrast, *An Exhibition of Contemporary Scandinavian Art,* which opened in February 1913 and included work by Edvard Munch, generated a great deal of negative comment.[11] Despite the somewhat defensive posture of the Art Institute, and the indifferent or negative comments the exhibitions elicited in the Chicago press, the institution that has traditionally been chided for its conservatism provided a place for these shows to take place.

The history of the Armory Show and the show's appearance and reception in Chicago have received a great deal of scholarly attention.[12] This was undoubtedly the first opportunity for many of the 189,500 individuals who came to the Art Institute to see the highly publicized exhibition in its three-and-one-half weeks at the Museum to view examples of European and American Modernism. The critical response was generally negative, demeaning jokes and cartoons were abundant, and the Director of the Art Institute, William French, conveniently scheduled his vacation to coincide with the run of the show. Students at the School of the Art Institute, urged on by their instructors, conducted a mock trial of one "Hennery O'Hair Mattress" and burned copies of Matisse's *Le Luxe (II), Goldfish and Sculpture,* and *La Femme Bleue (Blue Nude).*[13] Although the exhibition included thirteen oil paintings, one sculpture, and a number of drawings by Matisse, the selection of the particular works targeted by the students is telling.[14] All of them focus on nude female figures, the most highly valued subject in the traditional pedagogy of the School. To the faculty and students who revered the classically idealized nude fig-

ure as the core of the fine arts, expressive of a transcendent beauty and truth that was the essence of art and even and morality, it must have been particularly threatening and insulting to see Matisse's distortions of traditional perspective, shape, and color.[15] The nudes in the show were the focus of a good deal of morally charged criticism in the press, as well. For example, an editorial in the *Chicago Tribune* stated that "the nudes pervert the ideal of physical perfection, obliterate the line which has heretofore distinguished the artistic from the lewd and obscene, and incite feelings of disgust and aversion."[16]

Despite the negativity surrounding the exhibition and the frustration of the organizers, there were a number of thoughtful and tolerant responses to the show. Arthur Jerome Eddy, a lawyer and collector in Chicago, who had made extensive purchases at the New York Armory Show, gave several public lectures defending and explaining the art to the public.[17] Harriet Monroe, critic and editor of *Poetry* magazine, wrote in favor of learning about the new art and, despite her own misgivings, urged the public to try to understand it.[18] An editorial in the *Chicago Evening Post* also urged visitors to the Art Institute to give the work in the exhibit "a fair hearing and a serious consideration."[19] As the one museum in the country that hosted this show (the Metropolitan Museum in New York refused it), the Art Institute showed not only tolerance and openness to new ideas, but enormous courage and commitment to "give a hearing to strange and even heretical doctrines."

In 1915, Arthur Jerome Eddy persuaded the Art Institute to host an exhibition of twenty-five paintings by Albert Bloch, the only American to exhibit with the Blue Rider group in Germany. The show, described as "an echo of the International Exhibition of 1913," was accompanied by a catalogue with a foreword by Eddy, who by this time had already published his important introduction to and defense of Modernist art,

14. See Brown, *Armory Show*, 291–93, for a list of Matisse's works exhibited at the Armory Show.

15. That the idealized nude was a central focus of the education at the School of the Art Institute is discussed by Charlotte Moser, "'In the Highest Efficiency': The School of the Art Institute of Chicago," in Prince, ed., *The Old Guard and the Avant-Garde*, 193–98. John Vanderpoel, a revered professor of figure drawing at the School from 1888 until his death in 1911, published a book called *The Human Figure*, which became a standard text immediately after its appearance in 1907. Vanderpoel's conservative approach thus remained influential even after his death. The respect for tradition might also account for the difficulty that many critics had with Duchamp's *Nude Descending a Staircase*, which became a focus for much of the most virulent negative response to the exhibition. See also Martinez, "Mixed Reception for Modernism," 38; Ploog, "Critiquing Cubism," 58–72; Prince, "Chicago Critics Take on Modernism," 97–102; Brown, *Armory Show*, 205–10. It may also explain the form given a cartoon from the *Chicago Daily News* (26 July 1912) titled "How Modern Ideals Might Affect Classic Art: If Inanimate Objects Could Express Themselves." This illustration shows a group of well-known classical sculptures, including the *Venus de Milo* and the *Laocoon*, leaping off their pedestals in an effort to flee the entrance foyer of the Art Institute as several women with unusual decorative hats walk in; one of the sculptured lions is looking at the scene with an expression of dismay, his hair on end.

16. "The Cubist Art," *Chicago Tribune* (editorial), 2 April 1913, as quoted in Prince, "Chicago Critics Take on Modernism," 98.

17. Paul Kruty, "Arthur Jerome Eddy and His Collection: Prelude and Postscript to the Armory Show," *Arts* 61 (February 1987), 43–44.

18. Harriet Monroe, "International Art Show to Open at the Institute on March 24," *Chicago Daily Tribune*, 16 March 1913.

19. *Chicago Evening Post* (editorial), 23 March 1913, as quoted in Brown, *Armory Show*, 210–11.

20. *Bulletin of the Art Institute of Chicago* 96 (October 1915), 78.

21. Arthur Jerome Eddy, *Cubists and Post-Impressionism* (Chicago: A.C. McClurg, 1914); Kruty, "Arthur Jerome Eddy," 44–45; Henry Adams, "Albert Bloch: The Invisible Blue Rider," in Henry Adams, Margaret C. Conrads, and Annegret Hoberg, eds., *Albert Bloch: The American Blue Rider* (Munich and New York: Prestel-Verlag, 1997), 38.

22. As cited in Kruty, "Arthur Jerome Eddy," 45, n. 74.

23. Newspaper clipping with unreadable date and attribution, c. July 1915, Art Institute of Chicago Scrapbooks, Ryerson Library.

24. Lena M. McCauley, "Art and Artists," *Chicago Post,* 10 July 1915.

25. Lena M. McCauley, "Art and Artists," *Chicago Post,* 15 July 1915.

26. Albrecht Montgelas, "Abstract Art Pictures Emotion," *Chicago Examiner,* 19 July 1915.

27. By this time Kandinsky's own *Concerning the Spiritual in Art* was available in English translation.

Cubists and Post-Impressionism.[20] In this 1914 publication, Eddy wrote the first book-length English language explanation of Modernism to be published in America, relying particularly on the theories of Wassily Kandinsky, with whom he was personally acquainted. He became an avid collector of modern art after seeing the Armory Show, accumulating numerous works by Kandinsky and the German Expressionists in his circle, such as Gabriele Munter, Franz Marc, Alexei van Jawlensky, and at least twenty paintings by Bloch.[21] Reiterating the Institute's own stance on showing novel and unconventional art, Eddy emphasized the intellectual integrity of the Museum in supporting exhibitions such as the Bloch show "on the theory that its members and the public have the right to see and judge for themselves everything that is new and interesting in art."[22] The exhibition was greeted with mixed response in the press. One critic was completely negative, stating, "just because you were able to appreciate the *Nude Descending a Staircase,* don't think you are equipped for the present exhibition of Mr. Bloch's work." This reviewer goes on to assure the reader sarcastically that Mr. Eddy's explanation of one of Bloch's works should serve to assure the viewer that "the baby did not mark it all up with a crayon and an uncorked bottle of ink."[23] On July 10, Lena McCauley of the *Chicago Post* said that "the designs are chaotic, the colors lurid. One may fancy any tale he pleases from the crudely drawn sketches of human figures distorted under impossible conditions. Beauty of any sort, refinement and harmony of effects are wanting." She goes so far as to equate this art with "the same wave of unbalanced mentality that has led Europe to the madness of war, as well as madness in less terrifying directions of human activity."[24] By July 15, McCauley had moderated her views, now quoted extensively from Eddy's foreword to the catalogue, and praised the Art Institute for giving the public the opportunity to see "novelties" and "oddities" and for being "hospitable to the new idea."[25] Albrecht Montgelas expressed personal skepticism in the *Chicago Examiner,* but attempted to understand and communicate Eddy's interpretations of Bloch's abstracted images.[26] Eddy's discussion, based on Kandinsky's theories of inner necessity already explicated at length in his 1914 book, posited the communication of emotion directly through the colors, lines, and shapes on the canvas and emphasized the importance of expressing one's own inner truth by whatever means most suitable.[27] These ideas provided the budding Modernists in Chicago, some of whom were already involved with the School of the Art Institute or other institutions in Chicago, with a theoretical justification for their work, and such ideas became increasingly important as the circle of progressive artists widened in the 1920s. Both Montgelas and McCauley were serious critics of the Bloch exhibition and remained unconvinced of the value of the work, but they did credit the Art Institute and the city of Chicago for being open to new ideas. Once again the Art Institute created a venue for those interested in seeing controversial avant-garde art, and at least some of the critics treated that decision with intelligence and respect.

Even before the Armory Show made its appearance in Chicago in 1913, certainly the first time most observers saw European and American Modernism firsthand, there were opportunities to see Modernist art in Chicago. B. J .O. Nordfeldt, for example, lived in Chicago beginning in 1891, and entered the Art Institute School in 1898. He spent part of the first and second decades of the twentieth century in Chicago, periodically traveling and working in Europe. In 1911, he and his wife rented one of the shops on 57th Street that were among the only surviving remnants of the World's Columbian Exposition of 1893, and that were now serving as artists' studios and residences for a lively group of writers, visual artists, and performers.[28] During his Chicago period, he painted a series of Modernist works suggestive first of Whistler and Manet, and later demonstrated a familiarity with early-twentieth-century Modernism, particularly the work of the Fauves. His Modernist works were exhibited at the Roullier Galleries early in 1912, followed by a solo exhibition in the Frank Lloyd Wright-designed W. Scott Thurber Gallery in November of that year, where ten of his Modernist portraits and recent cityscapes were shown.[29]

Shortly after Nordfeldt returned to Chicago in 1911, Jerome Blum, an American Fauve-influenced painter, had an exhibition at the Thurber Gallery. Blum was raised in Chicago, although he spent considerable time in Europe, and never studied at the Art Institute. He was introduced to the Post-Impressionists and Fauves in France, where he developed a Modernist style characterized by bold colors and dynamic, thickly applied paint. His exhibition at Thurber's was met with a vigorously and almost unanimously negative response from the Chicago critics, and Blum had to persuade Thurber to keep it open. The extended run of the show brought curious viewers and critics and even resulted in Arthur Aldis's purchase of two paintings.[30]

The Thurber Gallery also sponsored the exhibition of the work of the East Coast artist, Arthur Dove, in 1912. Much of the work in this show was close to pure abstraction, although inspired by natural forms. Yet the critical reception was thoughtful and intelligent, as contrasted with the angry and anti-intellectual response to the Armory Show the following year. Ann Morgan attributes the acceptance of Dove's work in Chicago, where he even sold one painting to Arthur Jerome Eddy, to three factors: "First, there existed a vital, cultured society that already had experienced early Modernism in some areas of artistic expression, notably literature and architecture. Second, the art community had a long-standing, sophisticated familiarity with the period's major forms of painting (aside from radical Modernism). Third, there was an unusually strong awareness of the decorative and expressive potential of non-historical design based on organic motifs."[31]

It is against this artistic background, dominated by a conservative institution providing traditional education, as well as fairly regular exhibitions of avant-garde European and American art, that the first Modernists in Chicago began to emerge. Exposure to up-to-date art was neither the only, nor necessarily the

28. Paul Kruty, "Mirrors of a 'Post-Impressionist' Era: The Chicago Portraits of B. J. O. Nordfeldt," *Arts* 61 (January 1987), 30. For Nordfeldt's early years, see also Van Deren Coke, *Nordfeldt the Painter* (Albuquerque: University of New Mexico Press, 1972), 30–41.

29. For Wright's remodeling of the Thurber Gallery, see Ann Lee Morgan, "'A Modest Young Man with Theories': Arthur Dove in Chicago," in Prince, ed., *The Old Guard and the Avant-Garde*, 25–26. For the Nordfeldt exhibition at the gallery, see William H. Gerdts, *The Color of Modernism: The American Fauves: 1907–1918* (New York: Hollis Taggart Galleries, 1997), 117, and Kruty, "Mirrors of a 'Post-Impressionist' Era," 30.

30. Kenneth R. Hey, "Five Artists and the Chicago Modernist Movement, 1909–28," (Ph.D. diss., Emory University, 1973), 121–22; Gerdts, *Color of Modernism*, 116, cites the positive reviews of Harriet Monroe and Maud Oliver after the show was extended. Arthur Aldis was an important advocate for bringing the Armory Show to Chicago.

31. Morgan, "'A Modest Young Man with Theories,'" 36.

most important, foundation for the emergence of Modernism in Chicago, however. As Morgan pointed out in her analysis of Dove's reception in Chicago, the city's art community was familiar with the abstract aesthetic that emerged from the Arts and Crafts tradition, which was allied with the decorative and architectural arts. The tradition of decorative abstraction that emerged in Europe in the late nineteenth century, known variously as Art Nouveau, Jugendstil, or the Arts and Crafts movement, depending on its geographic location, proved of great importance in the development of abstract and nonrepresentational art. The artists of this tradition, along with the Symbolist artists, who also rejected the perceived materialism and corruption of the post-Renaissance European tradition and sought to represent deeper spiritual truth through formal artistic means rather than mimetic reproduction, provided a basis for Modernism to grow and find acceptance. Like Modernists, practitioners of these modes valued the abstract relationship of formal elements, often in service of a spiritual truth, above both academicism and visual fidelity to nature.

In many ways Manierre Dawson embodies the possibilities inherent in the circumstances of early-twentieth-century Chicago. Born and raised in the city, Dawson had a strong interest in painting, beginning in high school, but pursued a degree as a civil engineer as a compromise with his lawyer-father. He studied at Armour Institute (now Illinois Institute of Technology), earning a B.S. degree in 1909.[32] He continued to paint whenever he had time, devoting his weekends and summers to his art. In the spring of 1910, he produced what seem to be the first nonobjective works by an American artist; this was prior to a European trip when he was able to see examples of avant-garde art face to face for the first time. As Dawson scholar Randy Ploog has demonstrated, Dawson's abstraction was an outgrowth of his experience in Chicago, including the kind of drawings that he executed as a draftsman for the architectural firm of Holabird and Roche, rather than a derivative of Modernist European art. His early work shows the influence of Arthur Davies, whose dreamy Symbolist paintings differed from both the academic and Impressionist-derived styles so popular in Chicago at the time. Dawson was also clearly familiar with the theories of Arthur Wesley Dow, whose textbook *Composition* (published in 1899) was widely used in art education across the country and was particularly popular in Chicago. Dow was in favor of replacing the study of anatomy, perspective, and drawing from casts of antique sculpture that were typical of the traditional course of study in institutions such as the Art Institute School with a series of exercises designed to

32. Dawson's early development has been treated in great detail recently by Randolph Ploog, who has shown that the artist developed an abstract style independent of developments outside of his native Chicago. See Randolph J. Ploog, "Manierre Dawson: A Chicago Pioneer of Abstract Painting," (Ph.D. diss., The Pennsylvania State University, 1996); Randy Ploog, "The Chicago Sources of Manierre Dawson's First Abstract Paintings," in Susan Weininger, ed., *BlockPoints* 3/4 (Evanston, Ill.: Mary and Leigh Block Museum, Northwestern University, 1999), 32–57; Randy J. Ploog, "The First American Abstractionist: Manierre Dawson and His Sources," in *Manierre Dawson: American Pioneer of Abstract Art* (exh. cat., New York: Hollis Taggart Galleries, 1999), 58–81.

teach the student principles of abstract design. His system was geared toward creating a beautiful and balanced design rather than toward reproduction of nature. In addition, Dow valued both craft and fine art, seeing little distinction between the two. Like Dow, Dawson was also familiar with Japanese art, with its emphasis on relationships of line, color, and shape arranged in abstract patterns to achieve its effect; there were many opportunities to see such Japanese prints in Chicago, including the exhibition of Frank Lloyd Wright's collection, exhibited at the Art Institute in 1906. Ploog attributes Dawson's development from use of abstracted natural elements to pure abstraction to the influence of Denman Ross's *A Theory of Pure Design*, which advocated using pure form, with no imitation or copying of nature, to achieve a satisfying result based on scientific principles. In addition, Arthur Jerome Eddy's 1903 book *Recollections and Impressions of James A. McNeill Whistler*, which explained Whistler's work by using musical analogies to justify the elimination of subject matter, must have made a strong impression on the young artist. Dawson, who left Chicago for his family's Ludington, Michigan, farm in 1914, has been the subject of a number of studies in which his considerable achievements have been treated as an anomaly in the development of Chicago Modernism. And while he did work in isolation, without followers, it is worth considering the sources of his Modernism and how they might have influenced other artists working in the city, even if other artists responded to the influence in somewhat different ways.

Eddy's interest in Modernism dates back to his discovery of Whistler at the 1893 World's Columbian Exposition. In the same way that he relied extensively on Kandinsky in his later book *Cubists and Post-Impressionism*, Eddy presented Whistler's ideas in *Recollections and Impressions of James A. McNeill Whistler*, often quoting directly from the artist's own writing and from personal interviews with him. He conveys Whistler's convictions that art be free of sentiment and that whether or not there is recognizable subject matter, the pleasure of art should come from the harmonies of the formal elements. Whistler's famous assertions, "Art should be independent of all clap-trap, should stand alone, and appeal to the artistic sense of eye or ear, without confounding this with emotions entirely foreign to it, as devotion, pity, love, patriotism, and the like. All these have no kind of concern with it, and that is why I insist on calling my work 'arrangements' and 'harmonies'" were repeated in Eddy's book and most likely reiterated in the public lectures he gave on Whistler at the Art Institute in 1908.[33] These ideas prepared Chicagoans, conservatives and progressives alike, for experiments with nonacademic art.

Indeed, even the Art Institute School students were fascinated with Art Nouveau, if the student publication *The Sketch Book*, published between 1902–6, is a gauge. The students showed a continuing interest in the late-nineteenth-century movement, even treating

33. As quoted in Ploog, "The Chicago Sources of Manierre Dawson," 51.

the fine arts and the decorative with equal respect. Their exposure came via a variety of popular magazines, as well as firsthand from the exhibition of work by Alphonse Mucha, who also taught at the School and, in 1908, delivered the Scammon lectures. Aubrey Beardsley's work was exhibited in 1912.[34]

Chicago artists were prepared for much of what was presented at the Armory Show, which was meant to be a historical survey of the development of modern art from the middle of the nineteenth century. The Fauvist, Cubist, and Futurist work that garnered the most attention in the press was, in fact, only a tiny portion of the exhibition. The Armory Show was, however, an altering experience for many of the early Modernists in Chicago. Dawson was overjoyed and felt validation of what he was doing when he saw the work of other like-minded artists. After visiting the exhibition he wrote in his diary: "I am feeling elated. I had thought of myself as an anomaly and had to defend myself, many times, as not crazy; and here at the Art Institute many artists are presented showing these very fanciful departures from the academies."[35] Some of the other artists who were profoundly affected by the exhibition became the core of the Modernist movement in Chicago. Raymond Jonson, for example, who had studied at the Portland, Oregon, Museum Art School in 1909 with Kate Cameron Simmons, herself a student of Arthur Wesley Dow, was impressed with the Armory Show, although he thought "some of it's good and some is rotten." He was energized by its possibilities and was convinced by what he saw at the exhibition that "something surely is going to happen" in the art world and that he was positioned to "see, learn, and take part in the thing my system seems to be built with."[36] He had already established himself as a student of Nordfeldt and a collaborator on set designs at the innovative Little Theater founded by Maurice Browne. His work prior to the Armory Show has a conventional, Impressionist-derived quality, while his work from the later teens, such as *Violet Light*, the 1918 portrait of his wife Vera, is done in a highly decorative, pointillist style. He commented about the creation of this work that "I have tried to do a decorative realistic thing in a direct and clear way. I think I have succeeded."[37]

Other artists with the same interesting combination of pointillism and decoration in their work from the teens include Rudolph Weisenborn, Ramon

34. Esther Sparks, "A Biographical Dictionary of Painters and Sculptors in Illinois, 1808–1945," (Ph.D. diss., Northwestern University, 1971), 133; Mucha's delivery of the Scammon lectures is announced in the *Bulletin of the Art Institute of Chicago* 2:3 (April 1908), 42; the exhibition of Beardsley drawings is announced in the *Bulletin of the Art Institute of Chicago* 5:3 (January 1912), 35.

35. Manierre Dawson diary, 27 March 1913, as transcribed in *Manierre Dawson: American Pioneer of Abstract Art*, 172.

36. Letter from Raymond Jonson to his mother, 24 March 1913, as quoted in MaLin Wilson, "Cosmic Cityscapes: Desiring an Ideal," in *Raymond Jonson: Cityscapes* (exh. cat., Albuquerque, N.M.: Jonson Gallery, University Art Museum, 1989), n.p. For Jonson's education, see also Ed Garman, *The Art of Raymond Jonson, Painter* (Albuquerque: University of New Mexico Press, 1976), 9.

37. Raymond Jonson diary, 17 November 1918, Jonson Gallery Archives, University of New Mexico, Albuquerque. *Violet Light* is in the Collection of the Jonson Gallery, University of New Mexico, Albuquerque.

Shiva, and Gordon St. Clair.[38] Shiva, who was born in Spain and arrived in Chicago in about 1912, was deeply affected by the Armory Show, which persuaded him of two things: "First, he would give up all idea of becoming a commercial artist and would devote his talents to painting as his inspiration directed. Second, he would make his living entirely apart from art—never would he attempt to paint to sell."[39] Fortunately, Shiva's training as a chemist enabled him to formulate a highly successful line of oil paints, Shiva Artists Oil Colors, that eventually freed him of any need to sell his work. Shiva's work often focused on the nude figure, despite his decisive assertion that he did "not believe there should be any art schools. Teach art? How silly! Art does not come from without but from within, from the inside of the artist."[40] Shiva's assertion, made in 1925, reflects the ideas that had become common among Modernists by that time—that art is about the inner life of the artist rather than the imitation of nature. St. Clair, too, focused on the nude as a subject during this period. *Song at Dusk*, his entry in the *23rd Annual Exhibition of Artists of Chicago and Vicinity*, for example, was described as "executed somewhat after the pointellist [*sic*] method, a fact which is only to be noted, however, on careful inspection. The fascination of the work is to be found in its fancifulness and the little sharp accents of light and color in the flickering candle flame of the silken lantern which the nude nymph swings above her head, the orange bill of the black swan floating on the shallow waters through which she approaches and the red trumpets of the bed of cannas against the dusky sky where an enormous red gold moon hangs low upon the horizon."[41] From this description, St. Clair's work appears to have been a colored decorative work much like those of Jonson, Shiva, and Weisenborn at this time.[42] Carl Hoeckner, who along with Jonson, Shiva, and Weisenborn, was a leader of the radicals in the 1920s, was also working in a highly decorative style, often centering on the figure of a nude female, producing elegant paintings such as *Salome*, a richly colored and beautifully finished linear confection whose aim was "the search for and the expression of beauty."[43]

38. Weisenborn's painting *Correlations*, reproduced in *The Catalogue of the Twenty-Fifth Annual Exhibition by Artists of Chicago and Vicinity* (1921), has these qualities. *Correlations*, along with most of Weisenborn's early work, was destroyed in a studio fire in 1922. See "Benefit Musicale to Aid Painter Who Lost in Fire," unattributed, undated clipping and "Artist Loses All His Productions in Studio Blast," unattributed, undated clipping, Weisenborn Papers, Archives of American Art, Smithsonian Institution, Washington, D.C., reel 856, frame 1174. These articles detail the extensive losses as well as serious burns suffered by Weisenborn in this fire. See also, note 43 below.

39. "Introduction," *Exhibition of Paintings* (Chicago: M. Knoedler and Co., Inc., 29 March–12 April 1930), Art Institute of Chicago, Ryerson Library, pamphlet file.

40. Sam Putnam, "Ramon Shiva," *The Palette and Chisel* (April 1925), 2.

41. Frederic Paul Hull Thompson, "Twenty-Third Annual Exhibition of Chicago Artists," *The Fine Arts Journal* 38:3 (March 1919), 11.

42. A rare surviving work from Weisenborn's early period, *The Dancer*, is in the collection of Harlan and Pamela Berk, River Forest, Illinois. This painting, along with Ramon Shiva's *Chicago MCMXXIV* and Gordon St. Clair's *Xanadu* (c. 1915), also in the Berk Collection, displays the same qualities.

43. *Not a Pretty Picture: Carl Hoeckner 1883–1972: A Retrospective Exhibition* (exh. cat., San Francisco: Atelier Dore, Inc., 1984), 1. See also C. J. Bulliet, "Carl Hoeckner," Artists of Chicago: Past and Present, No. 86, *The Chicago Daily News*, 10 July 1937. *Salome* is now in the collection of the Illinois State Museum, Springfield.

In the second decade of the century, Hoeckner, Shiva, and Weisenborn were all members of the Palette and Chisel Club, which, when it was established in 1895, was progressive and open to new ideas. By 1915, the membership included a number of artists whose work was traditional or even conservative.[44] At the same time, its reputation for openness to innovation made it a logical home for some of the artists who, by the early 1920s, would establish themselves as leaders of the avant-garde. The decorative pointillist style that some of them experimented with at this time may have been absorbed in the Palette and Chisel milieu. Although Seurat was not represented in the Armory Show, there were examples of the late work of Camille Pissarro, as well as works by Paul Signac and Henri Cross that might have stimulated interest in this style. Its likely appeal to these artists was its decorative potential and pure, bright color rather than the scientifically oriented, rigorous optical analysis of Seurat. It is also possible that these Modernists-to-be were influenced by Samuel J. Kennedy, a pointillist painter and Palette and Chisel member who worked in Paris for six years, returning to Chicago in 1914. It was Kennedy's return from France, in combination with the Armory Show, that inspired the group to mount an "Abstractionist" exhibition in May 1915.[45] The contents of the show remain something of a mystery, although the Palette and Chisel artists were interested in the analogies between color and sound that by this time enjoyed great currency, even going as far as working with musicians to create color tones paralleling musical notes.[46] In her first review of the Albert Bloch exhibition, critic Lena McCauley praised the Palette and Chisel abstractions as "refined color schemes and fantasies in composition. Their pictures had the aroma of fairy tales, while the vision of Mr. Bloch's accomplishments savor of nightmares."[47] McCauley's aversion to Bloch's distortions of shapes and use of jarring colors and her comfort with the pleasant balanced harmonies of the Palette and Chisel abstractionists make it clear that it is not the simple fact of abstraction that the conservative establishment in Chicago rejected. As long as the abstract works remained harmonious and conventionally beautiful, they were acceptable.

44. Members of the Palette and Chisel Club at this time included Adam Emory Albright, Rudolph Ingerle, Wilson Irvine, Frank Peyraud, Antonin Sterba, and Carl Werntz, according to a typescript list of members, 1895–1940.

45. Untitled clipping from *Chicago Sunday Herald*, May 1915, sec. VI, p. 2, in Palette and Chisel Logbooks, vol. 2, 105, Newberry Library, Chicago. I am grateful to Wendy Greenhouse for sharing this information with me.

46. Like other artists who were interested in the color/music analogy, Shiva's paintings often had musical titles, such as *Intermezzo, Silent Sounds Symphony, Kreutzer Sonata, Ukelele Sounds, Nocturne,* and *Barcarole,* all exhibited at The Art Institute of Chicago between 1919 and 1923. See Peter Hastings Falk, ed., *Annual Exhibition Record of the Art Institute of Chicago, 1888–1950* (Madison, Conn.: Soundview Press, 1990), for complete records of these exhibitions.

47. McCauley, "Art and Artists," 10 July 1915.

A surviving abstract image by Victor Higgins, a Palette and Chisel member who was a participant in the abstractionist exhibition, demonstrates another aspect of the difference between Modernist abstraction and the experiments of the Palette and Chisel members. Although *Circumferences* was not exhibited in 1915, its pleasing combination of curving shapes and agreeable colors give us a suggestion of what kind of work he may have shown. More important here than its decorative qualities, however, is the matter of its highly literary content. Dean Porter associates it with a lost abstract image done in collaboration with composer Isador Berger, with whom he created colors that matched musical tones. Unlike Kandinsky, or even Whistler, this collaborative effort was to enable the viewer "to understand Mr. [Woodrow] Wilson's diplomacy."[48] In fact, in direct opposition to the antimaterialist, spiritual goals that Modernist theorists were espousing, a newspaper account explained this abstract picture as a geopolitical tract.[49] While Higgins and other generally conservative artists were experimenting with the Modernist formal vocabulary, they held fast to the old ideas emphasizing a clear and uplifting message. In contrast the artists who were moving toward a real embrace of Modernism may have been working in a more conventional style, but attempted to explain their work as a function of their individual "inner necessity."

In 1919, Weisenborn was a juror for a Palette and Chisel Club exhibition. He rejected a painting that he thought looked unfinished, although the artist insisted Weisenborn was incorrect. The exhibition committee selected the painting for the show anyway. Weisenborn, as he would many times in the future, withdrew from the organization in a rage, accompanied by Ramon Shiva.[50] Fortuitously, it was at this moment that the idea of egalitarian, independent artists' organizations was beginning to emerge in Chicago.

MODERNISM AS ANTI-INSTITUTIONALISM: THE RISE OF THE INDEPENDENTS

Stanislaus Szukalski, an idiosyncratic sculptor, painter, architect, and writer who immigrated from Poland to Chicago in 1913, embodies the Chicago-style quest for freedom from institutional oppression that underlaid the development of a series of independent exhibition societies in the late teens and twenties. Although he spent four years at the Krakow Academy before coming to the United States, he disdained the value of institutional education, declaring that his work emanated solely from his imagination. A series of highly publicized rebellious activities included destroying an honorable mention awarded to him for a sculpture titled *The Fall* at the *29th Annual Exhibition of American Art* at the Art Institute in 1916 "because he did not regard the trustees of the institute capable of judging his work sufficiently to give awards," and the following year violently smashing and tearing his work from a solo exhibition at the Art Institute after one of his drawings was removed by the trustees for its political content.[51] He was a well-known figure around town, and pronounced his views on art with great authority, asserting with assurance that

48. Dean Porter, *Victor Higgins: An American Master* (exh. cat., Salt Lake City, Utah: Peregrine Smith-Gibbs Smith Publishers, 1991), 80.

49. Porter, 81.

50. Hey, "Five Artists," 203–4.

51. "Artist Tears Pictures from Institute Wall," *Chicago Tribune*, 22 May 1917. Anecdotal accounts describing Szukalski's idiosyncratic, antiauthoritarian personality and its effect on the art world can be found in Ben Hecht, *A Child of the Century* (New York: Simon and Schuster, 1954), 239–43 and Alson J. Smith *Chicago's Left Bank* (Chicago: Henry Regnery, 1953), 167.

52. Stanislaus Szukalski, *Projects in Design* (Chicago: University of Chicago Press, 1931), 33.

53. Evelyn Marie Stuart, "The Twenty-Ninth Annual Exhibition at the Art Institute," *The Fine Arts Journal* (December 1916), 630.

54. *Bulletin of the Art Institute of Chicago* 2:2 (October 1908), 18–19.

55. Judith Zilczer, "The Eight on Tour, 1908–1909," *The American Art Journal* 14 (Summer 1984), 29 and 47, n. 38.

56. Daniel Catton Rich, "Half a Century of American Exhibitions," in Falk, ed., *Annual Exhibition Record*, 11, n. 9.

"virile and creative" art "aid[s] materially in the creation of a new civilization."[52] Despite his actions, he was not only juried into the Art Institute Annuals, but was given two solo exhibitions at the Museum, in 1916 and 1917. That the artist who was most openly contemptuous of the institution was supported in this way suggests several things. First, that the Art Institute remained open to exhibiting art that wasn't wholly in accord with its conservative principles. Second, and perhaps more important, Szukalski's work is characterized by a highly finished, finely crafted surface characteristic of traditional academic art, making it more acceptable than radically experimental work. His focus on the human form, his consistent and masterful use of techniques such as chiaroscuro, and his lengthy and complex explanations for his work suggest a strong connection to the training he eschewed. His sculptures are sometimes distorted, but in ways that relate to no mainstream Modernist movement; indeed, they seem to emerge from his imagination. In the words of one critic, "they seem to be the outward expressions of a soul in revolt, torn with the anguish of humanity," and "even those who could not understand or appreciate his work paused to study and comment upon it, so strong was its individuality."[53] And echoes of the peculiar angularity he employs—a distant cousin of Cubism, perhaps—can be seen in the fractured planes of Rudolph Weisenborn's charcoal portraits of the early twenties (such as *Clarence Darrow*) and Raymond Jonson's imaginative and literary early landscapes (such as *The Decree* of 1918). While Szukalski's Modernism is distinctive and unusual, and may have had limited influence on the actual art produced by others, his ideas resonated and had continued importance in the city. While he only spent a decade in Chicago, he was able to instill the spirit of rebellion in those who stayed.

By the early teens, Chicago artists were aware of the growing number of independent exhibitions in the United States. Indeed the traveling version of the exhibition of "The Eight," the group of New York urban realists who along with their followers became known as the Ashcan School, was shown at the Art Institute in 1908, the same year it appeared in New York. These artists, led by Robert Henri, sought to create an American art based on the modern urban experience. Dissatisfied with the academic tradition as well as the European-derived landscape tradition, they directed their attention to the streets, parks, and public places of New York, where they exhibited together for the first time at the Macbeth Gallery. When the exhibition came to Chicago, the artists were described in the *Bulletin of the Art Institute*, as a "group of eccentric New York painters," well-trained artists who deny "all conventional and classical qualities."[54] The *Bulletin* pointed out that the exhibition "excited much attention," although it failed to generate any newspaper coverage at all.[55] This was not the first time the members of the group had been seen in Chicago. Henri and Arthur B. Davies had both shown beginning in 1894. By 1908, all of the members of "The Eight" had already exhibited at the Art Institute.[56] The Ashcan School artists were seen frequently in Chicago, and the artists of the city had a

long, continuous, and satisfying exposure to them in the first two decades of the century.

The artists associated with this group, particularly Henri, Davies, and John Sloan, were instrumental in the various independent exhibitions that were held in New York in the first fifteen years of the century. In addition to their participation in the Armory Show (in which Davies was particularly involved), many members of the Ashcan School were involved in organizing an *Exhibition of Independent Artists*, in 1910, a forerunner to the more formalized Society of Independent Artists, which held its first exhibition in New York in 1917. The latter organizations had a no-jury policy in which artists paid a small fee to exhibit their work. In an effort to be absolutely egalitarian, the organizations formed a policy that the work was hung alphabetically, beginning with a letter of the alphabet selected randomly. These alliances were formed in reaction to the lack of exhibition opportunities and the dominance of what was perceived as a biased, restrictive, and rule-bound jury system in major arts institutions. In an effort to encourage freedom and individual expression, there was a suspension of value judgments in favor of allowing all artists to exhibit their work.[57]

In Chicago, both Modernists and conservatives showed an interest in independent exhibitions. In 1915, for example, an independent exhibition was held at the Art Institute. The group of artists who participated, all conservative members of the Chicago Society of Artists, claimed to have no grievances.[58] However, this exhibition was limited to a small group of artists, each of whom exhibited three paintings. Although there may have been no jury, the group itself was a self-selected jury, without any proclaimed agenda. A more egalitarian exhibit took place at the Academy of Fine Arts a few months later. Organized by Carl Werntz, a Palette and Chisel member, this exhibition of independent artists had no jury and the artists paid twenty-five cents a square foot for exhibit space. This group had exhibitions in 1916, 1917 and 1918, as well, although the limited exhibition space placed restrictions on the number of exhibitors.[59]

These shows were followed by a show by a New York-based group called the Introspectives. Finding a market for their work in the Midwest, several of them moved to Chicago, where they had a group show in 1921 at the Arts Club.[60] Claude Buck, one of the original New York group who moved to Chicago, worked in a highly literary Symbolist style, producing paintings of extraordinary detail and finish. Along with the four members of the New York group, Chicagoans Emil Armin, Raymond Jonson, Rudolph, Weisenborn, Fred Biesel, and Frances Strain also exhibited.[61] This demonstrates once again the fluidity of the Chicago artistic community: an apparently seamless joining together of Armin, Jonson, and Weisenborn, all of whom were well on their way toward Chicago's version of radical Modernism in 1921, with Strain and Biesel, whose work was heavily influenced by John Sloan, George Bellows, and Randall Davey of the Ashcan School, and the Symbolist artists of the original New York Introspectives.

57. For the complete history and records of the Society of Independent Artists, see Clark S. Marlor, *The Society of Independent Artists: The Exhibition Record, 1917–1944* (Park Ridge, N.J.: Noyes Press, 1984).

58. "Artist's Society Members Plan Independent Exhibition." *Chicago Herald*. 9 April 1915; these artists may have been reacting to what they saw as the increasingly progressive stance of the Chicago Society of Artists. See Louise Dunn Yochim, *Role and Impact: The Chicago Society of Artists* (Chicago: Chicago Society of Artists, 1979), 37–39, for the early history of the group. I wish to thank Gene Maier, who is working on a comprehensive study of independent exhibitions in Chicago, for sharing his research with me.

59. Kruty, "Declarations of Independents," 78; for the exhibitions of 1916–18, see Lena McCauley, "Art and Artists." *Chicago Evening Post*, April 1916; *Chicago Examiner*, 22 April 1915; Lena McCauley, *Chicago Evening Post*, 12 June 1917; Lena McCauley, *Chicago Evening Post*, 11 June 1918.

60. Kruty, "Declarations of Independents," 78–79.

61. Kruty, 79.

The Ashcan School artists and their followers exhibited regularly in Chicago in the teens. While the influence of George Bellows and Randall Davey, who each taught for short periods at the Art Institute School, has been noted and should not be minimized, the work of these artists and others in their circle was seen on a regular basis at the Art Institute, the Renaissance Society at the University of Chicago, and The Arts Club of Chicago.[62] Bellows, who may have been the American artist who exerted the strongest influence on the Chicagoans who identified themselves as progressives and Modernists in the early part of the century, had his first exhibition in the city at the Art Institute in 1914–15. By this time, the appraisal of his work in the official Art Institute publication was unequivocally positive, proclaiming Bellows' "ability to sum up the significant features of such complex subjects as a circus, a fight, a skating party, in a manner that gives the observer the keenest possible impression of the totality of the scene. Strength, color and vigor of action are the striking notes of his exhibition."[63] The Friends of American Art purchased from the show an ice skating scene, *Love of Winter*, for the permanent collection of the Art Institute. Not coincidental is the fact that artists such as Aaron Bohrod, Gustaf Dalstrom, Frances Foy, and Herman Menzel, all represented in the Bridges collection, did similar scenes. Although Bellows was not a member of the original group of The Eight, his style was aligned with the Ashcan School and his popularity and familiarity in Chicago continued to grow, along with the interest in his urban subject matter and representational mode of expression. He was featured in subsequent exhibitions at the Arts Club in 1916 and the Renaissance Society in 1917, and was invited to be a visiting teacher at the School of the Art Institute in 1919, followed by Randall Davey. Their emphasis on personal expression and sincerity rather than on the technical mastery and figure drawing emphasized in the traditional pedagogy of the School drew many of the progressive young students to their classes. Virtually all of the Modernists who were associated with the School of the Art Institute during his short tenure there cite Bellows as a significant influence on their work.

Frances Strain and Fred Biesel were invited to spend the summer of 1920 with Davey in Santa Fe, New Mexico, where they met John Sloan, with whom they returned to New York at the end of

62. Mosher, "'In the Highest Efficiency,'" 194, 202–4; Leon Kroll, a third artist associated with the Ashcan School visited in 1924. In an early, if not the first, exhibition at the Renaissance Society at the University of Chicago (1917–18), Bellows was represented. See "Documentation," in Joseph Scanlan, ed., *A History of The Renaissance Society: The First Seventy-Five Years* (Chicago: The Renaissance Society at The University of Chicago, 1993), 133.

In its first year, the Arts Club had an exhibition of Bellows, John Sloan, and Robert Henri (1916); other Ashcan School artists and their followers were represented regularly in exhibitions in the 1920s. See "Chronology of Exhibitions," in Sophia Shaw, ed., *The Arts Club of Chicago: The Collection, 1916–1996* (Chicago: The Arts Club of Chicago, 1997), 122–25. The regular appearance of these artists in exhibitions at the Art Institute has been discussed previously.

63. *Bulletin of the Art Institute of Chicago* 9:1 (1 January 1915), 4; although Bellows' work had been seen at the Art Institute previously, this was his first solo exhibition. Eighteen paintings by Randall Davey were exhibited in May 1915. He was described as a "modern" like Bellows, whose "work shows promise of no small future accomplishment," in *Bulletin of the Art Institute of Chicago* 9:5 (May 1915), 64.

the summer. They spent the following year working and even living with Sloan, returning to Santa Fe with him the next summer.[64] Not only did Sloan's subject matter and style infiltrate their art, in such works as Biesel's [Winter Morning] (cat. 13), but the germ of the No-Jury movement, so important for progressives in Chicago, was dependent on the Society of Independent Artists in New York, of which Sloan was a leader from its inception in 1917.[65]

The Chicago No-Jury Society was established in the wake of an enormously successful exhibition, dubbed the Salon des Refusés, protesting a particularly harsh jury for the 1921 American Annual at the Art Institute. This group brought together both the pioneering generation, including Hoeckner, Jonson, Shiva, St. Clair, and Weisenborn, and the group of artists who studied at the Art Institute in the postwar era, such as Biesel and Strain, Armin, Frances Foy, Gustaf Dalstrom, and Jean Crawford Adams. To give it a more cosmopolitan feel, the group actively sought participation from non-Chicagoans, and the exhibition included work by Florene Stettheimer and William Zorach, among others. As the classicizing catalogue cover demonstrates, there was no Modernist stylistic mandate, however. In fact, the Symbolist Claude Buck and the academic marine painter Charles Biesel, who served as the first secretary of the group, were active participants. As the introduction to the catalogue, written by the pro-Modernist critic C. J. Bulliet, makes clear, the idea of freedom to express oneself and independence from arbitrary rules was far more important to

these artists than adherence to a particular style. The Chicago No-Jury Society, which continued to sponsor exhibitions regularly through the early 1940s, enjoyed a longevity that the other independent groups did not.

A number of short-lived organizations emerged in the 1920s. The Cor Ardens (Ardent Hearts), founded by Jonson, Hoeckner, and Weisenborn in 1921, was dedicated to bringing together, "at least in spirit, sympathetic isolated individuals."[66] In that year, the Russian artist and writer Nicholas Roerich came to Chicago. His decorative paintings and his discourse on spiritualism and world peace made an impression on the young Modernists, and he became a charter member of the group. The leaders of Cor Ardens wanted an international membership, and they successfully recruited Augustus Johns, Norman Bel Geddes, George Bernard Shaw, and Rabindranath Tagore to their group.[67] The idiosyncratic but idealistic philosophy of Roerich, and its impact on these Modernists, is another example of the variety of disparate influences that had appeal to the progressive Chicago community. Cor Ardens had one exhibition, in 1922, and seems to have been supplanted by the success of the No-Jury Society.

Still other groups did form. In 1926, Weisenborn resigned from the No-Jury Society in a controversy over the annual fund-raising dances that he supported. He immediately formed another group, Neo-Arlimusc, dedicated to all of the arts, as well science. This idiosyncratic association sponsored lectures, exhibitions, and discussions for several years. Ten Artists (Chicago) was a smaller group

64. For Frances Strain and Fred Biesel's relationship with Davey and Sloan, see Frances Strain's "Biographical Notes," Biesel Family Papers, Archives of American Art, Smithsonian Institution, Washington, D.C., reel 4207, frames 9, 13; Harriet Michael, "Frances Strain: Joan d'Arc in Chicago Art Circles," The Clubwoman (March 1930), Biesel Family Papers, Archives of American Art, reel 4208, frames 660–61; also C. J. Bulliet, "Artists of Chicago: Past and Present, No. 57, Frances Strain," Chicago Daily News, 21 March 1936. According to Garnett Biesel, son of Strain and Biesel, his father studied with Robert Henri in New York before coming to Chicago. This, from an interview with Garnett Biesel, 28 May 1995, Furnessville, Indiana.

65. For Sloan's role in the Society of Independent Artists, see Clark S. Marlor, The Society of Independent Artists: The Exhibition Record, 1917–1944 (Park Ridge, N.J: Noyes Press, 1984). Sloan was one of the original signatories of the Certificate of Incorporation (53–54); he served as president from 1918–44 (56–57) and he exhibited with the group every year from 1917–44 (504–5).

66. Introduction to the "Tentative Constitution of Cor Ardens," as quoted in Kruty, "Declarations of Independents," 79.

67. A typescript list of the membership is in the possession of Carl Hoeckner Jr., who made a copy available to me.

that was established in 1929 by Strain and Biesel, along with eight other "moderate" Modernists.[68] They exhibited together through the thirties. Two open-air art fairs, in 1932 and 1933, were the culmination of the egalitarian art movement.

Beginning in 1934, the government-supported projects of the New Deal offered struggling artists both a way to support themselves and opportunities for exhibition at the Federal Art Gallery, paradoxically obviating earlier needs during a time of much greater general deprivation. A number of conservative groups were also founded to sponsor exhibitions during the 1920s.[69] Artists such as Tunis Ponsen and Macena Barton, among others, exhibited with both progressive and conservative groups.

Progressive artists established other exhibition venues in the second decade of the century. The Renaissance Society at the University of Chicago was founded in 1915, although its first exhibition dates to 1917–18. An eclectic group of nineteenth-and twentieth-century American and European paintings, the show included the work of at least one member of the Ashcan School, George Bellows, a perennial Chicago favorite. As its name indicates, the Renaissance Society did not initially have a commitment to contemporary art. It was only under the leadership of Eva Watson Schütze, beginning in 1929, that an aggressive program was begun to exhibit and promote modern art.[70] In contrast, The Arts Club of Chicago, founded in 1916, was almost immediately a site for important exhibitions of Modernist art. Founded as a club that would bring together "art lovers and art workers," its membership included collectors, as well as professional artists. The second exhibition of the Arts Club was devoted to Ashcan School artists Bellows, Sloan, and Henri, evidencing again their popularity for progressive audiences in Chicago. In 1918, under the joint leadership of Rue Winterbotham Carpenter and Alice Rouillier, the club extended its range from the promotion of local artists to active involvement in bringing modern European art, music, and literature to Chicago audiences, offsetting the paucity of commercial galleries where such work could be seen.[71] It is also worth noting that the original professional members of the club were a conservative group, including such artists as Ernest Lawson and Charles F. Browne.[72]

Although the independents, the

68. The original group consisted of Jean Crawford Adams, Emil Armin, Charles Biesel, Gustaf Dalstrom, Frances Foy, Emile J. Grumieaux, V. M. S. Hannell, Tennessee Mitchell Anderson, Biesel and Strain. After Anderson's death she was replaced by George Josimovich and he was subsequently replaced by Flora Schofield. They described themselves as Modernists, but as "sane modernis[ts]" (10 Artists, Exhibition Brochure, undated, Biesel Family Papers, Archives of American Art, reel 4208, frame 1019) not of the "'lunatic fringe' of modernism" (10 Artists, Third Exhibition brochure, 1932, Biesel Family Papers, Archives of American Art, reel 4208, frame 654).

69. Groups such as the Association of Chicago Painters and Sculptors (artists who seceded from the Chicago Society of Artists in 1923), the South Side Art Association (1925), the Chicago Galleries Association (1925), and the All-Illinois Society of Fine Arts (1925) were among the conservative groups established in the 1920s. See Sparks, "A Biographical Dictionary," 197–98, 691–700, and Kruty, "Declarations of Independents," 93.

70. Jean Fulton, "A Founding and a Focus: 1915–1936," in Scanlan, ed., A History of the Renaissance Society, 22.

71. Sophia Shaw, "A Collection to Remember," in Shaw, ed., The Arts Club of Chicago, 21–22.

72. Shaw, 21. I am grateful to Roberta Katz for bringing this fact to my attention.

rebels, and the radicals were active in the 1920s, it is not altogether surprising that the actual painting made in the city was rather staid. While Jonson was avidly studying the theories of Kandinsky and moving toward an abstraction based on those theories, most of the progressives were following the lead of the Ashcan School artists.[73] With a veneer of cheeriness typical of the Midwestern urban tradition, Dalstrom's *The Bridge, South Pond* (cat. 28) and Anthony Angarola's *Bench Lizards* (cat. 8) exemplify a cleaned-up version of the urban realism of the New Yorkers. Angarola, for example, found inspiration in the work of Ashcan School artist Arthur Davies, who was a great supporter of Modernism, an organizer of the Armory Show, and a friend and mentor to Manierre Dawson. Davies had a special standing in Chicago, having trained at the School of the Art Institute and exhibited regularly in the museum beginning in 1894. Unlike that of the other Ashcan School artists, Davies' work was not focused on urban reality. Rather, his work was characterized by abstract formal relationships rather than mimetic representation and the kind of languid forms seen in Art Nouveau decoration. His dreamy, ethereal, Symbolist work appealed to Angarola because it "is of the modern *but* it is not that new color school or that sensational or cubistic school.… [and] his subjects are of the deep, underneath stuff."[74] Angarola distinguished between the simply well done or skillful work done by such traditional artists as Peyraud, and the "real *Art*" that makes you "stop and think you are amazed you want to cry out your [sic] joyous it makes you happy."[75] Echoes of Davies' style and evidence of

its continuing popularity can be seen as late as 1928 in Tunis Ponsen's successful entry for the Bryant Lathrop traveling fellowship at the Art Institute.[76]

The same layer of prettified finish can be seen in Ramon Shiva's city scenes such as *Chicago MCMXXIV*, a combination of Precisionist geometry and Expressionist color that looks like something concocted in his chemistry laboratory. Even the experiments with Modernist stylistic vocabulary, such as Frances Foy's *Cheese Seller* (cat. 36) or William Schwartz's *Making a Lithograph* (cat. 68), depend much more on creating a pleasing image than on adhering to theoretical principles. At the same time, as I have argued elsewhere, artists in Chicago in the 1920s were certainly aware of the principles of Kandinsky expressed in *Concerning the Spiritual in Art* and translated into a comprehensible Midwestern vernacular early on by Arthur Jerome Eddy and later by critics such as J. Z. Jacobson and C. J. Bulliet. Jacobson's statement that "any artist who is genuinely alive, sincere and competent will of inner necessity produce modern art" allows for a wide range of stylistic modes, as long as the artist is expressing authentic individual experience.[77] And while it is clear that the Chicago Modernist community was alert, active, and productive, it is not surprising that Sheldon Cheney, writing his *Primer of Modern Art* in 1923, contacted Raymond Jonson to find out if he was the "lone voice in the Chicago wilderness." Jonson's response that "we in Chicago are not noticed.… The trouble is that there is so little in the way of printed matter," included a list of artists he recommended for the book, including

73. Jonson's study of Kandinsky is documented in his diary, for example the entry for August 5, 1921, Raymond Jonson Papers, Archives of American Art, Smithsonian Institution, Washington, D.C. See also Marianne Lorenz, "Kandinsky and Regional America," in Gail Levin and Marianne Lorenz, *Theme and Improvisation: Kandinsky and the American Avant-Garde, 1912–1950* (exh. cat., Boston, Toronto, and London: Little, Brown and Company, 1992), 91–94, and Susan Weininger, "'Genuinely Alive, Sincere, and Competent': Kandinsky and Modernism in Chicago," *Blockpoints* 3/4 (1996/1998), 67–69.

74. Letter from Anthony Angarola to Marie Ambrosius, July 11, 1917, Anthony Angarola Papers, Archives of American Art, Smithsonian Institution, Washington, D.C.

75. Ibid.

76. For a reproduction and discussion of this work, see Susan S. Weininger, "Tunis Ponsen," in *The Lost Paintings of Tunis Ponsen* (Muskegon, Mich.: Muskegon Museum of Art, 1994), 24, fig. 10.

77. Jacobson, *Art of Today*, xviii; C. J. Bulliet, *Apples and Madonnas* (Chicago: Pascal Covici Publisher, Inc., 1927), 6. For my discussion of Kandinsky and Chicago artists, see Susan S. Weininger, "Modernism and Chicago Art," in Prince, ed., *The Old Guard and the Avant-Garde*, 59–75, and "'Genuinely Alive, Sincere, and Competent,'" 58–75.

78. As quoted in Wilson, "Cosmic Cityscapes," n. 24.

79. Aaron Bohrod, *A Decade of Still Life* (Madison, Milwaukee, and London: University of Wisconsin Press, 1966), 5.

80. Jacobson, *Art of Today*, ix.

Hoeckner, Weisenborn, Szukalski, and Bloch.[78] While this explanation may have some validity, it is also true that many artists in Chicago were "thinking modern" rather than painting modern.

REGIONALISM, SOCIAL REALISM, AND THE NEW DEAL

Following the Modernist experiments of the teens and twenties, the United States was swept by a wave of xenophobia even before the devastation of the Great Depression. Artists across the country began to focus inward, emphasizing the representational style and accessible, often moralizing, content. The government-supported art projects of the New Deal, the majority of which were administered locally, emphasized traditional American values and strengths in an effort to communicate their efficacy to the struggling populace. The brief period in which local subjects were highly valued saw the further development of a specifically Midwestern artistic attitude that dovetailed with the goals of the government efforts.

By the late 1920s, the United States had entered a period of isolationism that elicited calls for an art free of influence from European traditions, an art that celebrated the heartland of America and those virtues that were considered essentially American. There was a widespread turn toward representational, easily readable images that often glorified the rural and small-town life seen as typical of the country west of the Hudson. The perpetuation of the Ashcan School tradition in Chicago provided the artists of the late twenties and thirties with a seamless transition into what was to become the mandated theme of the government-supported art projects of the 1930s. The strength of the Ashcan school tradition in the early 1930s is evidenced by Aaron Bohrod's commitment at that time to "do in my own way with my own city what Sloan had done with New York."[79] In a sense, Bohrod did that in such works as *State and Grand* (cat. 16), and like the urban realists of the early twentieth century, his city scenes emphasize the neighborhoods of small buildings and friendly interactions rather than the soaring skyscrapers and anonymity of the downtown, making it seem as if Chicago were a quiet, agreeable small town.

The 1933 Century of Progress exhibition at the World's Fair stimulated the publication of J. Z. Jacobson's *Art of Today: Chicago 1933*, with its collection of over fifty artists' statements and illustrations of "all but a very few of the modern artists of consequence who are at present living and working in Chicago."[80] While the art reproduced in the book covers a wide range of styles and attitudes, it is far removed from the futuristic universe of the fair. And while some Chicago artists contributed to the decoration of the fair, or made images of the fair for commercial purposes (see Ruth Ford's *Belgian Village* [cat. 33], which captures an aspect of the fair that is distinctly old-fashioned), the overriding Art Deco design did not have a major impact on the work of painters in the 1930s. Rather, Chicago artists participated in the national tendency to produce easily readable, representational images that fell into several acceptable categories, including regional images of rural life and landscape, often emphasizing the productivity or fertility of the land, and the virtues of small-town

life. Artists as disparate as Gertrude Abercrombie, Armin, Biesel, Strain, Foy, Dalstrom, Vin Hannell, William Schwartz (see *Briggsville, Wisconsin,* cat. 70), Herman Menzel, and Ponsen painted images that fell into these categories in the 1930s. In addition, artists often tackled contemporary problems of poverty, joblessness, and other inequities, most often in an urban setting. These subjects were popular with Modernists in Chicago, as elsewhere. Bernece Berkman, a student of Weisenborn's, Mitchell Siporin, and William Schwartz all did images critiquing current social conditions. Hoeckner became the major proponent of social realism in Chicago, producing images of mechanized factory workers and viciously caricatured images of elites enjoying themselves while the masses went hungry.

The vast government projects of the 1930s employed hundreds of artists just in Illinois. Hoeckner served as the supervisor of the Graphic Arts division of the Illinois Art Project (IAP), where his socially relevant work found its most suitable medium. Fred Biesel, too, rose in the hierarchy of the WPA administration, eventually rising to the office of state director of the IAP from 1941 to 1943.[81] There is a good deal of scholarly literature devoted to the government projects, but it is important to point out that the initial director of the IAP

(1935–38), who was responsible for employing most of the government-supported artists on the projects, was Increase Robinson, a Chicago artist and gallery owner in the early 1930s.[82] Robinson was a supporter of local artists, sponsoring regular exhibitions for them in her gallery. In her role as director of the IAP, she was a controversial figure, often increasing the mandated percentage of artists who were allowed on the projects in order to adhere to her own requirements for quality.[83] She also had strict rules regarding subject matter, including a restriction on nudes, and she discouraged extreme Modernist stylistic experiments, such as pure abstraction. While she sometimes irritated the artists and gave the Chicago project a somewhat provincial reputation, Robinson provided many artists with the means to continue developing their craft and keep working during a time when any work was difficult to get. Some artists, such as Gertrude Abercrombie, credit the projects with giving them their start. Abercrombie was not sure what direction her professional life would take until she was hired on the Public Works of Art Project (PWAP), the first of the government programs, in 1934. She felt validated by her selection and was able to move out of her parents' apartment, live independently, and develop her work as a painter because of the reg-

81. George J. Mavigliano and Richard A. Lawson, *The Federal Art Project in Illinois, 1935–43* (Carbondale and Edwardsville: Southern Illinois University Press, 1990), 8, 62–81.

82. For a short biography of Robinson, see Patricia A. Nikolitch, "Increase Robinson," in Rima Lunin Schultz and Adelle Hast, eds., *Women Building Chicago, 1790–1990* (Bloomington: Indiana University Press, 2001), 760–62. It is important to note that the Treasury Relief Art Project, which was responsible for the art in federal buildings, such as post offices, was administered entirely separately from the regional programs.

83. Mavigliano and Lawson, *Federal Art Project,* 8, 14–45. See also Maureen McKenna, "Introduction," in *After the Great Crash: New Deal Art in Illinois* (exh. cat., Springfield: Illinois State Museum, 1983), 7.

91. Bulliet, 218; Bulliet also profiled Pollack in his series "Artists of Chicago: Past and Present," *Chicago Daily News*, 24 June 1939.

92. C. J. Bulliet, "Artists Buy Paintings of Chicago 'Primitive,'" undated newspaper clipping, referring to the 1927 Neo-Arlimusc exhibition, in the Rudolph Weisenborn Papers, Archives of American Art, Smithsonian Institution, Washington, D.C., reel 856, frame 1277.

93. For an analysis of this painting, see Sue Ann Prince, "Macena Barton's Midwestern Salome," in Weininger, ed., *BlockPoints*, 98–115.

94. For an expanded discussion, see Susan Weininger, *The "New Woman" in Chicago, 1910–45: Paintings from Illinois Collections* (exh. cat., Rockford, IL, Rockford College, 1993).

95. These works were acquired from Bulliet's estate by a private collector in Illinois, where I saw them.

96. See Susan Weininger, "Ivan Albright in Context," in Courtney Graham Donnell, Susan S. Weininger, and Robert Cozzolino, *Ivan Albright* (New York: Hudson Hills Press, 1997), 55, for this reference and a longer discussion.

97. As told to Katharine Kuh, "Ivan Albright," *The Artist's Voice: Talks with Seventeen Artists* (New York: 1960), 28.

in the press, claiming that "there is no painter in America who displays so much elemental fire."[91] His dedication to Pollack inspired him to include large reproductions of his work in the newspaper and to describe Pollack's works as "powerful in their psychology and strongly expressionistic in their execution—difficult of appreciation except by the few painters and art lovers who have an inkling of the aims of the 'Moderns.'"[92]

Bulliet's dedication to other idiosyncratic artists gave them the opportunity to flourish, creating a climate where works uniquely imaginative, even if lacking in other qualities, were valued. Macena Barton was one of his special favorites, and his shameless promotion of her work despite their well-known personal relationship caused others to challenge his integrity. Barton's work was often quite conventional. She did many portraits and exhibited quite frequently with the Chicago Galleries Association, a conservative venue. But she also had an abiding interest in the nude, and works such as her enormous *Salome*, an unconventional, anticlassical, realistic nude figure holding a bloody knife over the decapitated head of St. John the Baptist, is both challenging and disturbing.[93] Interestingly, many of the artists Bulliet promoted were women, which created a community in which many women were able to achieve recognition and success.[94] In addition to Barton and Abercrombie, he was fond of Salcia Bahnc, Frances Foy, Beatrice Levy, and Fritzi Brod, all of whom dedicated works in his personal collection to him.[95] Brod, who was a skillful artist sty-

listically reminiscent of the German and Austrian Expressionist tradition, also did a number of more radical works in which she distorted forms and colors in an altogether original and peculiar manner. Paintings such as the provocatively staring *Tatiana*, a green-skinned, curvilinear nude seen from the waist up against a red-orange background, which was in Bulliet's personal collection, evidence this tendency.

Perhaps the most well-known of these idiosyncratic artists, Ivan Albright, spent most of his life in Chicago. The son of the prolific and popular Adam Emory Albright, he considered his father a "short-term" artist and himself a "long-term" artist, producing a "bit of philosophy [like] a writer who writes a book."[96] He was, like so many others, a paradox. He was dedicated to the tenets of the academy—finish, technical mastery, respect for the Old Masters—but his work is unique and imaginative. Although Albright claimed that he would have painted the same way "if he had lived on the moon,"[97] he flourished in the city that celebrated the individual. His paintings, painstakingly created, and often years in the making, attempt to convey the effects of time on material objects; the mottled and decaying flesh, frayed clothing, and barren surroundings of Ida (in *Into The World There Came a Soul Called Ida*) for example, convey, in a single still image, the poignant passage of a life. Many other eccentrics—Julia Thecla, Raymond Breinen, Julio de Diego—also found a comfortable environment in Chicago.

In 1936, when Doris Lee's regionalist image depicting a homey kitchen during Thanksgiving preparations won the Logan medal at the Art Institute, Josephine Hancock Logan was outraged. This innocuous painting motivated Logan to start the "Sanity in Art" movement, calling for a return to art that was uplifting, moralizing, and academic. Objecting not only to the "modernistic, moronic grotesqueries … masquerading as art," but to American Scene images such as Lee's, Logan yearned for a return to the art of uplift that had all but disappeared by the late 1930s.[98]

And although the Modernists in Chicago often defined themselves in relation to the background of very strict academic training, placing their individuality in the context of finely crafted and beautiful work, by the late 1930s they had moved far enough away from these roots to make viewers such as Logan anxious. Modernism in Chicago had entered a new era, and the openness to a wide variety of traditions, both "high" and "low," popular and academic, canonical and non-canonical, provided the basis for the generation of Chicago artists who followed to achieve international recognition. The artists who struggled to be modern in early-twentieth-century Chicago, "searching for greater and more beautiful things," had succeeded in representing, in the words of Arthur Jerome Eddy, "the spirit of change that is within and about us."[99]

98. For Ms. Logan's views, see Josephine Hancock Logan, *Sanity in Art* (Chicago: A. Kroch, 1937)

99. Arthur Jerome Eddy, *Cubists and Post-Impressionism*, 2nd ed. (Chicago: A.C. McClurg and Co., 1919), 66

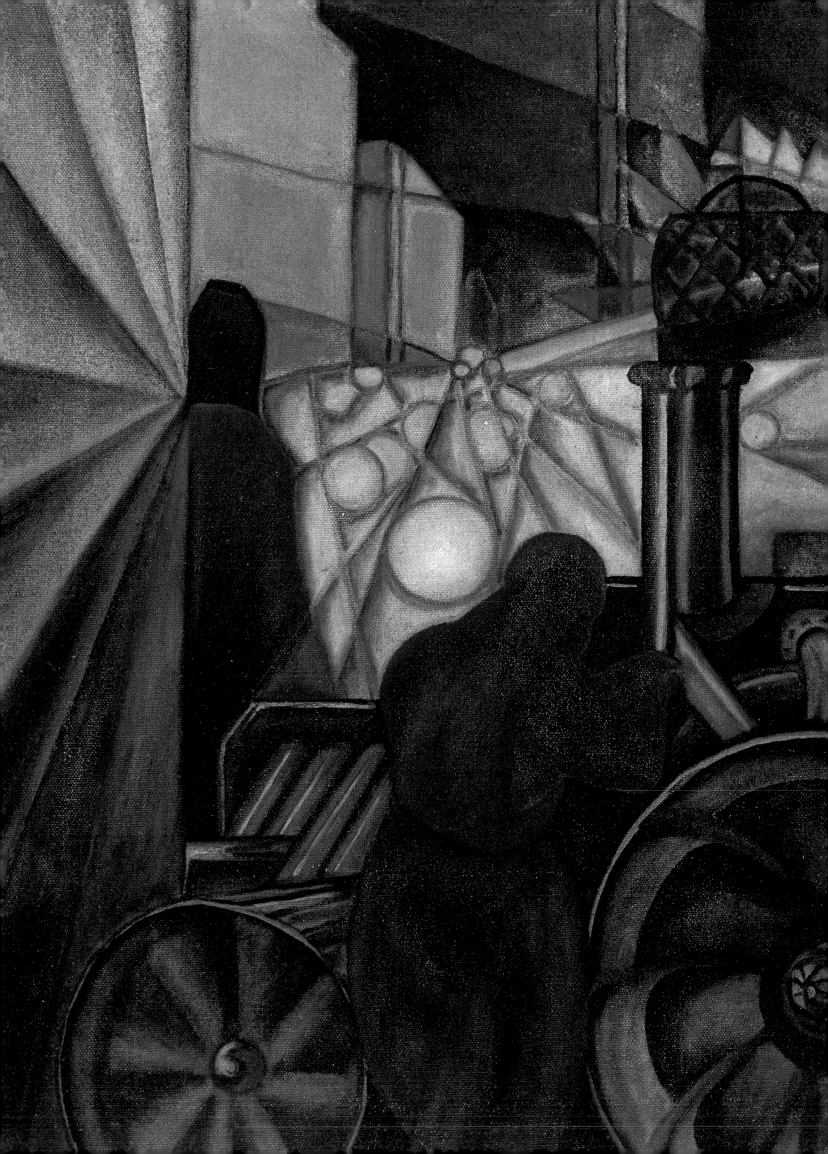

Wendy Greenhouse
Susan Weininger

Catalogue
of Works

Gertrude Abercrombie

1909–1977

NOTES

1. For detailed information on Abercrombie's life see Susan Weininger, "Gertrude Abercrombie," in *Gertrude Abercrombie* (exh. cat., Springfield, Illinois State Museum, 1991), 9–37. All the information in this entry relies on the research for that essay, which is fully documented in the catalog. It also includes an exhibition history and chronology of her life. The most important sources of information on Abercrombie include her papers, located in the Archives of American Art, Smithsonian Institution, as well as the important information supplied in my interviews with friends and family, particularly Margot Andreas, Don Baum, Gordon Cameron, Elinor Carlberg, Dinah Livingston, and Wendell Wilcox.

2. Ibid.

Gertrude Abercrombie was born in Austin, Texas, the only child of Tom and Lula Janes Abercrombie, who were working for a traveling opera company at the time of her birth.[1] The family spent a short time in Berlin, Germany, in 1913–14, returning to the United States at the beginning of World War I. After a short time in Tom Abercrombie's western Illinois hometown, Aledo, the family settled in the Hyde Park neighborhood of Chicago, where Abercrombie spent the rest of her life. Although she earned a degree in romance languages from the University of Illinois in 1929, she took as many art classes as she could, and studied at both the School of the Art Institute and the Chicago Academy of Fine Arts when she returned to Chicago after graduation. Abercrombie's multiple talents—languages, music, writing, and the visual arts made it difficult for her to settle on a career. Her appointment in 1934 to the Public Works of Art Project (PWAP), the first of the Depression-era government-supported art projects, however, gave her external validation as a painter, as well as enough money to live in her own apartment and gain independence from her strict parents, who had become ardent Christian Scientists. By the time Abercrombie married attorney Robert Livingston in 1940, she had formed many enduring friendships with other artists, musicians, and writers and had established the most important themes of her art. In 1944, the couple and their daughter Dinah moved to the house at 5728 South Dorchester that became the site of many social and artistic gatherings. Abercrombie saw herself as the Chicago counterpart of another Gertrude (Stein), who similarly presided over a "salon" that brought together musicians, artists, writers, and other intellectuals. Abercrombie's parties attracted jazz musicians such as Dizzy Gillespie, artists such as Karl Priebe, and writers such as James Purdy, all of whom remained lifelong friends.[2]

Self-Portrait of My Sister, with its mysterious title (Abercrombie was an only child), self-referential subject, and characteristic limitation of means, is an excellent and representative example of Abercrombie's work during a period of enormous productivity and creativity in her life. It is one of a series of large (for Abercrombie) self-portraits and portraits of others that were done early in her career. By the early 1940s, she had turned her attention to landscapes and interior scenes that often included a self-portrait, but were more richly evocative. After this time, she rarely included any-

(Continued on page 240)

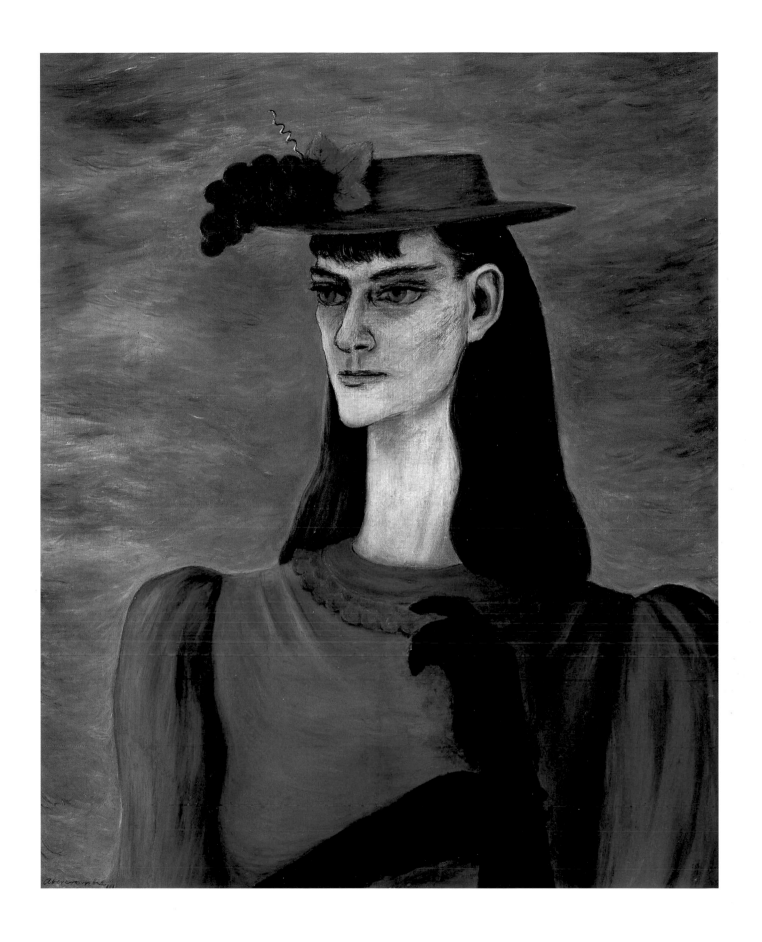

1

SELF-PORTRAIT OF MY SISTER, 1941

Oil on canvas, 27 × 22 in.
Signed and dated, lower left: *Abercrombie 41*

Jean Crawford Adams

1884–1972

NOTES

1. This painting is listed as no. 4 in the catalog. Other Chicagoans were also painting images such as these in the early 1920s. See, for example, Raymond Jonson's *The Night–Chicago* (1921) and Ramon Shiva's *Chicago MCMXXIV* (1924).

2. J. Z. Jacobson, *Art of Today, Chicago 1933* (Chicago: L. M. Stein, 1932), 33.

Jean Crawford Adams was born in Chicago and educated at the School of the Art Institute, where she studied with John Vanderpoel and George Bellows, among others. In the 1920s, she traveled widely both in the southwestern United States and in Europe, producing paintings that suggest familiarity with brightly colored, French Fauvist landscapes and American Modernism of the Steiglitz circle. Settling in Chicago in the late 1920s, she became an active member of the artistic community, a member of The Ten, an independent group of progressive artists (Chicago), and a regular exhibitor at juried exhibitions at the Art Institute. In addition, she exhibited at the prestigious national juried exhibitions at the Carnegie Institute in Pittsburgh, the Pennsylvania Academy of Fine Arts in Philadelphia, and the Whitney Museum of American Art in New York.

Although she focused on subjects such as still lifes and landscapes, particularly in the works shown in national exhibitions, she did a series of Chicago scenes emphasizing the simplified planes of the tall downtown skyscrapers, much as the images of New York by George Ault, Georgia O'Keeffe, or Charles Sheeler do. These precisionist images glorify the new American city as place of possibility—a clean, unpopulated, mechanized setting that both creates and reflects the peace and prosperity that were anticipated in the wake of World War I. Adams may have begun producing such works as early as 1922, when she exhibited a painting titled *Chicago River, Buildings* in the first show of the Chicago No Jury Society of Artists.[1] *[Looking West from the Fine Arts Building]* is a view from the vantage point of a high floor in the building, located on South Michigan Avenue, over rooftops of neighboring buildings to the clearly identifiable tower of the art deco Board of Trade Building (1930) topped by John Storrs's monumental sculpture *Ceres*. An early 1930s date is also supported by the similarity of *[Looking West from the Fine Arts Building]* to *[Federal Building]*, the painting reproduced in J. Z. Jacobson's *Art of Today*, published in 1932.[2] Like *[Federal Building]*, this painting has visible brushwork that softens the strict geometry typifying precisionism. Adams has also varied the smoke emerging from the half-dozen smokestacks visible in the distance, so that it ranges from a squiggle of blue-gray to a large, opaque puff of white, providing relief from the hard-edged structures with their snow covered roofs. Although Adams did more strictly geometric cityscapes, this one combines the clarity of precisionism with a humanizing break in the severity of the image. SW

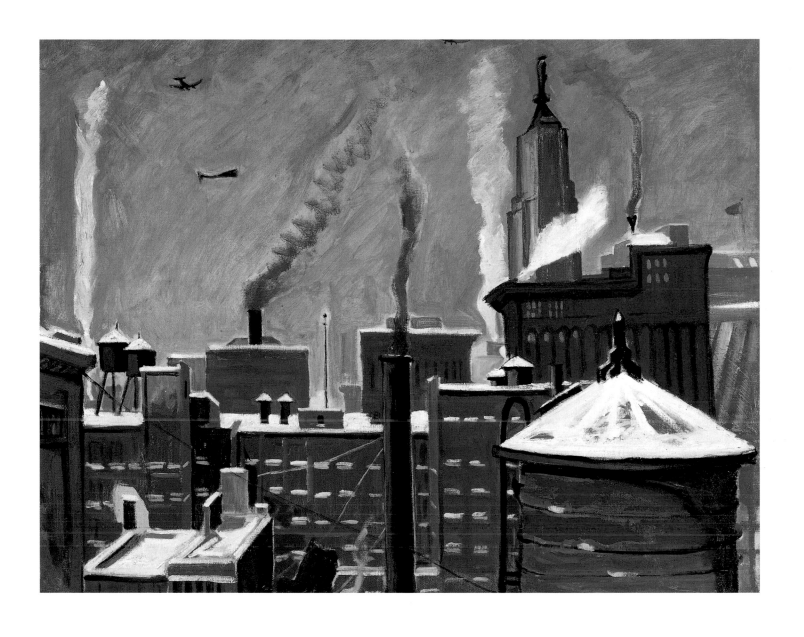

2

UNTITLED

[LOOKING WEST FROM THE FINE ARTS BUILDING], c. 1933

Oil on canvas, 25 ½ × 32 in.
unsigned

Adam Emory Albright

1862–1957

NOTES

1. William H. Gerdts, *Art Across America: Two Centuries of Regional Painting 1710–1920* (New York: Abbeville Press, 1990).

2. C. J. Bulliet, "Artists of Chicago Past and Present, No. 2: Adam Emory Albright," *Chicago Daily News*, March 2, 1935.

3. Adam Emory Albright, *For Art's Sake* (Chicago: privately printed, 1953), 109.

4. Henry E. Willard, "Adam Emory Albright, Painter of Children," *Brush and Pencil* 12 (Apr. 1903), 1, 11–12.

5. *American Art in the Union League Club of Chicago* (Chicago: The Club, 1980, 6).

6. Albright, *For Art's Sake*, 3, 6, 110.

7. "Art and Artists," *Chicago Post*, Sept. 19, 1914; "Art & Artists," *Chicago Post*, Sept. 11 and 30, 1915 (AIC Scrapbook vols. 32 and 33, microfilmed).

8. "Art and Artists," *Chicago Post*, Sept. 30, 1915, in AIC Scrapbook vol. 33, microfilmed.

9. Albright *For Art's Sake*, 112. One journalist recounted Albright's search for barefoot boys in a California town, where he asked the postmaster, a restaurant owner, and a waitress "whether the children went barefooted around there," and although being told no, continued his search, eventually happening on barefoot tracks in the sand of a country road. Marguerite B. Williams, "Barefoot Boy Theme of Albright's Brush," *Chicago Daily News*, Mar. 27, 1920 (AIC Scrapbook, vol. 41, 3).

Today known mainly as the father of the very different and much more famous artist Ivan Le Lorraine Albright, Adam Emory Albright had a successful career as a painter of idealized scenes of children at play in rural, outdoor settings. Albright arrived in Chicago to study at the Academy of Fine Arts (later The Art Institute of Chicago) in the early 1880s, and after further study in Munich and Paris returned to make his career in the Chicago area.[1] In 1899, according to one account, he dedicated himself to the subject matter with which he would become exclusively identified.[2] Albright painted many of his outdoor scenes on-site (fellow artists once quipped that this was obvious because "we found gnats on them"[3]). He often limited himself to only three colors, rose madder, cobalt blue, and chrome yellow, which he mixed to achieve the rosy, light-saturated palette that complements the tender, light-hearted themes of his paintings. Critics praised the "wholesome" and "strong native quality" of Albright's works.[4] He had more solo exhibitions at The Art Institute of Chicago than any of his contemporaries.[5]

According to Judy Holden Burns, who purchased this painting directly from the artist, it was executed in Pennsylvania. Both the artist's parents were born and raised in Centre County, Pennsylvania, in the heart of the Appalachian Mountains,[6] and Albright made at least two trips there, in the summers of 1914 and 1915, exhibiting the resulting paintings privately on his return.[7] As one critic noted, those summers' paintings showed a distinct lightening of his palette over his previous work.[8]

The distant background of purplish wooded hills in this painting is consistent with an Allegheny setting. But the children, representing a range of ages, coloring, and gender, are typical of the generalized types in Albright's idyllic images in their careless dress, bare feet, and seeming freedom from adult constraints or cares. Intent on his pursuit of a preconceived ideal of childish innocence, the painter sought out locales where "I would find boys and girls wearing my old hats, twisted suspenders, bare feet and all."[9] Ultimately, the theme of childhood innocence and summertime pleasures takes precedence over specific setting in Albright's works. Yet the artist traveled as far as California and Gloucester, Massachusetts, in pursuit of the picturesque backdrops and glowing light that would enhance that theme. Albright's idealizing images make no distinction between the idle summer pleasures of

(Continued on page 240)

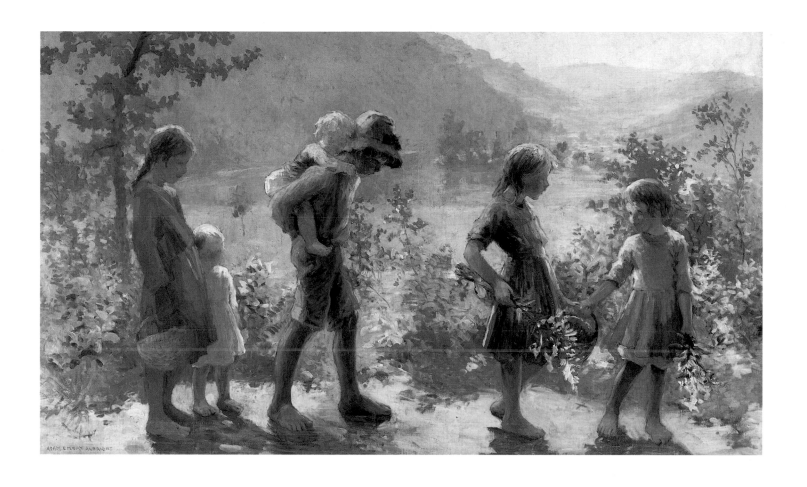

3

UNTITLED

[LANDSCAPE WITH SIX CHILDREN], c. 1914–15

Oil on canvas, attached to plywood by the artist; 36 × 50 in.
Signed, lower left: *ADAM EMORY ALBRIGHT*

Adam Emory Albright

(CONTINUED)

NOTES

1. Adam Emory Albright, *For Art's Sake* (Chicago: privately printed, 1953), chap. 26.

2. Minnie Bacon Stevenson, "A Painter of Childhood," *The American Magazine of Art* 11 (Oct. 1920), 434.

3. AIC, *Paintings of Children in South America and Southern California by Adam Emory Albright*, 1920.

4. *Little Water Carriers of the Andes*, dated 1918, is reproduced in Albright (1953), opp. p. 120.

With his family, Albright spent the winter of 1917–18 in Venezuela, in a rented suburban villa overlooking a valley of sugar cane, near Caracas.[1] According to a writer in *The American Magazine of Art*, the painter "thinks the tropics offer undeveloped fields for the painter with their brilliant atmosphere and backgrounds." In Venezuela he produced "colorful canvases of red-roofed villages, flowering shrubs, mountain and jungle, together with native children and ever present donkey."[2] Several such works, possibly including this one, were shown in Albright's one-man exhibition at The Art Institute of Chicago in 1920.[3] Also included was *Little Water Carriers of the Andes*, which features a trio of children closely related to those in the foreground of *[Venezuelan Landscape]*, the tallest child with a vessel on her head.[4] Though arranged in both paintings for picturesque effect, these figures are drawn from the Albrights' experience of the relatively primitive conditions of Venezuelan life, which the artist detailed in his *Autobiography* of 1953. Albright created his own hand-carved frame for this work, as he did for many of his paintings. WG

4

UNTITLED

[VENEZUELAN LANDSCAPE], 1917–18

Oil on canvas, 31 × 35¾ in.
Signed, lower left: *ADAM EMORY ALBRIGHT*

Ivan
Le Lorraine
Albright

1897–1983

NOTES

1. Courtney Graham Donnell.
"A Painter Am I: Ivan Albright"
in *Ivan Albright* exh. cat. (New
York: Hudson Hills Press, 1997).
18. and Susan Weininger, "Ivan
Albright in Context," in *Ivan
Albright*, 54–56.

2. As quoted by Robert Cozzolino
in *Ivan Albright*, nos. 66a and b.

van Albright, as the son of the popular and well-known Chicago artist Adam Emory Albright (see page 88 through 91) and identical twin brother of Malvin Marr Albright (also called Zsissly), grew up posing for his father's idyllic plein-air paintings and vowing not to follow in his path.[1] Although he was precocious, Ivan only committed to a career as an artist after his lackluster performance in college, and the experience of working as a medical illustrator in a hospital in Nantes, France during World War I. He studied at the School of The Art Institute of Chicago, the Pennsylvania Academy of the Fine Arts, and the National Academy of Design in New York, and briefly worked (along with Malvin) in studios in California and Philadelphia before establishing himself permanently in the Chicago area in 1926. Adam Emory, Malvin, and Ivan shared a studio complex and home in Warrenville, Illinois, until Ivan's marriage in 1946 to newspaper heiress Josephine Medill Patterson Reeve. He continued to commute to Warrenville for about a year, finally moving to a studio closer to his new home in Chicago.

An intensely competitive man, Ivan Albright almost obsessively entered his work in major juried exhibitions from the beginning of his career, accumulating a substantial number of prizes and awards. He achieved national prominence with the commission for the painting *Picture of Dorian Gray* for the eponymous film in 1943–44. In addition to painting, beginning in 1922 Albright recorded ideas and bits of philosophy in a series of notebooks until the end of his life, and he wrote poetry and prose. His major paintings were based on careful preparatory drawings and elaborate setups that often took months to build. Albright worked in a style that is uncategorizable, but is part of a strong figural tradition that flourished in the interwar period and continued, despite the dominance of abstraction, into the post-World War II period. He lived in Chicago until 1965, when he moved to Woodstock, Vermont.

Although this pair of paintings are the only objects to date to the 1970s in the Bridges Collection, they were conceived as early as 1945, when Albright recorded the following in a notebook: "Paint a picture with after-images—and carry it [further] so you have some third or fourth afterimages. Also paint afterimages of area and shape only, with original area all gone. Study the aftercolor of any and all objects and only paint the aftercolor."[2] The painting of "afterimages," the colors that result after staring intently at one

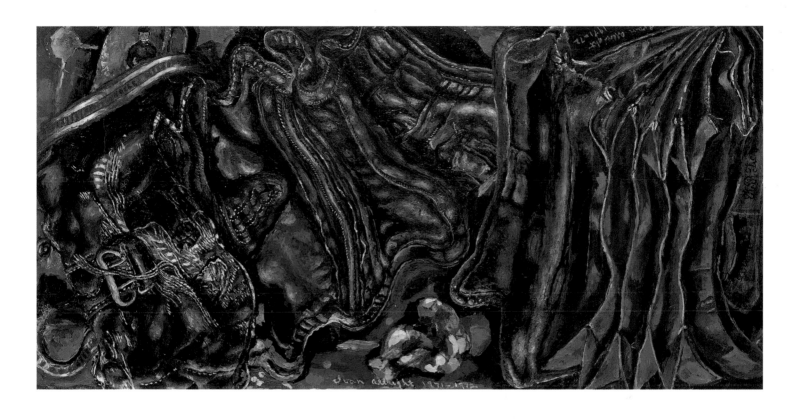

5

FROM YESTERDAY'S DAY, 1971-72

Oil on canvas, 8½ × 15¼ in.
Signed and dated, lower center and upper right: *Ivan Albright 1971*

Ivan
Le Lorraine
Albright
(CONTINUED)

NOTES

3. These appear in the background
of his *Self-Portrait in Georgia*
of 1967–68, reproduced in
Ivan Albright, no. 61. They
were sticks on which triangles,
squares, and circles of different
colors had been fixed so he could
hold them up to look at them,
then close his eyes to allow the
afterimage to appear.

color and closing one's eyes, had fascinated Albright for some time. In order to study this phenomenon, Albright had a series of color wands made for him in 1943.[3] These paintings are examples not only of Albright's experimentation with color, shape, and spatial organization (each one is signed top and bottom so that they can be hung either way), they are among the few images in his oeuvre to have personal allusions. The still-life objects displayed include a representation of a tintype of his mother and a purse and sewing kit brought by his father when he moved to Chicago to begin his career. This is coupled with the fact that these paintings are "twin" paintings, differing from each other only in color, and together forming a whole that attempts to create an unending continuum of space and color on a small, two-dimensional surface. Albright, who all his life was obsessed with his status as a twin, attempts to come to grips with it in these images. SW

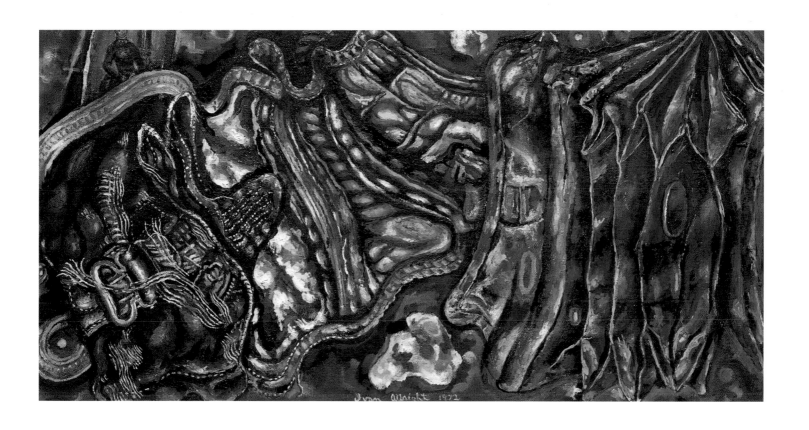

THE IMAGE AFTER, 1972

Oil on canvas, 9 ½ × 15 ¼ in.
Signed and dated, lower and upper center: *Ivan Albright 1972*

George Ames Aldrich

1872–1941

NOTES

1. Judy Oberhausen, *The Work of George Ames Aldrich, L. Clarence Ball & Alexis Jean Fournier in South Bend Collections* (exh. cat., South Bend, Indiana: The Art Center, Inc., 1982), unpaged; William H. Gerdts, "The Golden Age of Indiana Landscape Painting" in *Indiana Influence; The Golden Age of Indiana Landscape Painting; Indiana's Modern Legacy. An Inaugural Exhibition of the Fort Wayne Museum of Art, 8 April–24 June, 1984* (Fort Wayne, Ind.: Fort Wayne Museum of Art, 1984), 53. I am also indebted to Peter Lundberg of Janus Gallery, Madison, Wisconsin, for information about Aldrich's work and career.

2. Aldrich first exhibited at AIC in the 1918 annual Chicago and Vicinity show.

3. A closely related painting, *Winter Afternoon*, was sold at the Chicago Galleries Association and reproduced in its *Prospectus for the Second 3-Year Period* ([Chicago: the Association, 1929]), 25.

Born in Worcester, Massachusetts, George Ames Aldrich studied at the Art Students' League in New York and worked as an illustrator in London.[1] He pursued further studies in Paris and painted landscapes in Brittany and in New York before coming to Chicago around 1918.[2] Beginning in 1922 Aldrich also worked in South Bend, Indiana, where he found many of his patrons. He exhibited in Chicago venues, however, throughout his career.

After his return to the U.S., Aldrich continued to produce Breton landscapes, while he also painted idyllic views of Indiana and the Massachusetts coast. This painting shows one of Aldrich's most often repeated subjects: a rustic dwelling by the banks of a rapid stream.[3] Almost lost in the scene is a spectator, a dark-clad female figure barely visible against the dark doorway of the nearest cottage. Aldrich's softly rendered snowy banks and eddying water and his somewhat academic approach to Impressionism demonstrate the influence of Norwegian painter Fritz Thaulow, whose work he emulated.[4] Aldrich's decorative interpretation of the scene, with its almost melancholic mood, emphasizes the romantic charm of the Breton setting, a popular subject for late nineteenth- and early-twentieth-century European and American painters.

At some point, Aldrich cut down this canvas slightly to fit it into its present frame. A label attached to the back of the frame refers to another painting, *Christmas Eve, Montreuil-sur-Mer*, which Aldrich submitted unsuccessfully to the 1926 Carnegie International exhibition.[5] The Breton landscape in the Bridges Collection probably dates to about the same time. WG

4. Frederic Paul Hull Thompson, "Twenty-third Annual Exhibition of Chicago Artists," *Fine Arts Journal [Chicago]* 37 (Mar. 1919), 12. On Thaulow see William H. Gerdts, *American Impressionism* (New York: Abbeville Press, 1984), 235.

5. *Christmas Eve, Montreuil-sur-Mer*, though unlocated, has been identified as a peasant village scene from an illustration in an unidentified review of an exhibition at the Chicago Galleries Association of the work of Aldrich, Edward Grigware, and Oskar Gross, in April 1924, contained in a scrapbook of clippings and other material relating to Aldrich, compiled by his wife Estalena, and now in the possession of Peter Lundberg, Janus Gallery, Madison, Wisconsin. I am grateful to Peter Lundberg for this information.

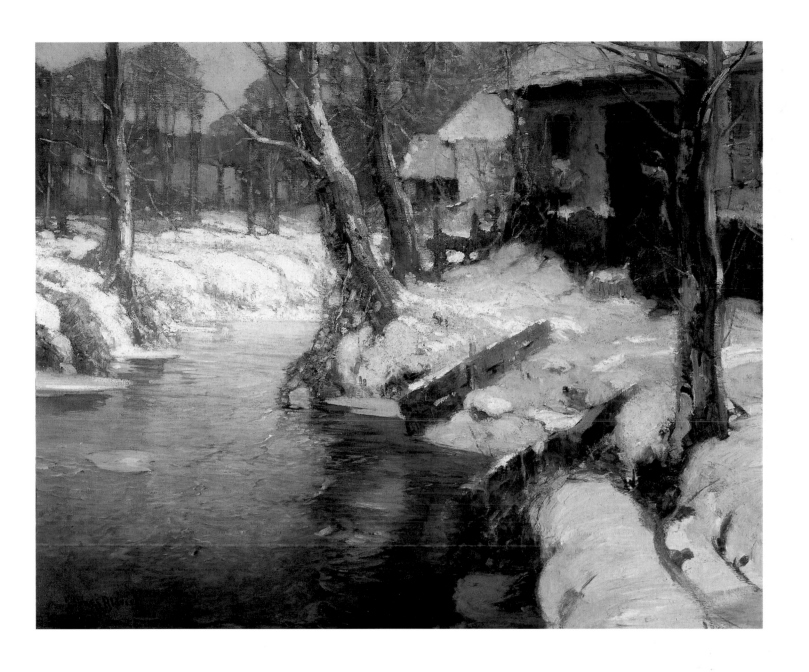

7

UNTITLED

[BRETON LANDSCAPE], c. 1926

Oil on canvas, 31 × 38 in.
Signed, lower left: *G Ames Aldrich*

Anthony Angarola

1893–1929

NOTES

1. Clarence J. Bulliet, "Anthony Angarola," (Artists of Chicago Past and Present, 78) *Chicago Daily News* 26 September 1936

2. Angarola Papers, AAA.

Anthony Angarola, the seventh of the eleven children of Italian immigrants Rocco and Anna Bonomo Angarola, was born in Chicago in 1893. Attracted to the work displayed in The Art Institute of Chicago, he decided early that he wanted to be an artist. With little support from his family, he worked at a series of jobs, including plumber, house painter, baker, theater usher, actor and singer, to pay for his education at the School of the Art Institute.[1] He began studying part-time in 1908, finally graduating in 1917. Along the way he accumulated an impressive series of honors including numerous honorable mentions in specific classes, best student of the year in 1915, and a full tuition scholarship in 1917. Although he studied with a number of people at the School, the most profound influence on him was the painter Harry Walcott. Angarola continued to garner awards, including the Clyde M. Carr Award at the Annual Exhibition of Artists of Chicago and Vicinity at The Art Institute of Chicago in 1921, the Silver Medal at the Chicago Society of Artists exhibition in 1925, and a Guggenheim Fellowship that allowed him to travel to Europe in 1928–29. He taught at the Layton School of Art in Milwaukee (1921), the Minneapolis School of Art (1922–25), the School of the Art Institute of Chicago (1926), and the Kansas City Art Institute (beginning 1926), where he was appointed Head of the Department of Drawing and Painting in 1927. He was a dedicated and successful teacher who took pride in his students' achievements, as evidenced by the file of clippings and correspondence referring to them found in his papers.[2]

Bench Lizards, painted in about 1922, is an important work of Angarola's early maturity. It is characterized by the flattened forms and bright, flat color areas of European Modernism combined with the interest in the American scene that typifies the art of both the Ashcan School artists of the first decade of the century and the more xenophobic American art of the late 1920s and 1930s. In the early 1920s, Angarola often turned his attention to ethnic neighborhoods that retained the character of the mostly European communities from which their inhabitants came. Paintings such as *Swede Hollow*, *Little Italy St. Paul*, *Bohemian Flats*, and *German Picnic* attest to this interest. At the same time he experimented with the more radical

(Continued on page 240)

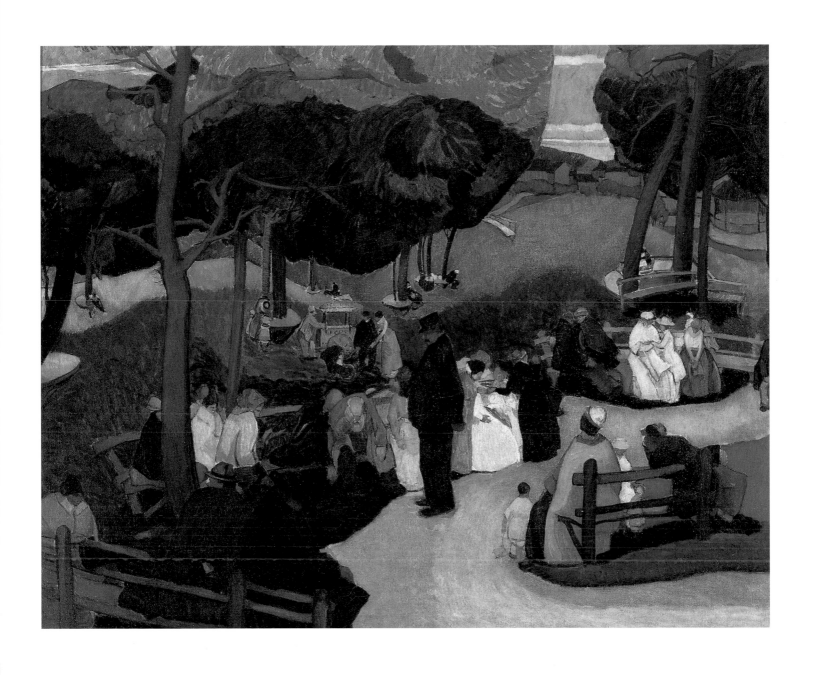

8

BENCH LIZARDS, 1922

Oil on canvas, $36 \times 44^{1}/_{2}$ in.
Signed, lower left

Emil Armin
(CONTINUED)

NOTES

1. J. Z. Jacobson, *Art of Today, Chicago 1933* (Chicago: L. M. Stein, 1932), 40.

Although, or perhaps because, Armin was an immigrant, the American city was a magical and wondrous place to him, its energy serving as an inspiration. This image, looking north down Michigan Avenue from Jackson Street, just south of The Art Institute of Chicago, is an image of the modern city of skyscrapers and commerce, complete with the hustling figures and automobiles that add to the dynamic quality of life in the twentieth-century metropolis. This image, in which the city is represented as a brightly colored, blue-skied embodiment of the potential that modern urban life holds, conveys Armin's characteristic optimism and positive outlook. He expressed this in a statement published in 1933: "I found the characteristics of the environment I live in expressed in my work, I found the steel ribs of the tall towers in the construction of my compositions, the earth being pushed up out of the lake for an outer drive in the texture of the paint and the whistlings, screeches, electric flashes, whirrings and fast motion mixed with sunlight contained in the light of the painting."[1] SW

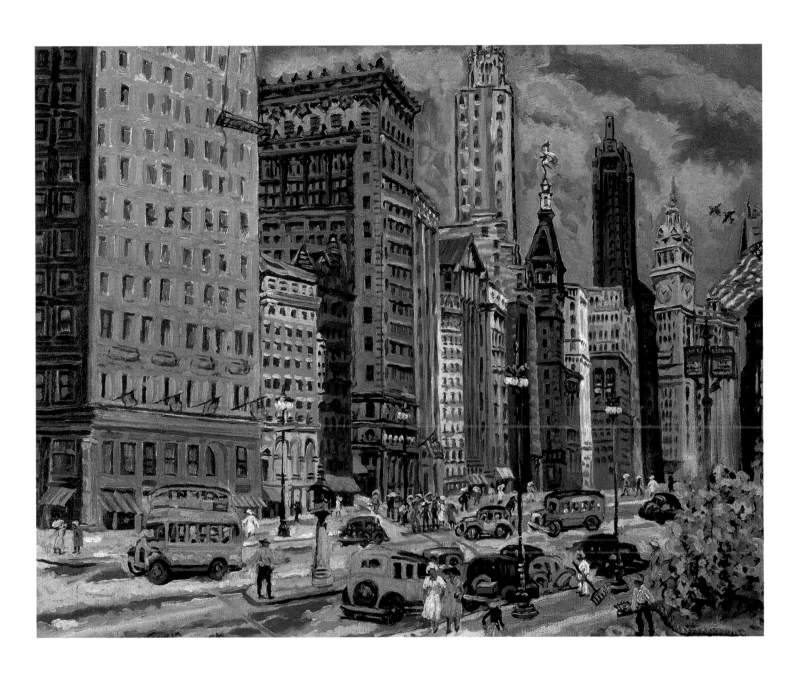

10

NORTH FROM JACKSON, 1934

Oil on canvas, 20 × 24 in.
Signed and dated, lower left: *Emil Armin 1934*

Frederic Clay Bartlett

1873–1953

NOTES

1. According to Helen Lefkowitz Horowitz, *Culture and the City* (Chicago: University of Chicago Press, 1989), 67. A C. Bartlett was also a trustee of the University of Chicago and a member of the Orchestral Association. For biographical information on Frederic Clay Bartlett, I relied on Courtney Graham Donnell, "Frederic Clay and Helen Birch Bartlett: The Collectors," *Museum Studies* 12:2 (1986), 85–101. Unless otherwise noted, information on Bartlett and his family depends on this article.

Today Frederic Clay Bartlett is best known as the collector (along with his wife Helen Birch Bartlett) who assembled the stellar group of late-nineteenth- and early-twentieth-century paintings that are exhibited as the Helen Birch Bartlett Memorial Collection, part of the permanent collection of The Art Institute of Chicago. The Bartletts' excellent taste and foresight led them to purchase Seurat's *A Sunday on La Grand Jatte*, Cezanne's *The Basket of Apples*, Van Gogh's *The Bedroom*, and Picasso's *The Guitarist*, works that are among the finest examples anywhere of painting from this period. Bartlett's own paintings, which he did not aggressively try to sell in his lifetime, are not only less well known than those he collected, but far less avant-garde.

Bartlett was born in Chicago to a self-made businessman and civic leader, Adolphus Clay Bartlett, in 1873. Like many of the commercial leaders in nineteenth-century Chicago, the elder Bartlett was a promoter of cultural institutions, and served as a member of the board of trustees of the Art Institute for thirty-five years beginning in 1883.[1] The younger Bartlett, inspired by the international exhibition of art at the World's Columbian Exposition of 1893, chose to forgo college and gained admission to the prestigious Royal Academy in Munich. This was followed by several years in Paris studying with Louis Joseph Collin, Edmond François Aman-Jean, and James Abbott McNeill Whistler. He spent at least five years studying and traveling in Europe before returning to Chicago, where he rented a studio in the Fine Arts Building on South Michigan Avenue and moved into a home with his first wife, Dora Tripp, who died in 1917. Bartlett attained success as an artist, exhibiting not only at the juried Art Institute exhibitions, but at the national juried exhibitions at Carnegie Institute in Pittsburgh, the Pennsylvania Academy of Fine Arts in Philadelphia, and the Corcoran Gallery in Washington, D.C. Although he did not associate himself with progressive groups, he was a member of the Society of Independent Artists in New York, and exhibited with them three times between 1918 and 1922. He was particularly popular as a muralist and has left a legacy in Chicago buildings from the University of Chicago, to the University Club and the Art Institute's library in the Loop, to the Second and Fourth Presbyterian Churches.

(Continued on page 241)

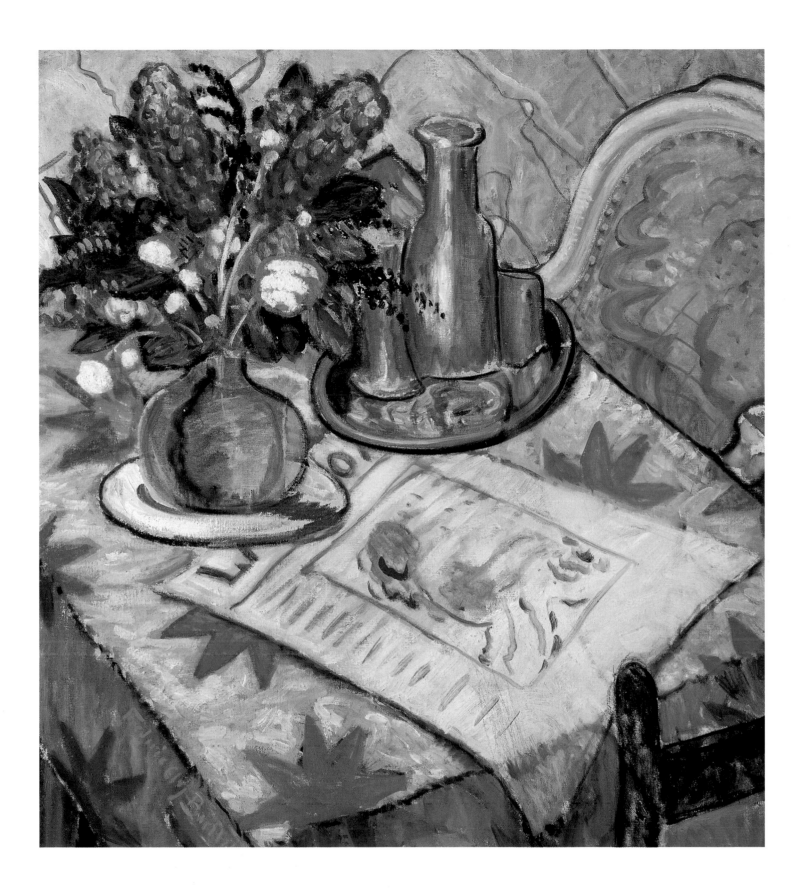

11

UNTITLED

[STILL LIFE WITH FLOWERS, NEWSPAPER, AND WATER ON AN ORANGE TABLECLOTH], c. 1929

Oil on canvas, 31 × 28¼ in.
Signed, lower left: *Frederic Clay Bartlett*

Macena Barton

1901–86

NOTES

1. C. J. Bulliet, "Macena Barton,"
Artists of Chicago: Past and Present,
no. 12. *Chicago Daily News* 13
May 1935. Barton had a close
personal relationship with the
critic Bulliet, who promoted her
work, sometimes shamelessly.
For a discussion of Bulliet and
Barton, see Sue Ann Kendall
(Prince), "Clarence J. Bulliet:
Chicago's Lonely Champion of
Modernism," *Archives of American
Art Journal* 26:2–3 (1986), 26.

Macena Barton grew up in Union City, Michigan, where she lived until 1919. From 1921–25 she studied at the School of the Art Institute of Chicago with John Norton, Allen Philbrick, and Leon Kroll, whose influence on many of the students with Modernist leanings is well-documented. Although Kroll was associated with the Ashcan School of urban realists, by the time he arrived in Chicago for his short teaching stint in 1924 he was painting primarily figures in a style characterized by a hard-edged and rather dry realism. Barton seems to have responded to this phase of his career in her work. Kroll was supportive of women and encouraged her to pursue her interest in the nude figure, emphasizing that in the field of art women were as capable as men.[1]

Barton's paintings ranged from academic portraits exhibited at conservative venues such as the Chicago Galleries Association to extremely personal and idiosyncratic large nudes such as the over life size image of *Salome* of 1936. This portrait is ostensibly one of her more conservative works, but is characterized by her personal approach nonetheless. Like most of her work of this period, Barton uses bright, unmodulated colors to create a hyper-realistic image reminiscent of the mysterious paintings of the members of the *Neue Sachlichkeit* movement in 1920s Germany. SW

UNTITLED

[PORTRAIT OF THE ARTIST'S FATHER WITH INDUSTRIAL LANDSCAPE IN BACKGROUND], c. 1933

Oil on canvas, 36 × 30 in.
Signed, lower left: *Macena Barton*

Fred Biesel

1893–1954

NOTES

1. Biographical information is based primarily on typescript biographies in the Biesel Family papers, AAA, Roll 4207, frames 29–32.

B orn near Philadelphia and raised in Newport, Rhode Island, Fred Biesel was the son of the well-known marine artist Charles Biesel. His father, a founder of the Newport Art Association and later an important figure in the Chicago art world, knew all the local and visiting artists in Rhode Island. The younger Biesel was employed as an apprentice to many of them during his high school years and on his summer vacations from the Rhode Island School of Design, from which he graduated in 1915. During 1915–16, he worked independently and continued his studies in the evening with Robert Henri and George Bellows. After service in the United States Naval Reserve from 1916 to 19, he went to Chicago where he did postgraduate study at the School of the Art Institute, working with George Bellows and Randall Davey during their tenure as visiting instructors, followed by a trip to Santa Fe to study with John Sloan in the summer of 1920. Along with his wife-to-be Frances Strain, he returned to New York, where he lived and worked in Sloan's studio.[1] Sloan's involvement with the Society of Independent Artists, a group formed to offer open-exhibition opportunities to artists, as well as his association with the Ashcan school of urban realists, had enormous influence on Biesel and Strain, and through them, on the artistic community of Chicago.

On their return to Chicago in 1921, they began to organize independent exhibition groups, most notably the Chicago No-Jury Society of Artists, which offered artists exhibition opportunities without the intervention of a jury. The No-Jury Society was extremely important in giving artists with no exhibit venue an opportunity to show their work for a small fee. Following the democratic and egalitarian model of the Society of Independent Artists, work was hung in alphabetical order. Both Charles and Fred Biesel and Frances Strain were in leadership positions in this and other progressive arts organizations in the 1920s and 1930s. In addition, both Biesel and Strain excelled in the realm of artistic administration, Fred acting in administrative positions in the government-supported art projects, eventually rising to the post of State Director of the Illinois Art Project from 1941–43. He served on the faculty of the Layton Art School in Milwaukee from 1946–53.

(Continued on page 241)

13

UNTITLED

[WINTER MORNING *or* MY BACK YARD, 5542 S. DORCHESTER], before 1933

Oil on canvas, 30 × 40 in.
Signed, lower right: *Fred Biesel*

Daniel Folger Bigelow

1823–1910

NOTES

1. *Chicago Evening Post*, Feb. 12, 1898, in AIC Scrapbook, vol. 9, p. 131.

2. J. W. Moran, "Works of Chicago Artists—Exhibition at Art Institute," *Fine Arts Journal* 20 (Mar. 1909), 169. Reference courtesy of Patrick Sowle, with additional thanks to Joel Dryer, Director, Illinois Historical Art Project.

A native of New York State, landscape painter Daniel Folger Bigelow arrived in Chicago in 1858, joining the first generation of resident artists in the city. In 1866, Bigelow was one of the founders of the Chicago Academy of Design, and he later served as its president. He painted still-lifes but specialized in views of familiar East Coast sites, executed in the Hudson River School style popular among Chicago's early art patrons.

Throughout his career in Chicago, Bigelow exhibited numerous depictions of Vermont, the Berkshire Mountains in Massachusetts, and the Adirondack Mountain region of upstate New York. This painting, an unusually large canvas for Bigelow, might represent any of these locales, although the brilliant autumn foliage and the reference to trout fishing in the rod and fish carried by the lone figure evoke the popular image of the untamed Adirondack wilderness as the resort of the adventurous sportsman. In the late-nineteenth century, Bigelow's subjects struck a chord in many well-to-do Chicagoans who hailed from the Northeast and returned there for vacations. His works remained popular in Chicago long after the bright palette, exacting detail, and romantic realism of works such as this had been outmoded by more sophisticated, cosmopolitan styles. (In 1898, for example, the Klio Club, a Chicago women's group, purchased one of Bigelow's Vermont images from the Art Institute's annual exhibition of work by Chicago artists.[1]) Around 1900, however, Bigelow's style changed, shifting toward richer, cooler colors, softer delineation of natural forms, and greater emphasis on atmosphere, in keeping with current trends in landscape painting.[2] WG

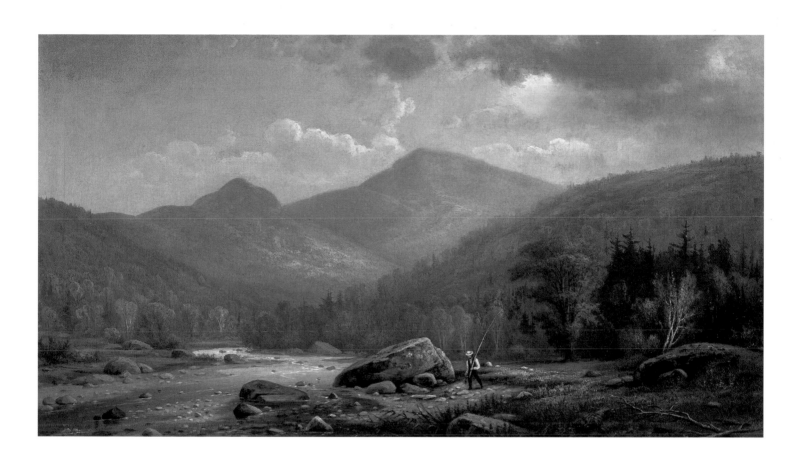

14

UNTITLED

[LANDSCAPE], c. 1895

Oil on canvas, 24 × 42 in.
Signed, lower right: *D F Bigelow*

Joseph Birren

1865–1933

NOTES

1. Birren's early career is described in Faber Birren, *Henry Birren (1812–1880) [and] Joseph Birren: a Family Chronicle and Narrative* (Chicago: privately printed, 1928), unpaged.

2. *S. & G. Gump Company San Francisco, Calif. 246–268 Post St. Announces an Exhibition of Paintings by Joseph Birren of Chicago Sept. seventh to Sept. twenty-first 1925.* Birren's penciled annotations, dated Sept. 4, 1925, on the copy of this catalogue now in the Ryerson Library, The Art Institute of Chicago, refer to "my Los Angeles May exhibit."

3. *Chicago Tribune*, Aug. 6, 1933, in AIC Scrapbook, vol. 62, p.12, microfilmed. Ironically, Birren had died suddenly the day before this notice appeared, as reported in a clipping from an unidentified newspaper, Art Institute of Chicago Scrapbooks, vol. 62, p.10.

4. Faber Birren, unpaged.

Chicago native Joseph Birren worked first as a painter of cycloramas before establishing himself as a successful newspaper illustrator and commercial artist.[1] In 1916, after studies in Paris and at the Art Institute, where he would later teach, Birren began to paint landscapes. He was founder and served as president of the Art Institute's Alumni Association, and he presided over the Palette and Chisel Club. In 1921 he founded the Birren Prize given at the annual architectural exhibition at the Art Institute. Like fellow Chicagoan Pauline Palmer, Birren established a summer studio in Provincetown, Massachusetts. Birren's son, Faber Birren, was a pioneer in color theory and design.

In 1925 Birren worked in Southern California, where the varied coastline and easy climate were attracting numerous painters. Birren exhibited his California work in separate shows in San Francisco and Los Angeles, and *September Valley* (under another title) may have been among them.[2] It may show a scene along the Pacific coast of Southern California. Eucalyptus trees overlook a pond connected by a meandering estuary to the distant sea just visible through a break in the lavender hills.

The trees dominate this image—not surprisingly, for Birren had "built up a unique reputation for himself through his interesting handling of trees," according to a 1933 report of his work at the Century of Progress exposition.[3] Birren's distinctive treatment of trees was the result of a thick, textured application of paint, termed "Tactilism," by which he "reaches the very innermost source of beauty found in nature."[4] In *September Valley* "Tactilism" meets the brilliant color and light of the California landscape, which inspired a generation of American Impressionist painters. WG

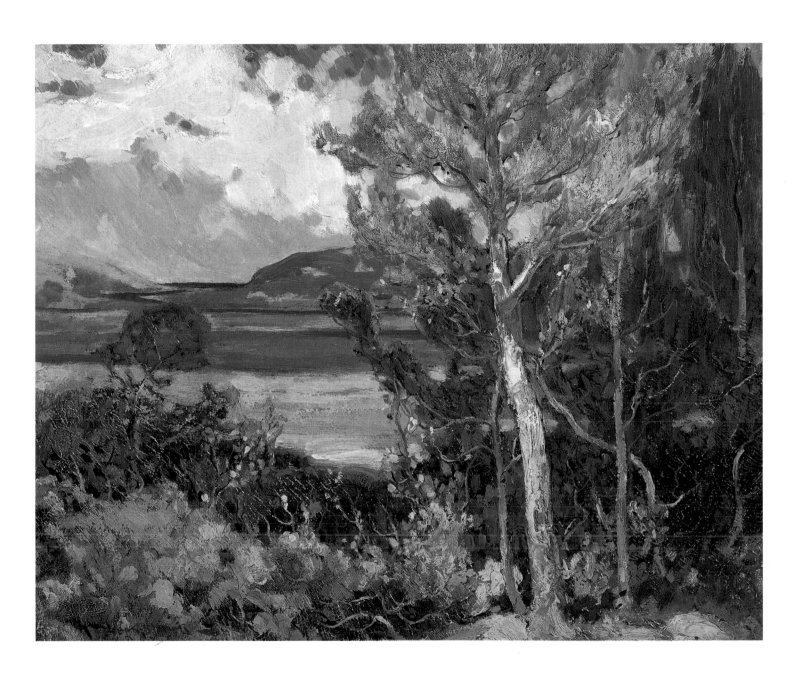

15

SEPTEMBER VALLEY, c. 1925

Oil on board, 20 × 24 in.
Signed, lower left: *Joseph Birren*

Aaron Bohrod

1907–92

NOTES

1. Aaron Bohrod, *A Decade of Still Life* (Madison, Milwaukee, London: University of Wisconsin Press, 1966), 5.

2. The newsstand operator has been identified by Nell Himmelfarb Schneider as Louis Schneider, who had a newsstand on State and Grand for 30 years.

Born on the west side of Chicago to immigrant parents from Bessarabia, Aaron Bohrod studied at the School of the Art Institute of Chicago beginning in 1927 and at the Art Students League in New York in 1929. Of the impressive roster of artists with whom he studied, including Kenneth Hayes Miller and Boardman Robinson, John Sloan was singled out by Bohrod as his most important inspiration. Sloan's respect and understanding for the Old Masters, combined with his attention to the ordinary scenes of the New York streets, motivated Bohrod to "do in my own way with my own city what Sloan had done with New York."[1] He settled in Chicago in the early 1930s, where he established relationships with some of the young progressives—Ivan and Malvin Albright, Francis Chapin, Constantine Pougialis, and William S. Schwartz—who were to become his close friends. In the 1930s, he began exhibiting at important juried exhibitions, such as the Carnegie International in Pittsburgh and at the Pennsylvania Academy of Fine Arts in Philadelphia, as well as The Art Institute of Chicago, and at the same time he began to accumulate awards and prizes. During the war he was a correspondent from both the European and Pacific fronts, and he contributed work to popular magazines, including *Time* and *Life*, in the 1940s and 1950s.

Like many artists working during the Depression, Bohrod turned his attention to the small towns and rural areas that were considered the "real" America, from which would emerge the hardworking, industrious individuals whose efforts would eventually result in the triumph over economic hardship. Even when painting the city, he focused on the neighborhoods that suggested small-town life rather than on the skyscrapers of the Loop. Bohrod's *State and Grand*, dominated by the figure of a fashionable matron reminiscent of the quintessential consumers of his teacher Kenneth Hayes Miller, also includes an entrepreneur operating a newsstand, and an inviting streetscape in bright reds, greens, and yellows under a clear blue sky.[2] Bohrod's work conveys the optimism common to many works of this period of hardship, an effort to highlight those values that would help to bring the country out of the Depression. Bohrod's idyllic street corner, with no evidence of breadlines, out-of-work men, or deprivation, is an image of the ideal American Scene. SW

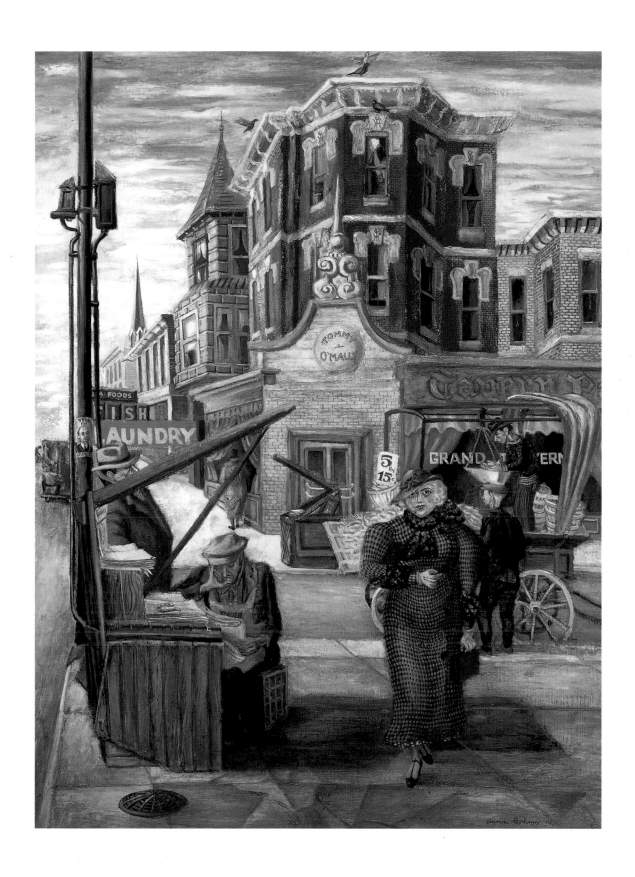

16

STATE AND GRAND, 1934

Oil on [panel] board, 40¾ × 30 in.
Signed and dated, lower right: *Aaron Bohrod 34*

Aaron Bohrod
(CONTINUED)

The representation of the storefront on North Clark Street reflects Bohrod's interest in the grittier aspects of the urban environment during the Depression era. The strip of North Clark Street near his home at the time provided him with a great deal of subject matter. The clutch of men who seem to be without employment chat at the entrance of the bar/restaurant near the rubble of a broken sidewalk, hinting at the pervasive poverty of the period. The bar sandwiched between two seedy hotels, while similar to many street scenes of the period, also contains a fore-shadowing of Bohrod's later style in which he creates his own variations on the tradition of trompe l'oeil still life established in the nineteenth century by such American masters as William Hartnett and Frederick Peto. Other works, such as the 1941 *Reflections in a Shop Window* (Metropolitan Museum of Art), share Bohrod's interest in detailed representation of ordinary objects. In *North Clark Street*, Bohrod lovingly details the advertisements and handwritten menu in the windows, as well as the reflections from the street and the scene inside. These three levels of reality merge on the surface of the glass into a single image, sometimes difficult to divide into its component parts. SW

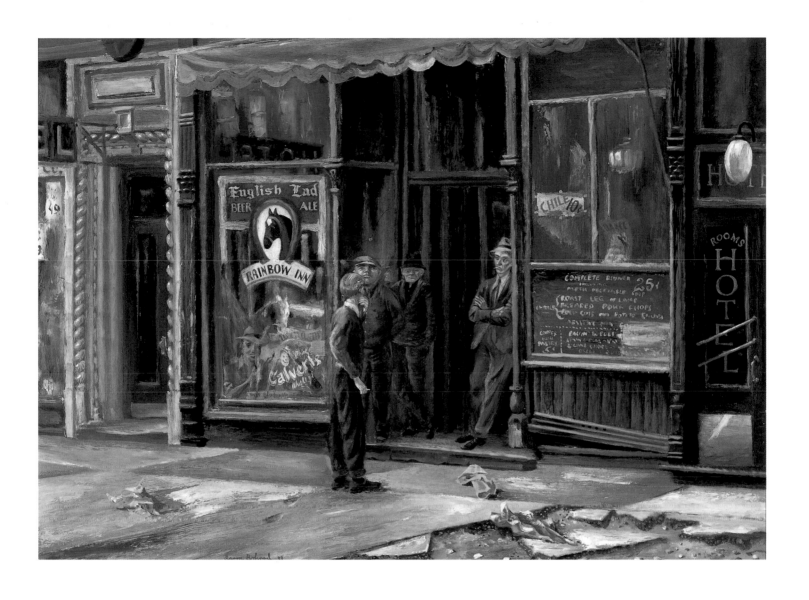

17

NORTH CLARK STREET, 1938

Oil on board, 24 × 32 in.
Signed and dated, lower left: *Aaron Bohrod 38*

Charles Francis Browne

1859–1920

NOTES

1. William H. Gerdts, *American Impressionism* (New York: Abbeville Press, 1984), 147–48, 246.

After study in Boston, Philadelphia, and Paris, Massachusetts native Charles Francis Browne came to Chicago with a commission to paint a mural at the World's Columbian Exposition. Browne painted mostly landscape views of rural France and Scotland and the area around Oregon, Illinois, where he was a member of the art colony known as Eagle's Nest. He was also influential as a conservative critic, teacher, and lecturer. He was the first editor of the art journal *Brush and Pencil* and, along with sculptor Lorado Taft and critic Hamlin Garland, was a member of the "Critical Triumvirate" that formed the core of the Central Art Association and promoted a conservative Impressionist aesthetic as the vehicle for a distinctly national art centered on the Midwest.[1]

Like many contemporary American landscape and genre painters, Browne throughout his career painted numerous views of the French countryside, including Brittany and Giverny, where an American colony had spring up around the home of Claude Monet. In this work, the French setting is clear from the red-roofed houses, the chalky white hillside, and its crowning row of poplar trees. The river, with its softly reflective still surface, is a common motif in both Browne's French and rural Illinois scenes. Browne, the most conservative voice in the "Critical Triumvirate," championed the Barbizon School of French landscapists, whose naturalism, intimate rural subjects, and delicate, cool coloring are evident here. Yet this work's informal composition, sketchy brushwork, and sense of atmosphere betray Browne's debt to Impressionism, which was widely accepted among American landscape painters by 1900.

In 1913 Browne's solo exhibition at the Art Institute included several scenes of France, including one entitled *Across the River*, possibly identical with this painting. WG

18

UNTITLED

[LANDSCAPE WITH RIVER AND BOAT] c. 1908

Oil on canvas, 20 × 28 in.
Signed, lower right: *C F Browne*

Charles Francis Browne

(CONTINUED)

NOTES

1. Josephine Craven Chandler. "Eagle's Nest Camp. Barbizon of Chicago Artists," *Art and Archaeology* 12 (Nov. 1921). 195–204: Timothy J. Garvey. *Public Sculptor: Lorado Taft and the Beautification of Chicago* (Urbana and Chicago: University of Illinois Press. 1988). 106–12.

2. Sterling. Illinois. *Gazette*. Mar. 2. 1917. in AIC Scrapbooks vol. 13. p. 154.

Browne was a member of Eagle's Nest, the exclusive summer art colony in Oregon, Illinois, established in 1898 on property owned by Chicago lawyer Wallace Heckman. Dubbed the "Barbizon of Chicago Artists," the colony brought together the most influential members of Chicago's art establishment and its important patrons and critics. Artists enjoyed informal living in "rustic" cottages, pursued their creative endeavors, and amused themselves by organizing costume pageants and similar entertainments.[1]

Eagle's Nest is located picturesquely on a bluff overlooking the Rock River. Browne was well known for his portrayals of the area, according to a review of the 1917 Chicago and Vicinity exhibition at the Art Institute, in which a number of such works were shown.[2] He included other such scenes in his one-man exhibition at the Art Institute in 1919–20. In *Autumn Hillside* the deep red of the sumac bushes at season's end sounds a note of intense color in an otherwise subdued landscape. This image of the steep hillside, flat expanse of curving river, and distant blue hills is innocent of human activity, and the quietly elegiac mood is enhanced by the end-of-season, autumnal setting. WG

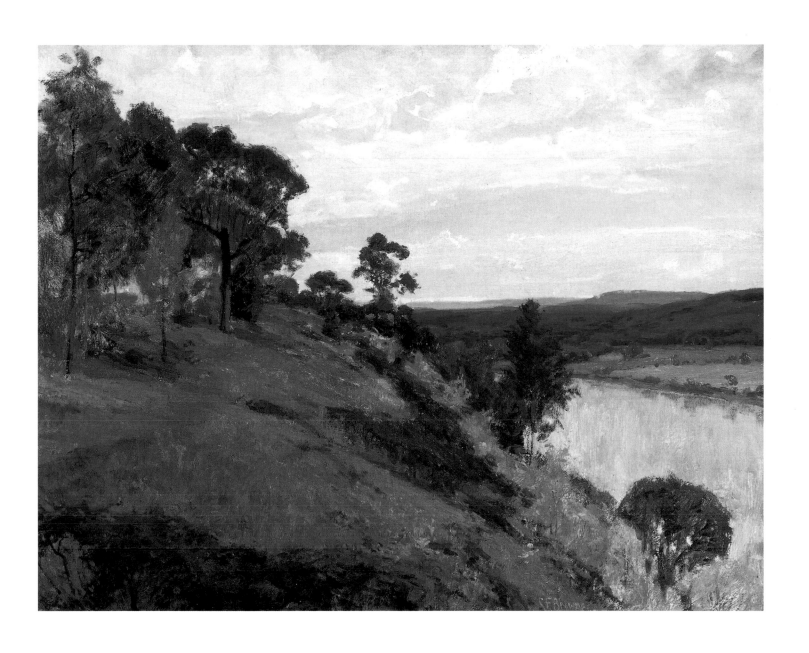

19

AUTUMN HILLSIDE, 1917

Oil on canvas, 24 × 30 in.
Signed and dated, lower right: *C F Browne 1917*; inscribed on verso:
Autumn Hillside/Eagle's Nest Bluff-Oregon-Ill./Ch. Fr. Browne Oct 1917

Edgar Spier Cameron

1862–1944

NOTES

1. "Pictures in Art Exhibit," *El Palacio* 4 (Nov. 1917), 94–96. Cameron exhibited Southwestern subjects at the Art Institute in 1918, 1920, 1927, and 1928.

2. "Cameron at Santa Fe," *Chicago Evening Post*, Nov. 6, 1917, in AIC Scrapbook vol. 36, microfilmed. Cameron also exhibited a number of New Mexico paintings in his solo exhibition at Newcomb & Macklin Galleries in Chicago in 1921 (*Chicago Evening Post*, Nov. 15, 1921, in AIC Scrapbook vol. 42).

3. Evelyn Marie Stuart, "Chicago Artists' Twenty-Second Annual Exhibition," *Fine Arts Journal* 26 (March 1918), 9.

4. Edgar L. Hewitt and Reginald G. Fisher, *Mission Monuments of New Mexico (Handbooks of Archaeological History)* (Albuquerque: University of New Mexico Press, 1943), 105.

5. Arrell Morgan Gibson, *The Santa Fe and Taos Colonies: Age of the Muses, 1900–1942* (Norman: University of Oklahoma Press, 1983), 90–91.

A native of Ottawa, Illinois, Edgar Cameron had a wide-ranging career in Chicago as an art critic, lecturer, painter, and muralist. Cameron studied at the Chicago Academy of Design, as well as in New York and Paris, and he worked throughout Europe and in the American Southwest. He was especially known for his historical scenes, including a group of twelve paintings illustrating the history of Chicago, painted for the City of Chicago in 1911.

By 1920 Santa Fe and Taos, New Mexico, were the sites of flourishing art colonies. Both Modernist and conservative artists from throughout the United States were attracted by the region's unique architecture, stark landscape, and colorful mixture of Native American and Spanish Catholic religious ritual and art. Cameron apparently visited the area a number of times, beginning in 1917, when one of his New Mexico scenes was included in the inaugural exhibition at the new New Mexico Art Museum in Santa Fe.[1] That same year Cameron's New Mexico paintings were featured in his solo exhibition held at the Governor's Palace in Santa Fe.[2] Cameron focused on the region's characteristic timber-and-adobe architecture in his straightforward, naturalistic depictions, which appealed to the growing number of tourists attracted to the region. He also exhibited these works in Chicago, where a critic described them as "very beautifully-colored and dignified canvases."[3]

The town of Santa Cruz, just outside Santa Fe on the road to Taos, boasts a large adobe mission church, Santa Cruz de la Cañada, dating to 1733. In 1900 gable roofs were placed over the sanctuary and each of the towers flanking the front entrance, in an effort to conserve the structure.[4] But Cameron, a champion of architectural preservation in Santa Fe,[5] chose to portray the church as it had originally appeared. Two Indians posed in the foreground add an authentic note, while their colorful robes relieve the flat expanses of tawny adobe caught in the midday glare. WG

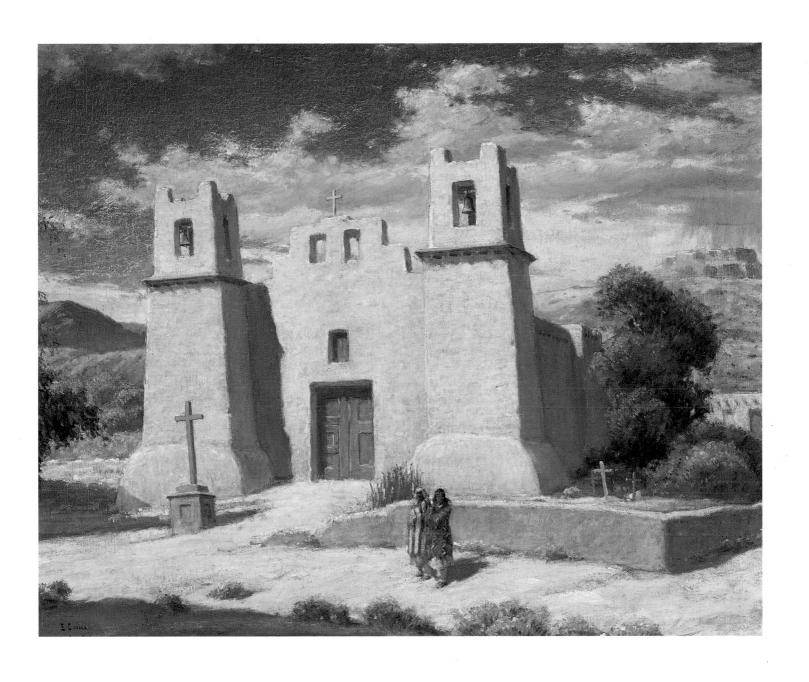

20

SANTA CRUZ

[CHURCH WITH FIGURES, SANTA CRUZ, NM] c. 1917–1921

Oil on canvas, 24 × 29 in.
Signed, lower left: *E Cameron/Santa Cruz*

Francis Chapin

1899–1965

NOTES

1. *Time* 19 June 1950, 65.

Francis Chapin, a quintessential Midwesterner, was born in Bristolville, Ohio, in 1899. After earning a B.S. degree at Washington and Jefferson College in 1921, he moved to Chicago to study at the School of the Art Institute. He completed his degree in 1925 and stayed at the School for several years of postgraduate study. In 1928 he went to Europe on a Byron Lathrop Traveling Fellowship, returning a year later to settle permanently in Chicago, where he painted prolifically, taught at the School of the Art Institute (1926–47) and was eventually identified as the "Dean of Chicago Painters." He was also a legendary teacher, and served as director of the Summer School at Ox-Bow in Saugatuck, Michigan, from 1942–46. In addition, he painted regularly in Martha's Vineyard, as well as in Mexico and Europe. He exhibited widely and regularly, winning awards in numbers that rivaled his friend Ivan Albright's record. In addition to routine representation in the juried Art Institute exhibitions, Chapin was frequently represented at the Pennsylvania Academy of the Fine Arts Annuals in Philadelphia, the National Academy of Design Annual in New York, the Corcoran Gallery of Art Biennial in Washington, D.C., the Whitney Museum of American Art Biennial and Annual exhibitions in New York, and numerous other museum shows both in the United States and abroad. In 1950, Chapin told *Time* magazine that Chicago, as contrasted to the East Coast, with all its advantages for artists, was a place where a painter "could develop his own style," rather than being forced into a preconceived mold.[1] While his own style, suggesting Dufy, Matisse, and John Marin, among others, was somewhat out of fashion in postwar America, Chapin's authentic exuberance, skillful use of color, and virtuoso technique deserve continued attention.

Chapin painted innumerable scenes of the Old Town neighborhood in Chicago where he lived and worked on Menomenee Street for many years. This view of a brilliantly colored red house visible behind the framework of the silhouetted elevated train tracks is typical of Chapin's proficient representations of the small-town aspects of this community located in the larger urban area of Chicago. Chapin's lifelong interest in this subject dovetailed perfectly in the 1930s with the mandate to create images of the American Scene. SW

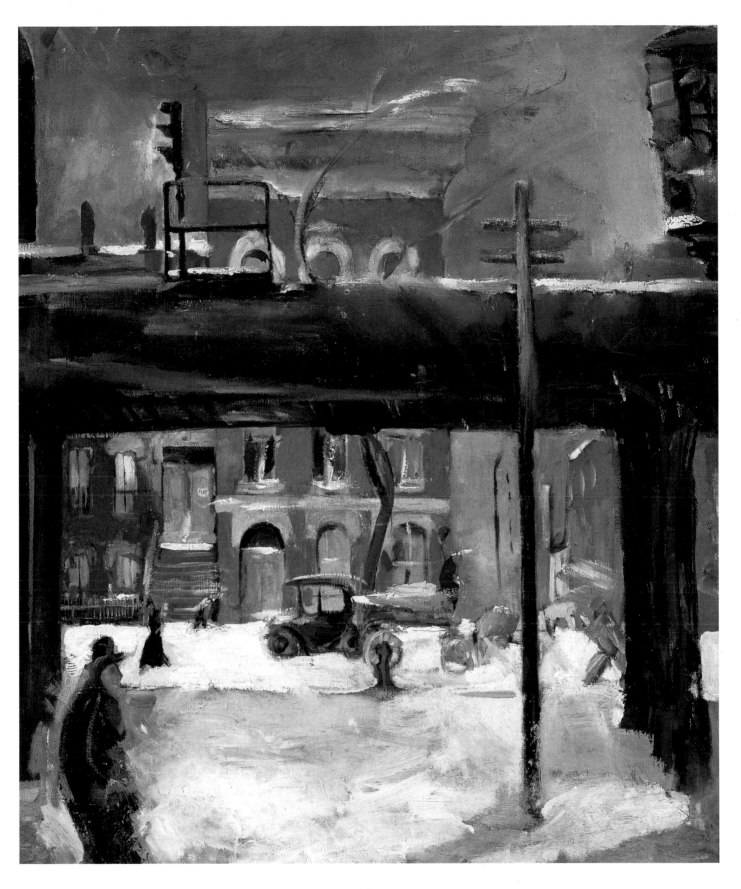

21

UNTITLED

[RED HOUSE AND ELEVATED TRAIN], early 1930s

Oil on canvas, $29^{3}/_{4} \times 24^{3}/_{4}$ in.
Signed, lower right: Francis Chapin

Francis Chapin
(CONTINUED)

NOTES

1. Powell Bridges pointed out the features of this location to me. Aaron Bohrod seems to have painted the same location from a slightly different perspective in a work called *Northside Street* of 1933, reproduced in *Aaron Bohrod: Early Works* (Hopkins, Minnesota: F. B. Horowitz Fine Art Ltd., 1988), p. 2. A preparatory drawing is reproduced in Bohrod's *A Decade of Still Life* (Madison, Milwaukee, London: University of Wisconsin Press, 1966), p. 1.

ity Arabesque is a large, ambitious, and complex image of the Old Town neighborhood in Chicago where Francis Chapin lived most of his adult life. The spire of St. Michael's Church, the Northern Illinois Gas storage tank, and the elevated train tracks, all in the area of North Avenue and Sedgwick Street, serve to identify location.[1] It is characterized by the bravura brushstroke and dazzling colors for which Chapin was celebrated by his contemporaries. Like [*Red House*], the painting serves to extol the virtues of the local area with its bustling human activity, rather than the sleek modernity of the skyscrapers of the city center. The contrast of the steamroller and the wheeled cart in the foreground, and the large gas storage tank and church steeple in the background subtly suggest the gradual encroachment of the modern world on this "small town" environment. SW

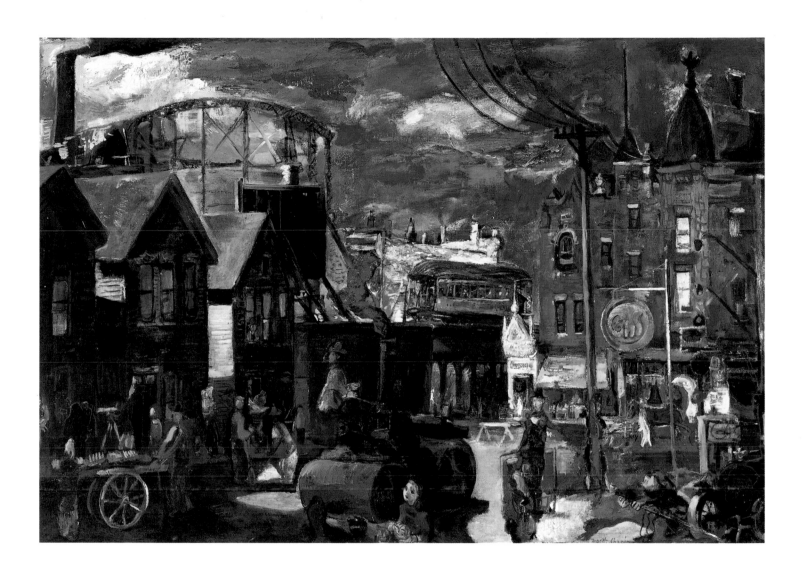

CITY ARABESQUE, before 1943

Oil on canvas mounted on masonite, 31¹/₄ × 44 in.
Signed, lower right: *Francis Chapin*

William Clusmann

1859–1927

NOTES

1. Typescript biographical note by the artist, in William Clusmann pamphlet file, Ryerson Library, AIC.

2. Daniel M. Bluestone, *Constructing Chicago* (New Haven and London: Yale University Press, 1991), chap. 2.

3. An almost identical photographic view of the bridge as pictured by Clusmann appears in *Centennial History of the City of Chicago: Its Men and Institutions. Biographical Sketches of Leading Citizens* (Chicago: The Inter Ocean, 1905), 180.

4. These structures, with red roofs uncharacteristic of Chicago, have not been identified.

5. "Exhibitions at Chicago Galleries," *Fine Arts Journal* 36 (April 1918), 38.

6. "Exhibitions at Chicago Galleries," 40.

Landscapist William Clusmann was born in LaPorte, Indiana, and studied at the Art Institute and in Munich and Stuttgart, Germany, returning to Chicago in 1884. Except for several years spent in Germany just prior to the outbreak of World War I, Clusmann spent his entire career in the Chicago area.[1] He specialized in views of Chicago parks and area riverways, to which he applied an Impressionist aesthetic of rapid, broken brushwork, fresh color, and brilliant light effects.

Chicago's ambitious system of parks and tree-lined boulevards was laid out in the 1870s. Humboldt Park, Douglas Park, and Central Park (later renamed Garfield Park after the assassinated president) were designed by architect William LeBaron Jenney. Smaller in area than the south parks and Lincoln Park on the north side, and lacking the relief of Lake Michigan's expanse, these westside parks were redeemed from their natural prairie monotony by artificial hills, irregularly shaped pools, generous plantings, and curving drives and walks. Such features were intended to make Chicago's parks an antidote to the city's congestion and relentless grid of straight streets.[2]

Clusmann's view of the picturesque stone bridge spanning the meandering waterways of Garfield Park shows an unpeopled scene of warm sunlight and luxuriant verdure.[3] There is little to indicate that the bridge carried motorized traffic across the water or that the lagoon itself was often crowded with boats; in the background, the red roofs and chimneys from which smoke curls lazily give the scene a domestic note and evoke the French countryside.[4] Like the creators of Chicago's nineteenth-century parks, the painter does his best to transport the viewer as far as possible from local urban actuality. Not surprisingly, one critic recommended Clusmann's park views for brightening up the walls of dark city apartment homes.[5]

Clusmann painted at least one other view of the bridge, an October scene reproduced in a review of his solo show at Marshall Field and Company in 1918.[6] In the 1930s the stone bridge was replaced by the concrete structure that stands today.

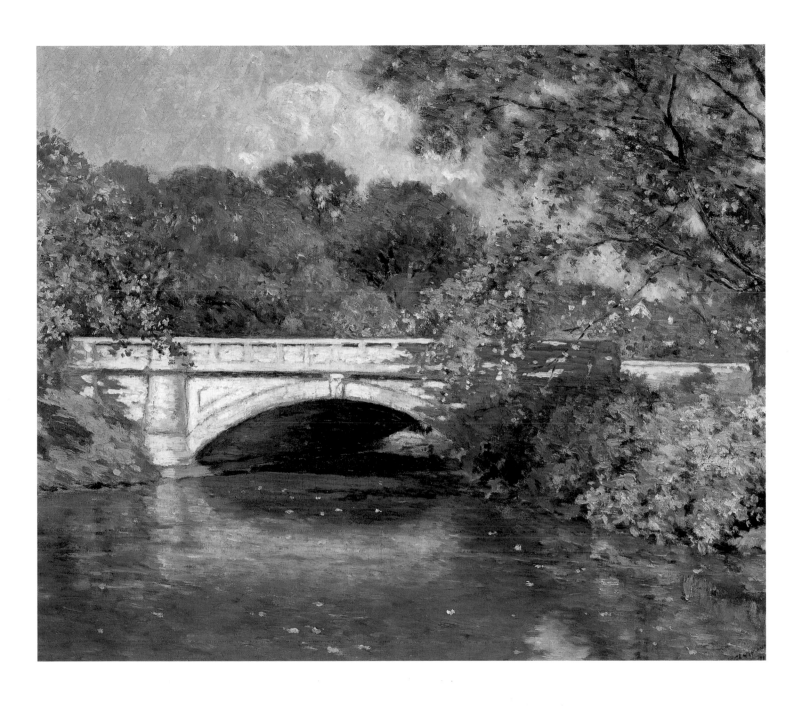

23

OLD STONE BRIDGE, GARFIELD PARK, 1917

Oil on canvas, 26 × 30 in.
Signed and dated, lower right: *W CLUSMANN 1917*

William Clusmann

(CONTINUED)

NOTES

1. Chicago Park District, *Historic Parks Inventory* (Chicago: the Park District, 1982), unpaged. The bandshell and park infrastructure generally have deteriorated badly since Clusmann painted the scene. The planters and light poles shown in his painting have disappeared, and the bandshell itself is in poor condition.

2. Joan E. Draper, "Paris by the Lake: Sources of Burnham's Plan of Chicago," in John E. Zukowsky, ed., *Chicago Architecture 1872–1922: Birth of a Metropolis* (Munich: Prestel–Verlag in association with The Art Institute of Chicago, 1987), 107–20.

The Garfield Park bandshell, attributed to architect Joseph Lyman Silsbee, was erected in 1896. The structure, with its elaborate octagonal copper-clad roof in a Moorish style, is the focus of the southern section of Garfield Park. Clad in white marble and inset with colored glass and marble mosaic work, the bandshell boasted electric lighting and was ringed by fountains. It could accommodate a hundred musicians for the free concerts that, along with the conservatory and the boathouse, offered residents of Chicago's west side a variety of recreational activities and amusements.[1]

Clusmann's view of the bandshell looks south from the boathouse that, until it burned down in 1981, stood on the north side of Washington Boulevard, which forms the foreground of the image. The image is enlivened by the colorful flowers in the planter in the foreground and the brilliant light bathing this sunny scene. Two straight promenades lead past a reflecting pool, hidden by greenery in the picture, toward the bandshell and what is actually a modest section of park land seems to stretch away generously into the distance. With its straight paths arranged symmetrically, its broad, low planters, and its graceful electric light fixtures, this section of Garfield Park evokes the formal parks of Paris, one important source of influence on Chicago's turn-of-the-century architects and planners.[2] Clusmann's park views, with their brilliant sunlight and broad vistas, recall William Merritt Chase's urban park scenes executed several decades earlier, as well as images of the "White City" of the 1893 World's Columbian Exposition painted by Childe Hassam, Theodore Robinson, and others. WG

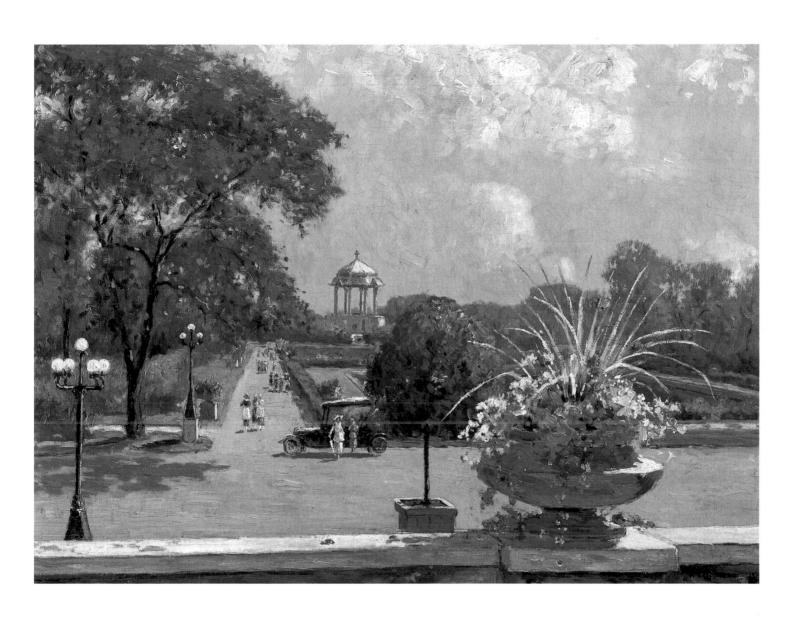

24

BANDSHELL, GARFIELD PARK, 1917

Oil on canvas, 18¼ × 24 in.
Signed, lower right: *W CLUSMANN 1917*

Charles William Dahlgreen

1864–1955

NOTES

1. The Charles Dahlgreen Papers have been microfilmed by the Archives of American Art (reels 3953, 3954) and provide important primary materials relating to Dahlgreen's life and career, including a manuscript autobiography by the artist.

2. "To Open Atelier Here," *Oak Leaves*, Apr. 2, 1921 (AIC Scrapbook of Art and Artists of Chicago and Vicinity) mentions that Dahlgreen "moved to Oak Park less than a year ago."

3. Dahlgreen, MS autobiography, 193, in Charles W. Dahlgreen Papers, Archives of American Art microfilm reel 3954.

4. On the Brown County Art Colony, see William H. Gerdts, "The Golden Age of Indiana Landscape Painting" in *Indiana Influence: The Golden Age of Indiana Landscape Painting: Indiana's Modern Legacy. An Inaugural Exhibition of the Fort Wayne Museum of Art, 8 April–24 June, 1984* (Fort Wayne, Ind.: Fort Wayne Museum of Art, 1984), 39–49; Lyn Letsinger-Miller, *The Artists of Brown County* (Bloomington and Indianapolis: The Indiana University Press, 1994), pp. xix–xxi.

5. Unidentified clipping, review of Dahlgreen's exhibition at the John Herron Art Institute, Indianapolis, in Grant Dahlgreen Papers, Archives of American Art microfilm reel 3954, frame 892.

6. Dahlgreen, MS autobiography, 194–97.

7. Dahlgreen, MS autobiography, 211.

Chicago native Charles Dahlgreen worked for almost two decades creating painted and embroidered signs before he felt financially secure enough to begin a career as a fine artist in 1904.[1] After training in Chicago and in Dusseldorf, Germany, Dahlgreen returned to Chicago. In 1920 he relocated to Oak Park, just west of the city, where a number of other painters, including Alfred Juergens and Carl Krafft, also resided.[2] Insisting on the importance of painting nature on-site,[3] Dahlgreen executed landscapes in numerous locales in a colorful Impressionist style. In 1908 he also took up the practice of etching, a medium in which he achieved considerable fame.

Dahlgreen was one of many Chicago artists who flocked to Brown County, Indiana, in the early decades of the twentieth century to take advantage of the region's beautiful natural scenery and unspoiled rural life.[4] Brown County was first "discovered" around 1907 by a group of Indianapolis painters who were soon joined by artists from Chicago and elsewhere. Dahlgreen's first encounter with Brown County, in 1915, was "like dropping into Paradise," he recalled.[5] On that visit the painter discovered a "perfect" subject, a scene that included the deserted cabin, which he rendered as part of a composition called *Good Morning*. Returning to the spot in 1920, Dahlgreen found several artists working there who had dubbed it "Dahlgreen's Hollow."[6] Such abandoned dwellings, noted Dahlgreen, were not typical, "Yet 50 years ago their [*sic*] must have been many places of this kind from the looks of some of the abandoned cabins, some of which are still to be seen in hopeless disrepair."[7] In *Deserted Cabin* the empty but not decrepit structure, seen partly shadowed by the surrounding trees, draws on the popular reputation of Brown County itself as a charmingly backward haven from the ravages of modern development. WG

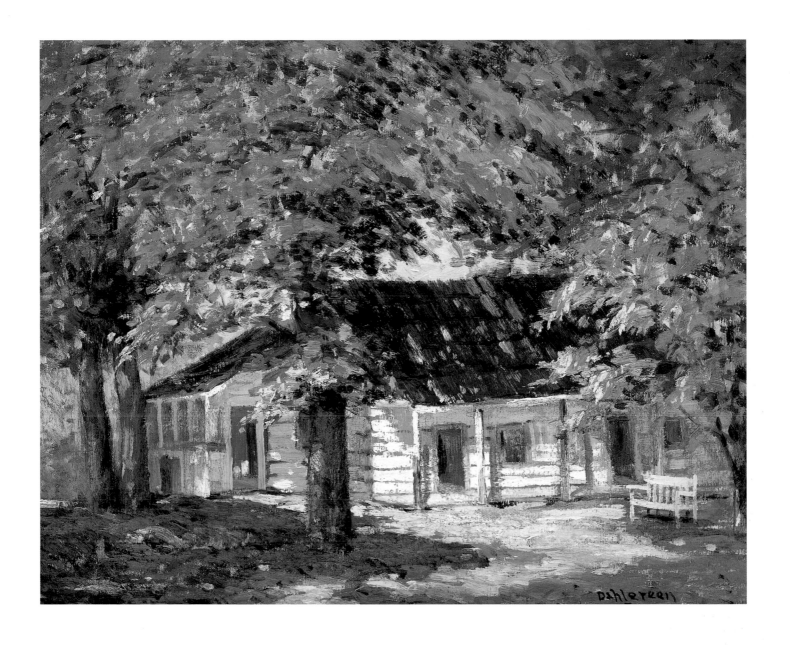

25

DESERTED CABIN, c. 1920

Oil on canvas, 16 × 20 in.
Signed, lower right: *Dahlgreen*

Charles William Dahlgreen

(CONTINUED)

NOTES

1. "Three Exhibitors at Chicago Galleries." *The Christian Science Monitor*, Feb. 23, 1929, in Charles W. Dahlgreen Papers, Archives of American Art, reel no. 3954, frame 887.

Arowboat complete with fishing rod, pulled up on the sandy bank of a river, is the focus of Dahlgreen's *Wolf River*. With its high horizon and thick greenery framing the bend in the placid stream, the brilliantly lit scene evokes a summer idyll in rural Wisconsin. It is rendered in a muscular Impressionist style and almost raw color that hints at the influence of Post-Impressionism. In the late twenties, as one critic noted, Dahlgreen's paintings of subjects such as "sylvan spots in Wisconsin" evidenced "more freedom of handling and love of color" than his work of a few years before.[1] WG

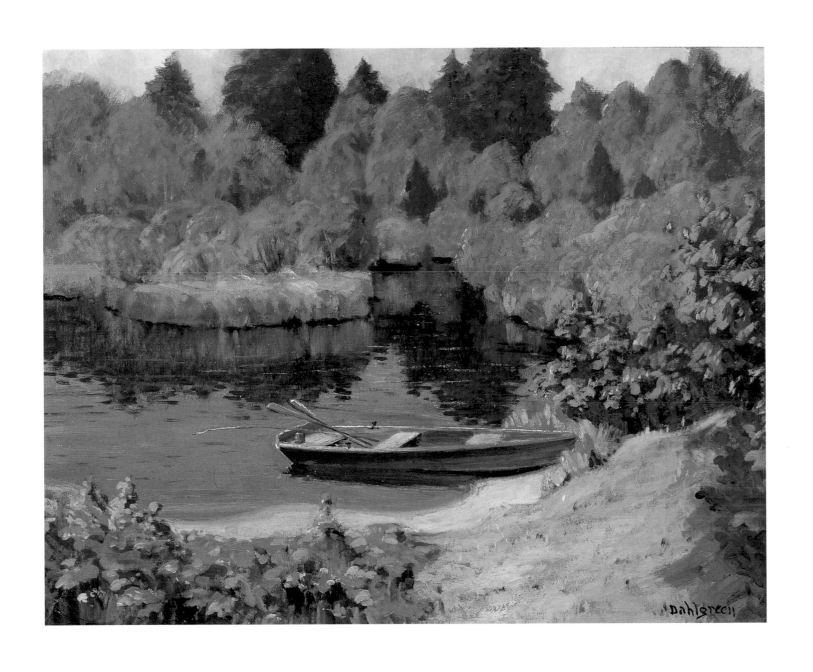

26

WOLF RIVER, c. 1927

Oil on board, 24 × 30 in.
Signed, lower right: *Dahlgreen*

Charles William Dahlgreen

(CONTINUED)

NOTES

1. Charles Dahlgreen, MS autobiography, 201, in Charles W. Dahlgreen Papers, Archives of American Art, microfilm reel 3954.

2. Dahlgreen, MS autobiography, 201. The tree was the subject of Dahlgreen's painting *The Old Cottonwood* (1931; Ball State University), which won a prize when exhibited in the 1932 Hoosier Salon exhibition at Marshall Field's ("The Old Cottonwood," *Oak Leaves*, undated clipping in Charles W. Dahlgreen Papers, Archives of American Art, microfilm reel 3954, frame 727).

3. Dahlgreen, MS autobiography, 237.

4. A reviewer's descriptions make it clear that *Refreshment* was quite different from *Homeward Bound*, which featured "two little bright figures in a wagon winding through the verdure down below as they make their way home" ("Art League Has Show of C. W. Dahlgreen Paintings," *Oak Leaves*, Nov. 30, 1944).

5. "Art League," 1944.

6. In 1934 Dahlgreen's *Breakfast Table*, painted in the wake of his study of the Eddy Collection of Modernist art at the Art Institute, was awarded the Brower Prize in the Chicago and Vicinity annual exhibition. Clarence Bulliet, "Artists of Chicago Past and Present, No. 25: Charles W. Dahlgreen," *Chicago Daily News*, Aug. 10, 1935.

n 1931 Dahlgreen made the first of several visits to the area around Taos, New Mexico, driving across the country in a truck specially outfitted as a traveling studio.[1] One of his favorite subjects was a large cottonwood tree that stood on the banks of a shallow stream by an Indian pueblo.[2] On the painter's return to Taos in 1935 he used the tree as the setting for a series of four landscapes with Indians: *Rendezvous, The Proposal, Homeward Bound,* and *Reminiscence.*[3] It seems possible that *Refreshment,* with its related subject and the inscription "No. 3" on the back of the canvas, was substituted at one time for *Homeward Bound,* the original third picture in the series. However, a newspaper description of *Homeward Bound* makes it clear the two paintings are not identical.[4]

Refreshment shows the cottonwood tree in the golden colors of autumn. A group of Indians on horseback suggest the origins of the title, though none of the horses are actually drinking from the stream that meanders from the foreground into the center of the image. On the right side of the stream stand an Indian man and a woman holding a child, a motif that Dahlgreen inserted into other depictions of the cottonwood tree. Loosely painted in the Impressionist style characteristic of Dahlgreen's landscapes, *Refreshment* illustrates his principle that every painting should have in it the three primary colors: red, yellow, and blue.[5] There is little in this painting to hint at the experiments in Modernism undertaken by the painter in this period.[6] WG

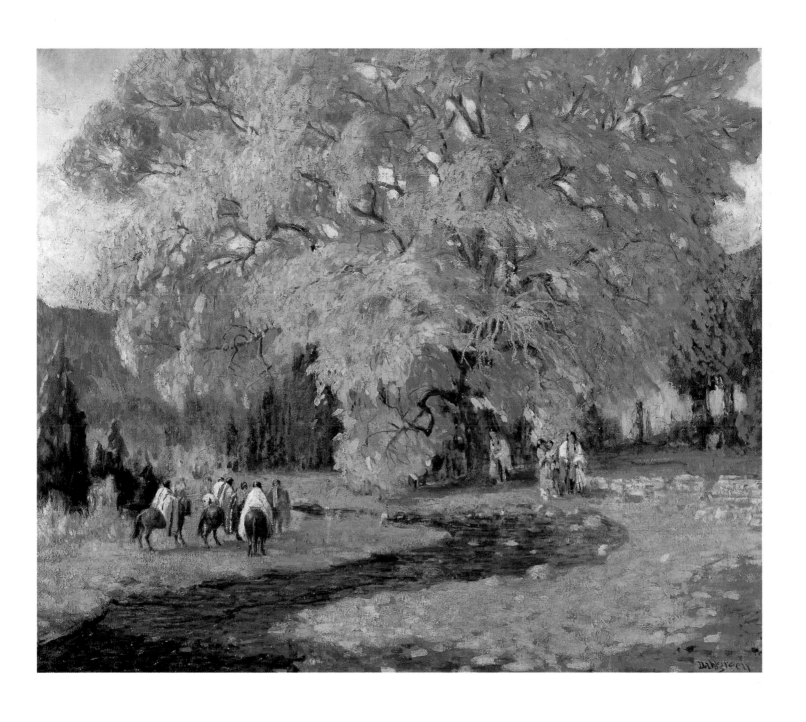

REFRESHMENT, c. 1931–1935

Oil on canvas, 42 × 48 in.
Signed, lower right: *Dahlgreen;*
inscribed on verso: *REFRESHMENT/No 3.*

Gustaf Dalstrom

1893–1971

NOTES

1. The Dalstroms exhibited 48 of their Lincoln Park paintings at the Chicago Historical Society in 1948. See Genevieve Flavin, "Exhibit Reveals Lincoln Park of Earlier Day." *Chicago Sunday Tribune* 8 August 1948 and "Dalstroms Capture 25 Years in Lincoln Park on Canvas." *North Side Sunday Star* 4 July 1948. It is probable, but not verified, that this painting was exhibited.

Born in Gotland, Sweden, in 1893, Gustaf Dalstrom came to the United States with his family in 1900. He studied at the School of the Art Institute of Chicago. Like many of the progressives in Chicago he was influenced by George Bellows and Randall Davey, who were visiting professors at the School for short periods in 1919 and 1920. Exposure to these New York urban realists introduced students to such ideas as using ordinary people and scenes as subjects for their work and emphasized the importance of freedom from conventional rules. Not particularly radical by East Coast standards, Bellows and Davey nevertheless had a tremendous influence in the context of the traditional Beaux-Arts pedagogy practiced at the School through the 1920s. Dalstrom was a leader in a number of artists' groups in Chicago, including the Chicago No-Jury Society of Artists and the Chicago Society of Artists (he was president of both of these organizations) and Ten Artists (Chicago), a group of ten artists including his wife, artist Frances Foy, as well as Frances Strain and Fred Biesel, and Vin Hannell. Like the Biesels, Foy, and Hannell, he exhibited with the Society of Independent Artists in New York in the 1920s. In 1928, the Biesels, Dalstroms, and Vin and Hazel Hannell traveled to Europe for an extremely fruitful study and painting trip. Dalstrom and Foy married in 1923 and lived in the Lincoln Park neighborhood of Chicago for the rest of their lives.

Both Foy and Dalstrom often used the large expanse of Lincoln Park, with its lagoon, shaded paths, zoo, and ice skating pond, as inspiration for their paintings.[1] In this scene, Dalstrom conveys the range of leisure activities on a sunny, warm afternoon. Adults and children walk and talk, sit on benches, row boats on the lagoon, and indulge in the luxury of the day in the tradition of Georges Seurat's *A Sunday on La Grande Jatte*, which became part of the permanent collection of the Art Institute of Chicago in 1926. This painting, along with many other Lincoln Park scenes painted by both Foy and Dalstrom, celebrates urban Chicago in much the same way as artists such as Bellows and Davey, who were associated with the Ashcan School in New York, glorified that city. The fashionable figures engaged in urban pleasures also suggest the artist's familiarity with the sophisticated flappers of Guy Pène du Bois. SW

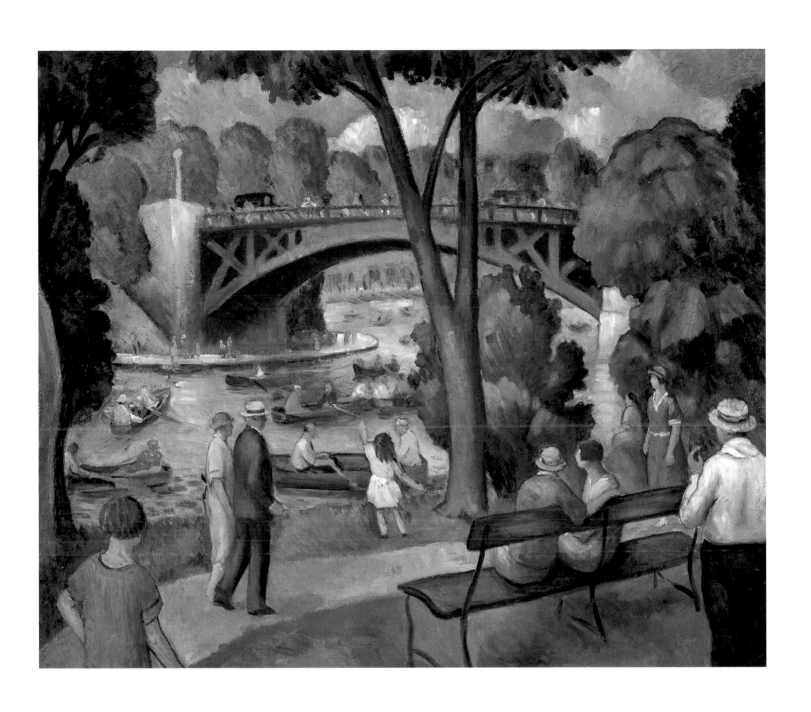

THE BRIDGE, SOUTH POND

[LINCOLN PARK], 1924

Oil on board, 26 × 30 in.
Signed and dated, lower left: *G. Dalstrom*

Gustaf Dalstrom
(CONTINUED)

NOTES

1. Foy did a bird's-eye view of the schoolyard, probably painted from the same location as Dalstrom's. Her *School Yard* is reproduced in C. J. Bulliet, "Frances Foy," Artists of Chicago: Past and Present, no. 27, *Chicago Daily News* 24 August 1935.

Dalstrom and his wife, artist Frances Foy, lived on Kemper Place behind the Lincoln School from 1932–36. This painting was probably done in the second-floor studio of their home.[1] The whimsical, sweet, pastel-toned image of tiny figures at recess seen from a bird's-eye view contrasts with the more substantial and somber toned *Bridge, South Pond.* Whether a result of a stylistic development or a response to the subject-matter, this is evidence of Dalstrom's ability to move easily from one stylistic mode to another. SW

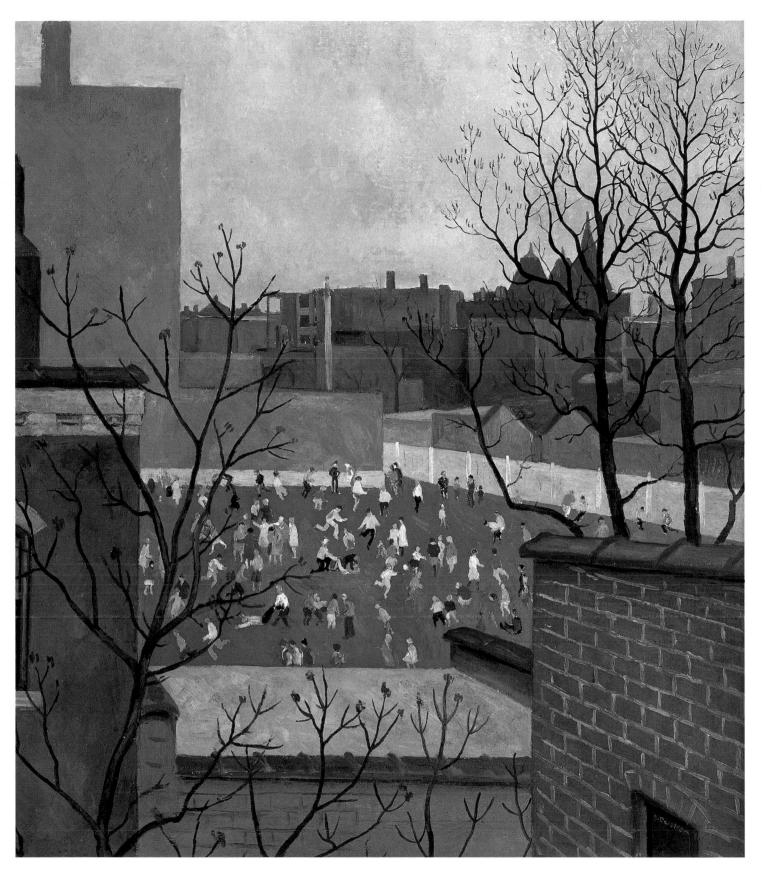

29

UNTITLED

[SCHOOL YARD, ABRAHAM LINCOLN SCHOOL, CHICAGO], c. 1932

Oil on board, 28 × 24 in.
Signed, lower right: *G. Dalstrom*

Manierre Dawson

1887–1969

NOTES

1. According to Dawson's Inventory, the painting *Fireman*, of 1912, was done on wood. The inventory is reprinted in Randy J. Ploog, "Manierre Dawson: A Chicago Pioneer of Abstract Painting" (unpublished Ph.D. dissertation, The Pennsylvania State University, 1996), 205.

Manierre Dawson was born and raised in Chicago. Despite an interest in painting that was strong from childhood, in an attempt to reach a compromise with his family, he was educated at the Armour Institute (now Illinois Institute of Technology), as an architectural draftsman, graduating in 1909. While pursuing his education and subsequently working at the architectural firm of Holabird and Roche after earning his degree, he continued painting, producing wholly abstract works prior to a European trip in 1910. As Randy Ploog has demonstrated in his study of Dawson, the factors that contributed to Dawson's progressive attitudes toward painting were all in place in Chicago in the first decade of the century. The influence of the Arts and Crafts movement, the writings and teachings of Arthur Wesley Dow, Denman Ross, and Arthur Jerome Eddy, as well as Dawson's education at the Armour Institute, all contributed to his approach to painting as pure form. Ploog demonstrates that these factors account for the almost simultaneous emergence of similar ideas in the work of Arthur Dove, Francis Picabia, and Frantisek Kupka, followed closely by Kandinsky, Malevich, Robert Delaunay, Stanton Macdonald-Wright, and Morgan Russell. Dawson was inspired by his first contact with European Modernism in Europe and found his first patron in Gertrude Stein, whose Parisian home he visited in 1910. He was a participant in the groundbreaking Armory Show in 1913 and the Milwaukee Museum's *In the Modern Spirit* the following year. Shortly thereafter, he decided that he would devote himself to a life outside the pressures of the city and became a fruit farmer in Ludington, Michigan, where his family had had property for many years. His artistic production fell off radically, and he exhibited rarely in the following years.

Fireman, an abstracted and energized figure suggestive of Duchamp's *Nude Descending a Staircase* done in the same year, is remarkable not only for its progressive style and highly accomplished technique, but for the fact that it is not Dawson's earliest foray into abstraction. His introduction to other avant-garde artists, as well as the Old Masters, during his European trip of 1910 further stimulated him to experiment with abstracting from the figural, as he does in *Fireman*. Consistent with his idea that painting was a way of communicating feeling through an arrangement of formal elements, Dawson did not like to give names to his paintings. The designation *Fireman* is probably accidental or arbitrary, like many of his other titles.[1] SW

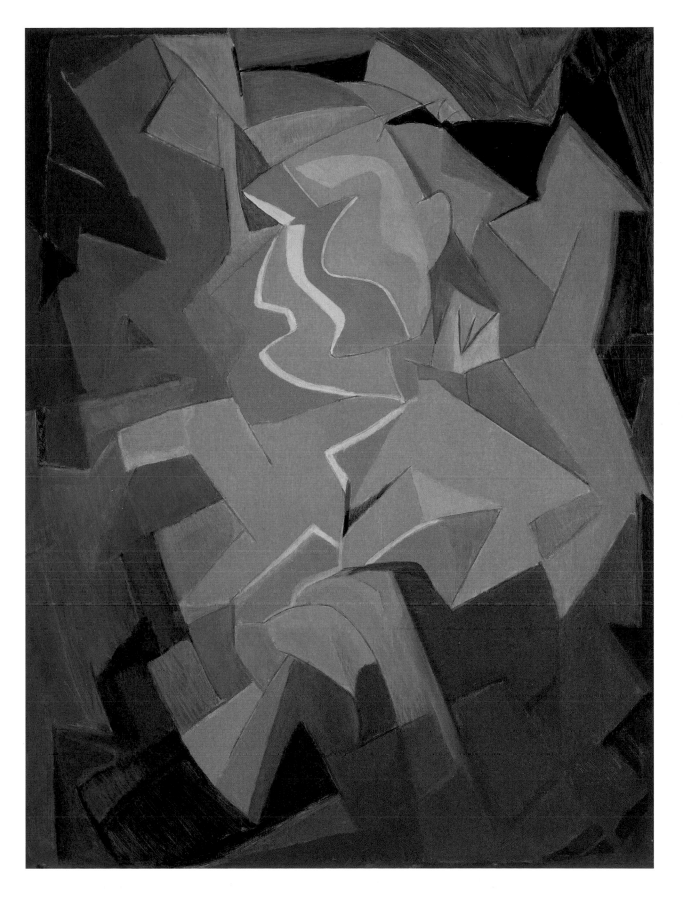

30

FIREMAN, 1912

Oil on board, 28 × 21 in.
Signed and dated, lower left: *Dawson 12*

Julio
de Diego

1900–79

NOTES

1. For biographical information, see Susana Torruella Leval, *Julio de Diego: The War Series or Los Desastres del Alma* (New York: Museum of Contemporary Hispanic Art, 1988), n.p., and Julio de Diego, *Julio de Diego: A Journey* (Sarasota, Florida: Corbino Galleries, 1992), n.p.

Julio de Diego was born in Madrid, Spain, where an apprenticeship to a scenery painter with the Madrid Opera Company provided him with his first artistic experience. He never pursued formal art school training, but was involved in a wide variety of creative activities in theater, film, ballet, and in the commercial arts as a magazine illustrator, graphic artist, and jewelry designer. After living in Spain, Italy, and finally Paris, he made his first trip to the United States in 1924, where he settled in Chicago until the early 1940s, when he moved permanently to New York. He participated actively in the Federal Art Project in Illinois, in both the mural and easel divisions. In addition, he exhibited with the Chicago Society of Artists, the Chicago No-Jury Society, and in the juried Art Institute Exhibitions, additionally having two solo shows at that institution (1935, 1942).[1] He also exhibited in the juried exhibitions of the Whitney Museum of American Art in New York and the Corcoran Gallery in Washington, D.C.

Linked to the Chicago art community by his highly developed sense of craftsmanship, de Diego produced works of varying styles, ranging from the large and powerful figure seen in *Maxine* to the Boschian fantasies of the 1943 *War Series*. In the former, one sees the influence of both the European Modernists, such as Picasso's classical figures of the early 1920s, and the Mexican muralists with whom he must have become familiar by 1939 when he made his first trip to that country. Maxine, whom he married in 1935 and divorced in the early 1940s, is represented in a vaguely Southwestern setting, with a potted cactus and adobe walls framing her figure. She is hanging a white cloth, which echoes the head covering she wears, on one of these walls, a mysterious gesture that is one of the few indications of the surreal quality often present in de Diego's work.

Chicago's art community was more than receptive to the surreal, nurturing artists such as Gertrude Abercrombie, Ivan Albright, Macena Barton, Raymond Breinen, Fritzi Brod, and Julia Thecla, whose work exhibits a quirkiness that resonates with that of de Diego. SW

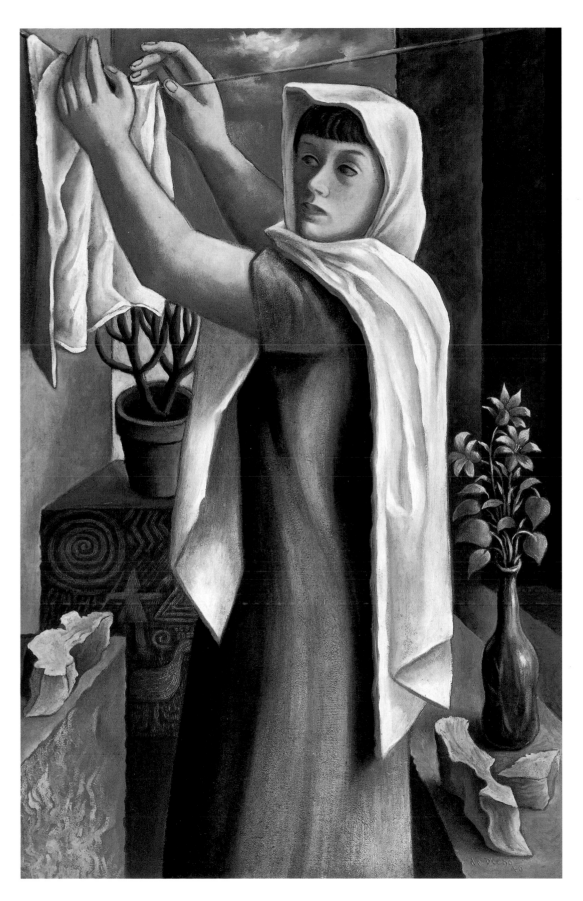

31

MAXINE

[THE ARTIST'S WIFE], 1940

Oil on board, 48 × 30 in.
Signed and dated, lower right: *de Diego '40*

Julio de Diego

(CONTINUED)

NOTES

1. "What They Think of Art New's [*sic*] Ten Best," *Art News* 15, 31 January 1944, as cited in Susana Torruella Leval, *Julio de Diego: The War Series or Los Desastres del Alma* (New York: Museum of Contemporary Hispanic Art, 1988).

De Diego's surreal vision differed from that of other Chicago artists its emphasis more on political events than personal fantasy. Like his Spanish predecessor Goya and the contemporary Mexican artists such as Diego Rivera, whom he admired, de Diego transmuted world events into haunting imagery. The world benefitted from his rejection from military service, which led to his vow to "fight my own war," using the only means he had—his art.[1] *The War Series* (1942–43) and the later *Armada* (1962) series are attempts to deal in his art with the horrors of World War II and the Cold War. *Spies and Counterspies* can be seen as part of de Diego's struggle with the forces of good and evil in his use of the quintessential symbol of an untrustworthy world. SW

SPIES AND COUNTERSPIES, 1941

Oil on masonite, 24 × 28 in.
Signed and dated, lower right: *de Diego*

Ruth
Van Sickle
Ford

1897–1989

NOTES

1. Shirley Lowry, "Critics 'Burn Up' Couple in House Built of Coal," unattributed newspaper clipping, Ruth Van Sickle Ford papers, Archives of American Art, Smithsonian Institution, Washington, D.C., Roll 3956, frame 299; Brenda Warner Rotzoll, "Architect Really Digs His House of Coal," *Chicago Sun Times* 4 July 1993.

2. Pictures of this sign and the house, both under construction and completed, can be found in the Ruth Van Sickle Ford papers, AAA, Roll 3956, frames 291–98.

R uth Van Sickle was born in Aurora, Illinois, where she lived most of her life. She was trained at the Chicago Academy of Fine Arts, a local institution with a commercial focus, from 1915–18. She also studied at the Art Students League in New York. In addition, she studied with urban realist George Bellows, as well as with the more traditional artists Guy Wiggins and Jonas Lie. She was a member of a number of organizations, most solidly conservative, including the Palette and Chisel Club and the American Water Color Society. She taught at the Chicago Academy of Fine Arts beginning in 1930 and was president and owner of the institution from 1937–60. In addition to her teaching and administrative duties, she continued to paint and exhibit her work in Chicago and elsewhere. She tended toward the traditional, and emphasized the importance of solid training over what she perceived as the chaotic experimentation of some contemporary art. Her students described her as a strict and demanding taskmaster, but they were devoted to her.

In 1949, Ford and her family commissioned a house dubbed the "Round House" or the "Umbrella House," designed by architect Bruce Goff, where they lived from 1950–61. The innovative and unusual structure, made of coal, glass, and steel, attracted a large audience from miles around, and made some of the neighbors extremely unhappy.[1] The negative responses from some visitors caused the Fords to erect a sign in front of the construction site of the house, stating "We Don't Like Your House Either."[2] Her commitment to building and living in this avant-garde structure situated on the outskirts of the traditional town of Aurora, Illinois, is a gauge of her steely individuality and her appreciation for progressive art forms. Despite her achievements and willingness to explore new modes of expression, if not in a radical way, she was a firm believer in traditional education and representational art. She often reiterated the need for mastering the basics before attempting distortion or abstraction.

Although Ford always worked in a representational style, she was clearly familiar with the many Modernist modes of the early-twentieth century. In *Belgian Village* she distorts and fragments the forms of the buildings and figures in order to create a dynamic and energetic image. The subject is the Belgian Village built for the Century of Progress Fair of 1933. The Fair itself was a celebration of the technological promise of the future, but included a

(Continued on page 242)

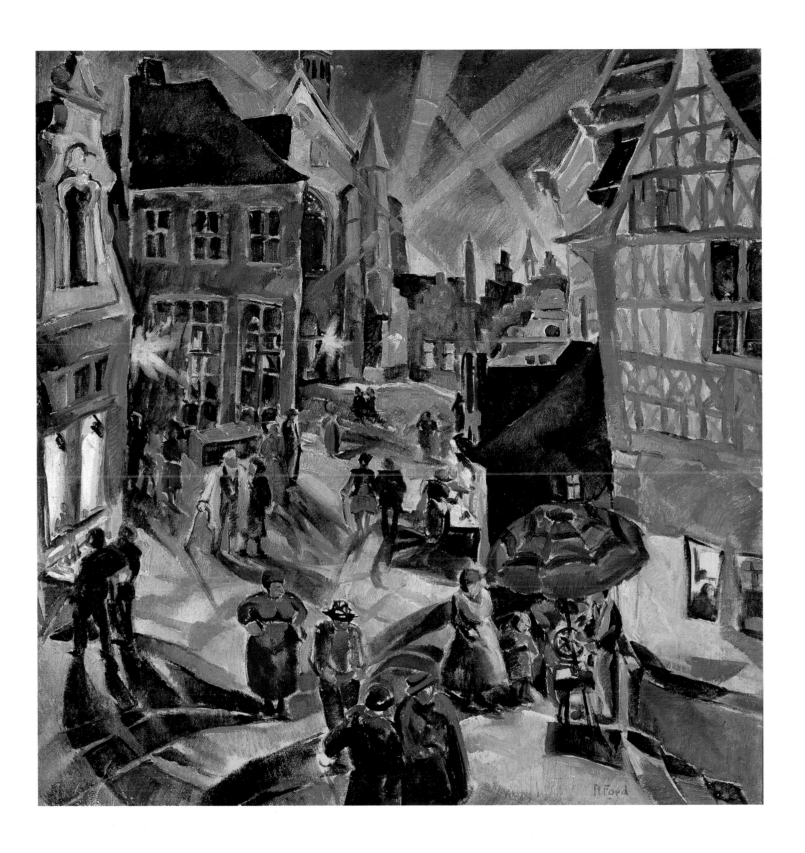

33

BELGIAN VILLAGE

[CHICAGO WORLD'S FAIR] , c. 1933

Oil on canvas, 32 × 30 in.
Signed, lower right: *R. Ford*

Ruth Van Sickle Ford
(CONTINUED)

NOTES

1. Mary Elizabeth Plummer, "Busy Woman Plans Routine," *Salisbury N.C. Post* 8 May 1941, Ruth Van Sickle Ford papers, AAA, Roll 3955, frame 1139.

In addition to painting urban scenes and landscapes, Ford was a particularly adept portraitist, as is evidenced in *Jenny*, a sensitive portrait of an aging woman absorbed in her work at a sewing machine in front of an open window. Ford commented that she liked to paint "things which have been lived in for years and years," because they have character, "and the same is true of people."[1] Ford made this painting during one of the summers that she taught at Guy Wiggins's summer art colony in Old Lyme, Connecticut. SW

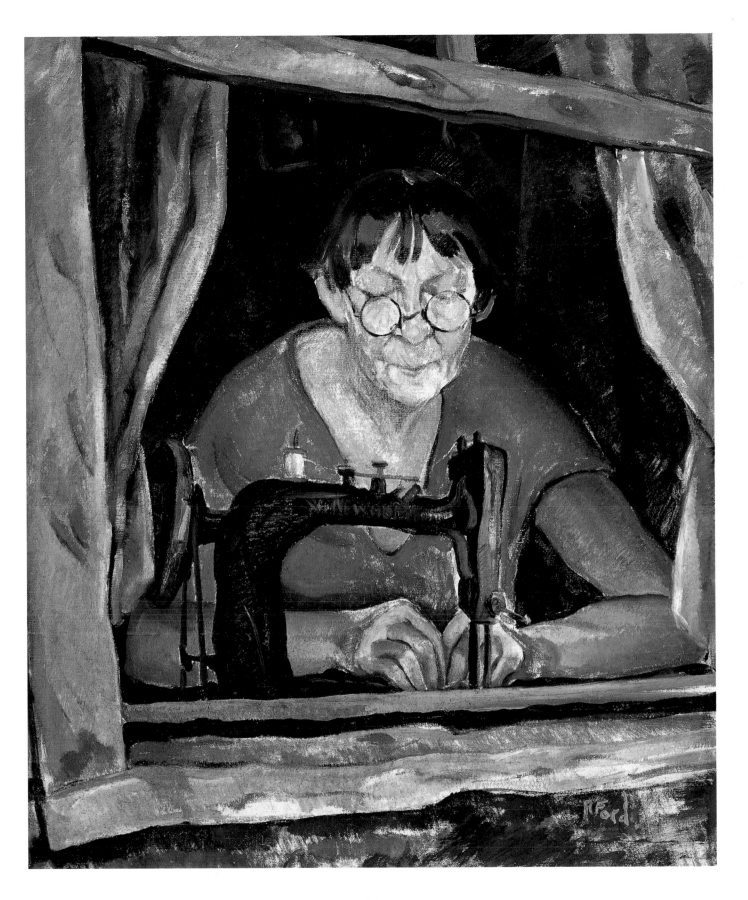

<div align="center">

34

J E N N Y

[A T O L D L Y M E] , C . 1 9 3 5

Oil on canvas, 36 × 30 in.
Signed, lower right: *R. Ford*

</div>

Ruth Van Sickle Ford

(CONTINUED)

NOTES

1. For an overview of the Tree Studios, see the exhibition catalog *Capturing the Sunlight: The Art of Tree Studios* (Chicago: City of Chicago Department of Cultural Affairs, 1999).

This monumental image of the corner of State and Ohio Streets in Chicago is based on the view from the window of the Tree Studios Building, where Ford maintained a studio in the 1930s. The Tree Studios and surrounding neighborhood attracted numerous artists from the time it was built, serving as home or studio to such varied artists as Macena Barton, Frederic M. Grant, John Warner Norton, Pauline Palmer, and John Storrs. The Tree Studios, built by Judge Lambert Tree in 1894 to provide artists with a place to work and congregate, was the North Side counterpart of the 57th Street art colony in Hyde Park. Artists, both traditional and progressive, lived and worked in this vibrant community, often congregating in the courtyard for social and intellectual gatherings.[1] Although traditional in many ways, *State and Ohio* captures the bustling movement of this busy corner, combining virtuoso painting technique with an eccentric point of view and a telescoped perspective that pushes the viewer toward the Loop, visible in the distance. SW

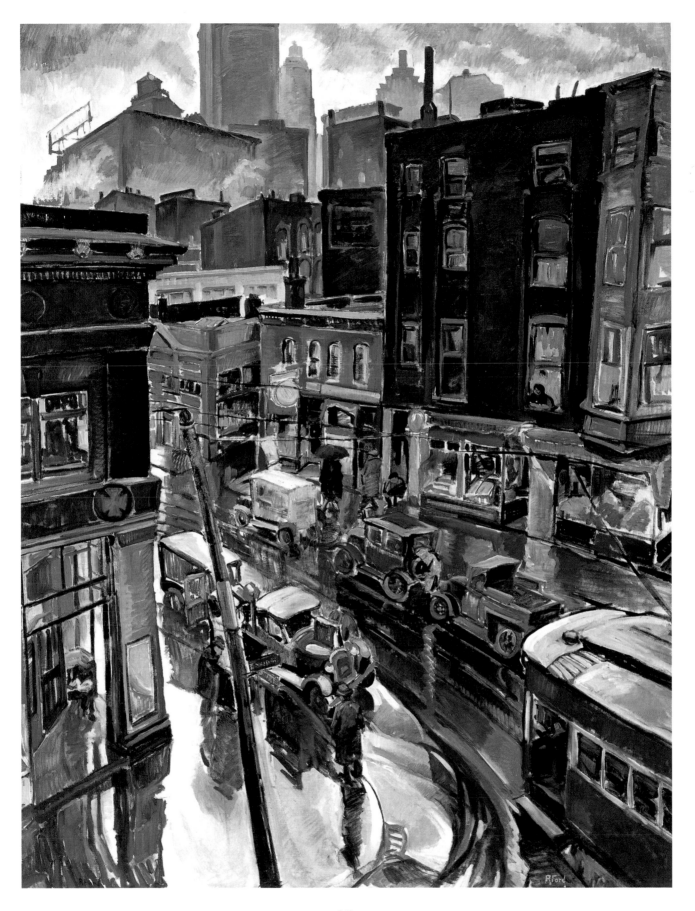

35

STATE AND OHIO, C. 1935

Oil on canvas, 72 × 54 in.
Signed originally, lower left and again in 1978, lower right: *R. Ford*

Frances Foy

1890–1963

NOTES.

1. C. J. Bulliet, "Frances Foy." Artists of Chicago: Past and Present, no. 27, *Chicago Daily News* 24 August 1935.

2. Letter from Thomas McCanna to Powell Bridges, 24 February 1994.

Frances Foy was born in Oak Park and attended night school at the School of the Art Institute where she studied with Wellington J. Reynolds, as well as George Bellows and Randall Davey when they were visiting professors in 1919–20. Like so many other young progressive artists in Chicago at the time, these New York urban realists exerted a great influence on her. Her successful career as a fashion illustrator enabled her to finance her education and travels.[1] Along with artist Gustaf Dalstrom, whom she married in 1923, she was active in the independent movement in the city, exhibiting regularly in the Chicago No-Jury Society of Artists exhibitions and with The Ten (Chicago) as well as in the juried Art Institute annuals, and with the Society of Independent Artists in New York. Foy was an accomplished portraitist and still-life painter, bringing her extraordinary delicacy and refinement to these subjects. She was active in the 1930s in the government-supported art projects, and was chosen by the competitive Treasury Section of Fine Arts Program to execute five murals.

In 1928, Foy and Dalstrom joined their colleagues and friends Frances Strain and Fred Biesel and Hazel and Vin Hannell on a working trip to Europe. According to Frances's nephew, the *Cheese Seller* was painted from Ernest Hemingway's Paris apartment window during this trip.[2] Foy's family lived in Oak Park, and the elder Hemingway was the family physician, so this is a possibility.

It is, however, one of Foy's most experimental works. Elements of street life swirl in abstracted patterns around the central image of the cart, with its bright yellow awning protecting the display of cheese beneath. Foy incorporates all the background elements, including the lettering in the shop signs, into an abstract design, while she retains her characteristic delicacy of color and texture. SW

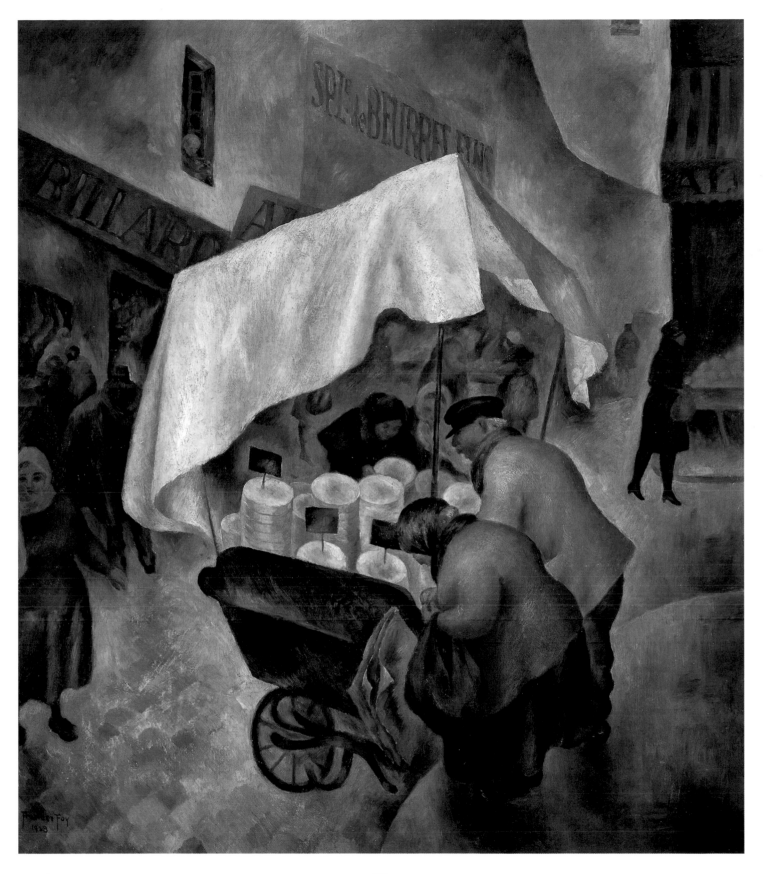

36

CHEESE SELLER

[PARIS CHEESE VENDOR, PARIS, FRANCE], 1928

Oil on masonite, 27³/₄ × 24 in.
Signed and dated, lower left: *Frances Foy 1928*

Frances Foy
(CONTINUED)

Foy and artist Frances Strain had a long and close working and personal relationship. Along with their husbands, they not only traveled together but were actively involved in a number of artists' groups, and regularly exhibited in the same shows. Foy, a talented portraitist, employed her subtle and delicate style in this image of Strain. It is noteworthy that Strain is presented more like a woman of leisure than the hardworking and independent artist and curator that she was. The image emphasizes Strain's passivity, as well as the stereotypical connection of women with nature, particularly beautiful flowers such as those on the tablecloth. This representation reflects a widespread movement to a return to traditional gender roles during the Great Depression. SW

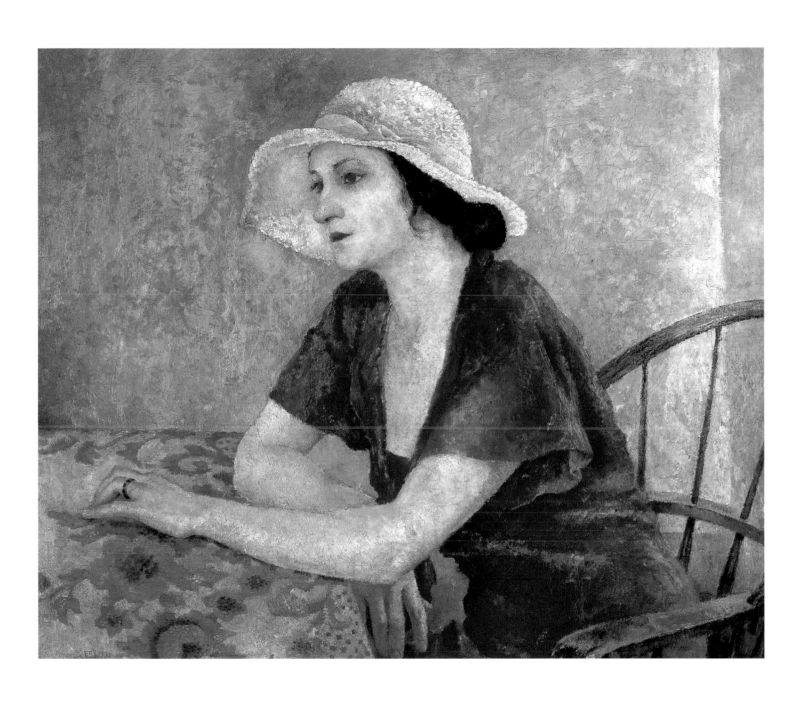

PORTRAIT OF FRANCES STRAIN, 1932

Oil on board, 26 × 30 in.
Signed and dated, lower left: *Frances Foy 1932*

Frances Foy
(CONTINUED)

NOTES

1. An interesting note to Foy from Ora Pollard Parkinson (Mrs. G. M.) praises *The Hostess* as an "exquisite painting," but is critical of Foy's inclusion of a cigarette in the subject's hand. Mrs. Parkinson states that "Your Hostess is a type of the gracious woman before cigarette days for women. She is not a 'modern' in any sense. Perhaps that's why she is so beautiful to us moderns." Frances Foy and Gustaf Dalstrom papers, Archives of American Art, Smithsonian Institution, Washington, D.C. Her critique supports Barbara Melosh's thesis in *Engendering Culture: Manhood and Womanhood in New Deal Public Art and Theater* (Washington and London: Smithsonian Institution Press, 1991), regarding the return to stereotypical gender roles in the 1930s. Although Melosh only discusses government-supported art, it is clear that the mandate for traditional roles extended beyond these projects.

This image of Helen Gertrude ("Dedie") Strain, the older half-sister of Frances, reflects the combination of two of Foy's favorite subjects, portraiture and still-life or flower painting. Dedie, a professional businesswoman who never married and served as a surrogate mother to Frances, is surrounded by a profusion of lively, curling stems and leaves. Like the portrait of Frances Strain, this work serves to emphasize her stereotypical female connection with the natural world.[1] SW

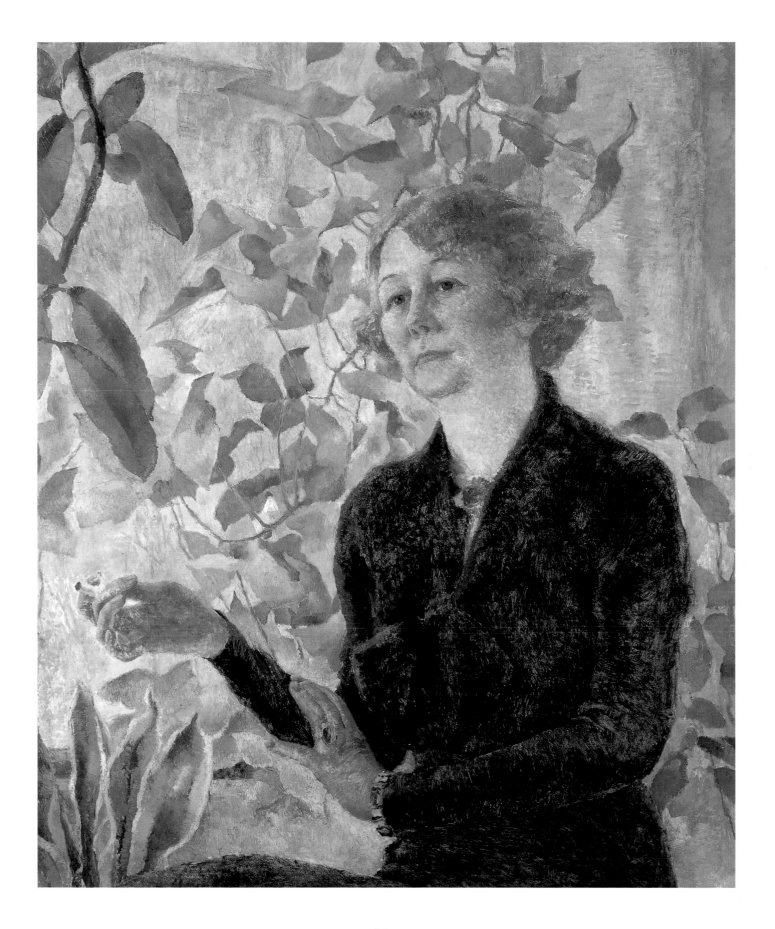

38

THE HOSTESS, 1936

Oil on board, 31³/₄ × 25³/₄ in.
Signed and dated, upper right: *Frances Foy 1936*

Frederick Frary Fursman

1874–1943

NOTES

1. Michal Ann Carley, "Frederick Frary Fursman: A Rediscovered Impressionist," (exh. cat., Milwaukee: University of Milwaukee-Wisconsin Art Museum, 1991), 8–9.

2. Sarelle R. Friedmann, "Frederick F. Fursman, Founder of Ox-Bow: His Life and Times," typescript, Ryerson Library, The Art Institute of Chicago, 1977), 3.

Frederick Frary Fursman was born outside the small town of El Paso, Illinois, into a well-to-do family. His first publicly exhibited work, a mural of a typical Illinois farmstead made entirely of grasses and grains grown in Illinois, was shown at the World's Columbian Exposition of 1893 and a number of other fairs, including one in Paris, France.[1] By the mid-1890s, he was enrolled in the Smith Academy of Art in Chicago, which employed the traditional pedagogy of the French Academy. Fursman was to continue to use this method of instruction in his many years of teaching, beginning at the Smith Academy, and culminating in his leadership of the Ox-Bow school in Saugatuck, Michigan, with which he became inextricably connected. During the first decade of the new century, Fursman studied at the School of the Art Institute of Chicago, followed by a European sojourn from 1906–9. In Europe he enrolled in the Academie Julian, traveled extensively, both in France and other European countries, and exhibited his landscape paintings at the Paris salon in 1909. Upon his return to Chicago, he began a long and influential teaching career at the School of the Art Institute and at the State Normal School in Milwaukee. More important, however, was the establishment of the Summer School of painting at Saugatuck in 1910, renamed the Ox-Bow summer school of art in 1921.[2] By 1914, the school was a permanent part of the community with Fursman as its director, a post he held until his death in 1943. The school reflected Fursman's pedagogical predilections, as well as his own preference for both figure painting and plein-air landscape. A second trip to Europe, spent painting in Brittany during 1913 and 1914, inspired a change from the Impressionist tendencies of his earlier work to an interest in the sensations produced by patterns of shape and color, a change that connects him with early Modernist movements, such as Fauvism. It also set him squarely in the camp of the Chicago Modernists who sought to achieve such effects in their work, even though his association with most of them was very slight. Fursman exhibited many times at the juried Art Institute annuals, as well as those of the Carnegie Institute (1910, 1912) and the Corcoran Gallery in Washington, D.C. (1916). He was a member of the mainstream Chicago Society of Artists, the Tavern Club, and the Cliff Dwellers.

(Continued on page 242)

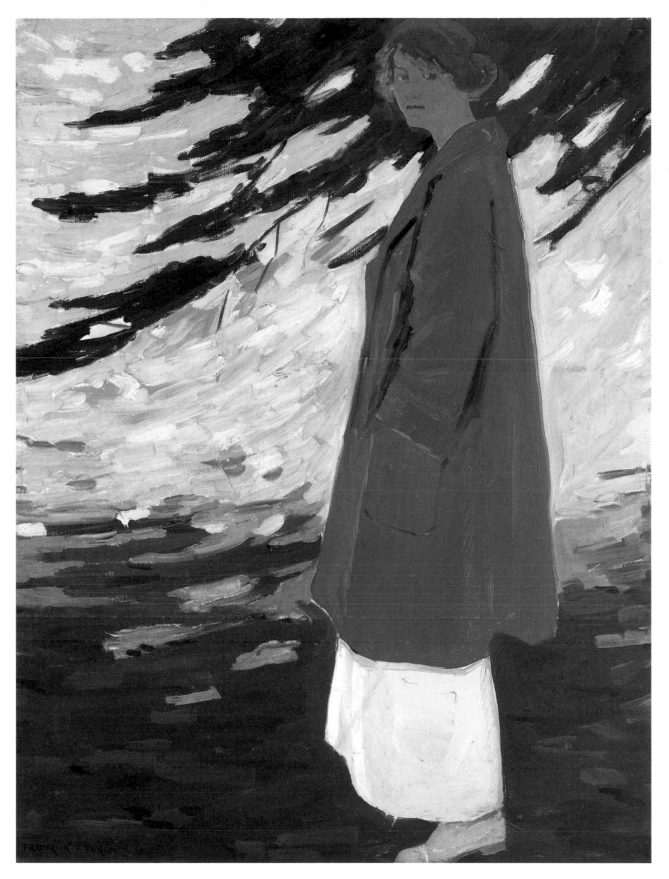

39

MAIZIE UNDER THE BOUGHS

[#16, SAUGATUCK, MICHIGAN], 1915

Oil on canvas, 40 × 30 in.
Signed and dated, lower left: *FREDERICK F. FURSMAN 1915*

**Frederick Frary
Fursman**

(CONTINUED)

The image of *Sam Gibson*, far more conventional than *Maizie under the Boughs*, is part of a series of character studies of Saugatuck residents undertaken by Fursman. The series became known as the "Saugatuck Anthology." These representations of ordinary local folk in simplified, yet believable, settings that emphasize their working-class lives is connected to his experience among the native Breton population, as well as to the increasing importance placed on such people in 1920s America. While the Breton peasants in native dress had long been less than authentic and a product of the interest of both tourists and artists, the small-town Americans that Fursman singled out for attention were authentic, albeit idealized, representatives of the heartland, increasingly hailed as exemplars of the values and morals of the "real" America. *Sam Gibson* is the prototype for the idealized Midwesterner of the Depression-era murals and easel paintings done with government support in the 1930s. His rugged features, strong and prominent hands that have clearly been used in hard work, his sturdy body clad in slightly rumpled blue work clothes, convey a straightforward, no-nonsense approach to life, characteristic of those who made this country strong. SW

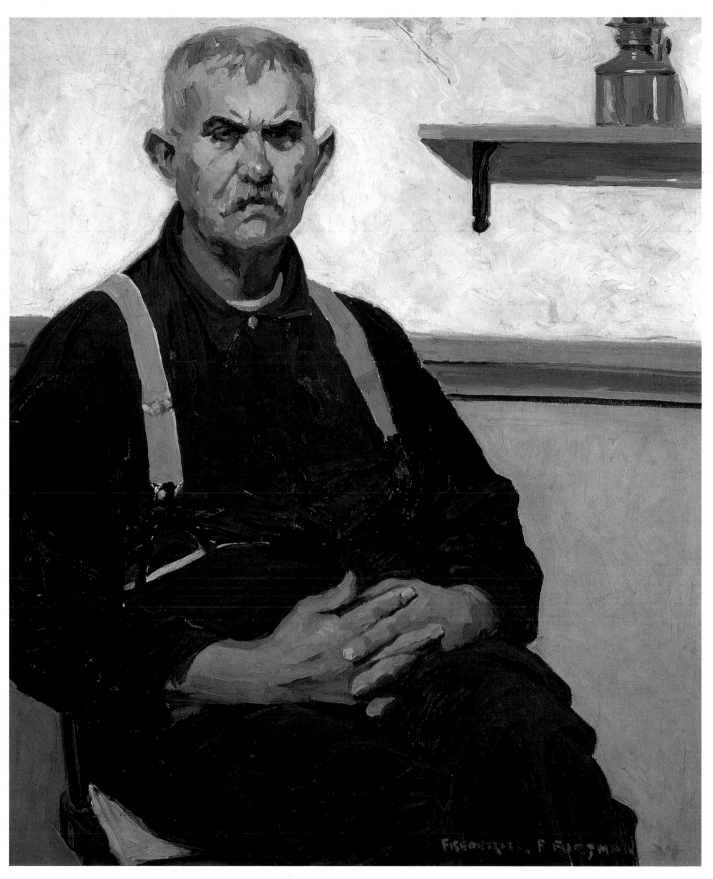

40

SAM GIBSON

[#23, SAUGATUCK, MICHIGAN], 1924

Oil on canvas, 36 × 30 in.
Signed and dated, lower right: *FREDERICK F. FURSMAN 24*

Frederick Frary Fursman

(CONTINUED)

This genre painting from the later part of Fursman's life demonstrates a confident style and technical virtuosity characteristic of many local artists, combined with a clear representational image presented in a readable fashion. The bold colors and slightly jarring juxtaposition—bright pink against red and green against orange—recall Fursman's earlier Fauvist-inspired paintings. Although the space is readable, Fursman's positioning of the cards on the table so as to make them appear to slide into the viewer's space, creates some spatial ambiguity. It is an image with a forceful quality, considering that it was produced in a period of increasing interest in figuration and clearly understandable subject matter, as well as a time of increasing conservatism in Fursman's own approach. SW

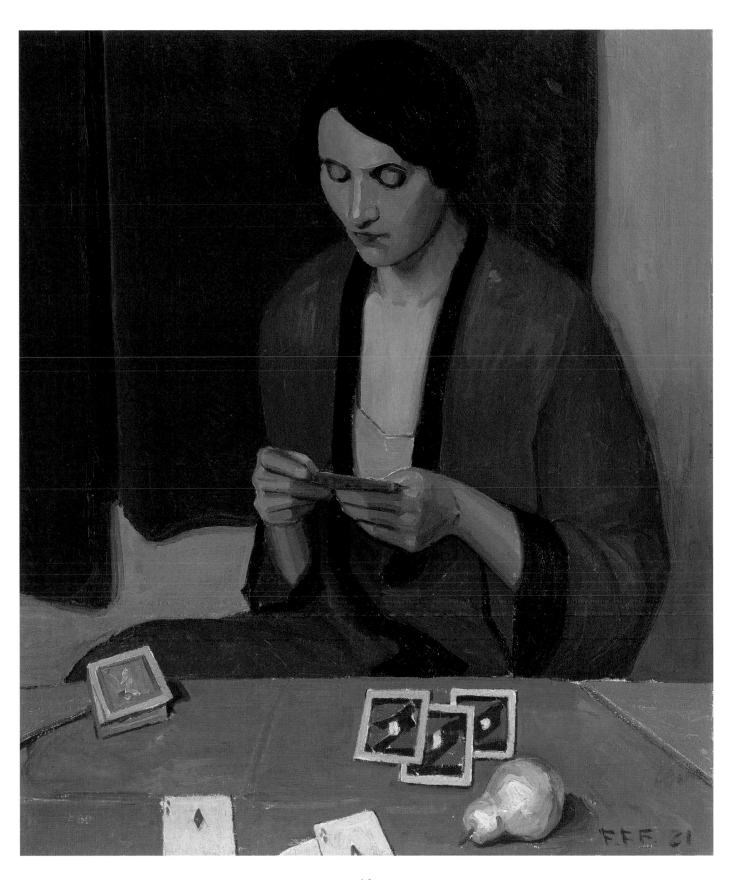

41

UNTITLED

[YOUNG WOMAN], 1931

Oil on canvas, *36 × 30* in.
Signed and dated, lower right: *FFF 31*

Frederic Milton Grant

1886–1959

NOTES

1. *Chicago Tribune*, Mar. 18, 1926, quoted in Dennis Loy, "Frederic Milton Grant (1886–1959)," *State of the Union* (published by the Union League Club of Chicago) 67 (Mar. 1991), pages unnumbered; Eleanor Jewett, *Chicago Tribune*, May 11, 1952, quoted in "Picture of the Month: 'County Fair' by Frederic M. Grant," *Union League Men and Events* 34 (Aug. 1958), pages unnumbered.

2. See Union League Club of Chicago curatorial file #UL1976.18.

3. "The Chicago Artists' Exhibition at the Art Institute," *American Magazine of Art* 18, no. 3 (Mar. 1926), 130.

4. "Annual Exhibition by Artists of Chicago and Vicinity," *Christian Science Monitor*, Feb. 12, 1926.

5. Frederic M. Grant, letter to Nita Herczel, Union League Club, dated Nov. 4, 1958 (location unknown; photocopy in Union League Club of Chicago curatorial file #UL1917.4.1).

6. The high arch on the right, however, appears to be an architectural fantasy.

Frederic M. Grant, born in Sibley, Iowa, made a career as an etcher, illustrator, painter, and muralist following study in Europe, California, and Chicago. One of Chicago's most popular painters in the 1920s, Grant was admired as a brilliant colorist.[1] He often painted street scenes and outdoor leisure scenes involving numerous figures rendered in patches of brilliant colors. He was one of many Chicago painters who in his art documented the wonders of the 1933 Century of Progress Exposition. Soon after World War II Grant relocated to California, where he painted semiabstract compositions inspired by music.[2]

The Departure of Marco Polo won the Logan Prize at the Art Institute's 1926 annual Chicago and Vicinity exhibition, a display characterized by "the impression of good craftsmanship, the ideal of clean color, of workmanlike technique, [and] of good drawing," according to one critic.[3] This "gorgeous decorative work"[4] was one of many romanticized Italian subjects painted by Grant, who had worked in Venice, as a student of William Merritt Chase. According to Grant, Chase advised his students that because so many artists had already portrayed Venice, they should chose "original and unusual motives," advice that "has always been a great help."[5] In this case Grant's response was the theme of Marco Polo's departure from Venice for the eastward expedition that brought him to China in 1271. While Polo's adventures were documented in his *Travels of Marco Polo*, Grant's immediate inspiration may have been the popular romance *Messer Marco Polo* by the Irish-American writer Donn Byrne, published in 1921.

Grant's image makes no pretense to historical accuracy; rather, it is a fantasy that provides an opportunity for a color-saturated scene of rich Renaissance pageantry framed by classical and Venetian Gothic architecture, including the famous Doge's Palace, the pink-and-white building to the left.[6] Grant was one of the few artists who responded in his art to the intense historical revivalism seen in American architecture and design of the early 1920s. WG

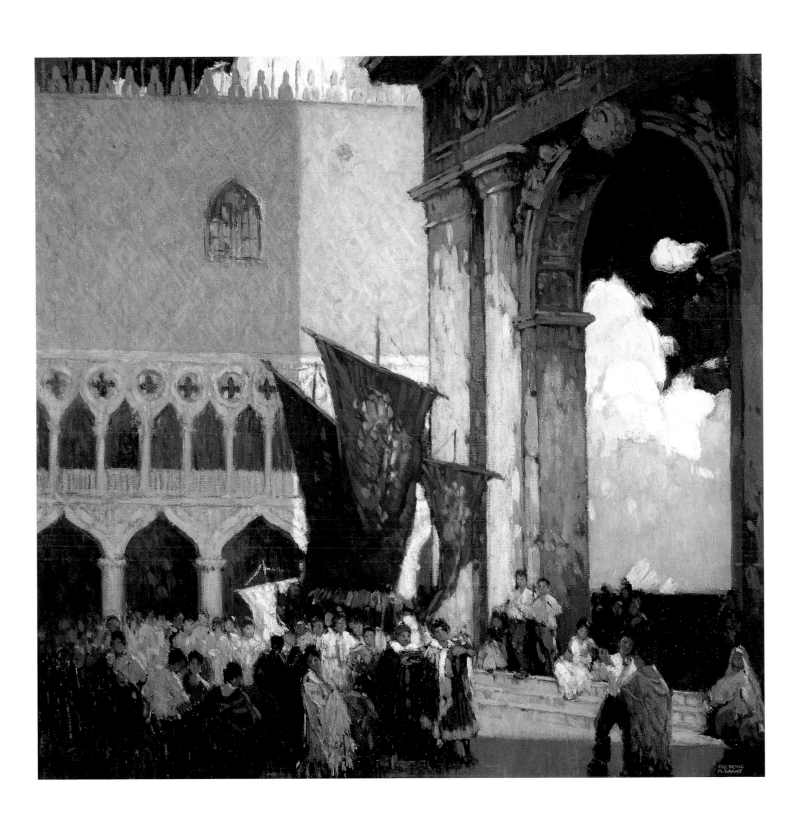

42

THE DEPARTURE OF MARCO POLO, c. 1926

Oil on canvas, 30 × 30 in.
Signed, lower right: *FREDERIC M. GRANT*

James Jeffrey Grant

1883–1960

NOTES

1. Eleanor Jewett. "Grant and Grigware Win Highest Praise." *Chicago Tribune.* Aug. 21. 1927 (AIC Scrapbook vol. 52. p. 143. microfilmed).

James Jeffrey Grant was a native of Aberdeen. Scotland. and the son of a painter. After studies in France and Germany he worked as an engraver and sign painter in Toronto and Chicago before opening a painting studio in 1920. Grant specialized in seascapes and in decorative nudes flavored with "just a trifle of the soap advertisement quality." according to critic Eleanor Jewett.[1] In the late 1920s. however. Grant's style showed new strength and solidity. while he broadened his subject matter to landscapes of small-town Illinois. the fishing villages of the New England coast. and Chicago.

In the 1930s Grant's interest in small-town settings coincided with a widespread artistic trend toward heartland subject matter and straightforwardly representational treatment. known as American Scene painting. In this Illinois scene Grant's characteristic manner of painting in flat patches of muted color meets a humble subject characteristic of Depression-era painting. The church is said to be Sts. Cyril and Methodius. in Lemont. Illinois. completed in 1929. With its original red-tiled roof (since altered). the structure imparts something of a European air to the scene. But the up-to-date local setting is evident in the utilitarian electrical poles. the unpaved road. and the trudging figures. whose formal dress suggests they are church-bound on a Sunday morning.

During the Depression many artists resorted to painting smaller canvases whose modest prices would stimulate sales. The Palette and Chisel Club. of which Grant was a member. held a series of sale exhibitions of small paintings. sketches. and studies. for which this work may have been executed. WG

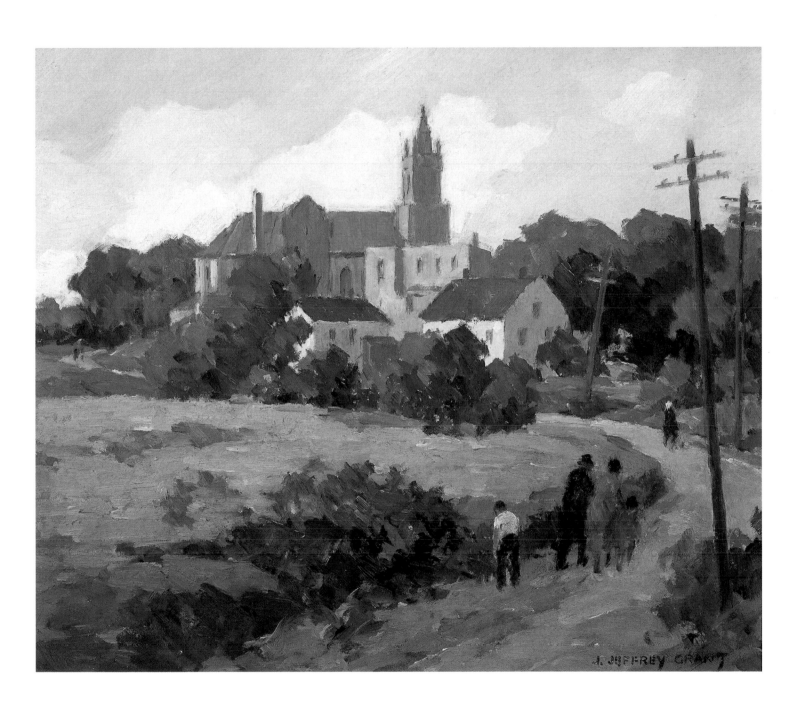

43

UNTITLED

[ILLINOIS SCENE], C. 1930

Oil on canvas mounted on board: 14 × 16 in.
Signed, lower right: *J. JEFFREY GRANT*;
inscribed on verso: *Illinois*

NOTES

1. Information from Alfred Muezenthaler, related to Powell Bridges, Sept. 11, 1990.

Like many Chicago landscapists, Grant found many painting subjects on the picturesque coast of New England. Rockport, Massachusetts, on Cape Ann north of Boston, was a sleepy fishing village to which painters had long been attracted. In the 1930s its weathered old houses and old-fashioned way of life were still preserved, offering painters such as Grant an effective vehicle for contemporary nostalgia for America's vanishing small-town life.

A Summer Day, Rockport, Massachusetts takes a backside view of the town from a rocky hill overlooking a cluster of modest dwellings described in rough brushstrokes that suggest the worn clapboard surfaces of their walls. At the center of the image, a line of laundry undulating in the breeze injects a bright note and a sense of movement into the scene. The town's more public life, embodied in the church steeple rising beyond the houses, is at a remove. In the foreground a faceless woman and child, almost submerged into the landscape, seem to approach the figure of a man leaning on a cane and accompanied by a dog. That figure may be the artist himself, for Grant often inserted himself into his works.[1] This quiet scene explores the modest setting of everyday life in a small town, glimpsed off the beaten tourist track. WG

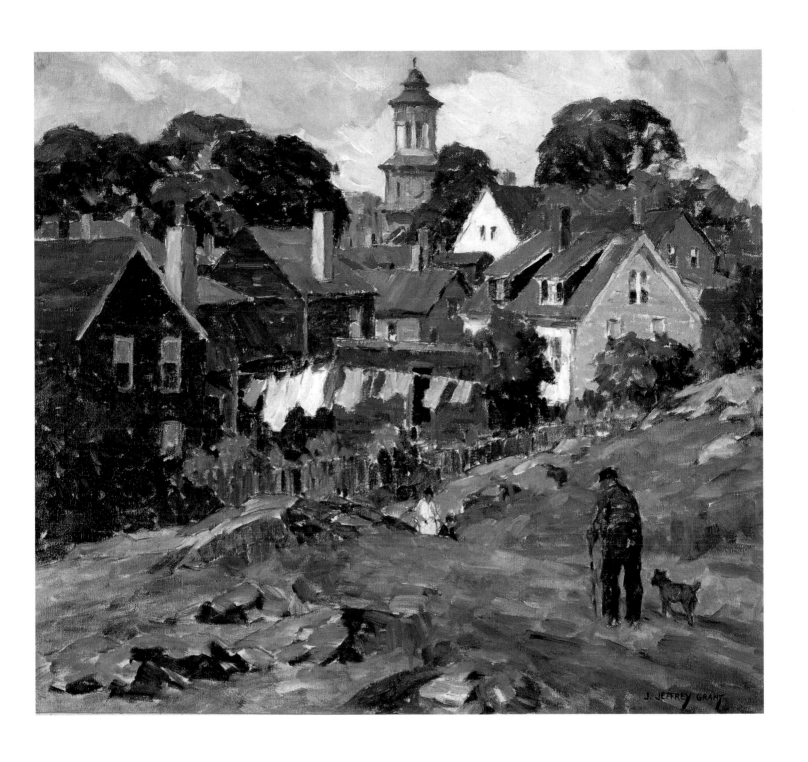

44

A SUMMER DAY, ROCKPORT, MASSACHUSETTS, c. 1932

Oil on canvas, 22 × 24 in.
Signed, lower right: *J. JEFFREY GRANT*

Oliver Dennett Grover

1861–1927

NOTES

1. "Face to Face With the Art Apaches in the Primitive Wastes of Chicago's Bohemia," *The Chicago Literary Times* 1, no. 4 (Oct. 23, 1923), quoted in Kenneth Robert Hey, "Five Artists and the Chicago Modernist Movement, 1909–1928" (Ph.D. dissertation, Emory University, 1973), 226; C. J. Bulliet, "Artists of Chicago Past and Present. No. 96: Oliver Dennett Grover," *Chicago Daily News*, July 22, 1939.

Intended by his father for a law career, Oliver Dennett Grover attended the old University of Chicago while studying art at the Chicago Academy of Design at night and during vacations. A legacy then enabled him to devote himself to art, and in 1879 he departed for Europe, where he studied in Munich, Italy (where he worked with Frank Duveneck), and Paris. Grover joined the faculty of the Art Institute's school on his return in 1884, was a principal in a set-design firm, and created murals for the World's Columbian Exposition. He was also adept at portrait, figure, and landscape painting and was a conspicuous member of the establishment art organizations of his day. In the view of Chicago's art radicals Grover, along with portraitist Ralph Clarkson and sculptor Lorado Taft, comprised a "Holy Trinity of our local art" that "dominated almost dictatorially" in the first quarter of the twentieth century.[1]

Both of Grover's paintings in the Bridges Collection contrast with the academic style of the artist's mural and figural work and the rich color schemes and the dramatic compositions, with high horizons, that characterize his large, more formal landscape views of Italy and the American West. These landscapes are marked by an informal intimacy appropriate to their local subjects. Though executed more than two decades apart, both may portray the rural landscape around the Rock River, not far from Grover's native town of Earlville, Illinois. In 1898 Grover was a founding member of the exclusive artists' colony known as Eagle's Nest, overlooking the river at nearby Oregon, and he had painted in the area in prior years.

Grover's 1894 landscape reveals a quiet naturalism achieved through tonal contrasts and loose brushwork, suggesting the influence of Duveneck and the Munich school. This carefully composed view of shore and water juxtaposes the detail of near ground with hazy distance, corresponding with contrasting massing of light and dark. The rich greens of the foliage at left are enlivened with flashing touches of white highlights that evoke the steady heat of a summer afternoon, while the far shore is hazily muted. The scene has the casual air of an abandoned spot, with the remnants of a tumbledown fence sprawling among the lily pads in the left foreground.

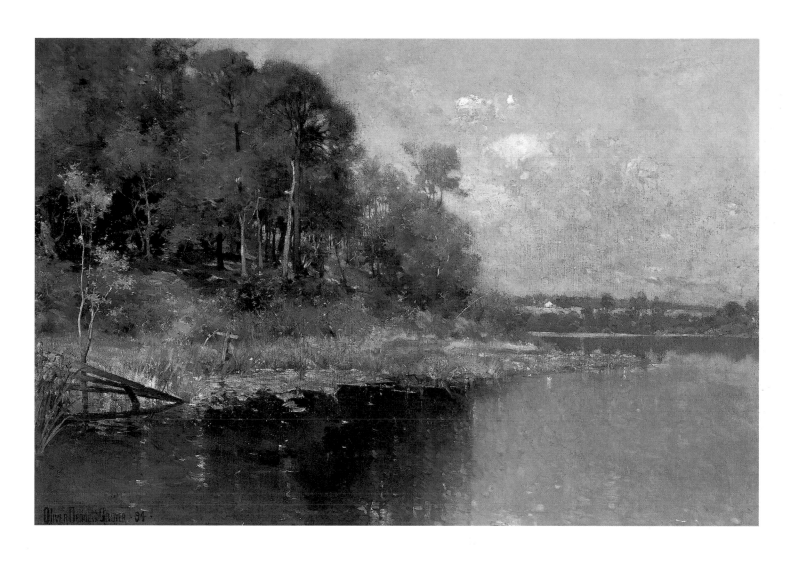

45

UNTITLED

[LANDSCAPE WITH WOODS, FENCE, AND WATER], 1894

Oil on canvas, 26 3/4 × 29 in.
Signed, lower left: *Oliver Dennett Grover '94*

NOTES

2. Bulliet, "Artists of Chicago."

By the time of the 1915 painting Grover may have begun to respond to the current practice of executing landscape paintings out-of-doors. Here the artist dispenses with the careful framing of the scene that leads the eye gently from near to far ground in the earlier composition. The relatively fresher colors and rapid brush-work of the 1915 image evince the on-the-spot transcription, a work executed as a fond memento of a treasured landscape.

In 1928, one year after Grover's death, the Art Institute held a memorial exhibition of his work. Included were "Chicago and Illinois scenes," among them possibly one or both of the paintings in the Bridges Collection, but the exact contents of the show are unrecorded.[2] WG

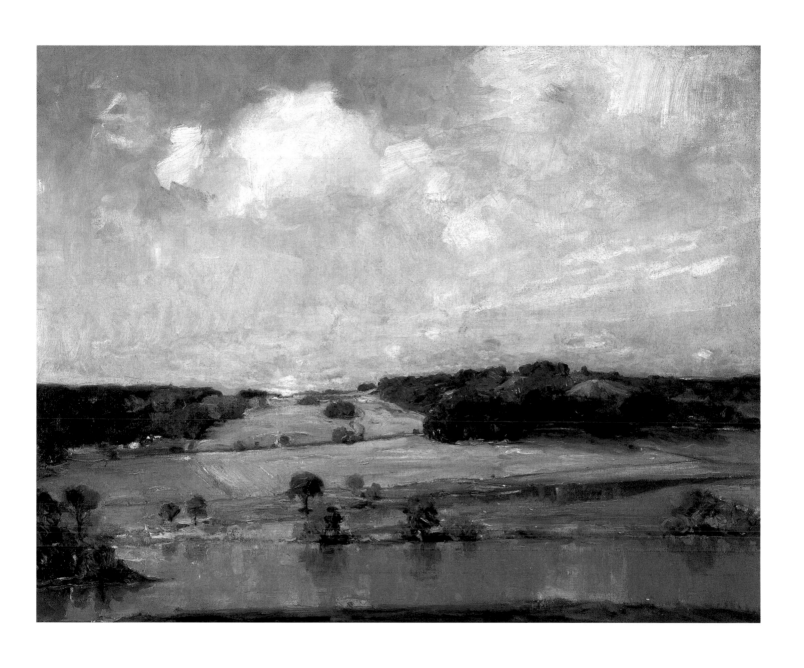

46

UNTITLED

[LANDSCAPE WITH RIVER], 1915

Oil on canvas, 24 × 30 inches
Signed, lower center: *Oliver Dennett Grover 1915*

V. M. S. Hannell

1896–1964

NOTES

1. For biographical information see Susan S. Weininger, *Hazel and Vin Hannell: Two Lives in Art* (Valparaiso, Indiana: Valparaiso University Museum of Art, 1994).

Born in Michigan, Vaino (Vin) Mathies Seth Hannell was on a family visit to Finland when he was about a year old and, because he fell ill, was left there in the care of extended family and did not return to the United States until he was in his teens. He studied at the School of the Art Institute, where he met his future wife, the artist Hazel Hannell. They settled on the South Side of Chicago and developed close friendships with two other artist couples, Frances Strain and Fred Biesel and Frances Foy and Gustaf Dalstrom, with whom they traveled to Europe in 1928. Unable to afford two homes after the Depression began, they decided to move their household to Furnessville, Indiana, where they had purchased property for a summer retreat some years earlier. Although Vin remained active in the art community in Chicago, exhibiting at the juried Art Institute annuals, with the Chicago Society of Artists, the Chicago No-Jury Society of Artists, and the Ten (Chicago), the Hannells remained in Indiana, at the center of an active group of artists and patrons, for the rest of Vin's life. Like the Biesels and the Dalstroms, Vin also exhibited with the Society of Independent Artists in the 1920s. In Furnessville, Vin pursued painting and sculpture while Hazel spent much of her time producing the earthenware vessels that were the source of their support.[1]

While Hannell's work ranged from representational images depicting the American Scene to his later purely abstract sculptures, *Lights* is a work in which Modernist experimentation and social concern are combined in ways that are similar to the work of his fellow Chicagoan Carl Hoeckner, who shared Hannell's interests. Like his later painting *Steelmaking*, Hannell uses Modernist form to focus on the dehumanizing work of factory labor in this image. His bold colors and fragmented surfaces also suggest the Italian futurists and French Cubists such as Robert Delaunay. Hannell's 1928 trip to Europe offered him the opportunity to experience these works firsthand. SW

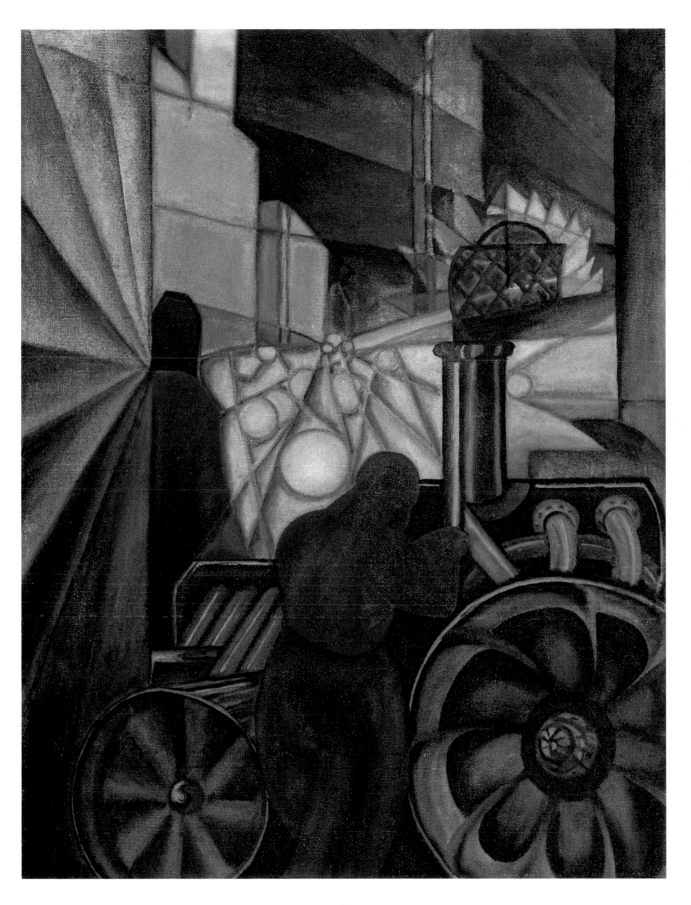

47

LIGHTS, 1927-28

Oil on canvas, 24 × 18 in.
unsigned (authenticated by Hazel Hannell)

Lucie Hartrath

1868–1962

NOTES

1. Hartrath's peripatetic early years are traced in detail by Bulliet.

2. Minnie Bacon Stevenson, "A Painter of the Indian Hill Country," *American Magazine of Art* 12 (Aug. 1921), 278–79.

3. "By the Editor," "Chicago Artists' Twenty-first Annual Exhibition," *Fine Arts Journal* 35 (Apr. 1917), 278.

4. Stuart, "Exhibitions at the Chicago Galleries," *Fine Arts Journal* 35 (May 1917), 374.

5. Unidentified printed biography tipped into *Illinois Artists* (Art Institute of Chicago Questionnaires [1918] and Illinois Academy of Fine Arts biographical data sheets [1929]) 2 (G–K), Hartrath entry, on deposit in the Ryerson Library, AIC. See also Stevenson (1921), 278.

6. The painter listed *The Creek* among her "important paintings" on the biographical questionnaire completed for the Illinois Academy of Fine Arts in 1929 (compiled in *Illinois Artists*, on deposit in the Ryerson Library, AIC).

Born in Boston, Lucie Hartrath grew up in Cleveland and studied at the Art Institute and in Paris. She taught at Rockford College from 1902 to 1904. Between 1905 and 1910 Hartrath seems to have divided her time between Chicago and Europe, especially Munich, where she had begun to specialize in landscape painting.[1] She was among the first of many Chicago painters who worked in Brown County, Indiana, beginning in 1908. In Brown County, the locale with which she is most associated and the source for many of her subjects, Hartrath found similar atmospheric conditions to those of northern France, and Brown County, therefore, an appropriate setting for her Impressionist aesthetic.[2]

In 1917, probably the year Hartrath executed *The Creek*, critics noted that her Impressionism had recently "mellowed" toward a softer, more decorative tonal approach that placed new stress on delicately tinted atmosphere suffusing a scene;[3] she painted "picture[s] full of splendid sunlight" rather than those of a particular color scheme.[4] *The Creek*'s modest, rural subject is scaled to its preoccupation with the interplay of glaring sunlight and bright shadow and their varied effects on trickling water and overhanging foliage. The scene, framed in a square composition that balances horizontal and vertical, recedes deeply into space as the eye follows the meandering creek away into the distance. There, at the exact center of the image, is the unobtrusive figure of a woman carrying a basket on her arm, the kind of "human touch" that lent the "intimate quality" for which Hartrath's landscapes were known.[5] In a 1929 statement, the artist recorded that *The Creek* was one of her most important works to date.[6] WG

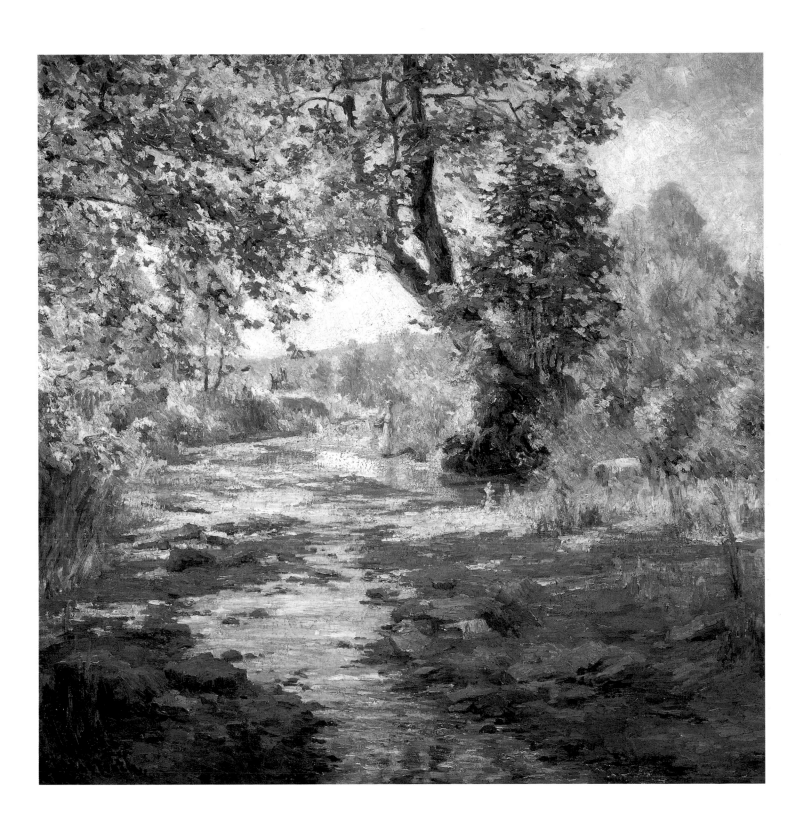

48

THE CREEK, c. 1917

Oil on canvas, 36 × 36 in.
Signed, lower left: *L Hartrath*

Carl Hoeckner

1883–1972

NOTES

1. He told the critic C. J. Bulliet that "My art aims, up to the outbreak of the world war, were the search for and the expression of beauty. During the war I became interested in truth—in bitter truth and the struggle of life in general." C. J. Bulliett, "Carl Hoeckner," Artists of Chicago: Past and Present, no. 86, *Chicago Daily News* 10 June 1937.

2. For information on Hoeckner, see the typescript catalog produced by Atelier Dore Incorporated, San Francisco, for the exhibition *Not a Pretty Picture: Carl Hoeckner, Social Realist, A Retrospective Exhibition* (San Francisco, 1984).

Born in Munich and educated in various cities in Germany, first by his printmaker father and subsequently in a number of art schools in European cities, Carl Hoeckner immigrated to the United States in 1910. He earned his living as a commercial artist while making highly decorative paintings, such as his *Salome*. When he arrived in Chicago, he joined the Palette and Chisel Club, a relatively conservative group. Radicalized by the events of World War I, to which he was particularly sensitive given his German heritage, Hoeckner began to engage social and political issues in his work.[1] He exhibited paintings and prints widely in Chicago, in both juried Art Institute exhibitions and with independent groups such as the Cor Ardens (Ardent Hearts), of which he was a founding member, and the Chicago No-Jury Society of Artists. His work was also exhibited nationally at the Pennsylvania Academy of the Fine Arts, and in New York with the Society of Independent Artists, beginning in 1918. His familiarity with the ideas of Kandinsky, to which he was exposed even before he left Europe, resonated with the attitudes of the Chicago Modernists, such as Rudolph Weisenborn and Ramon Shiva, with whom he became friends. Beginning in the late 1920s, he taught industrial design at the School of the Art Institute of Chicago and in the 1930s was active as an administrator and artist in the graphics division of the Illinois Art Project.[2]

Hoeckner often used religious themes as a metaphor for his dark social commentary. Convinced that art should generate social change, he devoted himself to looking at the social and political evils that he saw in the world. The rise of fascism in the 1930s in his native Germany, as well as the Great Depression in the United States, gave him an enormous reservoir of material. His image of a world transformed by the light of the cross in *Sermon on the Mount* shows the possibility of redemption, even in the darkest of times. In this work, Hoeckner combines the linear qualities characteristic of printmaking with the subtle but simple color scheme of golds and browns that are typical of his painted work to create a powerful work of both social realism and artistic quality. SW

49

SERMON ON THE MOUNT, 1933

Oil on canvas, 45 × 74 in.
Signed, lower left: *Carl Hoeckner*

Rudolph Ingerle

1879–1950

NOTES

1. C. J. Bulliet. "Art in Chicago [review of Ingerle's memorial exhibition, Chicago Galleries Association]." *Art Digest* 25 (Feb. 15, 1951), 15.

2. Ibid.

3. R. F. Ingerle, "A Painter's Paradise and Its Lure." *The Palette & Chisel* 8 (May 1931), 1–2.

4. Bulliet (1951), 15.

5. Ingerle (1931), 2.

6. Tuckasegee (also Tuckaseegee or Tuckaseigee) originates in the Cherokee word *tsiksitsi*, which may mean "crawling terrapin" to indicate the slow flow of its waters (Kelsie B. Harder, *Illustrated Dictionary of Place Names, United States and Canada* [New York: Van Nostrand Reinhold, 1976], 559).

7. *Along the Tuckaseegee, Smokie Mountains North Carolina* was exhibited in AIC's Chicago and Vicinity show of 1927. The following year Ingerle's *Swappin' Grounds*, a scene on the river's bank, won the William Randolph Hearst Prize and was acquired by the Art Institute ("Paintings Are Shown at Inn." *Asheville Citizen*, May 25, 1937, in Ingerle Scrapbook compiled by Jay N. Ingerle, copy in collection of Powell Bridges).

Born in Vienna of Moravian and Bohemian parentage and "with love of the mountains ingrained in him."[1] Rudolph Ingerle moved to Wisconsin and then to Chicago as a boy, around 1891. He attended the Art Institute's night classes and studied at Smith's Art Academy and also with Walter Dean Goldbeck, an early experimenter in abstraction. Ingerle, however, was a lifelong champion of artistic conservatism. One of Chicago's most successful landscape artists, he pioneered the portrayal of nature in Brown County, Indiana, the Ozark Mountains of Missouri, and the Great Smoky Mountains in western North Carolina. Critic Clarence Bulliet dubbed Ingerle a "poet of paint, living in a bluish twilight," for his preference for twilight, moonlight, and early dawn settings.[2]

Having abandoned increasingly popular Brown County for the Ozarks in 1912, Ingerle discovered the Smokies a decade later; he returned there every fall to paint until about 1940, gradually expanding his subject matter to include character studies of local "types." As he had for the Ozarks, he encouraged fellow Chicago artists to exploit the region's large variety of flora, its picturesque mountain "folk," and the "enduring charm" of the landscape.[3] A staunch conservative, Ingerle saw in the Smoky Mountains a redeemingly national subject for the American painter, and a healthy antidote to the corrupting influence of European-derived Modernism. He was active in the effort to make the Smokies a national park.[4]

Ingerle praised the Smoky Mountain region for its "crystal clear streams tumbling, roaring along" (the lack of standing water also prevented mosquitoes, he claimed).[5] The Tuckasegee, actually rather a sluggish river, flows northwest to join the Little Tennessee River on the southern border of what is now the Great Smoky Mountains National Park.[6] Between about 1925 and 1930 Ingerle painted at least five works with titles indicating that the Tuckasegee is pictured.[7]

In *Morn on the Tuckasegee*, the composition's high horizon and lofty vantage point dramatize the wild beauty of the setting. Ingerle's images of the Smokies are imaginative impressions created in the studio rather than recognizable transcriptions of specific locales. Ingerle was well known for his "poetic" treatment of trees, which generally dominate the middle ground of his compositions. This work, however, focuses rather on the brilliant blue river, seen from above through a thin tracery of

(Continued on page 242)

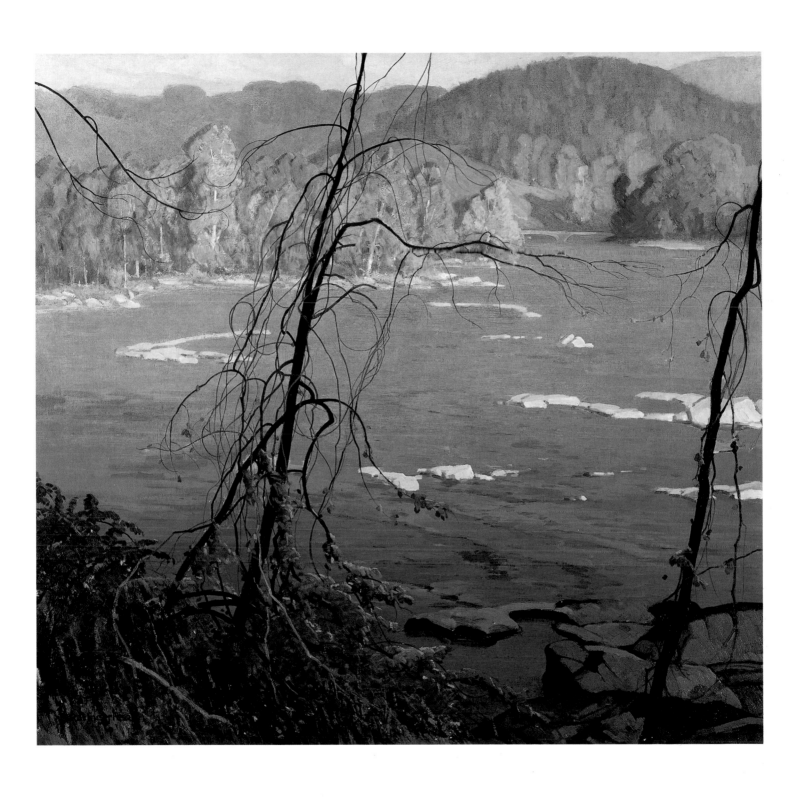

MORN ON THE TUCKASEGEE, 1928

Oil on canvas, 28⅛ × 40¼ in.
Signed and dated, lower left: *R F Ingerle 28*

Alfred Jansson

1863–1931

NOTES

1. Evelyn Marie Stuart. "Chicago Artists' Twenty-Second Annual Exhibition." *Fine Arts Journal* 36 (Mar. 1918), 7.

2. William H. Gerdts, *American Impressionism* (New York: 1984), 142, 249.

Alfred Jansson studied art in his native Sweden and in Paris. He arrived in Chicago in 1889 with a commission to execute murals for the Swedish Building at the World's Columbian Exposition of 1893 and remained in Chicago throughout his career. He was active in the art exhibitions sponsored by the Swedish Club of Chicago that began in 1911, but he exhibited little after the early 1920s.

Jansson devoted his career to landscape painting. He was especially known for unpeopled, snowy winter settings and glowing skies of sunset and twilight. One critic dubbed him "the most cheerful of snow painters, his winters never seeming gloomy."[1] His titles rarely indicate specific locations, but he worked in the Chicago area and in Sweden, to which he returned for several painting trips.

In this relatively late work, Jansson abandons the decorative Impressionism and mystical view of nature that characterized his earlier work. Here the frigid atmosphere of a winter day is conveyed in the almost stark composition of three broad horizontal bands of snow-covered foreground, an expanse of forest marked by blue shadows stretching to the distant horizon, and a glowing sunset sky that graduates from pinkish-gold to pale blue. Relief is provided by the strong vertical of the pair of trees at the left, which unites the three horizontal sections. Jansson's interest in the cool tones of snow glowing in evening and morning light may have been influenced by the paintings by Scandinavian Impressionists exhibited at the World's Columbian Exposition.[2] WG

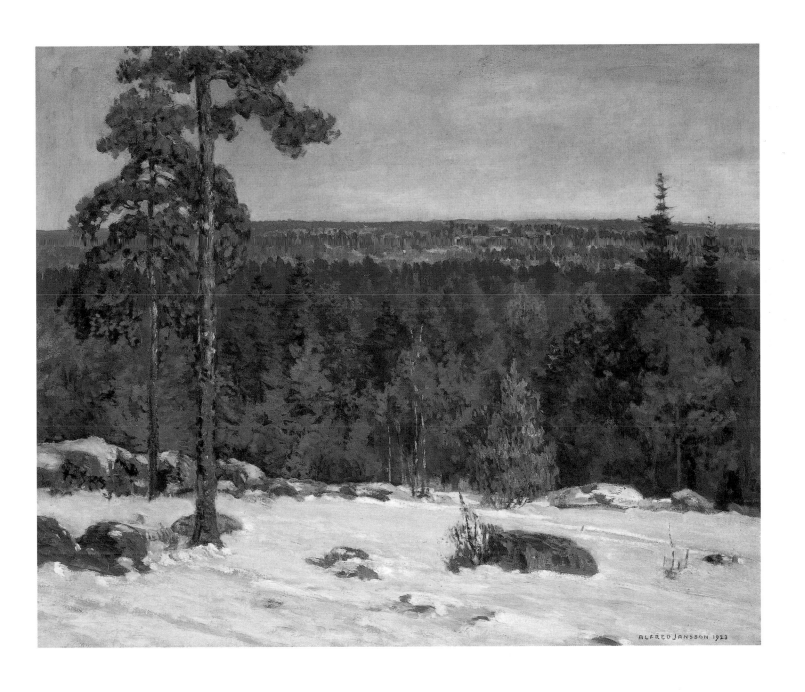

51

UNTITLED

[LANDSCAPE WITH SNOW], 1923

Oil on canvas, 32¹/₂ × 38¹/₂ in.
Signed and dated, lower right: *ALFRED JANSSON 1923*

Alfred Juergens

1866–1934

NOTES

1. Oney Fred Sweet, "Beauty of Oak Park Immortalized on Canvas," *Chicago Sunday Tribune*, Oct. 19, 1930, Metropolitan Section, p. 1. Although Juergens described himself as unmarried in this interview, he apparently did marry at a later date, for a woman described as his "octogenarian widow" moved the painter's works after his death in 1934 from his Oak Park studio to a Grand Rapids, Michigan, farmhouse, where they were discovered after her death in 1949 (*New York Times*, July 14, 1949; *Detroit News*, July 12, 1949).

2. *The Art League Book* (Oak Park, Ill.: The Art League, 1941), unpaged. Records of the early exhibitions of the Art League are extremely sketchy.

ike *A September Garden* (cat. 56), Juergen's *The Back Porch* probably portrays the artist's own backyard in Oak Park, Illinois. The view, looking west toward the back of a neighboring house, is unobstructed by the coach houses and garages that were being erected throughout the village at about the time Juergens executed his painting. The identity of the seated woman is un-known, but she may be Juergens's sister, Helen, who kept house for him after the death of their mother.[1]

In *The Back Porch* Juergens explores the popular subject of the woman in or framed against a garden setting—a theme treated, for instance, by Anna Lee Stacey in another painting in the Bridges Collection (see cat. 72). Here the mood is prosaically domestic: the woman appears to be peeling potatoes and behind her stretches a fenced-in yard that clearly signals a suburban setting. Softly shadowed on the porch, the figure, the still life of containers and a broom on the right, and the porch structure itself frame the sun-drenched yard beyond. Juergens's muted pastel colors and soft forms enfold near and far objects alike in a veil of domestic tranquility.

Like many members of the art community that flourished on either side of Chicago's western border in the 1920s, Juergens belonged to the Austin, Oak Park and River Forest Art League (now the Oak Park Art League), founded in 1921, where this painting may have been exhibited.[2] The artist probably donated *The Back Porch* to the Art League, which maintained a collection for exhibition and for circulation to local public schools. WG

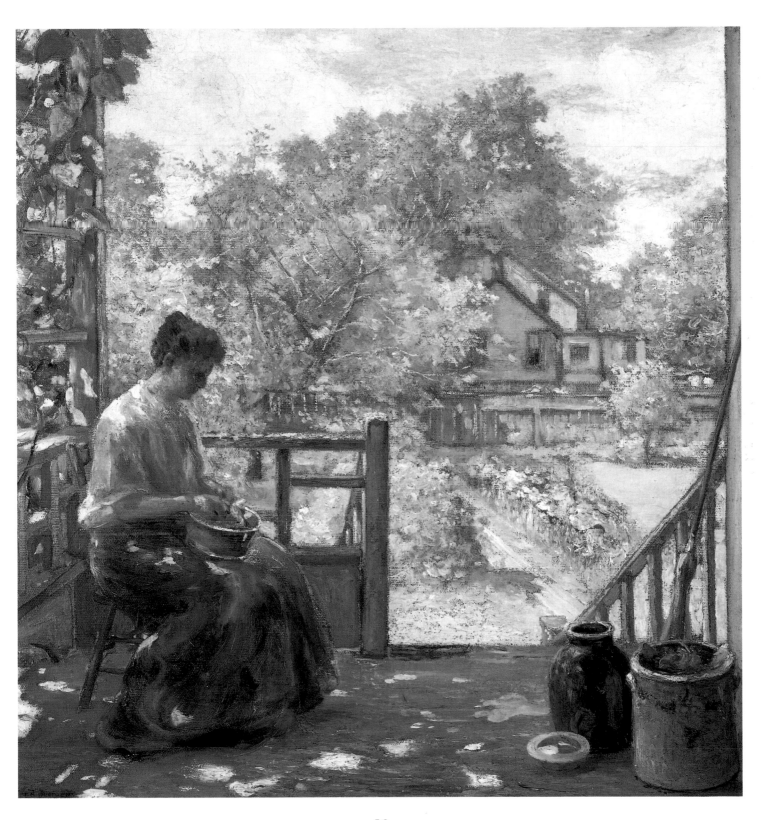

52

THE BACK PORCH, 1911

Oil on canvas, 27¼ × 25¼ in.
Signed, lower left: *Alfred Juergens*

Alfred Juergens

(CONTINUED)

NOTES

1. Peter Bruik, "Public May View Remarkable Display of Rare and Exquisite Canvases," *The Oak Parker*, May 27, 1932, 31.

2. Frank A. Randall, *History of the Development of Building Construction in Chicago* (Urbana: The University of Illinois Press, 1949), 64.

3. In 1928 two additional stories were added to the Northern Trust Company building, making it somewhat taller today than it appears in Juergens's painting.

4. *Northern Trust Company* (oil on panel, 13 (16 inches, owned by Mrs. M. B. King, Kalamazoo, Michigan) is listed in *Centennial Exhibition of the Works of Alfred Juergens 1866–1934* (exh. cat., The Art Center, Kalamazoo Institute of Arts, Kalamazoo, Mich., 1966), #23.

Alfred Juergens's father was in the paint business, which, the artist noted, "furnished me with the proper environment and helped to encourage my desire to be an artist."[1] A student first at the Chicago Academy of Design, Juergens was among the first generation of American painters to study in Munich, where his works met with considerable success. From his Oak Park home and studio Juergens made numerous trips to England, Holland, Austria, and France, where he absorbed the Impressionist technique and palette that led him to specialize in landscapes with floral themes. He also executed murals.

Juergens's view of a busy streetscape on a rainy evening is taken from the Tacoma Building (built in 1889 and demolished in 1929), looking southwest across the intersection of LaSalle and Madison Streets in Chicago's Loop. Immediately across Madison, on the left edge of the picture, looms the corner of the office building known as the Major Block, reconstructed after the Chicago Fire of 1871 and demolished to make way for the Roanoke Building in 1915, the year Juergens painted this work.[2] Across LaSalle Street can be seen the thirteen-story Women's Temple, completed in 1892, and, on the far right, the Otis Building, from 1912. The Northern Trust Company building, dating to 1905, dominates the center of the painting, which may have been commissioned by the bank, its first recorded owner.[3] Juergens also executed at an unknown date another smaller painting of the building.[4]

Juergens's Impressionist treatment of this everyday scene, in which soft pinks and smoky lavenders counterpoint the golden glow of lighted windows, distills an unexpected charm from his subject. The composition's high vantage point holds the notorious street-level chaos and congestion of Chicago's business district at a refining distance, further enhanced by the romantic effect of reflections in the shiny wet pavement, a favorite motif of Impressionist interpreters of the urban scene. Juergens's determination to interpret the city through the soft-focus lens of gentility seems consistent with his main occupation as a painter of garden landscapes. WG

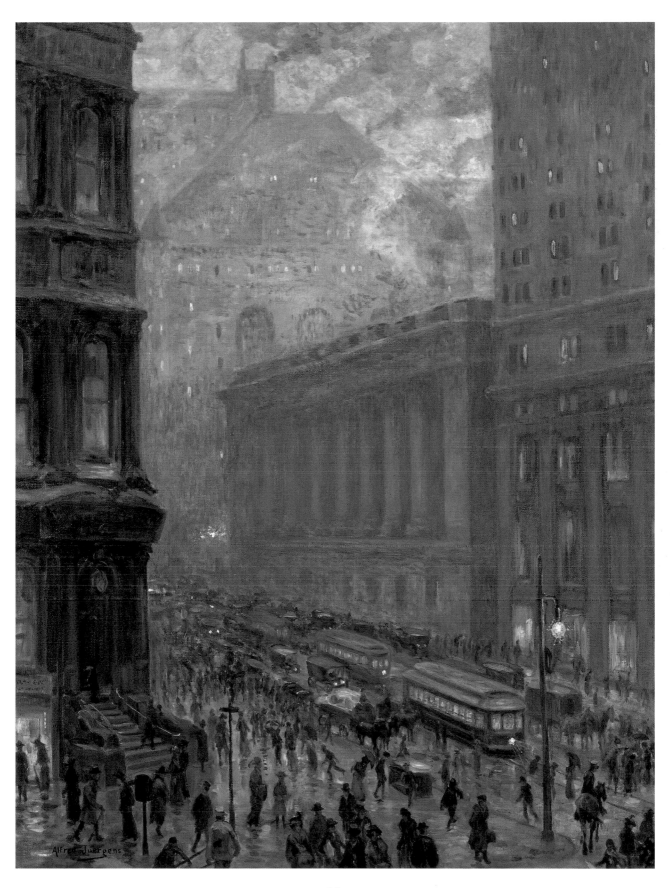

53

LASALLE STREET AT CLOSE OF DAY, 1915

Oil on canvas, 40 × 30 in.
Signed, lower left: *Alfred Juergens*

Alfred Juergens

(CONTINUED)

NOTES

1. Harold M. Mayer and Richard
 C. Wade, *Chicago: Growth
 of a Metropolis* (Chicago:
 The University of Chicago
 Press, 1969), 284.

2. Mayer and Wade, 284.

Although the Great War had been a popular cause in Chicago, the armistice was greeted with wild enthusiasm. Within hours of the announcement of peace on November 11, 1918, thousands of Chicagoans gathered to celebrate at what was known as "the world's busiest corner," at State and Madison.[1]

Juergens's view looks south on State Street from the elevated train station that bridges the busy thoroughfare at Lake Street—surely an excellent post from which to take in the celebrations. On the left is the dark red facade of the Masonic Temple (demolished in 1939) and beyond that the Marshall Field & Company store, with its signature clock projecting from the building's corner. Contemporary photographs of the site on Armistice Day indicate that the streets were jam-packed with crowds, particularly the intersection of State and Madison, visible in the distance.[2] But Juergens portrays a leisurely scene in which decorous onlookers yield the street to an impromptu parade and vehicles. WG

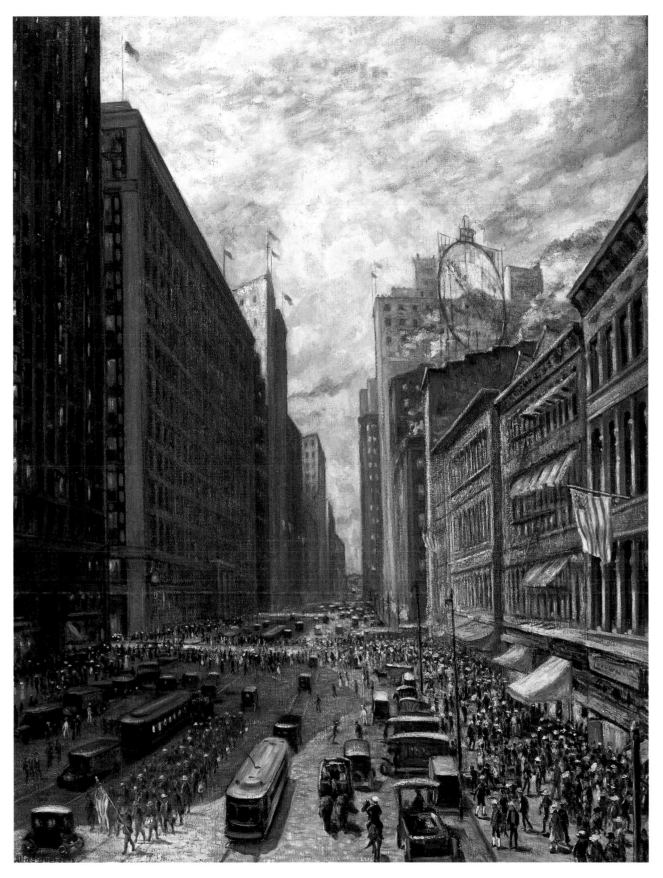

54

STATE STREET, ARMISTICE DAY, 1918

Oil on canvas, 40 × 30 in.
Signed, lower left: *Alfred Juergens*

Alfred Juergens

(CONTINUED)

NOTES

1. Frank A. Randall, *History of the Development of Building Construction in Chicago* (Urbana: The University of Illinois Press, 1949), 54. The architect, John Van Osdel, who had designed the two earlier structures of the Palmer House, was one of Chicago's most prolific architects of the nineteenth century. The third Palmer House was demolished in 1925 to make way for the present Palmer House, designed by Holabird & Roche.

2. Unlike Louis Sullivan's groundbreaking design on the rest of the building (to the north on State Street), with its extravagant cast iron ornament on the first two floors, this section shows a simpler design by Burnham & Company.

The Palmer House, Chicago's premier hotel from the mid-1850s to the 1920s, dominates Juergens's view of the intersection of State and Madison Streets in Chicago. The Palmer House that stood in 1920 was the third such building on the site. Constructed immediately after the Great Chicago Fire of 1871, its seven stories combined Second Empire and classical styles, extravagant luxury, and the latest fireproofing technology.[1]

Towering over the now-venerable Palmer House in the right distance is the nineteen-story Republic Building that Holabird & Roche, architects, completed in 1909. On the left side of the image is the southern section of the Carson Pirie Scott & Company store, built in 1906.[2] Across the street, on the right edge of the composition, appears to be the facade of the Boston Store, a department store on the northwest corner of State and Madison, whose awninged display windows attract the attention of several figures in the foreground.

Juergens presents State Street, at the heart of the city, in its busy heyday and from the pedestrian's point of view: buildings soar in the background while a dense crowd fills the scene at eye level. Juergens suggests the diversity of social types that mingled in Chicago's crowded Loop. In the right foreground, the walking stick of a nattily dressed man gazing into the store window is juxtaposed with the handle of the broom pushed by a street sweeper. Somewhat isolated from the fashionable shoppers surrounding her is a woman carrying a child; her head scarf and apron indicate that she is an immigrant. The loose brushwork of Juergens's Impressionist technique suggests the constant flux of the crowd and the hazy sunlight that bathes this upbeat scene. WG

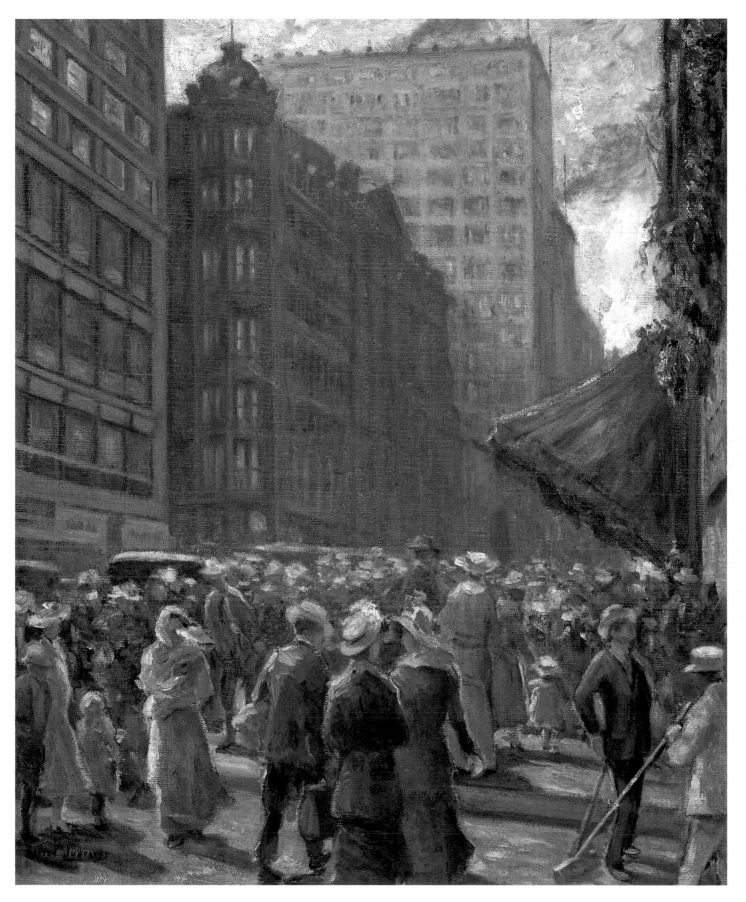

55

STATE STREET, c. 1920

Oil on canvas, 22 × 18 in.
Signed, lower left: *Alfred Juergens*

Alfred Juergens

(CONTINUED)

NOTES

1. Oney Fred Sweet, "Beauty of Oak Park Immortalized on Canvas," *Chicago Sunday Tribune*, Oct. 19, 1930, Metropolitan Section, p. 1.

2. Untitled notice of Juergens's memorial exhibition, *Chicago Tribune*, Sept. 30, 1938 in AIC Scrapbook vol. 72, 106.

Alfred Juergens's family moved from Chicago to a new house in Oak Park, Illinois, in 1889; except for the periods spent in Europe the artist lived there for the rest of his life. The village, on Chicago's western border, was one of the area's first bedroom communities and developed rapidly between 1890 and 1920. As the home of Frank Lloyd Wright and other contemporary architects, Oak Park became the birthplace of the Prairie School of architecture. It was also famous for its many trees, parks, and gardens and counted numerous artists among its residents.

"In this beautiful suburb there is plenty of inspiration to lend itself to the artistic mind," Juergens told a newspaper interviewer in 1930.[1] The artist, who exhibited mainly floral landscapes in the Art Institute's annual shows over a 24-year period, found many of his subjects in the village and immediately around his house. *A September Garden* probably depicts the artist's own backyard, with a view over a fence to the garage and house on a neighboring property. He remarked, possibly in reference to this painting: "Sometimes people think I must have a whale of a place out here. But neighbors don't object if you look over into space across the line."

Around 1905 Juergens studied and worked in France, absorbing the Impressionist approach evident in *A September Garden*. Broken brushwork and soft, bright colors convey the scintillating effect of masses of varied flowers, shrubs, and trees and suggest the lingering warmth of an afternoon as the season draws to a close. Juergens, who was compared by one enthusiastic critic to Monet,[2] applied an Impressionist's preoccupation with light-saturated color, the suggestion of atmosphere, and informal composition to an intimate, local subject. WG

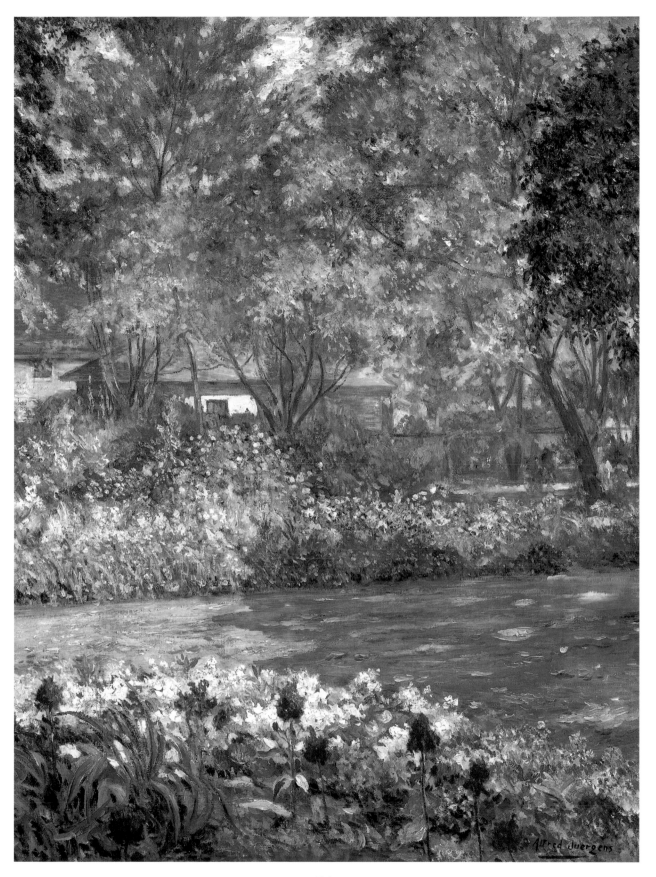

56

A SEPTEMBER GARDEN, c. 1921

Oil on canvas, 40 × 30 in.
Signed, lower right: *Alfred Juergens*

Carl
Rudolph
Krafft

1884–1938

NOTES

1. Lal (Gladys Krafft) Davies,
 *Carl R. Krafft; An Artist's
 Life* (New York: Vantage
 Press, 1982), 6.

2. *The Art League Book*
 (Oak Park, Ill.: The Art
 League, 1941), unpaged.

3. V. E. Carr, "Carl R. Krafft,"
 *American Magazine of
 Art* 17 (Sept. 1926), 478.

Carl Krafft, son of a German Lutheran pastor, grew up in Chicago and attended night classes at the Art Institute while working as a commercial artist; later he opened a commercial art studio with Rudolph Ingerle.[1] Krafft painted in Brown County, Indiana, but in 1912 he discovered the beauties of the scenery in Missouri's Ozark Mountains and, with Ingerle, organized the Society of Ozark Painters. Krafft painted figure paintings and portraits, as well as landscapes. In 1927 he moved from Chicago's Austin neighborhood to Oak Park, where he had been the moving force behind the founding of the Austin, Oak Park and River Forest Art League (now the Oak Park Art League), in 1921.[2] Krafft taught widely, including at his own summer landscape school in Willow Springs, Illinois.

Krafft's figural compositions, with their static but monumental imagery of ordinary folk, may demonstrate the influence of his fellow students and friends Leon Kroll and Eugene Savage.[3] In his lyrical landscapes of the Ozarks, however, Krafft demonstrates his affinity with a decorative landscape tradition that is thoroughly Midwestern. Often unpeopled, the works evince an urban culture's longing for escape into a nature at once arcadian and native. Krafft's landscapes of the teens and early twenties were softly lit, tonal impressions that emphasized the mystical aspect of nature in America's heartland. By the late twenties his style had evolved, evidently under the influence of Post-Impressionism, toward the energetic linearity and strong color contrasts that mark this landscape. The old mill was a favorite subject of Krafft, who executed several views of it in the mid-1920s. WG

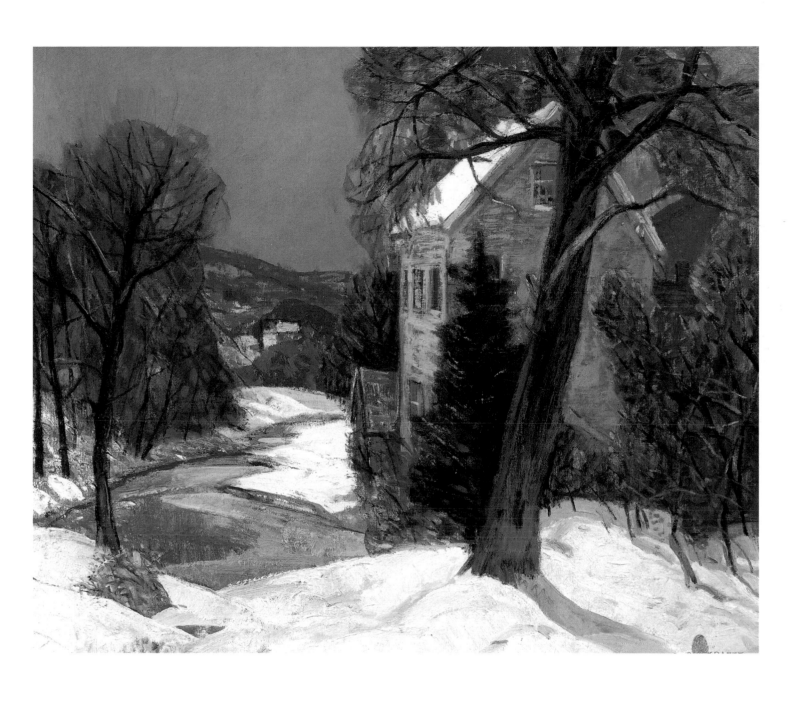

57

OLD MILL IN WINTER, c. 1925-26

Oil on canvas, 25 × 29 ½ in.
Signed, lower right: *Carl R* [thumbprint] *Krafft*

Herman Menzel

1904–88

NOTES

1. For biographical information on Menzel, see Wendy Greenhouse and Susan Weininger, *Herman Menzel: A Rediscovered Regionalist* (exh. cat., Chicago: Chicago Historical Society, 1994).

Born in Chicago in 1904, Herman Menzel grew up on the South Side and, with the exception of regular trips to paint in locales ranging from Woodstock, New York, to the Great Smoky Mountains in North Carolina, and fishing and camping trips to Wisconsin and Minnesota, he spent his entire life in the area. His father, a strict Lutheran minister of German heritage, was not supportive of his son's interest in painting. Making his own way, Menzel studied first at the Chicago Academy of Design and the National Academy of Art, a commercial art school, where he met Willa Hamm, who later became his wife. Both of them subsequently studied at the new Studio School with Marques Reitzel and Charles De Witz. Herman also studied there with muralist John Warner Norton and William Bishop Owen, both of whom impressed upon him the importance of dedicating himself to painting rather than teaching or commercial art. After their marriage in 1933, Willa's job as a commercial artist enabled him to paint full-time. Although he exhibited his work a number of times at juried Art Institute shows in the late 1920s and 1930s, was selected for the Century of Progress Exhibition (1933), and contributed at least one painting to the Illinois Art Project, he was largely isolated from the Chicago art world. By the time he and Willa moved to Hubbard Woods in 1943 to take up residence in Willa's childhood home, he was totally deaf, which seems to have added to his reclusiveness. His paintings are all figurative works, carefully finished and skillfully constructed, yet full of a kind of romance and mystery. The depictions of Chicago neighborhood life, of the intersection of the city and the natural world in his many images of the urban lakefront, and of the idyllic wilderness of the Wisconsin and Minnesota lakes where he loved to fish, comprise a vivid picture of the aspects of the world that he loved.[1]

Menzel's industrial landscape, like those of many of his Chicago contemporaries, pays homage to the modern urban landscape without excluding the human beings who live and work in the built environment. The geometric forms and dark tones of the factory towers, smokestacks, and steelworks contrast with both the organic exuberance and rich colors of the sky and smoke and with the people and dogs in the foreground. Menzel's work combines the promise and attraction of the modern industrial landscape with an apprehension and fear not often seen in the work of this period. SW

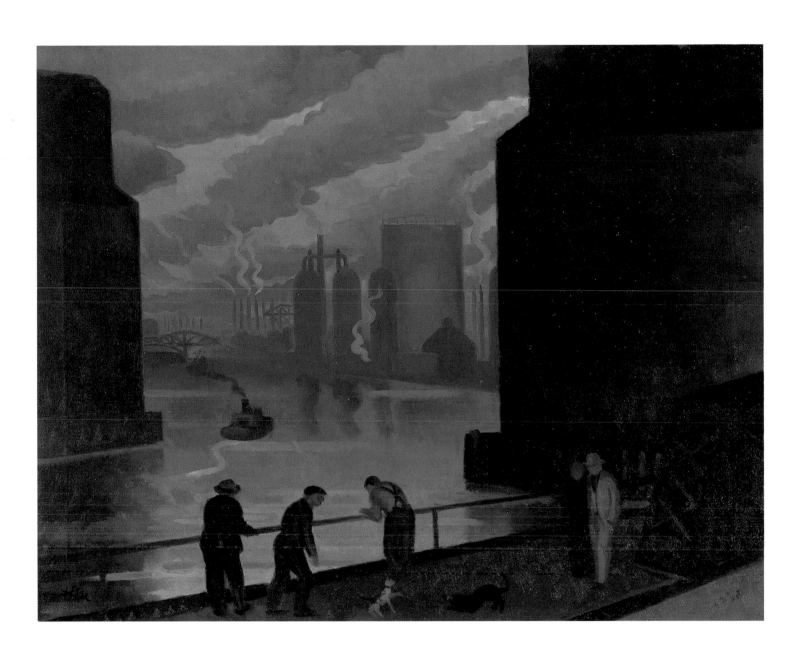

B R I D G E S , S O U T H C H I C A G O , c . 1 9 3 7

Oil on canvas, 22 × 28$\frac{1}{4}$ in.
Signed, lower left: *HM*

James Bolivar Needham

1850–1931

NOTES

1. Information about Needham is limited to Jerome Beam, "This Man Loved Chicago: Portrait of a Dreamer," *Chicago Daily News*, 18 March, 1931, reprinted in *James Bolivar Needham*, exhibition brochure issued by Robert Henry Adams Fine Art, 1998. Beam evidently knew Needham; his article also records Needham's brother's recollections of the artist.

2. Joel Dryer, Director of the Illinois Historical Art Project, speculates that Needham may have been a student in a private sketch class taught by Albert Fleury (1848–1924) beginning in 1898. Fleury was a French-trained painter who was in Chicago by 1889, when he painted murals in the new Auditorium Theater; he began teaching at the Art Institute in 1902. In the 1890s Fleury was painting Impressionist images of Chicago, including river views.

3. In "Successful Efforts to Teach Art to the Masses," *The Forum* 19 (July 1895), 609, Hamlin Garland, in describing the activities of the Central Art Association, notes that recent exhibitions sponsored by the Association in Chicago include "the pictures of shipping in the Chicago River by James Needham." I am grateful to Joel Dryer for this reference.

4. Beam, "This Man Loved Chicago," notes that Needham threw away three out of five of his paintings.

5. The painting was published as "ca. 1905" in *James Bolivar Needham*. However, the inscribed date of "90" has been authenticated as original by conservator Agass Baumgartner.

African-American artist James Needham was born in Chatham, Ontario, a terminus of the Underground Railroad.[1] He arrived in Chicago at the age of seventeen, after working his way around the Great Lakes as a boathand. Essentially self-taught, Needham supported himself as a decorative and house painter, and later worked as a janitor and caretaker, while devoting his spare time to portraying Chicago in paintings and watercolors. He is said to have received instruction and encouragement from Lorado Taft and Albert Fleury,[2] and his Impressionist technique indicates his awareness of contemporary art.[2] But except for a small exhibition of his work in 1895 under the auspices of the Central Art Association,[3] Needham went unrecognized in his lifetime for his pioneering work in the picturing of his adopted hometown.

As an outsider to the Chicago art world of the late-nineteenth century, Needham turned his artistic attention to the world immediately surrounding him. Beginning in the 1870s, unencumbered by conventional prejudices against the portrayal of the modern industrial city, Needham found abundant subjects in Chicago, especially the shipping and waterways with which he was intimately familiar. He apparently executed his paintings on the spot, often with oils on easily transported small wood panels. On many the artist recorded the date of execution. Needham is said to have destroyed many of his paintings;[4] others were lost in a 1931 fire that hastened the artist's death. The 1890 painting *[Tugboats and Grain Elevator]* is his earliest extant dated work.[5]

Boldly executed in strong contrasts of earth tones, this small work is an exercise in the orchestration of compositional elements, with diagonals and subtle curves played against one another. Needham's focus here on the forms of a few relatively close-up objects—two side-by-side tugboats and a massive grain elevator looming in the distance—is uncommon in his work. Typical of this artist, however, is the picture's sense of palpable atmosphere and concern for light. In contrast to the glassy stillness of the river's water, curving trails of smoke billowing up from the tugs' funnels join the hazy sunlight in an almost blinding effect. WG

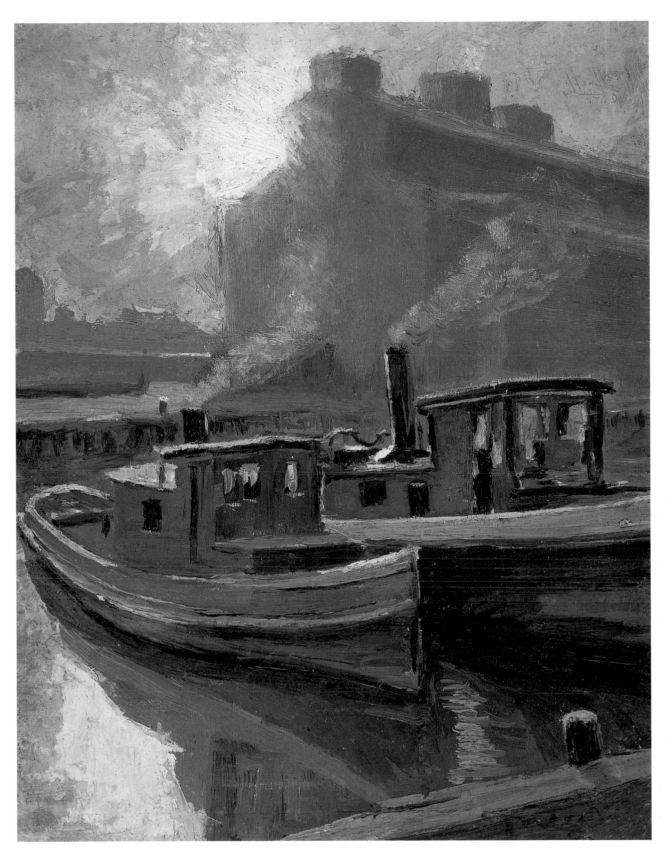

<u>59</u>

UNTITLED

[TUGBOATS AND GRAIN ELEVATOR], 1890

Oil on board, 12 × 9 in.
Signed, lower right: *J Need[ham] / 90*

Like *Halsted Street Bridge* (cat. 61), another Needham work in the Bridges Collection, this diminutive image of the crowded bank of the Chicago River probably portrays a scene along the river's north branch, for the skyline is low and the span of water, relatively narrow. The view looks directly across the river toward a cluttered array of shipping, buildings, and other utilitarian structures rendered as a concatenation of sticklike forms that evinces an unexpected fragility. As elsewhere in Needham's work, these structures are portrayed with just enough physical distance to imply an unpeopled quietude. The slightly rippling surface of the water casts broken reflections in spontaneous strokes of delicate browns that reveal Needham's direct, on-the-spot portrayal of his local subject. WG

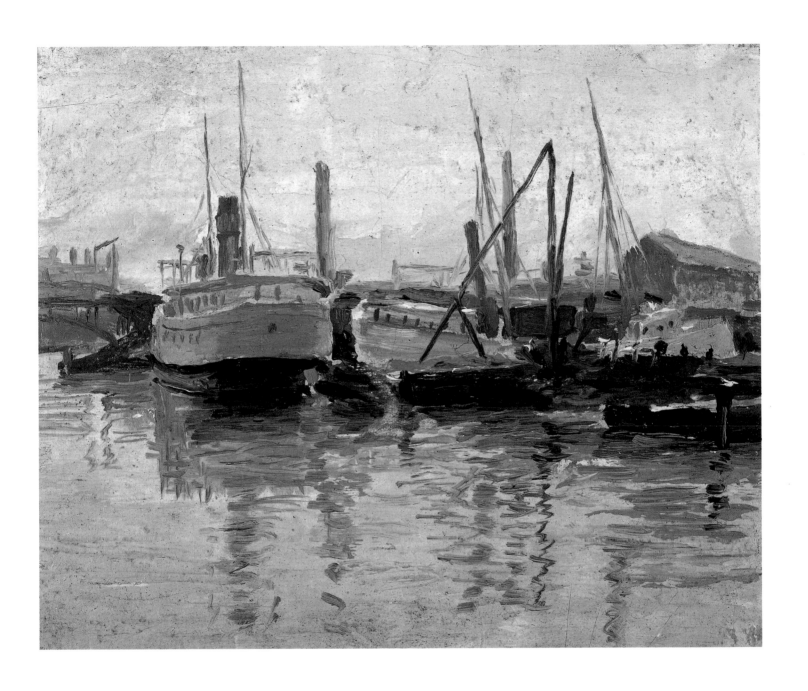

60

[CHICAGO RIVER SCENE], 1906

Oil on board, 6½ × 8 in.
Inscribed on verso: *1906*

**James Bolivar
Needham**

(CONTINUED)

The Chicago River of Needham's early decades in the city was a hub of activity, bristling with the rigging of transport vessels, lined with warehouses, factories, and storage elevators, and crossed by numerous bridges. Its waterways symbolized Chicago, for the city owed its origin and fantastic growth to its central position in the nation's early water-based transportation network. The site of the city's early industrial heart, the river and lake harbor also provided perhaps the most interesting views for an artist, offering the varied elements of buildings, water, boats, and expansive sky.

Halsted Street Bridge combines these elements in a composition that balances the curving strutwork of the bridge against the slender verticals of the shipping drawn up on the river's left bank; the darker forms of buildings frame the image on either side. The view looks west. The Halsted Street bridge spans the Chicago River at the southern end of industrial Goose Island, just north of Chicago Avenue. Little of the scene recorded by Needham survives, but the domed tower just visible on the horizon to the left of the bridge is probably the pinnacle of the still-extant church of St. John Cantius, on Carpenter Street. The viewer's impression of the densely built landscape of Chicago's near northwest side is tempered by a sense of unexpected calm created by the picture's relative emphasis on water and sky, rendered in an Impressionist technique of rapid, broken brushwork. WG

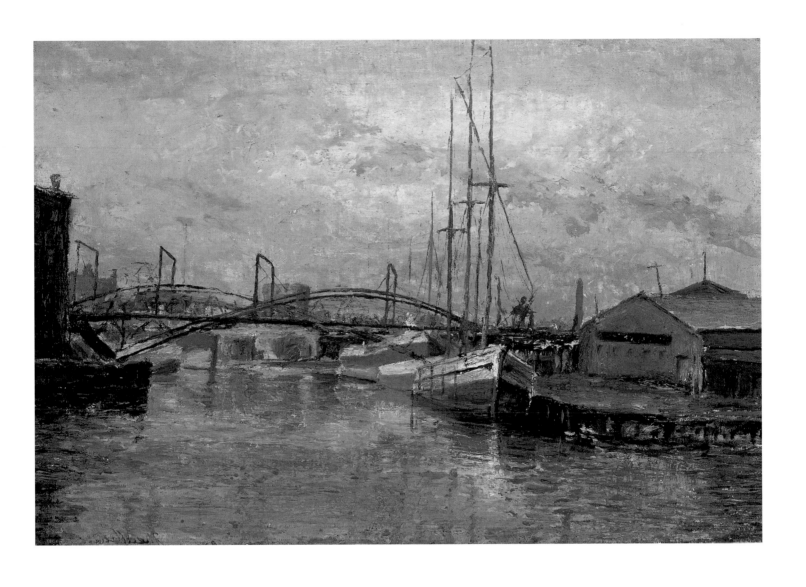

61

HALSTED STREET BRIDGE, 1918

Oil on board, 14 × 21 in.
Signed, lower right: *J Needham;* inscribed on verso: *1918*

Arvid Nyholm

1866–1927

NOTES

1. Nyholm's biography is given in Mary Em Kirn and Sherry Case Maurer, *Härute—Out Here: Swedish Immigrant Artists in Midwest America* (exh. cat., Augustana College Art Department, Rock Island, Ill., 1984), 130. Kirn and Maurer state erroneously that Nyholm was elected to the National Academy of Design.

A rvid Nyholm trained in his native Sweden and in Paris.[1] His most important teacher was Anders Zorn, whose facile style of dashing brushstrokes and dramatic tonal contrasts he emulated. Nyholm emigrated to New York in 1891. In 1903 he joined the large community of Swedish immigrant artists in Chicago, where he exhibited in the art shows organized by the Swedish-American Art Association and the Swedish Club of Chicago, as well as at the Art Institute.

This colorful work unites Impressionist technique and subject matter and shows the specific influence of Zorn's paintings and etchings in the shoreline setting, bright sunlight, and attractive female subject. Nyholm's composition is dominated by the pretty young woman seated in the center. Fashionably dressed and shaded by a colorful Oriental parasol, she seems to be fully aware of, even to welcome, the viewer. Her surroundings—a wooden dock in dappled shadow, gently rippling water in the background, and willow fronds hanging down from above—offer a variety of colors, textures, and light effects that suggest the transience of a sunny summer day. Such details as the fashionable Oriental parasol and the bunch of yellow gladiolus in the foreground, along with the figure's direct glance and casual pose, give the image a real-life, anecdotal quality. The young woman's identity is unknown, but rather than a posed model, she appears as a personal acquaintance of the artist and, by extension, of the viewer. WG

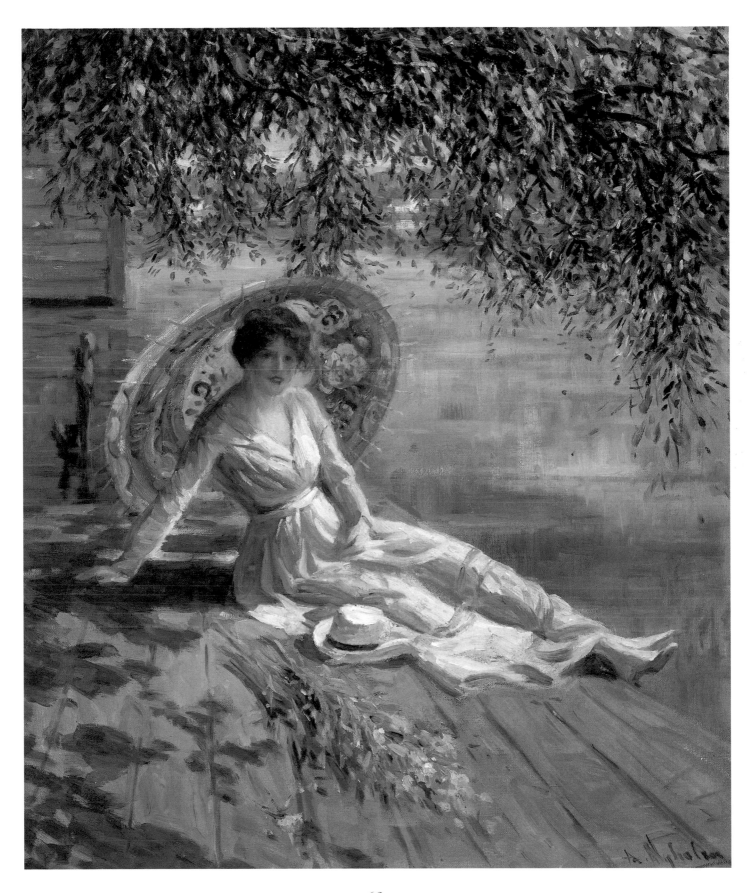

62

UNTITLED

[WOMAN WITH PARASOL], c. 1922

Oil on canvas, 27 × 22 in.
Signed, lower right: *A Nyholm*

Pauline Lennards Palmer

1867–1938

NOTES

1. Information on Palmer is drawn from Fred W. Soady, "A Brief History of the Artist" in *Pauline Palmer* (exh. cat., Lakeview Museum of Arts and Sciences, Peoria, Ill., 1984), unpaged, and David Sokol, "Palmer, Pauline Lennards" in *Women Building Chicago, 1790–1990: A Biographical Dictionary*, Rima Lunin Schultz and Adele Hast, eds. (Bloomington: Indiana University Press, 2001).

2. Frank Holland, "Memorial Show for 2 Conservatives," *Chicago Sun-Times*, Sept. 16, 1951; "Face to Face With the Art Apaches in the Primitive Wastes of Chicago's Bohemia," *The Chicago Literary Times* 1, no. 4 (Oct. 16, 1923), quoted in Kenneth Robert Hey, "Five Artists and the Chicago Modernist Movement, 1909–1928" (Ph.D. dissertation, Emory University, 1973), 226.

3. "In the Galleries," *The International Studio* 51 (Nov. 1913), 111.

4. Chase taught at the Art Institute for one month in 1894 and in 1897 (Keith L. Bryant, Jr., *William Merritt Chase: A Genteel Bohemian* (Columbia and London: University of Missouri Press, 1991), 177.

5. "Child Model to Become Artist. 'Winter Girl' Held Marvel at 11," *Chicago Examiner*, Feb. 10, 1913 (AIC Scrapbook vol. 30, 14). I am grateful to Joel Dryer, Director, Illinois Historical Art Project, for bringing this article to my attention

Pauline Palmer was born in McHenry, Illinois, to immigrant parents who encouraged her artistic leanings. She worked as a supervisor of art in the Chicago Public Schools, and she studied at The Art Institute of Chicago and in Paris.[1] Following her marriage in 1891 to Albert Palmer, a well-to-do physician, she was able to devote herself to painting. Although Palmer's fame rested on her portrait and figure paintings, she also executed landscapes and still lifes, many painted in France and Italy, to which she made numerous trips, and at her summer studio in Provincetown, Massachusetts. An influential figure in the art establishment of her day, she became the first woman president of the Chicago Society of Artists, in 1919, and later led the Chicago Association of Painters and Sculptors, a breakaway faction of conservative artists. Her militant leadership in the cause of traditionalism earned Palmer the special ire of the city's radical artists.[2]

It is surely Chicago's own notorious winter that Palmer evokes in *The Winter Girl*'s virtual armor of fur-trimmed coat, muff, hat, and umbrella. The theme of dress or ornament and the contemplative female figure were mainstays of American figure painting of the late-nineteenth and early-twentieth centuries. For this indoor wintertime subject Palmer abandoned the Impressionist color and light that generally characterize her landscapes and genre scenes,[3] emulating instead the subdued palette and alternately patchy and dashing brushwork of the figural paintings of William Merritt Chase, briefly one of her teachers at the Art Institute.[4] Otherwise, however, *The Winter Girl* is typical of Palmer's widely popular figural work in its accessible, almost sentimental appeal. Well-bundled and fixedly posed, the young sitter penetrates her static situation by the intimate immediacy of her direct gaze and flushed cheeks. Similarly, the notes of bright color sounded by the red stripes on her coat and the gold bracelet on her right wrist glow energetically against the somber dark blues and browns of the composition.

The model for *The Winter Girl* was 11-year old Anzonette Fisher, a popular child-model among Chicago's artists. She created a sensation when, outfitted as in the portrait, she visited the Art Institute to view the painting as it hung in the 1913 Chicago and Vicinity annual exhibition.[5] At about that time the painting was acquired by Edward B. Butler, trustee of the Art Institute and amateur painter and collector of American art. WG

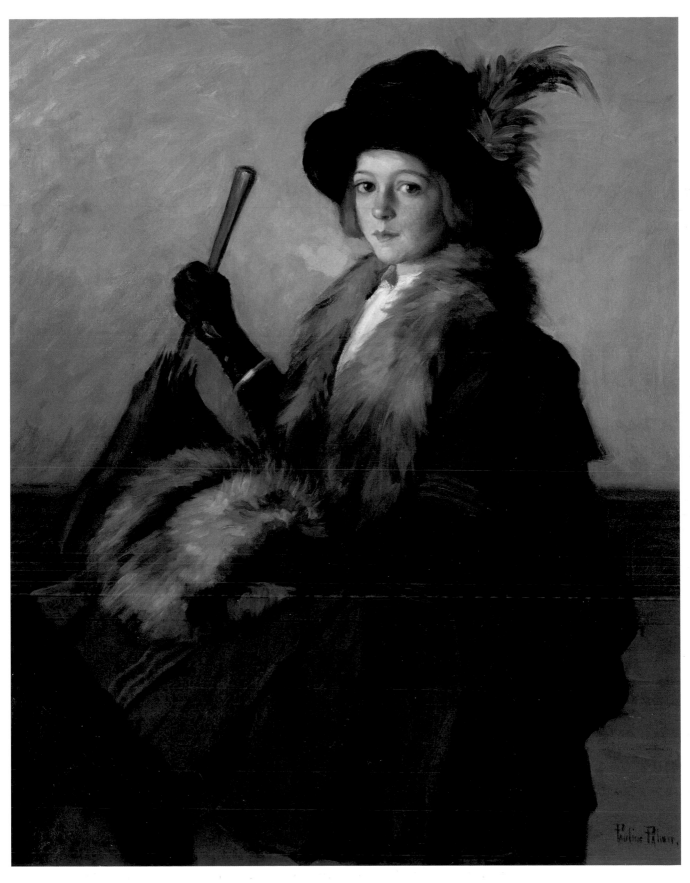

63

THE WINTER GIRL, c. 1913

Oil on canvas, 39 × 31³/₄ in.
Signed, lower right: *Pauline Palmer*

Frank
Charles
Peyraud

1858–1948

NOTES

1. For biographical data on Peyraud
 see *Frank C. Peyraud: Dean of
 Chicago Landscape Artists* (exh.
 cat.: Lakeview Museum of Arts
 and Sciences, Peoria, Ill., 1985),
 unpaged; on Peyraud's training
 and early career see also C. J.
 Bulliet, "Artists of Chicago Past
 and Present, No. 5: Frank Charles
 Peyraud," *Chicago Daily News*,
 Mar. 23, 1935, and William H.
 Gerdts, *Art Across America: Two
 Centuries of Regional Painting,
 1710–1920. The South and the
 Midwest* (New York: Abbeville
 Press, 1990), 300–301, 327.

2. G. E. Kaltenbach, quoted in
 Frank C. Peyraud (1985), [12].

3. *In the Berkshires*, a work included
 in Peyraud's solo exhibition at
 The Art Institute of Chicago in
 1915 (no. 9) may be identical
 with *Souvenir of the Berkshires*.

4. Bulliet (1935). Butler (1853–1928)
 became a competent landscapist
 in his own right and exhibited his
 paintings at the Art Institute. He
 also donated his collection of paint-
 ings by George Inness to the Art
 Institute in 1911. Butler endowed
 the Edward B. Butler Prize for the
 Chicago and Vicinity annual exhibi-
 tion at the Art Institute, which
 Peyraud won in 1912. In 1915,
 the year after Peyraud painted his
 Souvenir of the Berkshires, Butler's
 closely related landscape *A Restful
 Day*, showing a river receding
 between grassy banks and low hills
 in the distance, was exhibited at the
 Chicago and Vicinity exhibition at
 the Art Institute and was illustrated
 in the exhibition catalogue.

Frank Peyraud was born in Bulle, Switzerland, and trained as an architect in Paris.[1] Peyraud arrived in Chicago in 1881 to practice architecture but found more ready employment as a painter of cycloramas. He studied at the Art Institute and by 1889 had begun to paint the Impressionist rural landscapes that would occupy him for the rest of his career. Peyraud divided his time between Chicago and Peoria, where he also executed murals, and worked in Switzerland and Italy from 1921 to 1923. By that point he was considered Chicago's leading landscapist.[2]

Peyraud exhibited landscape paintings of scenes in Massachusetts's Berkshire Mountains in 1915–16 and 1919.[3] On his travels there he may have been accompanied by Edward Burgess Butler, to whom *Souvenir of the Berkshires* is inscribed. Butler, a successful merchant and "nervous capitalist," turned to painting as therapeutic recreation and was advised to study with Peyraud. For eighteen years the two shared a studio and went on sketching trips together.[4]

Souvenir of the Berkshires, with its soft, bright colors, rapid brushwork (especially in the foreground detail), and sense of palpable atmosphere is a departure from Peyraud's typically more stylized, lyrical renderings of nature. This intimate work has the freshness of an on-the-spot transcription, yet it is carefully composed, with balanced horizontal color masses and a prescribed recession into space effected by the stream winding through the meadow. In its adherence to such conventions of pictorial illusion of space and form, *Souvenir of the Berkshires* is typical of the combination of Impressionist technique and landscape tradition that characterizes the relatively conservative mainstream of American Impressionism. WG

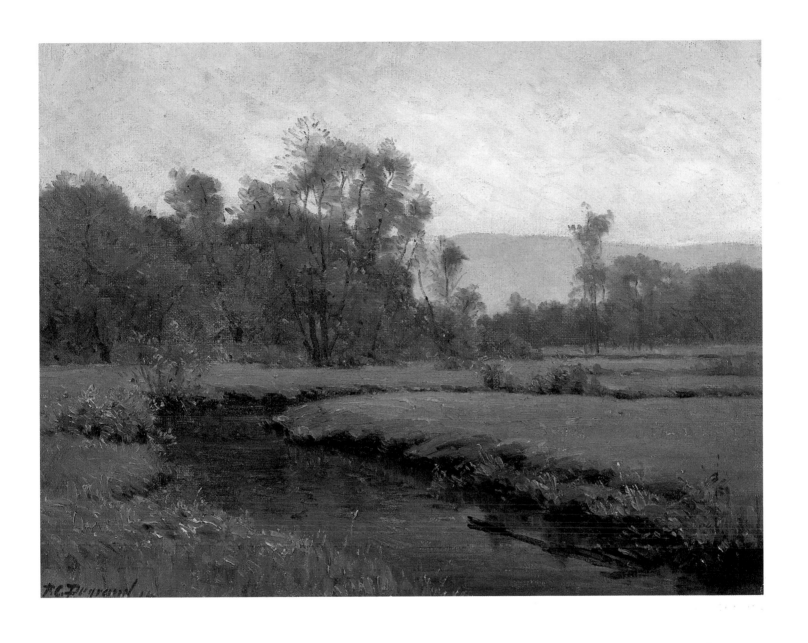

64

SOUVENIR OF THE BERKSHIRES, 1914

Oil on canvas, 20 × 26 in.
Signed and dated, lower left: *F. C. Peyraud 14*; inscribed on verso: *Souvenir of the Berkshires*
Autumn 1914/to my Friend E. B. Butler Christmas 1914 F. C. Peyraud

Frank Charles Peyraud
(CONTINUED)

NOTES

1. *Late Afternoon on the Desplaines* and *Summer on the Desplaines* were included in Peyraud's solo exhibition at the Chicago Galleries Association in 1929; *Full Moon on the Desplaines* has been dated to c. 1947 (Lakeview Museum catalogue, no. 34).

2. Lena M. McCauley, "Illinois Landscape as the Inspiration of Chicago's Painters," *Chicago Evening Post Magazine of Art*, Aug. 14, 1928, 1, 4.

3. Peyraud quoted in C. J. Bulliet, "Artists of Chicago Past and Present. No. 5: Frank Charles Peyraud," *Chicago Daily News*, Mar. 23, 1935.

Autumn on the Desplaines typifies Peyraud's mature style, with its rather heavy paint application and stylized outlining of forms. The artist favored compositions such as this, with tall masses—typically trees—silhouetted in the middle ground, a body of water, and subdued light. By the twenties the influence of Post-Impressionism is evident in the relative abstraction of natural forms and patterned brushwork in his paintings. In addition, Peyraud had abandoned the lyrical tonalism of his earlier work.

In his landscapes Peyraud was concerned more with evoking a generalized mood of a place, season, and time of day than with topographical specificity. Many of the titles he chose for his works are correspondingly generic. However, the titles of at least four of his paintings indicate that they specifically picture the Des Plaines River at various seasons and times of day.[1] The river, which runs mostly north-south close to Chicago before turning south-west toward Joliet, offered local artists convenient access to picturesque rural subjects and was a popular setting for local landscapists. "Follow a byway to the Des Plaines River … and the narrowing trail will end at the easel of a painter," observed one art critic.[2]

In *Autumn on the Des Plaines*, the glassy expanse of the river itself is in the background, and the focus of the picture is a cluster of five trees whose dark trunks and golden foliage create a lacy pattern against a bright but overcast sky. Typical of Peyraud's compositions, this work demonstrates the conscious influence of his architectural training. "A landscape should be built up architecturally to something monumental," he declared in 1935. "It is the silhouette of form against the sky that counts. Unless that is interesting, the picture cannot interest, no matter what else you do to it."[3] WG

65

AUTUMN ON THE DESPLAINES. c. 1925-30

Oil on canvas, 28 × 34 in.
Signed, lower right: *F. C. Peyraud;* inscribed on label originally attached to stretcher:
F. C. Peyraud/Autumn on the Desplaines/$500.00

Tunis Ponsen

1891–1968

NOTES

1. For biographical information, see *The Lost Paintings of Tunis Ponsen* (exh. cat., Muskegon, Michigan: Muskegon Museum of Art, 1994), particularly Susan S. Weininger, "Tunis Ponsen," 18–35, and Patrick Coffey, "Chronology," 36–55.

2. For example, the similar scene reproduced in *The Lost Paintings of Tunis Ponsen*, no. 25, p. 76. Ponsen produced a number of Modernist urban scenes, including *Chicago Silhouettes* (plate 24, p. 75), in Weininger, "Tunis Ponsen," 25–28.

Tunis Ponsen was born in Wageningen, the Netherlands, and immigrated to the United States in 1913 after the death of both of his parents. He settled in Muskegon, Michigan, the home of a sizable Dutch population that stretched down the Eastern Shore of Lake Michigan to Holland and Benton Harbor. He made his living as a house painter, but continued to develop the interest in fine art that had begun in the Netherlands by enrolling in classes at the Hackley Art Gallery (now the Muskegon Museum of Art). His studies resulted in two solo exhibitions at the Hackley in 1922 and 1923, and with the support of the director, Lulu Miller, he applied to the School of the Art Institute of Chicago, where he studied with Karl Buehr, George Oberteuffer and Leon Kroll, graduating in 1925. He continued with graduate studies, and was awarded the competitive Bryan Lathrop Travelling Fellowship in 1928, which allowed him to go to the Netherlands and France where he produced a series of important paintings. Ponsen also made regular trips to the Atlantic coast, painting pleasing scenes of Gloucester, Massachusetts, Boothbay Harbor, Maine, and the Gaspe Peninsula in Canada. He exhibited regularly in the juried Art Institute annuals and with a number of groups in the area, including the conservative Chicago Galleries Association and the All Illinois Society of Fine Arts, as well as the more moderate Chicago Society of Artists. A prolific painter who never married or had children, he was able to support himself with sales of his work and occasional teaching jobs.[1]

While much of Ponsen's work consists of pleasant, uncomplicated landscapes or figure studies, he seems to have effortlessly crossed over into the area of a bold, Modernist style when it suited him. He rarely dated his work, and he often produced a number of versions of the same scene, but this Precisionist industrial landscape can be associated with a group of similar works done in the early 1930s.[2] Unlike some of his contemporaries who glorified the built environment of the modern city to the exclusion of its inhabitants, Ponsen, like a number of other Chicago artists, almost always humanizes his paintings by including human figures. The men in the foreground are most likely some of the many left unemployed during the Great Depression, viewed against the Wrigley Building and Tribune Tower in the distance. SW

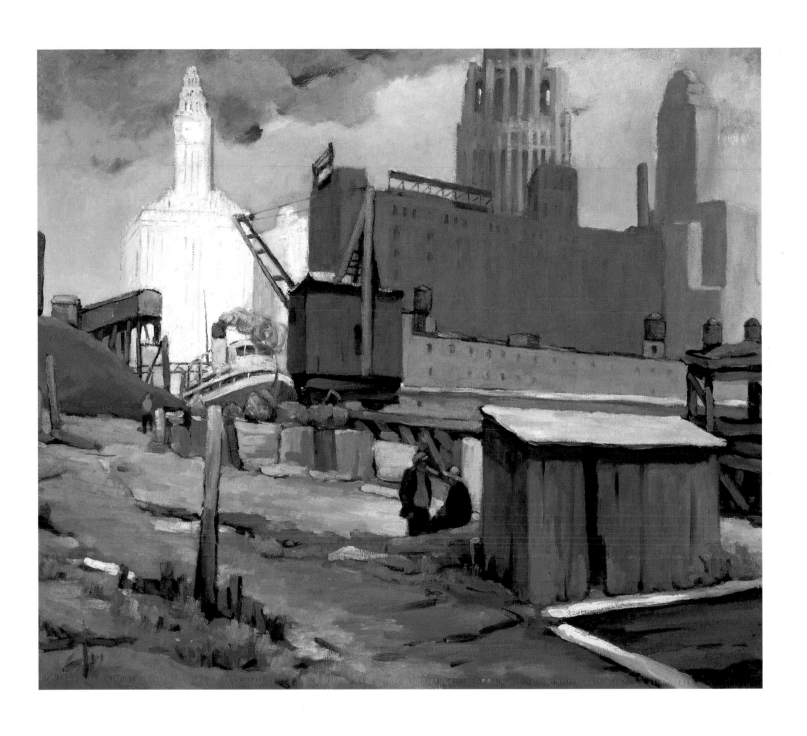

66

CHICAGO RIVER AND WRIGLEY BUILDING, c. 1932

Oil on canvas, 32 × 36 in.
Signed, lower right: *Tunis Ponsen*

Cadurcis Plantagnet Ream

1838–1917

NOTES

1. Esther Sparks, "A Biographical Dictionary of Painters and Sculptors in Illinois, 1808–1945," (Ph.D. dissertation, Northwestern University, 1971), vol. 2, 569.

2. Giselle D'Unger, "Cadurcis Plantagnet Ream," *Fine Arts Journal* 16 (Oct. 1905), 430.

3. *Purple Plums*, or *Just Gathered*, 1865. See Gerdts, *Art Across America: The South and the Midwest*, 294–95.

4. William H. Gerdts and Russell Burke, *American Still-Life Painting* (New York: Praeger Publishers, 1971), 73.

5. "Ream's Paintings" [Chicago: privately printed, circa 1909], unpaged. This pamphlet, clearly printed for Ream as promotional material, consists mostly of a reprint of D'Unger's article from *Fine Arts Journal*, plus extracts from press reviews and Ream's warning against forgeries. A copy is in the collection of the Chicago Historical Society.

6. For an exhaustive discussion of the apple in nineteenth-century American painting see Bruce Weber, *The Apple of America: The Apple in 19th Century American Art* (exh. cat., Berry-Hill Galleries, N.Y., 1993).

7. Weber, 14–15.

Ohio native C. P. Ream specialized in paintings of fruit throughout his career, purportedly from the age of 10.[1] Ream worked in New York and possibly in Europe before settling permanently in Chicago in 1878. Dubbed "the King of Fruit Painters,"[2] Ream was especially famous for his lush naturalistic depictions of ripe plums and grapes. One such work was the first painting by a Chicago artist to be acquired by the Art Institute in 1899.[3] Although he also painted landscapes, cityscapes, and figural subjects, these were vastly outnumbered by Ream's popular fruit pictures, several of which were published as chromolithographs by Louis Prang & Company of Boston in its series of "dessert pictures."[4] The artist warned his buyers against forgeries of his popular paintings.[5]

Apples were a popular subject among American still-life and genre painters of the nineteenth century.[6] From its traditional biblical and classical associations the apple came to symbolize national identity and popular democracy. After mid-century, however, many painters chose to emphasize simply the visual aspects of their still-life subjects. Available year-round, apples were appreciated for their variety of color, markings, and shapes.[7] Ream painted several different varieties, although he generally did not mix them within one picture. He showed them in natural settings rather than with the containers and tabletops that frequently figure in the work of other still-life painters. He worked in a complementary naturalistic style with softly rendered surfaces, uneven lighting, and casual arrangements of the fruit.

Ream's characteristically straightforward approach is evident in the painting of apples in the Bridges Collection. The eight apples, along with a few curling leaves, appear to have been spilled out randomly onto a gray marble surface. They are rendered individually, distinguished by position and lighting, as well as by slight marks and bruises. Ream has chosen a tall variety (possibly related to our present-day Delicious) with a distinctly contoured, somewhat lumpy bottom, though he portrays each specimen lying on its side, with the yellow-green bottom toward the viewer. This allows him to explore the rich range of colors on each piece of fruit as it is set against a dark background and illuminated from the left front by a single light source that leaves the apples in the background somewhat in shadow. WG

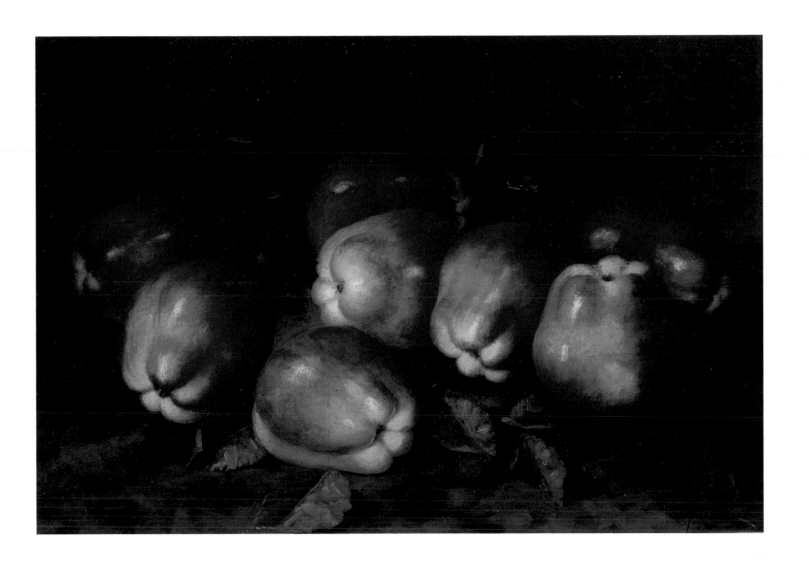

67

UNTITLED

[APPLES], undated

Oil on canvas, 14 × 20 in.
Signed, lower right: *C. P. Ream*

William S. Schwartz

1896–1977

NOTES

1. Wallace served as an important
mentor to Schwartz and since
he had come to Omaha from
Chicago, it is reasonable to
assume that he encouraged
Schwartz in pursuing his
education at the School of the
Art Institute. See Douglas
Dreishpoon, "Introduction,"
*The Paintings, Drawings, and
Lithographs of William S.
Schwartz* (New York: Hirsch
and Adler, Inc., 1984), 16 n. 2.

2. This story is recounted by
Manual Chapman. *William S.
Schwartz: A Study* (Chicago:
L. M. Stein, 1930), 5.

3. He exhibited *La Commedia*,
his homage to his good friend,
Anthony Angarola who had
died in 1929, in the 9th
Annual Chicago No-Jury
Society of Artists Exhibition
of 1931. Aside from this single
instance, he did not choose to
show his work with this group
during the 1930s and 1940s.

Born in Smorgon, Russia, in 1896, William Schwartz was a scholarship student at the Vilna Art School before immigrating to the United States in 1913. He lived in New York with a sister for a short time, but in 1915 he headed for Omaha, Nebraska, to live with his brother and pursue his interest in art. He studied briefly with J. Laurie Wallace at the Kellom School in Omaha before setting his sights on the more prestigious and challenging School of the Art Institute of Chicago.[1] Schwartz graduated with honors in life drawing, portraiture, and general painting, areas that he pursued throughout his long career. While establishing himself as a progressive individualist aware of Modernist art, with his blue and green nude produced for a class at the Art Institute,[2] he was reluctant to join the "radicals" and exhibited only once with the No-Jury Society.[3] He had a small circle of close artist friends, including the Albright twins Ivan and Malvin, Anthony Angarola, and Aaron Bohrod. His work is characterized by a high level of craftsmanship and a versatility and willingness to experiment with a range of styles and subject matter, ranging from pure abstractions to nudes, portraits and still lifes, to works evoking memories of the lost past of his youth and both the small town, rural, and urban present he found in America. Like Ivan Albright, he achieved a great deal of success nationally, exhibiting in juried shows at the Whitney Museum of American Art, and the National Academy of Design, both in New York, the Pennsylvania Academy of the Fine Arts in Philadelphia, the Corcoran Museum in Washington, D.C., and the Carnegie Museum in Pittsburgh, in addition to regular appearances at the juried Art Institute exhibitions.

Schwartz's self-portrait in his Chicago studio at Wabash and Ohio (which he shared with Anthony Angarola) shows him working on a lithograph of a nude model, his future wife Mona, who stands before him in the shadowy room. He is surrounded by carelessly discarded failed attempts, as well as an array of his other work, which hangs on the walls of the room. The painting is executed in Schwartz's meticulous technique, in this case showing evidence of Cubist influence in the faceted planes of the room and the model's figure. SW

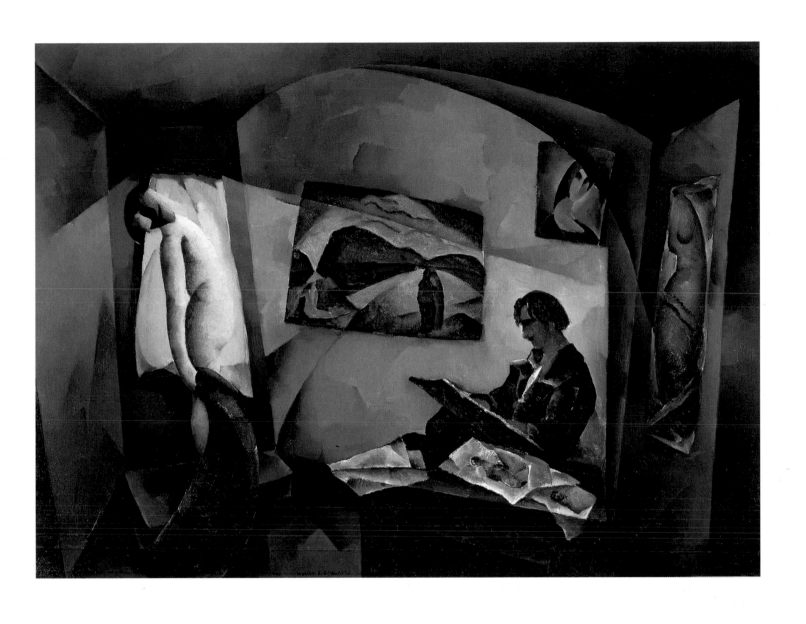

68

MAKING A LITHOGRAPH, c. 1929

Oil on canvas, 30 × 40 in.
Signed, lower center: *William Schwartz*

William S. Schwartz

(CONTINUED)

NOTES

1. Douglas Dreishpoon.
"Introduction." *The Paintings,
Drawings, and Lithographs of
William S. Schwartz* (New York:
Hirsch and Adler. Inc.. 1984). 11.

2. Recognition of the connection
between Schwartz and the
musical analogies of Kandinsky
has been made in a number
of published sources. See. for
example. Charles Eldredge.
"Nature Symbolized: American
Painting from Ryder to Hartley."
in *The Spiritual in Art: Abstract
Painting 1890–1985* (exh. cat..
New York: Abbeville Press. 1986).
126–27. with a reproduction
of *Symphonic Forms No. 16*;
Marianne Lorenz. "Kandinsky
and Regional America." in *Theme
and Improvisation: Kandinsky
and the American Avant-Garde,
1912–1950* (exh. cat.. Boston.
Toronto. London: Little. Brown
and Company. 1992). 84: Susan
S. Weininger. "Kandinsky and
Modernism in Chicago." in
BlockPoints (Evanston. Illinois:
Mary and Leigh Block Gallery.
Northwestern University. 1999).
62–64.

3. Meyer Zolotareff. "Music Caught
in Painting." *The Chicago
American* 17 September 1931.
as quoted in Dreishpoon. 11.

4. "Chicago Artist Describes His
Symphonic Paintings." *Boston
(Massachusetts) Post* 28 July
1935.

Although Schwartz often painted in a representational mode, he also actively experimented with avant-garde styles, including fully abstract works such as this one. It is part of a series of sixty-six paintings that Schwartz called *Symphonic Forms*, which he produced between 1924 and 1967.[1] A trained musician, he conceived of these works as a kind of visual music, which needed no recognizable forms to communicate. Like the Russian-born artist and theorist Wassily Kandinsky, Schwartz articulated the idea that these abstractions were a pure form of communication between painter and spectator.[2] He noted that "viewing these paintings is like listening to music, but it is the spectator who 'makes' the music."[3] On another occasion he explicitly connected particular colors to instruments in the orchestra, explaining that the "same original form is repeated over and over again but the colors are all different—which answers to the composer's method of repeating over and over a certain beautiful melody. This, you probably have observed, is carried first by the violins, next taken up by the coronets, clarinets and woodwinds, then again by the bass instruments—thus you have a delightful symphony. And that is what I have tried to do—to make a symphonic painting."[4] The abstract forms are clearly related to those in the representational works where recognizable forms are often reduced to flattened, angular shapes filled with subtle and fluctuating color. SW

69

SYMPHONIC FORMS NO. 16, c. 1932

Oil on canvas, $36^{1}/_{8} \times 40$ in.
Signed, lower right: *William S. Schwartz*

William S. Schwartz

Schwartz and his future wife Mona were fond of this picturesque Wisconsin locale where they married in 1939, and they often traveled there so he could paint. This peaceful image of an ideal small town in Middle America is typical of the American Scene painting that was popular in this period. It glorifies a fast-disappearing way of life that some saw as one of the country's unique strengths. Although his forms are clearly recognizable, Schwartz always distorts them to some extent, as is evident in the patterned sky, tilted telephone poles, and abstracted trees. SW

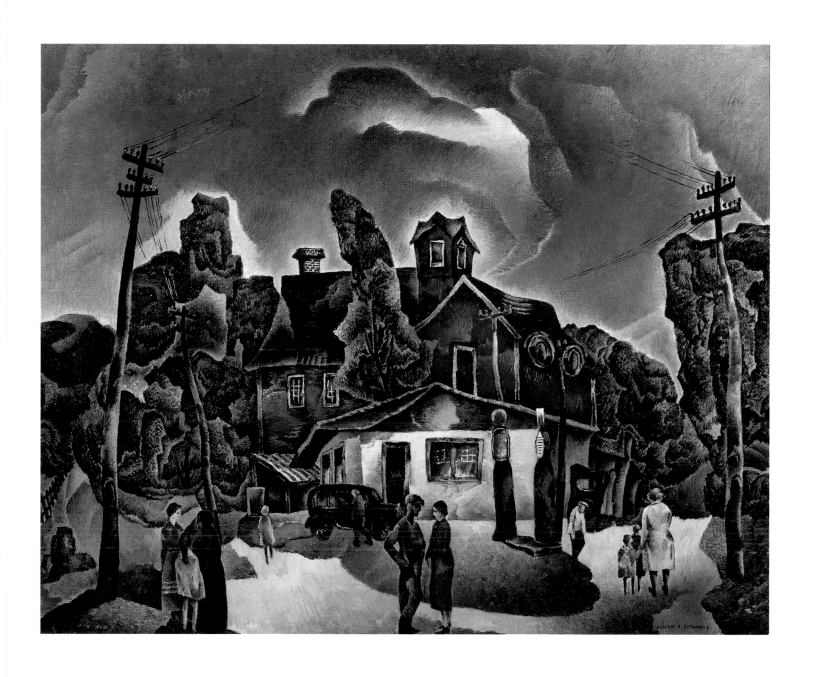

70

B R I G G S V I L L E , W I S C O N S I N , 1 9 3 6

Oil on canvas, 30⅛ × 36¼ in.
Signed and dated, lower right: *William S. Schwartz*

Anna
Lee
Stacey

1871–1943

NOTES

1. The particular theme of a woman reading in a semi-outdoor setting that provides a decorative natural backdrop can be seen in the most familiar works of two fellow Chicagoans: Pauline Palmer's *From My Studio Window* (1927, Union League Club of Chicago) and in Frederic Clay Bartlett's *Blue Rafters* (1919, AIC), and in several works by Karl Buehr.

After studies in her native Missouri, Anna Lee Stacey studied at The Art Institute of Chicago. Between 1900 and 1914 she made several trips to Europe for further instruction. Stacey worked in several media and painted portraits, genre scenes, and landscapes portraying French, Spanish, and Italian settings, as well as far-flung American subjects. Around 1891 she married John F. Stacey, a landscape painter and Art Institute teacher, with whom she often exhibited. They worked in studios in the Tree Studios Building, at Ohio and State Streets, which became the headquarters of Chicago's conservative artists.

Gardens and flowers numbered among Stacey's many subjects. Here, she combines that theme with her interest in portraiture in an image of an unidentified woman reading in what appears to be a screened-in porch. The painting taps a theme common among Impressionist painters: women of leisure in a garden setting.[1] Stacey's decorative handling of the thick paint in the branches, leaves, and flowers that form the backdrop to the figure suggests the influence of Post-Impressionism. The reader's face and form, however, are delineated with careful attention to contours and shadows, and she sits solidly in her upholstered rattan chair. The rigid framework of the screens behind her enframe and contain the riot of color and shapes of the garden outside, echoed within in the brilliant hues and dashed forms of the cut flowers that fill the lower left corner of the composition. WG

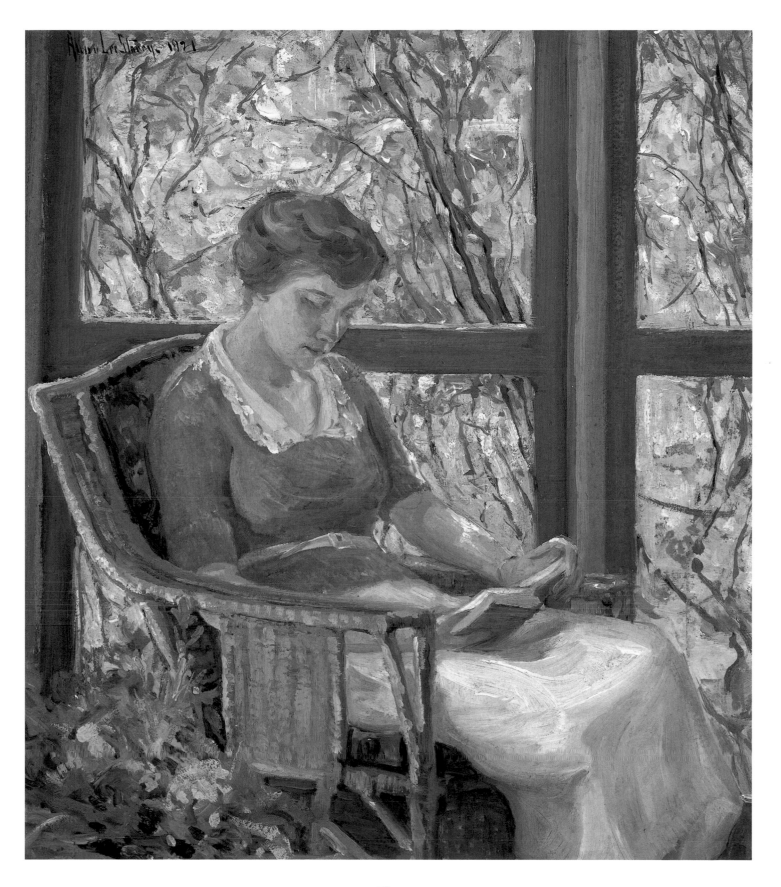

72

UNTITLED

[WOMAN READING], 1921

Oil on board, 16 × 14 in.
Signed and dated, upper left: *Anna Lee Stacey – 1921*

Frances Strain

1898–1962

NOTES

1. For biographical information, see Susan Weininger, "Frances Strain Biesel," in *Women Building Chicago, 1790–1990, A Biographical Dictionary* (Bloomington: Indiana University Press, 854–56, 2001).

In addition to her lifelong work as a painter, Frances Strain was an ardent advocate for other artists in her roles as a founding member of several progressive artists' groups in the 1920s (the Chicago No-Jury Society of Artists and Ten Artists [Chicago]) and as the exhibition director of the Renaissance Society at the University of Chicago from 1941 to 1962. She worked tirelessly to bring modern art to the public. Born in Chicago, Strain attended the School of the Art Institute of Chicago and studied, as did many of her progressive contemporaries, with George Bellows and Randall Davey during their short teaching stints in the 1919–20 school year. Along with a number of other students, including her future husband Fred Biesel, Strain accompanied Davey to Santa Fe the following summer. There she met Ashcan School artist John Sloan, with whom she and Biesel returned to New York in the fall, staying for over a year to study with him before settling in Chicago in 1922. She and Biesel became acquainted with numerous artists and writers in Sloan's circle, as well as with the Society of Independent Artists, with which they both exhibited, and which served as a model for the Chicago No-Jury Society of Artists. They lived most of their married lives in Hyde Park and in their vacation home in Furnessville, Indiana, in a community of artist friends including Vin and Hazel Hannell. Strain and Biesel maintained a connection with Sloan and other acquaintances of this period that Strain was able to exploit in her curatorial work. Strain also participated in the Easel Division of the Illinois Art Project during the Depression.[1]

Strain and Biesel's friend and neighbor, the artist Emil Armin, also worked with them in the Southwest. In *The Visitor*, Armin is pictured in Biesel and Strain's Hyde Park studio surrounded by bright-colored Navaho rugs that are reminders of these trips, and a New Mexican pot filled with brushes of their trade. Stacked canvases are visible in the next room of the studio. On the wall behind Armin is a painting by Fred Biesel. While Strain experimented with a number of styles over the years, the thick application of paint in brilliant colors is characteristic of her work of this period. SW

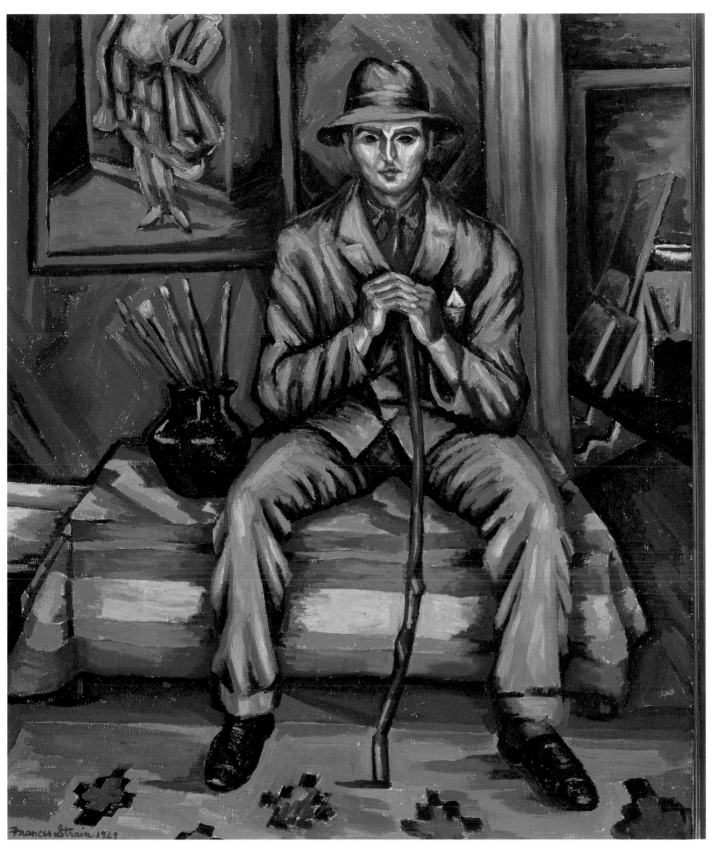

73

THE VISITOR

[EMIL ARMIN], 1929

Oil on canvas, 36 × 30 in.
Signed and dated, lower left: *Frances Strain 1929*

A. Frederic Tellander

1878–1977

NOTES

1. Tellander's introduction to *An Exhibition of Paintings by Frederic Tellander* (exh. cat., Chicago Galleries Association, 1926), unpaged. A manuscript note titled "Artist's Data fr. Paxton, Ill. Record 11/15/27" in the pamphlet file for Tellander in the Ryerson Library, AIC, records that Tellander studied with Samuel B. Wright (a pupil of Thomas Eakins) in Valparaiso, Indiana. Esther Sparks, "A Biographical Dictionary of Painters and Sculptors in Illinois, 1808–1945" (Ph.D. dissertation, Northwestern University, 1971), vol.2, 632, notes that he studied in Rome and Paris.

2. John W. Stamper, *Chicago's North Michigan Avenue: Planning and Development, 1900–1930* (Chicago and London: University of Chicago Press, 1991), 35.

3. Visible from left to right are the domed classical tower of the Jewelers Building (1926: 35 E. Wacker), the 38-story white Pittsfield Building (1927: 55 E. Washington), the slender, needlelike Mather Tower (1928: 75 E. Wacker), and the tan limestone of the Gothic-style Willoughby Tower (1929: 8 S. Michigan). Just to the right of the latter appears a bit of the dark, steeply hipped roof of the Tower Building, the headquarters of the Montgomery Ward Company (1899, tower removed in 1947: 6 N. Michigan), and far up Michigan Avenue gleams the brilliant white glazed terra-cotta facade of the Wrigley Building (1921: 410 N. Michigan). To its right the pinnacle of the 333 N. Michigan Avenue building (1928) emerges above the pinkish bulk of the Bell Building (1925: 307 N. Michigan). The skyscraper that appears to be next door is actually north across the river at 435 North Michigan Avenue: the gothic Tribune Tower, completed in 1925. In the lower right corner of

the image is Grant Park, to the east of Michigan Avenue, still dominated at its north end by railroad tracks.

4. Tellander's composition recalls *July*, one of twelve mural panels of the months created by John Warner Norton for the Pierce School in Chicago in 1924–25. *July* is a roofline view of the city dominated by the new Tribune Tower, juxtaposed with two billowing American flags. See Jim L. Zimmer, *John Warner Norton* (exh. cat., Illinois State Museum, 1993), 23.

Frederic Tellander was born in the small east-central town of Paxton, Illinois, and claimed to be mainly self-taught as an artist.[1] He had a dual career as a landscape painter and commercial artist, and was adept at watercolor painting. His subjects included the landscape of New England, marines, and picturesque views of Italian cities, as well as Midwestern scenes. His well-crafted, accessible images of familiar settings found considerable favor in the 1920s.

Now known as the Britannica Center, the Straus Building, at 310 South Michigan Avenue, was designed by Pierce Anderson of the Chicago architectural firm Graham, Anderson, Probst & White and was completed in 1924.[2] Tellander's view, looking north up Michigan Avenue, appears to be taken from near the summit of the 28-story structure. It emphasizes the even greater height of several skyscrapers built in the years immediately before and after the Straus Building, in an era that favored soaring towers in commercial architecture.[3]

The construction of the Michigan Avenue Bridge and Wacker Drive in the early 1920s stimulated new development on Michigan Avenue on both sides of the river. Tellander's panorama of the Michigan Avenue horizon celebrates the dynamism of Chicago's urban architecture and, by implication, the city's commercial life. The upbeat tone of the image is accentuated by the billowing cumulus clouds that form a backdrop to the parade of skyscraping towers and by the Stars and Stripes rippling in the gusty wind just outside the window.[4] Only the red drapes that frame the view and the objects on the windowsill in the foreground—a metallic bottle and a female figurine whose billowing skirts mimic the motion of the flag outside—anchor the viewer prosaically in an office interior. WG

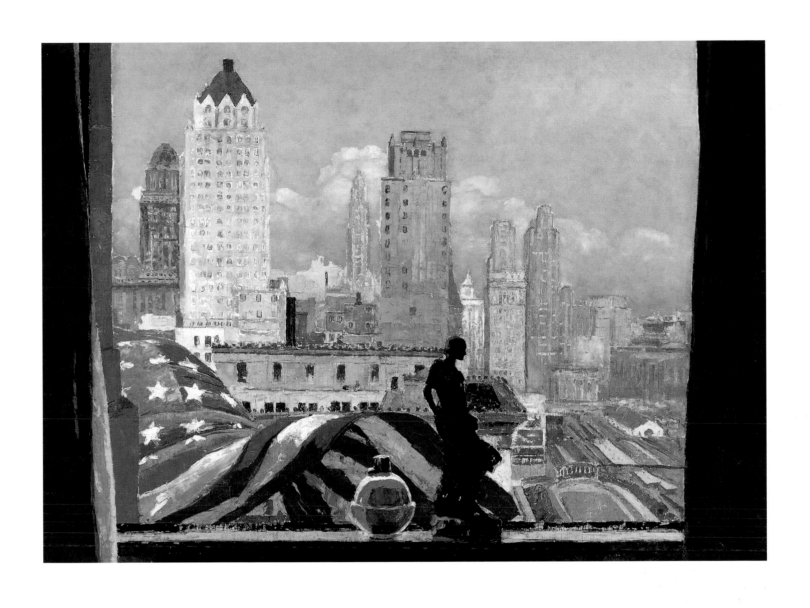

NORTH FROM STRAUS TOWER, 1930

Oil on canvas, 40 × 55 in.
Signed and dated, lower right: *Frederic Tellander '30*

A. Frederic Tellander

(CONTINUED)

NOTES

1. In subject, composition, and brushwork this work appears to be related to Tellander's *Wheatfields*, an undated vertical landscape probably painted around the same time, which is said to show a scene in northwestern Wisconsin. Until 1984 it was owned by the Union League Club of Chicago. *Art in the Union League Club* (Chicago: Union League Club, [1971]), 17.

2. Tellander's introduction to *An Exhibition of Paintings by Frederic Tellander* (exh. cat., Chicago Galleries Association, 1926), unpaged.

This painting probably represents the gently rolling moraines of Wisconsin.[1] The brilliant red of the dominant tree is set among the gradually receding planes of gentle slopes. Within the nearly square proportions of the canvas, the relatively low horizon emphasizes the grandeur of the Midwestern sky, here filled with billowing fair-weather cumulus clouds set in a clear blue canopy. The execution of the sky in a somewhat facile, rapid manner reflects Tellander's experience as a commercial artist and something of the muscular, streamlined look of contemporary design. The result is an optimistic image consistent with Depression-era nostalgia for the American heartland. Such nostalgia was prompted not only by economic and political concerns. For Tellander and many other conservative artists, the "wholesomeness and saneness" of "an openhearted attitude toward nature," was also an antidote to the "warped vagaries" of Modernism.[2] WG

75

UNTITLED

[LANDSCAPE WITH RED TREE], 1932

Oil on canvas, 29 × 30 in.
Signed and dated, lower right: *Frederic Tellander '32*

Alice De Wolf Kellogg Tyler

1862–1900

NOTES

1. Tyler's birthdate is listed variously as 1864 and 1866; recent research confirms that 1862 is correct. Annette Blaugrund, et al., *Paris 1889: American Artists and the Universal Exposition* (exh cat., Pennsylvania Academy of the Fine Arts in association with Harry N. Abrams, Inc., 1989), 177–78 and note #1. See also Melissa Pierce Williams, "Alice Kellogg Tyler 1866–1900: Private Works" and its untitled supplement, undated small catalogues published by Williams & McCormick American Arts. One of Kellogg's fellow students at the Chicago Academy of Fine Arts was the painter Arthur B. Davies, with whom she developed a close relationship that ended with his marriage in 1892.

2. Tyler's letters home from Paris are on deposit in the Archives of American Art, Smithsonian Institution. See Annette Blaugrund with Joanne W. Bowie, "Alice D. Kellogg: Letters from Paris, 1887–1889," *Archives of American Art Journal* 28, no. 3 (1988), 11–19. On Taft's comments see Williams, "Private Works," unpaged.

3. "Chicago Women In Art," *Chicago Times-Herald*, Feb. 12, 1899, AIC Scrapbook vol. 10, 118.

4. Williams, "Private Works."

Chicago native Alice Kellogg Tyler began her art studies at the Chicago Academy of Fine Arts (the predecessor of The Art Institute of Chicago), where her talents soon gained her the position of assistant teacher.[1] After two years of study in Paris, Kellogg returned to Chicago in 1889 to become what Lorado Taft described as a leader among the city's artists.[2] She was a popular teacher at the Art Institute and presided over the Palette Club, a women artists' group. Kellogg contributed several murals to the Women's Building at the World's Columbian Exposition of 1893, the year before she married Orno Tyler. The artist's promising career was cut short by her premature death, at age 37.

Tyler made her reputation for portraits and academic figure paintings early, but she also executed landscapes.[3] In the 1890s, she painted numerous small oil paintings in which she experimented with the new techniques of Impressionism. Sketchlike in scale, spontaneity of brushwork, and compositional informality, these often portrayed family members and friends. Among the most finished is this image of Tyler's sister Mabel Rich, who had also studied at the Art Institute, and her son, John.[4] Pictured enclosed by their outdoor setting, they reiterate Tyler's favorite theme of mother and child. Though thinly painted and sketchily rendered, the figures convey the intense familial communion of parent and child in the intimate familiarity of their pose and their seeming unconsciousness of the viewer. WG

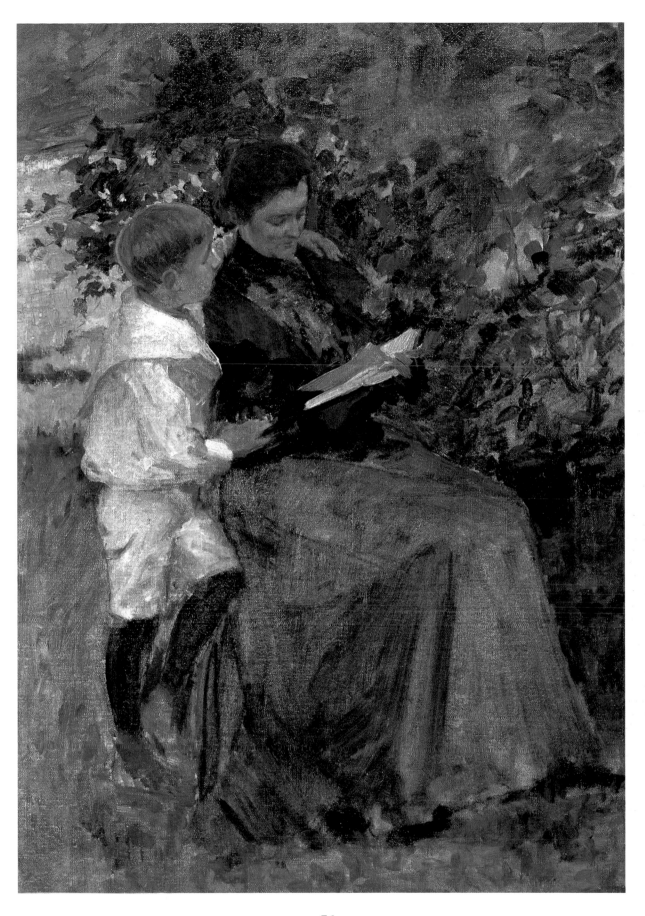

<div align="center">

76

U N T I T L E D

[M A B E L A N D J O H N I N T H E G A R D E N], c. 1 8 9 8

Oil on canvas, 27 × 19¹⁄₂ in.
unsigned

</div>

Laura Van Pappelendam

1883–1974

NOTES

1. The Ph.B. (Bachelor of Philosophy) was the standard undergraduate degree in the College of Arts, Literature, and Science at the University of Chicago at this time. It was later replaced with the more common B.A. degree. Unless otherwise noted, biographical information is dependent on the materials assembled by Edna McLeod, the artist's niece.

2. In a letter dated 26 July 1930, she wrote a letter to the Dean of the Art Institute School, Charles Fabens Kelley, explaining her reasons for wishing to extend her summer visit to study with Rivera: "Nothing could mean more to me: I am in second heaven at the prospect. ... I know this experience will enlarge my viewpoint and so indirectly should have effect upon my teaching. I am just wild to do it!" This is cited in Sandra D'Emilio, "Laura Van Pappelendam: A Lively and Generous Spirit," *Antiques and Fine Art* VIII:3 (March–April 1991), 117.

Raised in Keokuk, Iowa, Laura Van Pappelendam was trained at the School of the Art Institute, where she earned a degree in the teacher training department in 1909. She continued studying at the School and at University of Chicago, where she was awarded a Ph.B. degree in 1929.[1] Like so many of her progressive Chicago contemporaries, she was influenced by George Bellows. She also was inspired by the Russian mystic painter Nicolas Roerich, who was extremely popular in the 1920s. Van Pappelendam taught for 50 years at the School of the Art Institute (1909–59) and is remembered by many students as an inspiring, enthusiastic, and gifted teacher. At the same time, she was an instructor at the University of Chicago. She spent her summers on painting trips to a wide variety of locales, particularly Santa Fe, New Mexico, where she cultivated a circle of artist friends; Mexico, where she studied with Diego Rivera in 1930;[2] and Keokuk Iowa, where her stepmother and aunt still lived. She exhibited widely both nationally and in Chicago, at the Art Institute juried annuals, at the Renaissance Society, the Arts Club, and with the Chicago Society of Artists. She tended to affiliate with more moderate or even conservative exhibition groups such as the Chicago Galleries Association. She was a prolific artist who continued to produce the landscape and still-life subjects for which she was known for most of her long life.

Executed in Keokuk, Iowa, where Van Pappelendam had a studio in her stepmother's home, *Around a Birdhouse* is a characteristic work by the artist, who favored outdoor scenes done both in and around Chicago, and on her frequent trips to Mexico and the American Southwest. The broken brushstrokes and bright colors are combined with a carefully composed and planned composition anchored by the blocky buildings on either side of the picture. SW

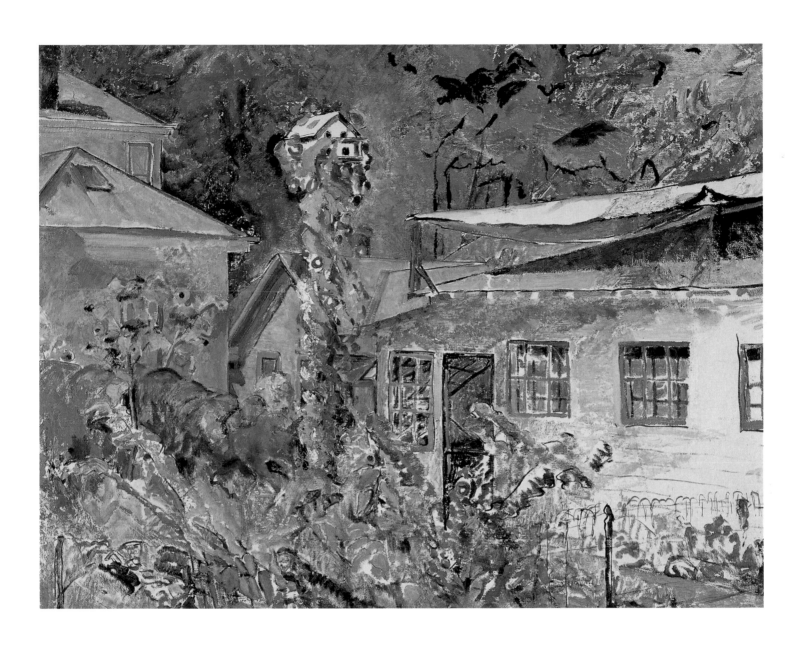

77

AROUND A BIRD HOUSE, c. 1943

Oil on board mounted on masonite, 29 × 36½ in.
unsigned

Rudolph Weisenborn

1881–1974

NOTES

1. For information on Weisenborn, see C. J. Bulliet, "Rudolph Weisenborn," Artists of Chicago, Past and Present, no. 11, *Chicago Daily News* 4 May 1935; Kenneth Hey, "Five Artists and the Chicago Modernist Movement, 1909–1928," Ph.D. diss., Emory University, 1973; Paul Kruty, "Declarations of Independents," and Susan S. Weininger, "Modernism and Chicago Art," in Sue Ann Prince, ed. *The Old Guard and the Avant-Garde* (Chicago: University of Chicago Press, 1990), 77–93 and 67–70.

Rudolph Weisenborn's early years were spent at farm labor in South Dakota, Wisconsin, Minnesota, and other Midwestern states. He began studying art in Denver and supported himself doing commercial work while painting in the academic style fashionable in the early years of the twentieth century. He arrived in Chicago at about the time as the Armory Show (1913), and was gradually drawn to Modernist styles. Although Weisenborn began his transformation under the influence of the flamboyant and charismatic Stanislaus Szukalski, producing numerous eccentric portraits of Chicagoans—both known and unknown—made up of sharp, flattened geometric forms, he soon developed a personal style that was wholly abstract. He taught at the Chicago Academy of Fine Arts from 1922–34, after which he taught privately from his studio for many years. He was an active and vocal member of the "radical" art community in Chicago and a founder of such independent groups as the Cor Ardens, Chicago No-Jury Society of Artists, and the Neo-Arlimusc. He exhibited in the Chicago and Vicinity shows at the Art Institute many times and was dedicated to furthering the cause of artists in Chicago.[1]

Of the many artists working in Chicago in the early-twentieth century, none was more engaged with abstraction than Rudolph Weisenborn. Although on occasion, he included recognizable forms in his work, he never painted in the representational modes so popular in the inter-war period, but continued to produce an original sort of abstract painting throughout his long life. He favored heavy paint application, as is evident in this geometric composition based on primary colors, typical of his approach. SW

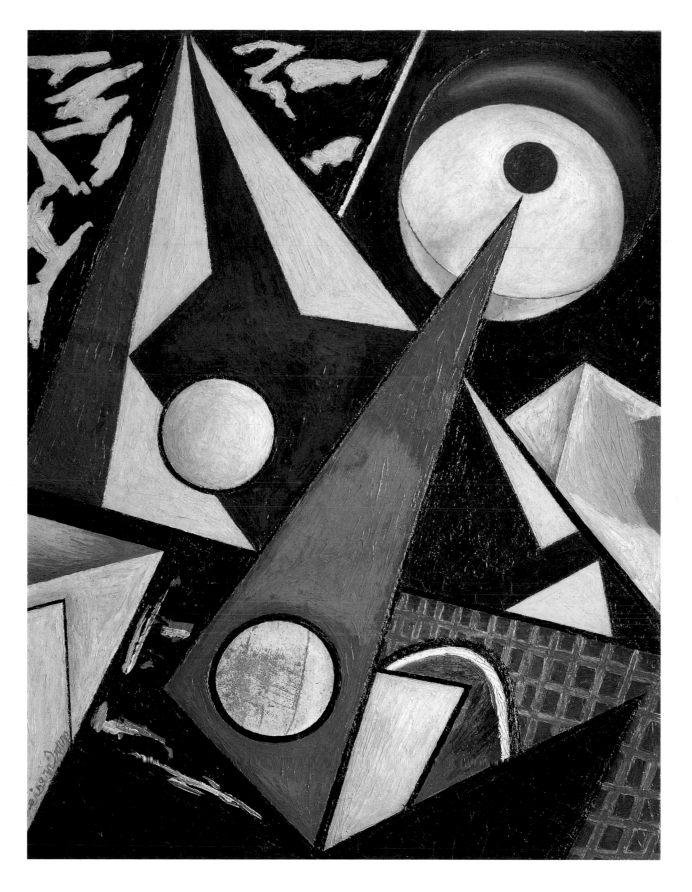

78

UNTITLED

[GEOMETRIC ABSTRACTION], 1939

Oil on masonite transferred to canvas, 48 × 36 in.
Signed and dated, lower left: *1939 Weisenborn*

Abercrombie

(Continued from page 84)

NOTES: ABERCROMBIE

3. Weininger, *Gertrude Abercrombie*, 18-20, 24, for a discussion of these personal emblems and *Self-Portrait of My Sister*.

4. Ibid., 19, for Abercrombie's purposeful identification of herself as a witch.

NOTES: A. E. ALBRIGHT

10. Albright, *For Art's Sake*, 115.

NOTES: ANGAROLA

3. Richard Angarola in conversation with Powell Bridges.

one but herself in her painted images. Indeed, although I have argued elsewhere that all of her work can be seen as a kind of exploration of herself, the subject in this case leaves no doubt.[3] The elongated neck and sharp features contribute to a haunting quality often found in the many images Abercrombie painted that include a self-portrait, either as the main subject, as in *Self-Portrait of My Sister*, or as part of a landscape or interior scene. Personal emblems such as the bunch of grapes, the hat on which they are pinned, and the long black gloves reappear in numerous paintings by Abercrombie, in an almost infinite variety of combinations, so that even when they emerge in paintings without an identifiable self-portrait, they come to stand for Abercrombie herself.[4] Her witchlike appearance is also purposeful and is one of the guises through which she could exercise power in her art as well as her life. While certainly a recognizable image of the artist, *Self-Portrait of My Sister*, like most of Abercrombie's oeuvre, combines mystery and austerity with the self-exploration that enabled the artist to navigate and control the often chaotic inner world in which she lived. SW

Albright, A. E.

(Continued from page 88)

middle-class youth like his own offspring (the models for many of his pictures) and the necessity of his poor, rural child-models to fish or to gather berries for food. He was, in his own words, "really depicting their rural beauty and the charm of simple life,"[10] in images that glorified rustic youth for the pleasure of middle-class, adult urbanites. WG

Angarola

(Continued from page 98)

stylistic experiments inspired by the Post-Impressionists, Fauvists, and Cubists to whom he was exposed in 1913, when the International Exhibition of Modern Art (known as the Armory Show) was shown at The Art Institute of Chicago.

The peaceful park in which the eponymous Bench Lizards are congregating could be the area of Lincoln Park in Chicago just across the street from the Roslyn Place home on the north side of Chicago where Angarola lived with his wife Marie and their two children Yvonne and Richard, until the couple divorced in 1923. According to Angarola's son Richard, the figures on the bench in the foreground represent his mother, his sister, and himself.[3] SW

Bartlett

(Continued from page 104)

With Bartlett's marriage to Helen Birch in 1919, he spent less and less time in Chicago. When Helen died in 1925, Bartlett was already beginning to suffer from the failing eyesight that made it increasingly difficult for him to paint. His own production had diminished considerably beginning in the late 1920s. He married Evelyn Fortune Lilly in 1931 and began to spend most of his time in Massachusetts and Florida at Bonnet House, the estate he inherited from his wife.

Unlike Bartlett's large decorative projects, [Still Life] shows his awareness of the Modernist artists whose work he so astutely collected. The bright colors, abundant patterning, and curvilinear shapes are reminiscent of Matisse, while the flattening of forms and two-dimensional emphasis suggest Picasso. Although this painting was exhibited in 1929, we might assume a date several years earlier, since his eyesight was quite poor by the late 1920s.[2] The Modernist style of this painting corresponds to the work Bartlett and his wife, Helen, were collecting in the early 1920s. Perhaps he was inspired by his intense involvement with these paintings to experiment a bit in his own work. SW

Biesel

(Continued from page 108)

Biesel and Strain lived and worked on the south side of Chicago and in the northwest Indiana community of Furnessville, near Chesterton, where they were part of an active artistic community that included their good friends Hazel and Vin Hannell, Ethel Crouch Brown, Lillian Hall, and many others. Beginning in the late 1920s they spent their summers in Indiana, where they painted and relaxed, and actively participated in events such as the Chesterton Art Fair.

[Winter Morning, or My Backyard], was done in the Hyde Park community where the Biesels lived most of their married life. Characteristically, it reflects the interests of Sloan, Bellows, and Davey, as well as the Regionalists who emerged in the late 1920s. The combination of urban realism and the choice of a view that stresses the small-town quality of neighborhood life bring together these two important American traditions. Biesel's peaceful image of life in his community reflects the government mandate to make images of the American Scene during the Depression; his backyard exalts the ordinary and glorifies the virtues associated with small-town life through the slice of reality he shows us. WG

NOTES: BARTLETT

2. Bartlett had a cataract operation in 1932, but it did not enable him to see well enough to paint. It was in this year that he purchased the last painting he was to acquire, Toulouse-Lautrec's *Ballet Dancers*. See Courtney Graham Donnell, "Frederic Clay and Helen Birch Bartlett: The Collectors," *Museum Studies* 12:2 (1986), 96.

Ford

(Continued from page 148)

NOTES: FORD

3. The guidebook *La Belgique Pittoresque (Picturesque Belgium)* (Chicago, 1933), 46–62, provides a detailed guide to the buildings in the village, with a map and photographs. There are also a number of photographs in *The Official Pictures of a Century of Progress Exposition, Chicago 1933*, intro. James Weber Linn (Chicago: The Lakeside Press, 1933), n.p. The photographs were taken by Kaufmann and Fabry Co., official fair photographers. The village was constructed in an amazing seventeen days ("Picturesque Belgium" *Official World's Fair Weekly*, 1:9 [25 June 1933], 47) and was one of the first of the international villages to be built (there is a photograph of the groundbreaking in Progress 3:14 [5 April 1933], 1).

NOTES: INGERLE

8. See their works reproduced in William H. Gerdts, *Art Across America* 2, 311. In this respect Ingerle's works also bear similarities to the landscapes of Daniel Garber of the Pennsylvania school of Impressionist painters. See Gerdts, *American Impressionism*, (New York: Abbeville Press, 1984), 237–38; *An American Tradition: The Pennsylvania Impressionists* (exh. cat., Beacon Hill Fine Art, New York, 1995), 18–21.
9. Frank Holland, "Memorial Show for 2 Conservatives," *Chicago Sun-Times*, Sept. 18, 1951 (in Scrapbook of Art and Artists of Chicago for 1951, 38).

series of displays commemorating various cultures, including the imagined sixteenth-century Belgian village, with its re-creations of typical and historic buildings dating from the Middle Ages through the sixteenth century, depicted in Ford's painting. She painted the village looking north toward the replica of the church of St. Nicolas of Antwerp (c. 1450) visible in the distance.[3] The representation of the traditional village contrasts with the vitality of the composition, augmented by the modern searchlights that illuminate the night sky in an abstract pattern, reflecting Ford's Modernist attitude. SW

Fursman

(Continued from page 160)

Maizie under the Boughs, painted in Saugatuck in 1915, reflects Fursman's familiarity with Modernist European art. The use of brilliant shades of green, yellow-green, purple, and pink arranged in broad, flat, unmodulated areas to create a figure in the out of doors suggests the experiments of Matisse, the Fauves, and the German Expressionists This work is part of a series of paintings depicting models posed in the landscape, and which was probably provided for the

students at the Saugatuck Summer School. Similar to a number of standing female figures of the period, it is very close to *In the Shade* of 1916, in which the palette and composition are strongly reminiscent of *Maizie under the Boughs*. While Fursman's interests in the figure in nature were well developed by this time, his movement beyond the fidelity to nature preached by his early teacher John Vanderpoel is also very clear. Although it was completed after the Armory Show's 1913 appearance in Chicago, *Maizie under the Boughs* still represents an early example of Modernist experimentation in the Midwest, by an artist who was in many ways a conservative. SW

Ingerle

(Continued from page 182)

branches, in a manner reminiscent of the Ozark landscapes both of Ingerle and of his friend Carl Krafft.[8] A later critic had such works in mind when he noted derisively that Ingerle excelled at "those over-large, squarish and semi-decorative landscapes ... [that] for many years were prominent in Art Institute shows."[9] WG

Checklist of the Collection

GERTRUDE ABERCROMBIE 1909–1977

1. *Self-Portrait of My Sister*, 1941[1]
 Oil on canvas, 27 × 22 in.
 Signed and dated, lower left: *Abercrombie 41*

 Provenance: Scott Elliott and Gordon Cameron family, c. 1976–94; Robert Henry Adams Fine Arts, Chicago, 1994.

 Exhibited: The Art Institute of Chicago, *52nd Annual Exhibition of American Paintings and Sculpture*, 1941–42, no.1; Associated American Artists, New York, 1946, no.9 [solo exhibition]; Ohio University, Athens, 1947; Chicago Public Library, Art Room, 1948, [solo exhibition]; Mandel Brothers Gallery, Chicago, 1953, *Exhibition of Chicago Artists' Self-Portraits*; Newman Brown Gallery, Chicago, 1953 [solo exhibition]; John Fordon Gallery, Aurora, Illinois, 1953 [solo exhibition]; Hyde Park Art Center, Chicago, 1977, *Gertrude Abercrombie: A Retrospective Exhibition*, no. 25 [as *Self-Portrait*]; Illinois State Museum, Chicago and Springfield, 1991, *Gertrude Abercrombie*.

JEAN CRAWFORD ADAMS 1884–1972

2. *Untitled [Looking West from the Fine Arts Building]*, c. 1933
 Oil on canvas, 25½ × 32 in.
 unsigned

 Provenance: Studio Gallery of Barton Faist, Chicago, and Robert Henry Adams Fine Art, Chicago, 1990.

 Exhibited: Robert Henry Adams Fine Arts, Chicago, 1990, *Chicago: The Modernist Vision*; Mary and Leigh Block Gallery, Northwestern University, Evanston, Illinois, 1992, *Thinking Modern: Painting in Chicago, 1910–40*.

ADAM EMORY ALBRIGHT 1862–1957

3. *Untitled [Landscape with Six Children]*, c. 1914–15
 Oil on canvas, attached to plywood by the artist; 36 × 50 in.
 Signed, lower left: *ADAM EMORY ALBRIGHT*

 Provenance: The artist, to 1954 or 1955; Judy Holden Burns, 1954 or 1955 to 1986.

4. *Untitled [Venezuelan Landscape]*, 1917–18
 Oil on canvas, 31 × 35¾ in.
 Signed, lower left: *ADAM EMORY ALBRIGHT*

 Provenance: The artist, to 1954 or 1955; Judy Holden Burns, 1954 or 1955 to 1986.

IVAN LE LORRAINE ALBRIGHT 1897–1983

5. *From Yesterday's Day*, 1971–72
 Oil on canvas, 8½ × 15¼ in.
 Signed and dated, lower center and upper right: *Ivan Albright 1971*

6. *The Image After*, 1972
 Oil on canvas, 9½ × 15¼ in.
 Signed and dated, lower and upper center: *Ivan Albright 1972*

 Provenance: William Benton, 1972; Marjorie and Charles Benton, Evanston, Illinois to 1997.

 Exhibited: The Art Institute of Chicago, 1997, *Ivan Albright*, nos. 66a and b.

GEORGE AMES ALDRICH 1872–1941

7. *Untitled [Breton Landscape]*, c. 1926
 Oil on canvas, 31 × 38 in.
 Signed, lower left: *G Ames Aldrich*

 Provenance: A Grosse Pointe, Michigan, estate, to 1992; purchased from Vahlkamp Art Galleries, 1993.

ANTHONY ANGAROLA 1893–1929

8. *Bench Lizards*, 1922
 Oil on canvas, 36 × 44½ in.
 Signed, lower left

 Provenance: Estate of the artist to 1988; ACA Galleries, 1988; private collection, 1988–; ACA Galleries, 1995.

 Exhibited: The Art Institute of Chicago, *35th Annual Exhibition of American Paintings and Sculpture*, 1922, no. 12; Minnesota State Fair, Minneapolis, 1922; The Pennsylvania Academy of Fine Arts, Philadelphia, *118th Annual Exhibition of Paintings and Sculpture*, 1923, no. 439; Carnegie Institute, Pittsburgh, *The 1923 International Exhibition of Paintings*, 1923; Corcoran Gallery, Washington, D.C, *The Ninth Exhibition of Contemporary American Oil Paintings*, 1923–24; Detroit Institute of Arts, *100 Selected American Paintings*, 1924; Chicago Galleries Association, *Exhibition of William S. Schwartz and Anthony Angarola*, 1926–27, no. 9; The Art Institute of Chicago, *Memorial Exhibition*, 1929–30; ACA Galleries, New York, *Anthony Angarola: An American Modernist*, 1988; Mary and Leigh Block Gallery, Northwestern University, Evanston, Illinois, *Thinking Modern: Painting in Chicago, 1910–1940*, 1992.[2]

1. Abercrombie's records refer to this painting as *Portrait of Artist as Ideal–Self-Portrait of My Sister*. Abercrombie Papers, Archives of American Art, Smithsonian Institution, Roll 1433, frame 452.

2. This painting may have been exhibited elsewhere, but these additional venues have not been confirmed. A typescript "List of paintings by Anthony Angarola," in the Angarola Papers, Archives of American Art, Smithsonian Institution includes a mention of a showing in Cleveland; in a letter to his children of 19 November 1923, Angarola refers to an exhibition at the Krauschaar Gallery, New York, which included *Bench Lizards* (Angarola Papers, AAA); and an essay by Richard Angarola for the Illinois Historical Art Project (forthcoming) refers to an exhibition of the painting at the Beard Gallery, Minneapolis, 1923.

EMIL ARMIN 1883-1971

9. *Tawny Dunes, 1924*[3]
 Oil on canvas, 20 × 24 in.
 Signed and dated, lower right: *Emil Armin 24*

 Provenance: Gertrude [Helen] Strain; estate of
 Signe Hester; Garnett Biesel to 1990.

 Exhibited: The Kansas City Art Institute, Missouri,
 Exhibition of Paintings by Emil Armin, 1930; Illinois
 Art Gallery, Chicago, *Emil Armin: Escapes and
 Cityscapes*, 1995.

10. *North from Jackson*, 1934
 Oil on canvas, 20 × 24 in.
 Signed and dated, lower left: *Emil Armin 1934*

 Provenance: Ernest A. Feldmann, 1962;[4] Robert Henry
 Adams Fine Art, Chicago, 1997.

 Exhibited: Chicago Society of Artists, *Annual Exhibition*,
 1934, no. 22 (as *North of Jackson Street*); KAM Temple
 Community Center Gallery, Chicago, *Diamond Anniversary
 Exhibition*, 1958; Mary and Leigh Block Gallery,
 Northwestern University, Evanston, Illinois, *Thinking
 Modern: Painting in Chicago, 1910–1940*, 1992; Illinois Art
 Gallery, Chicago, *Emil Armin: Escapes and Cityscapes*, 1995.

FREDERIC CLAY BARTLETT 1873-1953

11. *Untitled [Still Life with Flowers, Newspaper, and Water
 on an Orange Tablecloth]*, c. 1929
 Oil on canvas, 31 × 28¹⁄₄ in.
 Signed, lower left: *Frederic Clay Bartlett*

 Provenance: Clay S. Bartlett, 1989.

 Exhibited: The Jordan Marsh Company, Boston, 1929,
 label on back "The Jordan Marsh Co.," March 1929.

MACENA BARTON 1901-86

12. *Untitled [Portrait of the Artist's Father with Industrial
 Landscape in Background]*, c. 1933
 Oil on canvas, 36 × 30 in.
 Signed, lower left: *Macena Barton*

 Provenance: Tree Studio Gallery, Chicago, 1990.

FRED BIESEL 1893-1954

13. *Untitled [Winter Morning or My Back Yard, 5542 S.
 Dorchester]*, before 1936
 Oil on canvas, 30 × 40 in.
 Signed, lower right: *Fred Biesel*

 Provenance: Estate of the artist, 1954–62; Garnett Biesel,
 1962–90.

 Exhibited: The Art Institute of Chicago, *40th Annual
 Exhibition by Artists of Chicago and Vicinity*, 1936, no. 23;
 Marshall Field Galleries, Chicago, *10th Annual Exhibition
 of the 10 (Chicago)*, 1938; World's Fair Exhibition, New
 York, 1939; Layton School of Art, Milwaukee, 1946.[5]

DANIEL FOLGER BIGELOW 1823-1910

14. *Untitled [Landscape]*, c. 1895
 Oil on canvas, 24 × 42 in.
 Signed, lower right: *D F Bigelow*

 Provenance: Chicago Art Galleries sale, March 13, 1964,
 lot 1074; Keggereis family, Elkhart, Indiana; Jack
 Turnock, M.D., Elkhart, Indiana, to 1994.

JOSEPH PIERRE BIRREN 1865-1933[6]

15. *September Valley*, c. 1925
 Oil on board, 20 × 24 in.
 Signed, lower left: *Joseph Birren*

 Provenance: Wedding gift from the artist's widow to
 Robert (the artist's great-nephew) and Jeanne Birren
 in 1942, to 1989.

AARON BOHROD 1907-92

16. *State and Grand*, 1934
 Oil on [panel] board, 40³⁄₄ × 30 in.
 Signed and dated, lower right: *Aaron Bohrod 34*

 Provenance: The artist, to 1975.

 Exhibited: Madison Art Center, Madison, Wisconsin,
 Aaron Bohrod: A Retrospective Exhibition, 1929–1966,
 1966, no. 23 (as *North State Street, Chicago*); Terra
 Museum of American Art, Chicago, *200 Years of American
 Painting from Private Chicago Collections*, 1983; Mary
 and Leigh Block Gallery, Northwestern University,
 Evanston, Illinois, *Thinking Modern: Painting in Chicago,
 1910–1940*, 1992.

3. In Armin's records, he lists this painting under the year 1925. In the same ledger, he records its owner as Gertrude Strain. Strain was the sister of artist Frances Strain, Garnett Biesel's mother. Emil Armin papers, Archives of American Art, Smithsonian Institution, Washington, D.C., Roll 3769, frame 1181.

4. Armin noted the name Ernest A. Feldmann and the date 1962 in his records. Emil Armin papers, Archives of American Art, Smithsonian Institution, Roll 3769, frame 1182.

5. The painting was illustrated in the *Milwaukee Journal*, 24 November 1946; an unattributed review of 10 November 1946 titled "Biesel-Strain Paintings in Layton Here" describes the different way in which Biesel and Strain interpreted the view from the back window of their house: "Miss Strain's picture ... reveals her strong interest in pattern. Mr. Biesel's picture ... shows his interest in color. It is hard to realize that the pictures are of an identical view." Biesel Family Papers, Archives of American Art, Smithsonian Institution, Washington, D.C., Roll 4208, frame 875.

6. *Who Was Who in American Art* and an obituary (unidentified clipping in AIC Scrapbook, vol. 62, p.10) give 1864 as Birren's year of birth and this has been corroborated by Birren family members, according to Joel Dryer, Director, Illinois Historical Art Project. However, Birren gave 1865 as the date in biographical questionnaires completed by the artist for the Art Institute in 1918 and 1929 (collected in scrapbooks under the title *Illinois Artists*, in the Ryerson Library, AIC, vol. 2 [G–K]).

17. *North Clark Street*, 1938
Oil on board, 24 × 32 in.
Signed and dated, lower left[7]: *Aaron Bohrod 38*

Provenance: Oehlschlager Galleries, to 1973; Breslow Collection, to 1988; consigned to Sazama Brauer Gallery, Chicago, 1988–89.

Exhibited: University of Wisconsin, Madison, Madison Memorial Union, *Aaron Bohrod Paintings*, 1972; Sazama Brauer Gallery, Chicago, *Aaron Bohrod Retrospective Exhibition*, 1988.

CHARLES FRANCIS BROWNE 1859–1920

18. *Untitled [Landscape with River and Boat]*, c. 1908
Oil on canvas, 20 × 28 in.
Signed, lower right: *C F Browne*

Provenance: Purchased at Leslie Hindman Auctioneers, Chicago, Oct. 16, 1988, lot 231.

19. *Autumn Hillside*, 1917
Oil on canvas, 24 × 30 in.
Signed and dated, lower right: *C F Browne 1917*; inscribed on verso: *Autumn Hillside/Eagle's Nest Bluff– Oregon–Ill./Ch. Fr. Browne Oct 1917*

Provenance: Milligan Antique Galleries, Evanston, Illinois, to 1988.

Exhibited: The Artists' Guild, "Special Exhibition by Charles Francis Brown, A.N.A." 1917, #10; AIC, "Paintings by Charles Francis Browne," Dec. 16, 1919– Jan. 22, 1920, #20.

EDGAR SPIER CAMERON 1862–1944

20. *Santa Cruz*, c. 1917–21
Oil on canvas, 24 × 29 in.
Signed, lower left: *E Cameron/Santa Cruz*

Provenance: Purchased from Marjorie L. Kimberlin, niece of the artist's wife, Marie Gelon Cameron, 1992.

FRANCIS CHAPIN 1899–1965

21. *Untitled [Red House and Elevated Train]*, c. early 1930s
Oil on canvas, 29³/₄ × 24³/₄ in.
Signed, lower right: *Francis Chapin*

Provenance: Estate of the artist; The Francis Chapin Collection, 1991.

22. *City Arabesque*, before 1943
Oil on canvas mounted on masonite, 31¹/₄ × 44 in.
Signed, lower right: *Francis Chapin*

Provenance: Estate of the artist; The Francis Chapin Collection, 1992.

Exhibited: Whitney Museum of American Art, New York, *Annual Exhibition of Contemporary American Art*, 1943, no. 17 (as *City Arabasque*); Mortimer Brandt Galleries, New York, 1943.

WILLIAM CLUSMANN 1859–1927

23. *Old Stone Bridge, Garfield Park*, 1917
Oil on canvas, 26 × 30 in.
Signed and dated, lower right: *W CLUSMANN 1917*

Provenance: Purchased from Eckert Fine Art, Indianapolis, 1988.

24. *Bandshell, Garfield Park*, 1917
Oil on canvas, 18¹/₄ × 24 in.
Signed and dated, lower right: *W CLUSMANN 1917*

Provenance: Sotheby's, New York, sale #5644, 12/3/87, lot 266 (illus.) (as *Jackson Park, Chicago*); Barry Kassel, Pound Ridge, New York, to 1989.

CHARLES WILLIAM DAHLGREEN 1864–1955

25. *Deserted Cabin*, c. 1920
Oil on canvas, 16 × 20 in.
Signed, lower right: *Dahlgreen*

Provenance: Purchased from Grant Dahlgreen (the artist's son), 1989.

Exhibited: "Paintings and Etchings of Brown County, Indiana, by Charles W. Dahlgreen." John Herron Art Institute, Indianapolis, Sept. 1923.[8]

26. *Wolf River*, c. 1927
Oil on board, 24 × 30 in.
Signed, lower right: *Dahlgreen*

Provenance: Purchased from Robert Henry Adams Fine Art, Chicago, 1989.

27. *Refreshment*, c. 1931–35
Oil on canvas, 42 × 48 in.
Signed, lower right: *Dahlgreen*; inscribed on verso: *REFRESHMENT/No 3*

Provenance: Purchased from Tree Studio Gallery, Chicago, 1990.

Exhibited: "Exhibition of Paintings and Sculpture by Artist Members," Austin, Oak Park and River Forest Art League, Dec. 1938, #6; Dahlgreen solo exhibition, Austin, Oak Park and River Forest Art League, 1944.

7. Bohrod had continued to work on the painting while it was in his possession, adding the date '67 to the painting when he completed his small corrections. The later date was removed with Bohrod's permission when the painting came into the Bridges Collection. According to Bohrod, in a letter to Mr. Breslow of 16 September 1988, there were not any substantive changes to the original painting, therefore the later date was not really necessary.

8. *Indianapolis News*, Sept. 15, 1923, reported that *Deserted Cabin* was among the paintings exhibited.

GUSTAF DALSTROM 1893–1971

28. *The Bridge, South Pond [Lincoln Park]*, 1924
Oil on board, 26 × 30 in.
Signed and dated, lower left: *G. Dalstrom*

 Provenance: Estate of Gustaf Dalstrom and Frances Foy,
Chicago, to 1971; Estate of George Lee, Chicago; Robert
Henry Adams Fine Art, Chicago, 1993.

 Exhibited: Chicago Historical Society, [Exhibition of
Lincoln Park Paintings with Frances Foy], 1948.[9]

29. *Untitled [School Yard, Abraham Lincoln School, Chicago]*,
c. 1932
Oil on board, 28 × 24 in.
Signed, lower right: *G. Dalstrom*

 Provenance: Robert Henry Adams Fine Arts, Chicago,
1991.

 Exhibited: The Art Institute of Chicago, *45th Annual
Exhibition of American Paintings and Sculpture*, 1933,
no. 54; 10 Artists (Chicago), *3rd Annual Exhibition*,
1932, no. 14.[10]

MANIERRE DAWSON 1887–1969

30. *Fireman*, 1912
Oil on board,[11] 28 × 21 in.
Signed and dated, lower center: *Dawson 12*

 Provenance: Estate of the artist, 1969; Mrs. Lili Dawson,
1979; Dr. Lewis Obi, Jacksonville, Florida, 1979–94;
Tilden-Foley Gallery, New Orleans, 1994.

 Exhibited: National Museum of American Art,
Washington, D.C., 1984; Tilden-Foley Gallery,
New Orleans, 1989.

JULIO DE DIEGO 1900–79

31. *Maxine [the artist's wife]*, 1940
Oil on board, 48 × 30 in.
Signed and dated, lower right: *de Diego '40*

 Provenance: Kiriki de Diego Metzo and Vincent Metzo,
New York, 1979–92.

32. *Spies and Counterspies*, 1941
Oil on masonite, 24 × 28 in.
Signed and dated, lower right: *de Diego*

 Provenance: Kiriki de Diego Metzo and Vincent Metzo,
New York; Fletcher Gallery, Woodstock, New York, 1996.

 Exhibited: The Art Institute of Chicago, *46th Annual
Exhibition by Artists of Chicago and Vicinity*, 1942, no. 36.

RUTH VAN SICKLE FORD 1897–1989

33. *Belgian Village [Chicago World's Fair]*, c. 1933
Oil on canvas, 32 × 30 in.
Signed, lower right: *R. Ford*

 Provenance: private collector, Aurora, Illinois, ca. 1980–90;
Tree Studio Gallery, Chicago, 1990.

34. *Jenny [at Old Lyme]*, c. 1935
Oil on canvas, 36 × 30 in.
Signed, lower right: *R. Ford*

 Provenance: Barbara Ford Turner, Orchard Lake,
Michigan, 1997.

 Exhibited: The Art Institute of Chicago, *39th Annual
Exhibition by Artists of Chicago and Vicinity*, 1935,
no. 61 (winner of Chicago Women's Aid Prize of $100);[12]
Chicago Academy of Fine Arts, *Exhibition of Oils and
Watercolors*, 1936.

35. *State and Ohio*, c. 1935
Oil on canvas, 72 × 54 in.
Signed originally, lower left and again in 1978, lower right:
R. Ford

 Provenance: On loan to Aurora public schools district
129 (Franklin Junior High School, Aurora High School,
administrative offices), c. 1935–91; Barbara Ford Turner,
Orchard Lake, Michigan, c. 1991–93.

 Exhibited: Rockford College Art Gallery, Rockford, Illinois,
*The "New Woman" in Chicago, 1910–45: Paintings from
Illinois Collections*, 1993; traveled to Illinois Art Gallery,
Chicago, Illinois State Museum, Lockport, 1994; Chicago
Cultural Center, *Capturing the Sunlight: The Art of Tree
Studios*, 1999.

9. The Dalstroms exhibited 48 of
their Lincoln Park paintings at the
Chicago Historical Society in 1948.
See Genevieve Flavin, "Exhibit
Reveals Lincoln Park of Earlier Day,"
Chicago Sunday Tribune 8 August
1948 and "Dalstroms Capture 25
Years in Lincoln Park on Canvas,"
North Side Sunday Star 4 July 1948.
It is probable, but not verified, that
this painting was exhibited.

10. Tom Vickerman, "The '10' Decide
to Laugh Back at Their Rivals,"
Chicago Evening Post 16 February
1932, Biesel Family Papers, Archives
of American Art, Smithsonian
Institution, Roll 4208, frame 804;
Eleanor Jewett, "The Ten, Group
of Modernists, Hold Exhibition"
Chicago Daily Tribune 17 February
1932, Biesel Family Papers, AAA,
Roll 4208, frame 803.

11. According to Dawson's Inventory
the painting *Fireman*, of 1912, was
done on wood. The inventory is
reprinted in Randy J. Ploog, "Manierre
Dawson: A Chicago Pioneer of
Abstract Painting" (unpublished Ph.D.
dissertation, The Pennsylvania State
University, 1996), 205.

12. There is some confusion about the
date of the Chicago Woman's Aid
Prize, as the date is sometimes given
as 1932. The records of exhibitions
at the Art Institute confirm the date
of the exhibit and award at the Art
Institute as 1935. In addition, see
reproductions with reference to the
prize in *Chicago Times* 2 March 1935
and *Chicago Daily News* 31 January
1935. For an erroneous citation see,
for example, *Joliet Illinois Evening
Herald* 23 November 1941, where
the date is given as 1932 (Ruth
Van Sickle Ford papers, Archives
of American Art, Smithsonian
Institution, Washington, D.C., Roll
3955, frame 1165).

FRANCES FOY 1890–1963

36. *Cheese Seller [Paris Cheese Vendor, Paris, France]*, 1928
Oil on masonite, 27³/₄ × 24 in.
Signed and dated, lower left: *Frances Foy 1928*

Provenance: Alice and Grace Foy, to 1983;[13] Benjamin Thomas McCanna III (nephew of the artist), Woodstock, New York,1992; James and Jean Young, Real Estate and Fine Art, Woodstock, New York; Robert Henry Adams Fine Art, Chicago, 1994.

Exhibited: Exhibition of the work of Frances Foy and Gustaf Dalstrom, 1929;[14] Art Center Inc., New York, *Ten Artists (Chicago)*, 1930, no. 7.

37. *Portrait of Frances Strain*, 1932
Oil on board, 26 × 30 in.
Signed and dated, lower left: *Frances Foy 1932*

Provenance: Garnett Biesel, 1992

Exhibited: The Ten (Chicago), *3rd Annual Exhibition of the 10*, 1932, no. 18; Renaissance Society of the University of Chicago, Chicago, *Retrospective Exhibition of Frances Strain Biesel, 1898–1962: Oil Paintings, Water Colors, Drawings*, 1963; Rockford College Art Gallery, Rockford, Illinois, *The "New Woman" in Chicago, 1910–45: Paintings from Illinois Collections*, 1993 (also traveled to Illinois Art Gallery, Chicago, 1994; Illinois State Museum, Lockport, 1994).

38. *The Hostess*, 1936
Oil on board, 31³/₄ × 25³/₄ in.
Signed and dated, upper right: *Frances Foy 1936*

Provenance: Estate of Frances Strain;[15] Garnett Biesel, 1990.

Exhibited: The Ten (Chicago), *11th Annual Exhibition*, 1939.[16]

FREDERICK FRARY FURSMAN 1874–1943

39. *Maizie under the Boughs, [#16, Saugatuck, Michigan]*, 1915
Oil on canvas, 40 × 30 in.
Signed and dated, lower left: *FREDERICK F. FURSMAN 1915*

Provenance: Frederick F. Fursman Art Foundation 1948–89.

Exhibited: Charles Allis Art Library, Milwaukee, *Frederick Fursman: Retrospective Exhibition*, 1969; University of Wisconsin-Milwaukee, Art Museum, *Frederick Frary Fursman: A Rediscovered Impressionist*, 1991; Hollis Taggart Galleries, New York and Washington, D.C., *American Fauve: The Influence of Fauvism and Matisse on American Artists, 1904–18*, 1996.

40. *Sam Gibson [#23, Saugatuck, Michigan]*, 1924
Oil on canvas, 36 × 30 in.
Signed and dated, lower right: *FREDERICK F. FURSMAN 24*

Provenance: Fursman Art Foundation, 1948–89.

Exhibited: Ox-Bow Inn and The Saugatuck Women's Club, Saugatuck, Michigan, *Frederick Frary Fursman Retrospective Exhibition*, 1964; Charles Allis Art Library, Milwaukee, *Frederick Fursman: Retrospective Exhibition*, 1969; University of Wisconsin-Milwaukee, Art Museum, *Frederick Frary Fursman: A Rediscovered Impressionist*, 1991.

41. *Untitled [Young Woman]*, 1931
Oil on canvas, 36 × 30 in.
Signed and dated, lower right: *FFF 31*

Provenance: Frederick F. Fursman Art Foundation, 1948–89.

Exhibited: University of Wisconsin-Milwaukee, Art Museum, *Frederick Frary Fursman: A Rediscovered Impressionist*, 1991.

FREDERIC MILTON GRANT 1886–1959

42. *The Departure of Marco Polo*, c. 1926
Oil on canvas, 30 × 30 in.
Signed, lower right: *FREDERIC M. GRANT*

Provenance: Purchased from Barton Faist Gallery, Chicago, 1994.

Exhibitions: The Art Institute of Chicago, Chicago and Vicinity annual exhibition, 1926, #97 (winner of Logan Prize).

13. Although Thomas McCanna, Foy's nephew, asserted that his Aunts, Alice and Grace owned the painting from "early on" (Letter from Thomas McCanna to Powell Bridges, 24, February 1994), the Frances Foy and Gustaf Dalstrom papers contain a letter from Robert Harshe of The Art Institute of Chicago to Frances Foy of 22 November 1929, with a check for $100 for *Paris Cheese Vendor*, sold at the special summer exhibition. The $100 represented the sale price less 20% commission. Frances Foy and Gustaf Dalstrom papers, Archives of American Art, Smithsonian Institution, Washington, D.C., Roll 4077, frame 493.

14. J. Z. Jacobson, *The Chicagoan*, 17 August 1929, mentions the Foy-Dalstrom joint exhibition and calls the *Cheese Vendor* a most delight-ful work. Biesel Family Papers, Archives of American Art, Smithsonian Institution, Washington, D.C. Roll 4208, frames 663–64

15. The painting was given to Frances Strain in exchange for *From the Garden*. Biesel Family papers, Archives of American Art, Smithsonian Institution, Washington, D.C., Roll 4207, frame 444.

16. The painting was identified as *The Hostess* in this exhibition. See Biesel Family papers, AAA, Roll 4208, frames 472–73. An article titled "Ten holding 11th Annual Exhibition" *Chicago Sunday Herald and Examiner* 26 Feb 1939 calls Foy's *The Hostess* and *Summer* two of the best in the exhibition. See Biesel Family papers, AAA, Roll 4208, frame 845.

JAMES JEFFREY GRANT 1883–1960

43. *Untitled [Illinois Scene]*, c. 1930
 Oil on canvas mounted on board, 14 × 16 in.
 Signed, lower right: *J. JEFFREY GRANT*; inscribed
 on verso: *Illinois*

 Provenance: Alfred Muezenthaler (purchased from artist,
 1940s), to 1990.

44. *A Summer Day, Rockport, Massachusetts*, c. 1932
 Oil on canvas, 22 × 24 in.
 Signed, lower right: *J. JEFFREY GRANT*

 Provenance: Alfred Muezenthaler (purchased from artist,
 1940s), to 1990.

OLIVER DENNETT GROVER 1861–1927

45. *Untitled [Landscape with Woods, Fence, and Water]*, 1894
 Oil on canvas, 26³/₄ × 29 in.
 Signed and dated, lower left: *Oliver Dennett Grover '94*

 Provenance: Chicago Woman's Club; purchased from
 Leslie Hindman Auctioneers, Chicago, 1994.

46. *Untitled [Landscape with River]*, 1915
 Oil on canvas, 24 × 30 in.
 Signed and dated, lower center: *Oliver Dennett Grover
 1915*

 Provenance: Purchased from Lawrence Ashby, M.D.,
 Pekin, Illinois, 1989.

VAINO (VIN) MATHIES SETH HANNELL 1896–1964

47. *Lights*, c. 1927–28
 Oil on canvas, 24 × 18 in.
 unsigned (authenticated by Hazel Hannell)

 Provenance: Hazel Hannell, to c. 1980; Carmen
 Kammann, 1997.

LUCIE HARTRATH 1868–1962

48. *The Creek*, c. 1917
 Oil on canvas, 36 × 36 in.
 Signed, lower left: *L Hartrath*

 Provenance: Gift of the artist to Brother Toni at a
 monastery on Lake Wawasee, northern Indiana, to 1950s;
 Mrs. Seiffert (area resident); Byron and Son Galleries,
 Indianapolis, to 1989.[17]

 Exhibited: "Paintings by Lucie Hartrath," Carson Pirie
 Scott & Company, Chicago, May 15–June 10, 1917.[18]

CARL HOECKNER 1883–1972

49. *Sermon on the Mount*, 1933
 Oil on canvas, 45 × 74 in.
 Signed, lower right: *Carl Hoeckner*

 Provenance: Jeff Becker (nephew of the artist, received
 work as a gift from the artist); Robert Henry Adams
 Fine Art, Chicago, 1995.

 Exhibited: The Art Institute of Chicago, [solo exhibition],
 1935; *Chicago Charter Jubilee Exhibition of Paintings
 and Sculpture on Navy Pier*, 1938; Sheil School of Social
 Studies, Chicago, *Second Annual Art Exhibition: Paintings
 and Lithographs by Carl Hoeckner*, 1944, no. 7.[19]

RUDOLPH FRANK INGERLE 1879–1950

50. *Morn on the Tuckasegee*, 1928
 Oil on canvas, 28¹/₈ × 40¹/₄ in.
 Signed and dated, lower left: *R F Ingerle 28*

 Provenance: Mrs. Fran Horowitz, Minneapolis; Robert M.
 Hicklin, Jr., Inc., Spartanburg, South Carolina, to 1989.

 Exhibited: Rockford Art Association, Chicago Artists'
 Show, 1928, #21.

ALFRED JANSSON 1863–1931

51. *Untitled [Landscape with Snow]*, 1923
 Oil on canvas, 32¹/₂ × 38¹/₂ in.
 Signed and dated, lower right: *ALFRED JANSSON 1923*

 Provenance: Purchased from Hanzel Galleries, Inc.,
 Chicago, sale, Oct. 20, 1988, lot 23.

ALFRED JUERGENS 1866–1934

52. *The Back Porch*, c. 1911
 Oil on canvas, 27¹/₄ × 25¹/₄ in.
 Signed, lower left: *Alfred Juergens*

 Provenance: Purchased from Oak Park Art League, 1994.

 Exhibited: Pennsylvania Academy of the Fine Arts
 Annual Exhibition, 1913, #14.

53. *LaSalle Street at Close of Day*, 1915
 Oil on canvas, 40 × 30 in.
 Signed, lower left: *Alfred Juergens*

 Provenance: Northern Trust Company, to 1989.

54. *State Street, Armistice Day*, 1918
 Oil on canvas, 40 × 30 in.
 Signed, lower left: *Alfred Juergens*

 Provenance: By descent to Theodore Juergens (the artist's
 great-nephew), to 1989.

17. Information from Michael E.
 Byron letter to Powell Bridges,
 May 25, 1989.

18. Evelyn Marie Stuart, "Exhibitions
 at the Chicago Galleries," *Fine
 Arts Journal* 35 (May 1917), 375
 (illus.); C. J. Bulliet, in "Artists of
 Chicago. No.73 Lucie Hartrath,"
 Chicago Daily News, July 25,
 1936, states that Hartrath's
 Brown County painting *The
 Creek* won a purchase prize at

the recent (1936) annual sum-
mer Hoosier Salon at Lake
Wawasee. This probably refers
to another painting of the same
title, for it seems unlikely
that the artist would have exhibit-
ed there a painting executed
almost two decades earlier.

19. The catalog of this exhibition
 gives 1933 as the date for this
 painting.

55. *State Street*, c. 1920
Oil on canvas, 22 × 18 in.
Signed, lower left: *Alfred Juergens*

Provenance: Henry Dykhouse, to c. 1966; Mrs. Charlotte Whitney, Olivet, Michigan, to 1989.

Exhibited: All-Illinois Society of the Fine Arts, Inc., Chicago, April 1941; The Art Center: Kalamazoo Institute of Arts, Kalamazoo, Michigan, *Centennial Exhibition of the Works of Alfred Juergens 1866–1934*, #22 (illus.).

56. *A September Garden*, c. 1921
Oil on canvas, 40 × 30 in.
Signed, lower right: *Alfred Juergens*

Provenance: Vahlkamp & Probst (art dealers), Chicago, to 1988.

Exhibited: The Art Institute of Chicago, *Twenty-Fifth Annual Exhibition by Artists of Chicago and Vicinity*, 1921, #175.

CARL RUDOLPH KRAFFT 1884–1938

57. *Old Mill in Winter*, c. 1925–26[20]
Oil on canvas, 25 × 29 1/2 in.
Signed, lower right: *Carl R* [thumbprint] *Krafft*

Provenance: Purchased at Leslie Hindman Auctioneers, Chicago, Oct. 16–18, 1988, #351.

HERMAN MENZEL 1904–88

58. *Bridges, South Chicago*, c. 1937
Oil on canvas 22 × 28 1/4 in.
Signed, lower left: *HM*

Provenance: Estate of the artist (Mrs. Willa Menzel); Aaron Gallery, Chicago, 1996.

Exhibited: Chicago Historical Society, *Herman Menzel: A Rediscovered Regionalist*, 1994.

JAMES BOLIVAR NEEDHAM 1850–1931

59. *Untitled [Tugboats and Grain Elevator]*, 1890
Oil on board, 12 × 9 in.
Signed and dated, lower right: *J Need[ham]/90*

Provenance: Robert Henry Adams Fine Art, Chicago, to 2000.

Exhibited: "James Bolivar Needham," Robert Henry Adams Fine Art, Chicago, 1998.

60. *Untitled [Chicago River Scene]*, 1906
Oil on board, 6 1/2 × 8 in.
Inscribed on verso: *1906*

Provenance: Aaron Galleries, Chicago, to 2000.

61. *Halsted Street Bridge*, 1918
Oil on board, 14 × 21 in.
Signed, lower right: *J Needham*; inscribed on verso: *1918*

Exhibited: Chicago Historical Society, 1991.

Provenance: Derrick Beard, to 2001.

ARVID FREDERICK NYHOLM 1866–1927

62. *Untitled [Woman with Parasol]*, c. 1922
Oil on canvas, 27 × 22 in.
Signed, lower right: *A Nyholm*

Provenance: Purchased from Robert Henry Adams Fine Art, Chicago, 1997.

PAULINE LENNARDS PALMER 1867–1938

63. *The Winter Girl*, c. 1913
Oil on canvas, 39 × 31 3/4 in.
Signed, lower right: *Pauline Palmer*

Provenance: Edward B. Butler; by descent to his nephew, Floyd Butler Evans; Mrs. Floyd Butler Evans; art trade, Connecticut; The Caldwell Gallery, Manlius, New York, to 1995.[21]

Exhibited: Art Institute of Chicago, *Seventeenth Annual Exhibition of Works by Artists of Chicago and Vicinity*, 1913, #175; Art Institute of Chicago, *Paintings by Pauline Palmer*, 1913, #1.

FRANK CHARLES PEYRAUD 1858–1948

64. *Souvenir of the Berkshires*, 1914
Oil on canvas, 20 × 26 in.
Signed and dated, lower left: *F. C. Peyraud 14*; inscribed on verso: *Souvenir of the Berkshires Autumn 1914/to my Friend E. B. Butler Christmas 1914 F. C. Peyraud*

Provenance: E. B. Butler, c. 1914–?; purchased from Leslie Hindman Auctioneers, Sept. 25, 1988, lot 95.

65. *Autumn on the Des Plaines*, c. 1925–30
Oil on canvas, 28 × 34 in.
Signed, lower right: *F. C. Peyraud*;
inscribed on label originally attached to stretcher: *F. C. Peyraud/Autumn on the Desplaines/$500.00*

Provenance: Gift of the artist to Mrs. Frank (Agnes) Bennett, Green Bay, Wisconsin, from 1930s; purchased at Leslie Hindman Auctioneers, Chicago, Sept. 25, 1998, lot #95.

20. The painting's present title apparently originated in the catalogue of the 1988 auction at Leslie Hindman Auctioneers. This work is one of many images Krafft painted of the mill in wintertime, to which he gave similar titles and which he exhibited in various venues. For information about Krafft, I am grateful to Rob Adams of Robert Henry Adams Fine Art, Chicago, and Joel Dryer, Director, Illinois Historical Art Project.

21. Provenance information according to Joseph L. Caldwell, The Caldwell Gallery, Manlius, New York, in a letter to Powell Bridges dated Sept. 27, 1993.

TUNIS PONSEN 1891–1968

66. *Chicago River and Wrigley Building*, c. 1932
Oil on canvas, 32 × 36
Signed, lower right: *Tunis Ponsen*

Provenance: Campanile Galleries, 1992.

Exhibited: Muskegon Museum of Art, *The Lost Paintings of Tunis Ponsen*, 1994, Muskegon, Michigan (also traveled in Michigan to Kalamazoo Institute of Arts, 1995; Dennos Museum Centre, Traverse City, 1995; Flint Institute of Arts, 1995; Michigan State University, Kresge Art Museum, East Lansing, 1996; Hillsdale College, Sage Center for the Arts, Hillsdale, 1996; and, in Illinois, to Harold Washington Library Center, Chicago, 1996).

CADURCIS PLANTAGENET REAM 1838–1917

67. *Untitled [Apples]*, undated
Oil on canvas, 14 × 20 in.
Signed, lower right: *C. P. Ream*

Provenance: Christie's East, New York, sale no. 7103, Nov. 20, 1990, lot #62 (illus. in cat.).

WILLIAM S. SCHWARTZ 1896–1977

68. *Making a Lithograph*, c. 1929
Oil on canvas, 30 × 40 in.
Signed, lower center: *William Schwartz*

Provenance: Estate of the artist;[22] Hirschl and Adler Galleries, Inc., New York, 1986; Christie's, New York, 1994.

Exhibited: The Art Institute of Chicago, *Exhibition of Paintings and Lithographs by William S. Schwartz*, 1929, no. 6; University of Wisconsin, Assembly Room of the Memorial Union, Madison, *Exhibition of Paintings by William Schwartz*, 1929, no. 26; The Little Gallery, Cedar Rapids, Iowa, *An Exhibition of the Progressive Art of William S. Schwartz, Modernist*, 1930, no. 1; Municipal Art Gallery, Davenport, Iowa; The Oshkosh Public Museum, Oshkosh, Wisconsin; The Kansas City Art Institute, Missouri; The Museum of Fine Arts, Houston, Texas; The Public Art Gallery, Dallas, Texas; and University of Nebraska, Lincoln; *Paintings and Lithographs by William S. Schwartz*, 1930–31; and Hirschl and Adler Galleries, Inc. New York, Grand Rapids Art Museum, Michigan; Illinois State Museum, Springfield; State of Illinois Art Gallery Chicago, *The Paintings, Drawings, and Lithographs of William S. Schwartz, 1984–86.*

69. *Symphonic Forms No. 16*, c. 1932
Oil on canvas, 36⅛ × 40 in.
Signed, lower right: *William S. Schwartz*

Provenance: estate of the artist; Hirschl and Adler Galleries, Inc., New York, 1984; Bryce Bannatyne Gallery, Santa Monica, California, 1995.

Exhibited: The Art Institute of Chicago, *Exhibition of Paintings and Lithographs by William S. Schwartz*, 1935, no.11; Flint Institute of Art, Michigan, *Works of Six Chicago Artists*, 1935; Memorial Gallery of Art, Rochester, New York, *A Group Exhibition by Four from Chicago: Francis Chapin, Walter Krawiec, William Schwartz, and Aaron Bohrod*, 1936; The Associated American Artists Galleries, New York, *Exhibition of Paintings and Lithographs by William S. Schwartz*, 1943, no. 11; The Associated American Artists Galleries, Chicago, *Exhibition of Paintings and Watercolors by William S. Schwartz*, 1946, no. 1; and Hirschl and Adler Galleries, Inc., New York, Grand Rapids Art Museum, Michigan; Illinois State Museum, Springfield; State of Illinois Art Gallery, Chicago, *The Paintings, Drawings, and Lithographs of William S. Schwartz*, 1984–86, no. 26.

70. *Briggsville, Wisconsin*, 1936
Oil on canvas, 30⅛ × 36¼ in.
Signed, lower right: *William S. Schwartz*

Provenance: Estate of the artist, to 1982; Hirschl and Adler Galleries, Inc., New York, 1982; Mongerson-Wunderlich Gallery, Chicago, 1990.

Exhibited: The Art Institute of Chicago, *41st Annual Exhibition by Artists of Chicago and Vicinity*, 1937, no. 177.

JUNIUS RALSTON SLOAN 1827–1900

71. *Memphremagog, Vermont*, 1871
Oil on canvas, 10½ × 18½ in.
Signed with initials and dated, lower left: *JRS/Memphremagog Vt. 1871*

Provenance: St. Albus Fine Arts, Chicago, to 1982.

ANNA LEE STACEY 1871–1943

72. *Untitled [Woman Reading]*, 1921
Oil on board, 16 × 14 in.
Signed and dated, upper left: *Anna Lee Stacey—1921*

Provenance: Lynn B. Thomas, Avenue Arts, Hinsdale, Illinois, to 1993.

22. In a communication to Powell Bridges of 21 August 1994, the late Phyllis Helford, William Schwartz's stepdaughter, stated that the painting had been in storage between 1932 and 1980.

FRANCES STRAIN 1898–1962

73. *The Visitor [Emil Armin]*, 1929
Oil on canvas, 36 × 30 in.
Signed and dated, lower left: *Frances Strain 1929*

Provenance: Garnet Biesel; Carmen Kammann; Robert Henry Adams Fine Art, Chicago, 1992.

Exhibited: Ten Artists (Chicago), *2nd Annual Exhibition*, 1930, no. 28 (as *Portrait of Emil Armin*);[23] Rockford College Art Museum, Rockford, Illinois, *The "New Woman" in Chicago, 1910–45: Paintings from Illinois Collections*, 1993 (also traveled to Illinois Art Gallery, Chicago, 1994; Illinois State Museum Lockport, 1994).

A. FREDERIC TELLANDER 1878–1977

74. *North from Straus Tower*, 1930
Oil on canvas, 40 × 55 in.
Signed and dated, lower right: *Frederic Tellander '30*

Exhibited: The Art Institute of Chicago, *Forty-Third Annual Exhibition of American Paintings and Sculpture*, 1930, #182 (illus. in cat.); The Art Institute of Chicago, *Paintings by Frederic Tellander and Vladimir Rousseff*, July 23–Oct. 11, 1931, unnumbered.

Provenance: Hanzel Galleries auction, Chicago, Apr. 18–20, 1982; Robert Henry Adams Fine Art, Chicago, to 1993.

75. *Untitled [Landscape with Red Tree]*, 1932
Oil on canvas, 29 × 30 in.
Signed and dated, lower right: *Frederic Tellander '32*

Provenance: St. Albus Fine Arts, 1988.

ALICE DE WOLF KELLOGG TYLER 1862–1900

76. *Untitled [Mabel and John in the Garden]*, c. 1898
Oil on canvas, 27 × 19 1/2 in.
unsigned

Provenance: Estate of the artist; Williams & McCormick American Arts, Columbia, Missouri, to 1987; Henry C. and Virginia Llop, Minneapolis, to 1997.

LAURA VAN PAPPELENDAM 1883–1974

77. *Around a Bird House*, c. 1943
Oil on board mounted on masonite, 29 × 36 1/2 in.
unsigned

Provenance: Alice Roost, Kenosha, Wisconsin, and Edna McLeod, (niece of the artist), Concord, New Hampshire, 1967–90.

Exhibited: The Art Institute of Chicago, Room of Chicago Art, *Paintings by Jean Crawford Adams and Laura Van Pappelendam*, 1945; Keokuk Pubic Library, Iowa, *Exhibition of Paintings by Laura van Pappelendam*, 1967; Kenosha Art Association, Kenosha Public Museum, Wisconsin, *Exhibition of Paintings by Laura Van Pappelendam*, 1967; Rockford College Art Gallery, Rockford, Illinois, *The "New Woman" in Chicago, 1910–45: Paintings from Illinois Collections*, 1993 (also traveled to Illinois Art Gallery, Chicago, 1994; Illinois State Museum, Lockport, 1994).

RUDOLPH WEISENBORN 1881–1974

78. *Untitled [Geometric Abstraction]*, 1939
Oil on masonite transferred to canvas, 48 × 36 in.
Signed and dated, lower left: *1939 Weisenborn*

Provenance: Estate of Clark Hess, Chicago; Robert Henry Adams Fine Art, Chicago, 1990.

Exhibited: Mary and Leigh Block Gallery, Northwestern University, Evanston, Illinois, *Thinking Modern: Painting in Chicago, 1910–40*, 1992.

23. A number of reviewers singled out Strain's painting for praise in reviews of this exhibition. See, for example, J. Z. Jacobson, "The Big Ten" *The Chicagoan*, [1930], undated clipping in the Biesel Family papers, Archives of American Art, Smithsonian Institution, Washington, D.C. Roll 4208, frame 634, in which he describes "Strain's *Portrait of Emil Armin* [as] a song in brilliant color. It sparkles like the spirit of the Fourth of July, without being in any way sentimental." Frances Farmer, "Paintings of Ten Chicago Artists on Exhibit" *Chicago Evening American*, undated clipping, Biesel Family papers, AAA, Roll 4208, frame 636, refers to Strain's *Portrait of Emil Armin* as being in her "new manner." According to her records, she submitted *The Visitor* to The Art Institute Exhibition of Artists of Chicago and Vicinity in 1934. See Biesel Family papers, AAA, Roll 4207, frame 432.